Advance

"WE ARE THE MODS"

"In *We Are the Mods,*' Christine Jacqueline Feldman presents a fascinating, informed, and incisive chronicle of the history and cultural dynamics of the Mod subculture. Feldman deftly shows how the street-sharp, effortlessly cool Mod movement first took shape among style-savvy youth cliques of 1960s Britain, their bold élan developing into one of the decade's abiding icons of pulsating modernity. Carefully unravelling the minutiae of Mod panache, Feldman demonstrates the myriad nuances the style accrued as it was transposed to different global and local contexts. Exploring the contemporary 'reanimation' of Mod style in locales stretching from Cologne to Kyoto, *'We Are the Mods'* compellingly demonstrates how retro-chic cannot be dismissed as merely a depthless, postmodern 'imitation of dead styles,' but instead should be recognized as an active cultural enterprise in which media forms of the past are commandeered and mobilized in meaningful ways in the lived cultures of the present.

Drawing on a wealth of original fieldwork—including extensive oral testimony and many unique photographs—Feldman provides a perceptive and absorbing analysis of contemporary youth culture. Anyone interested in fashion, style, and identity will find *'We Are the Mods'* a tremendous resource, and the book deserves a wide audience."

—*Bill Osgerby, London Metropolitan University*

"WE ARE THE MODS"

mediated
youth

Sharon R. Mazzarella
General Editor

Vol. 7

PETER LANG
New York • Washington, D.C./Baltimore • Bern
Frankfurt am Main • Berlin • Brussels • Vienna • Oxford

Christine Jacqueline Feldman

"WE ARE THE MODS"

A TRANSNATIONAL HISTORY OF A YOUTH SUBCULTURE

PETER LANG
New York • Washington, D.C./Baltimore • Bern
Frankfurt am Main • Berlin • Brussels • Vienna • Oxford

Library of Congress Cataloging-in-Publication Data

Feldman, Christine Jacqueline.
"We are the mods": a transnational history of a youth subculture /
Christine Jacqueline Feldman.
p. cm. — (Mediated youth; v. 7)
Includes bibliographical references and index.
1. Subculture—History—20th century.
2. Youth—Social life and customs—20th century.
3. Popular culture—History—20th century.
4. Popular music—20th century. I. Title.
HM646.F45 305.2350941'09046—dc22 2009017956
ISBN 978-1-4331-0370-4 (hardcover)
ISBN 978-1-4331-0369-8 (paperback)
ISSN 1555-1814

Bibliographic information published by **Die Deutsche Bibliothek**.
Die Deutsche Bibliothek lists this publication in the "Deutsche
Nationalbibliografie"; detailed bibliographic data is available
on the Internet at http://dnb.ddb.de/.

Cover design and author photo by Corey LeChat

The paper in this book meets the guidelines for permanence and durability
of the Committee on Production Guidelines for Book Longevity
of the Council of Library Resources.

© 2009 Peter Lang Publishing, Inc., New York
29 Broadway, 18th floor, New York, NY 10006
www.peterlang.com

Printed in the United States of America

Contents

Figures

Foreword

The concept of "Mod" has had an enduring presence in the history of contemporary popular culture. From its original emergence in the 1960s, to its resurgence at the end of the 1970s and various "revivals" in ensuing decades, Mod has continually adapted and changed, with nuanced degrees, to suit the fashion and musical sense of respective generations of followers. At the same time, Mod retains a freshness and vitality, musically, visually and culturally, that has made it quintessentially appealing to young people the world over. Christine Jacqueline Feldman's book, *"We Are the Mods"* is a highly valuable, and truly fascinating, examination of Mod culture on a global level. It is both meticulously researched and, in the spirit of all well-conceptualized ethnographic studies, gets to the very heart of the topic through its lively engagement with those individuals involved in Mod culture today. As Feldman illustrates, from its U.K., youth-based origins, Mod has grown and developed to become a translocal, multi-generational cultural phenomenon. At the same time, however, the basic ingredient of Mod culture, a passion for and devotion to Mod among its devotees, remains as central today as was the case in the 1960s.

"We Are the Mods" brings home this inherent quality of Mod culture with incisive clarity. Feldman's attention to detail is impeccable. Through thoughtfully constructed vignettes, the reader is offered a series of highly detailed insights that span the history, style, locations, and cultural politics of Mod. In each case, Mods themselves are presented as significant interlocutors of the Mod story. Offering highly detailed narratives that mix personal insight with more collective knowledge, Mod is portrayed as a highly animated, reflexively experienced cultural practice. The historically rich dimensions of Mod culture are also brought dramatically to life, interviewees bringing to bear the full resonance of the, now increasingly applied, term "cultural memory". Rehearsing elaborate knowledges of Mod, that take in literary and media representations, the contemporary Mods in Feldman's book convey a collective understanding of Mod's highly rich cultural heritage. As such, the story presented in *"We Are the Mods"* is not, as is so often the case, a secondhand account based on film and documentary texts, archive material and so forth. Such elements are certainly integral to Feldman's account but are effectively interwoven with the everyday voices of those whose knowledge and cultural experiences of Mod provide new dimensions of expertise and authorship in the practice and representation of Mod culture.

Each of the four case studies of Mod culture, in the U.K., Germany, America, and Japan, respectively, presented by Feldman compellingly demonstrate the extent to which Mod has been reinterpreted and rearticulated in

a global context. Crossing borders of language and culture, Mod simultane-
ously draws people with ostensibly quite different life experiences together in
a trans-local celebration of a characteristic musical and stylistic aesthetic with
which they each identify. Although more recent work on youth culture and
music has begun to examine its trans-local qualities, "We Are the Mods" offers
perhaps the first truly in-depth, ethnographic study of this phenomenon.

Each of the aforementioned qualities of Feldman's book raise it to a new
level of importance, one that concerns not just Mod culture but also the
whole of youth cultural studies, and indeed what we may now wish to refer
to as post-youth cultural studies per se. A point that has often been made
about the academic literature on post-1950s youth culture, and one that
scarcely needs reiterating here, is that, despite its richness in terms of theo-
retical depth, such literature has often failed to engage in any meaningful way
with those young people at the center of its debate. Nowhere is this more
apparent than in the work of the Birmingham Centre for Contemporary
Cultural Studies. While there is much to credit in this work, many have ar-
gued that it also in many respects represents a series of lost opportunities, not
least of all in its rather one-sided documentation of a highly vibrant era of
post-World War II youth cultural history. Distinctive youth cultural groups
such as Teddy Boys, Skinheads, and Mods are depicted as highly localized
examples of youth cultural practice whose modus operandus was intimately
tied to its fixity within the class relations of late-capitalist Britain. As such,
the mode of analysis applied to such youth remains inherently limited; a
characteristically diverse range of cultural practices are interpreted using a
neo-Marxism analysis that reduces their cultural significance to signs and
symbols of an on-going class conflict. Within this context, any recourse to
the accounts explanations of the young actors themselves becomes unneces-
sary—such actors, we are told, would in any case not readily understand the
full social meaning of their actions. That such a means of explaining and ac-
counting for an entire era of youth cultural history has held sway for a long
period of time has produced a rather stultified knowledge of this history.

Similarly, more recent, post-subcultural accounts of youth, although
proposing a different set of theoretical tools to study youth culture, has rarely
revisited earlier eras of youth. Rather, much of the work published within
this new theoretical paradigm has focused on more contemporary youth cul-
tural forms, notably dance and hardcore. Indirectly, this has offered an op-
portunity for criticism of post-subcultural accounts on the basis that what
they are in fact dealing with here is a more "postmodern" manifestation of
youth cultural practice that is not as tightly arranged around issues of class,
territory and so on as its forbearers were. Again, however, no attempt is

made to join up the dots. Confined to history, accounts of Teddy Boys, Skinheads, Mods and Rockers have been allowed to speak through their representation—rather than through the words of those who have made such terms into living cultures. In this sense *"We Are the Mods"* represents a critical innovation in the field. Not content to deal with her topic matter at the representational level of the established academic canon, Feldman has gone all out to retell the story of a pivotal chapter in the history of post-1950s youth culture from the point of view of those who have lived and continue to live it. And there is undoubtedly much more scope for such highly innovative and important empirical research of this nature. A vast cultural territory of post-1950s youth culture waits to be mapped, empowering the voices of those that youth cultural research has often chosen to ignore.

At the time of writing it continues to be the case that academic research on music and style-based youth cultures remains largely unfunded by major grant awarding bodies around the world. As such, highly important empirical work in the field is all too often conducted by lone researchers funded by small scholarships or pursuing their research as a labor of love. In my view, *"We Are the Mods"* shines as a critical example of why youth cultural research in the field of popular music and culture should be taken more seriously as a critical area of socio-cultural and historical research. As a social, cultural, and historical document, *"We Are the Mods"* importantly demonstrates that, in a contemporary context, discussions of social and cultural development are inextricably bound up with the popular cultural developments of the last fifty years. The popular music and broader cultural practices of youth are an important aspect of this. As Feldman's work illustrates, the very essence of what we now refer to as global culture resonates with an array of sounds, images, styles, and associated cultural products and accessories that are continually being reappraised and reinscribed with meaning by successive generations in globally diffuse locations. In Feldman's case, the topic is Mod culture, but as her masterful work implies, a whole spectrum of popular cultures from the past continue to be implicated and articulated in the present.

In summary then, *"We Are the Mods"* is an absolutely crucial book for those interested in the intersection between youth culture, style and music as this has manifested itself since the mid-twentieth century. Feldman writes in a direct and commendably lucid style that will make this book accessible to both academic and lay readers. My hope now is that other writers will take inspiration from Feldman's work and produce studies of equal quality that map similar eras of pivotal importance in youth cultural history and their impact on current articulations of youth cultural practice.

—Andy Bennett, Griffith University (Queensland, Australia)

Acknowledgments

The completion of this book could not have been possible, to quote Lennon and McCartney, without "a little help from my friends." Though some may not normally categorize professional guidance and sponsorship as a kind of friendship, this experience has left me confident in being able to describe it as such. First and foremost, this project could not have been possible but for the encouragement, unequivocal support, and painstakingly detailed feedback given me by my advisor, Dr. Ronald J. Zboray, as well as Mary Saracino Zboray. Their enthusiasm for the topic was evident from day one and was unwavering throughout this lengthy endeavor. Without their wise and often calming words, I do not think the process would have been half as enjoyable, or the results as good. I am incredibly thankful for Mary Savigar at Peter Lang and Dr. Sharon Mazzarella, the editor of the *Mediated Youth* series. I am so very grateful that they, too, believed in the scholarly potential of this project. I owe an extra special thank-you to Sharon, who greatly helped me conceptualize how a 500-page dissertation could be the book you now hold in your hands! Thanks and respect also go out to Professors Sabine von Dirke, Akiko Hashimoto, Brent Malin, Jane Feuer, Lester Olson, and William Fusfield at the University of Pittsburgh. Additionally, I would like to thank Communication professors Peter Simonson (University of Colorado at Boulder), Robin Means Coleman (University of Michigan), and Jonathan Sterne (McGill University) for their involvement during the early stages of this project. Since this dissertation required on-the-ground research in Germany, Japan, and the U.K., funding for time abroad was necessary. I am eternally grateful to the German-American Fulbright Association for generously supporting my year abroad at the University of Hamburg. While there, I was helped enormously by Professor Axel Schildt, Director of the Forschungsstelle für Zeitgeschichte (FZH) at the University of Hamburg, and Ulf Krüger, who is the owner of the archive and store K&K Center-of-Beat. My research in Japan was funded by the University of Pittsburgh's Nationality Room summer scholarships. As the recipient of the 2004 Solis Horwitz grant, I was able to do research on the Japanese Mod scene in June and July of that year. I am more than appreciative of the stunning photographs of this trip taken by Corey LeChat—a few of which are found within these pages. Special thanks go out to Pittsburgh alumnus Dr. Junya Morooka and current University of Pittsburgh Communication Ph.D. candidate Takuzo Konishi for their help with Japanese-to-English translation. Though I was able to gather many excellent primary sources through the University of Pittsburgh's Hillman and Carnegie Mellon University's Hunt libraries, I would like to acknowledge the Popular Culture Association for awarding me the Marshall

Fishwick Popular Culture Collections Travel Grant. This allowed me to look at many more 60s-era magazines and ephemera housed in the Popular Culture and Music libraries at Bowling Green State University, Ohio. I would like to thank the helpful librarians there, as well as the equally accommodating staff members at the Colindale and St. Pancras branches of the British Library, the central branch of the Liverpool Public Library, the Archiv der deutsche Jugendbewegung (Burg Ludwigstein, Witzenhausen), Archiv der Jugendkulturen (Berlin), Staats- und Universitätsbibliothek Hamburg Carl von Ossietzky and the FZH Bibliothek (Hamburg), the Deutsche Bücherei (Leipzig), and the library of the Institut für Volkskunde/Europäische Ethnologie at Ludwig-Maximilians-Universität, Munich. Since this work relied so heavily on Mods to help tell their cultural history, I am forever indebted to the many participants from these three countries—and the United States—who graciously took time to share their experiences and insights with me. Some did indeed become friends. Many of those whom I met and interviewed also allowed me access to their private collections of fanzines, photos, hard-to-find 60s-era films and TV episodes, and ephemera. For this one-of-a-kind information, I sincerely thank Alain Ayadi, Thomas Czerlach, Dietmar Haarcke, Ulf Krüger, Carina Marrder, Olaf Ott, Eddie Piller, and Thomas Schmidt. Permission to reprint has been cited where possible; every effort was made to verify permissions on rare visual materials. Finally, I would like to thank my dear family and friends—near and far: Reynold Feldman; Marianna, Harper, and Sarah Levine; the Rizzo-Busacks, the Widdows; the Hamburg WG Ladies and Svandje Carstens; the staff at the 61C Café, Pittsburgh; and all of you who mean so much to me and have supported my "Mod Odyssey." I wish I could list all your names here, but you know who you are!

Most especially, love and thanks go to my late mother, Simone Hannelore Feldman (1931–2006). Though she was a child of war, she never lost faith that people are inherently good—a key principle I learned from her. Though she is no longer here to read this book, I think she would be pleased with both the substance and spirit of what is found within these pages.

"We Are the Mods!"

"Are you a Mod or a Rocker?" When Ringo Starr responded to this question in a famous scene from the Beatles' 1964 feature *A Hard Day's Night*, his answer was that he was a "Mocker." While the line drew laughs in English-speaking countries, it is questionable how many non-British audience members knew what either a "Mod" or "Rocker" really was. Flash forward to 1979: The film *Quadrophenia*, which is set in 1964 and was produced by British band the Who, depicted the conflict between these two youth "gangs" in England during that year. Halfway through the film, moments before the two groups are about to rumble, the Mods march toward the Rockers chanting "We are the Mods! We are the Mods! We are, we are, we are the Mods!" Though serving as a war cry in the film, it is also a bold affirmation of both individual and collective identity. In 1964 these two subcultures fought each other on the beaches of Brighton, Hastings, and Clacton en masse. While a new generation of Mods had begun appearing in Punk Rock's shadow by 1977, *Quadrophenia*'s 1979 debut drew even more would-be participants to this youth culture riot. The question then remains: "Why?"

The Mods, dressed in dapper attire and riding Vespas, believed they were truly *modern*—that they alone personified "the future" and "change." Originally they were mostly working-class youths who wanted out of their social "caste." They also thought the Rockers—dressed in leather and riding motorcycles—symbolized the past. Rockers embodied the uncouth ignorance and urban grit of working-class life that Mods wanted to escape. However, this story of identity moves well beyond southern British beaches and the stereotypical Mods depicted in *Quadrophenia*. This book hopes to answer not only the question *"Who* are the Mods?" but also *"What* is Mod?" and *"Where* is Mod?" Most importantly, though, it answers *"What does Mod mean* for those who embrace the lifestyle?" In doing so, the chant "We are the Mods!" grows in volume over time and space and, as it does, more nuances surface. Suddenly, this metaphorical queue of young people extends farther back than the eye can see. In distant, but distinct, voices one hears shouts in multiple accents and languages. Is that a Japanese Mod back there? Did I hear some German slip in? Are there dissonant voices that refuse to fight?—those who

see Mod as a more celebratory identity than one that requires desperate acts of violence? While this subculture spread to locations as disparate as Brasilia and Baghdad during its initial 1960s incarnation, this book examines the adoption and adaptation of Mod in Germany, the United States, and Japan from the 60s onward.[1]

While the Mod scenes chronicled here do not usually resemble those shown in *Quadrophenia*, four country-specific visions of Mod culture do mirror the meaning of Pete Townshend's neologism "Quadrophenia." Quadrophenia, according to Townshend, is a personality disorder (for my analysis, I prefer the term "state of mind") which allows four distinct identities to emerge—personalities he based on the four very different band members of the Who.[2] The film's Mod protagonist is said to suffer from this supposed affliction, but it is also the key to his identity. Here, through the lenses of British, German, American, and Japanese history and culture, four different "personalities of Mod" come to life. This international quadrophenia is, in fact, essential to Mod identity.

In 2007, while researching Mod culture at the Deutsche Bucherei in Leipzig, I read a book written by a German woman living in England circa 1964. In her book, *Die Beatles: Fabelwesen unserer Zeit?* (*The Beatles: Mythical Figures of Our Time?*), the author devotes a chapter to the British youth subcultures of Mods and Rockers. About the Mods she writes, "This 'movement' is remarkable—someone should study it."[3] Indeed, more than forty years since Mod culture first emerged in the United Kingdom and traveled on to countries such as Germany, the United States, and Japan, this book attempts to explain how yesterday's coolest version of modernity has remained an attractive lifestyle.

This study unashamedly crosses disciplinary boundaries. It is a cultural history of a highly mediated youth phenomenon, which owes its longevity to rebroadcast and recycled images from the early-to-mid 60s. It is also a story told in large part through an assembly of "Mod voices." Those who have participated in or closely observed Mod culture help unravel and clarify this untold story. German artist and musician Klaus Voormann (b. 1938) recounted to me that he was first acquainted with the word "Mod" through the Beatles, whom he befriended during the band's musical tenure in Hamburg. "I heard this because they were saying 'Mods and Rockers' and we [in Germany] were saying 'Exis and Rockers.'" Japanese Mod Kae Doi (b. 1970) told me: "I am a Modernist, so I like modern music…. Mod music is past music. So I am interested in techno… more technology." Londoner Sasha Hopkinson (b. 1988) guiltily admitted of the classic Mod movie, "The minute I saw *Quadrophenia*—I don't like to say it—but it did influence me in a way and a

lot of people don't like saying that." San Francisco musician Paul Bertolino (b. 1969) believed the Beatles, who were not originally considered Mod in the U.K., epitomized the culture to U.S. audiences in the 60s. "I don't think your average American kid in 1965 was hip to the full-on British scooter Mods."[4] As this collection of voices illustrates, defining the term *Mod* is complex. Thus, this originally British sensibility has captivated the imagination of young people around the world since the early 1960s and has evolved while doing so.

While numerous books offer detailed descriptions of the fashions and music of the Mod 60s period, this work hopes to display the grandeur and playfulness of this effervescent era by couching it within the utopian thinking attributed to generational change and "modernization," or "progress" established in the industrial era. Mod culture's merging of technology, playful consumerism, and a desire for a unified "world youth culture," created a map for youth culture styles to follow. However, despite the emergence of subcultures like Hippie, Glam, Punk, Goth, Rave, and Hip-Hop, Mod culture "scenes" remain active in many parts of the world. In May 2004, young people from many different countries attended the "Modstock" festival in London celebrating forty years of Mod culture. Mods today also educate themselves about the culture through websites such as Mod Culture and the Uppers Organization, which allow them to connect via new media.[5] I maintain that late nineteenth-century and early twentieth-century visions of technological progress positioned the original Mods as inheritors of an unequivocally "advanced" world. Young people who embrace Mod today, whether conscious of it or not, are incorporating this past dream of idealized modernity into their lives and can use it to counter current subcultural trends that appear cynical or nihilistic.

In this sense, the playful interpretation of technology espoused by the Mod generation via fashion, music, design, and consumerism emerged as a result of the crises engendered by the fallout of World War II and the developing Cold War division between East and West. I agree that "the A-bomb's apocalyptic revelation precipitated a new kind of global consciousness and a new kind of psychology. Faced with the prospect of instant vaporization, many human beings began to focus on the present, if not the instant."[6] Mod first appeared approximately twenty years after the war ended and was conceived by a generation born during economic crisis in the U.K., occupation and reconstruction of former Axis nations Germany and Japan, and the increasing affluence and influence attributed to the U.S. as the premiere Western power of the emerging Cold War period. In its initial appearance, Mod culture replaced despair with hope.

The unique cultural positions of these nations following World War II set the groundwork for Mod cultures to flourish. As the subculture's birthplace, Great Britain is my starting point. By the end of World War II, Britain was indebted to the U.S. for billions of pounds and much of its infrastructure needed rebuilding. The genesis of this subculture there occurred during the late 50s, a time when its citizens were slowly emerging from economic devastation into a period of heightened consumerism. Given this milieu, it is not surprising then that the British baby boomers were eager to leave this collapsed version of England behind and welcome a newly conceived modern age.

While Great Britain's postwar problems appeared primarily economic and structural, the aftermath of the war left Germany with similar problems coupled with a crisis of ideology and identity. Germany's National Socialists relied heavily on the enthusiasm of youthful participants, whether as soldiers or as "Hitler Youth." This dependence on the young was not an anomaly of Nazism, but stemmed from a long-standing view in German culture that youth held the key to cultural change.[7] Nonetheless, the discovery of Nazi brutality, as exemplified by the Holocaust, created a postwar climate where German youth were disillusioned by the older generation and looked elsewhere for inspiration.

Japan found itself in a similar position as that of Germany, although the end of the war brought a different version of cruelty and disillusionment in the form of the firebombing of Tokyo and the atomic bombings of Hiroshima and Nagasaki. Due to this end, the disappointment was with both the Japanese government and the Americans alike. Quickly occupied by American forces, postwar Japanese were thrust into a situation where they had to take direction from their occupiers in order to form a new government and way of life. This was especially difficult considering the Americans had razed many of Japan's cities.

Finally, as the country to suffer least physical and psychological devastation on its soil, the U.S. emerged economically and politically powerful after the war. Though a seemingly comfortable climate, the immediate postwar years in the United States were also made up of nefarious policies such as racial segregation, tightly policed gender roles, an atmosphere of social conformity, and the paranoid actions of the House Un-American Activities Committee (H.U.A.C.) lead by Senator Joseph McCarthy.

The extreme and unprecedented events that occurred within World War II, such as discovery of the German death camps and the atomic bombings of Japan, set the tone for a postwar climate that, despite the emergence of the Cold War, looked for ways to prevent a third world war. With the term

"mutually assured destruction" hovering between East and West, international understanding was nevertheless the wished for atmosphere of this new world. Given the governmental responses after the War to foster salutary foreign relations, particularly the advent of global organizations such the U.N. and U.N.E.S.C.O., or American exchange programs such as Fulbright, the Council for International Educational Exchange (C.I.E.E.), and the American Field Service (A.F.S.), it is easier to glean how Mod's international mindedness, on a micro-level, was part of the larger cultural climate of the times.[8]

In its global outlook upon Mod culture, this cultural history builds on, but also modifies landmark scholarship on youth subcultures. This Britain-specific work emerged at the University of Birmingham's Centre for Contemporary Cultural Studies (C.C.C.S.) during the 1970s. As illustrated in 1975's anthology *Resistance through Rituals*, scholars such as Stuart Hall and Dick Hebdige chronicled Mod as British, working-class, and male. In this narrative, the Mod's goal was to look more elegant than an upper-class "gentleman." This narrative, however, ignores that British lower-to-middle-class Jewish teenagers developed the first wave of Mod in the late 50s and earliest years of the 1960s.[9] And, excepting Angela McRobbie and Jenny Garber, these scholars do not fully recognize the importance Mod held for young women early on.[10] The leitmotif of this body of work seemed to be that subcultures lose their significance and dissolve once they are appropriated, translated, and "diffused" into mainstream, commercial culture.[11] However, this postmortem was premature, as Mod's existence has transcended both the 1960s and Britain.

Mod's international diffusion is often linked to the first wave of "British Invasion" bands, most notably the Beatles, who captured the attention of American youth with their arrival in New York on February 7, 1964, and who would soon become unofficial messengers for Mod style outside Great Britain.[12] Because the C.C.C.S. was mournful of mainstream co-optation, they did not recognize how this diffusion into mass culture liberalized Mod. In its later phase, Mod style became more fun-loving and less regulatory, global versus regional, and open to young women as well as men. It is in this progressive spirit that Mod became historicized as a radically ebullient cultural phenomenon. Due to this transformation, the word *Mod* became synonymous with the youth culture impulse of the times. What started as a sartorial rebellion by predominantly working-class, male teens in London during the early 60s had transformed mid-decade into an international youth movement of streamlined style and forward-thinking idealism.

By 1964, Mod culture's pictorial language included the Union Jack and the Royal Air Force target symbol, dandified male fashion and girlish female clothing, Modernist-cum-futuristic design, and hip forms of transport such as Italian scooters and Cooper "Mini" cars. Images of Mod style, as well as its accompanying commodities, traveled the globe with a soundtrack comprised of bands such as the Beatles, the Who, the Kinks, and the Rolling Stones. Within this cosmopolitan movement, the U.K., the U.S., Germany, and Japan are among the developed nations continually mixing past and present concepts of Mod into reconfigured notions of the style and culture.[13]

This project charts a temporal, conceptual, and geographic cartography of this youth culture phenomenon beyond the confines of Mod in the 60s. With the technological connections that have brought terms such as "globalization" into vogue since the 1960s, the cosmopolitan yearnings of 60s Mods are manifested today in new media options supported by a wider swath of contemporary youth culture. The ubiquity of personal computers, portable laptops, and the Internet, for instance, coupled with the continuation of exchange programs championed in the postwar era, influence how Mod is continued, redefined, and celebrated by youth in different corners of the planet. According to geographer Anoop Nayak, the vastness of globalization's effects must nonetheless be examined on a local level to understand the depth of its influences. Of course, this book will look at larger socio-historical circumstances that set the stage for Mod to be interpreted in varying ways. Mod culture is examined here as the ultimate youth culture on the cusp between the peak of late industrial society and the rise of postindustrial society. This project seeks to discover the multifaceted nature of Mod culture as created, transmitted, and ritualized *for* and *by* a slice of the world's youth since 1964. In sum, the origin of Mod's odyssey is contingent on the agency felt and individual choices made by young people from the 60s to today.

Due to its scope and method, my work on Mod is complementary to, yet different from, prevailing youth culture scholarship. Some of this difference arises from the methodology employed. This project combines archival methods and oral history, with participant observation completed in the United States, Germany, England, and Japan. Theories of youth culture past and present, emanating from communication studies, anthropology, sociology, and history will anchor this research. To examine thoroughly the genesis of this cultural phenomenon, I have consulted primary source documents from between 1960 and 1967. This archival and visual communication analysis has allowed me a close reading of original images, texts, and typography that defined Mod during these years. This methodology provided insights not found in strictly theoretical texts or secondary sources. Reviewing articles

and advertisements from the period allowed for a direct glimpse into the cultural milieu of the period.

Ethnographic research greatly contributed to my methodology because it allowed me to be as inclusive as possible of contemporary Mods' views of their culture. Ethnographic fieldwork, which complemented my archival research, was necessary to understand how Mod was initially, and continues to be, received. This fieldwork was comprised of both oral history interviews and participant observation. Oral histories provided autobiographical information to supplement archival data, while participant observation allowed me a close reading of the contemporary Mod scene in the four countries included in this study.

Oral history has often been used to document cultures or stories not necessarily included in "official histories," and it is a methodology that is beginning to be of service to popular or youth culture studies.[14] There are two reasons why this became my preferred method of ethnographic research. Since youth cultures and their activities have only recently been deemed worthy of careful examination, primary sources about Mod culture, like British Mod fanzines from the 1980s, which add first-person, contemporaneous observations were not systematically collected and are therefore scarce. For instance, even at a vast archive such as the British Library, one may only find a few issues of the many Mod fanzines that have existed. According to one historian, youth cultures like Mod are comprised of leisure activities that "rarely leave many records." Because of this dimension in studying Mod, I agree with his opinion that cultures such as these "cannot be seriously examined without oral evidence." Even when primary source material in the form of magazine articles or documentary footage about Mod culture appears, it has limitations similar to those of the C.C.C.S.'s textual analyses of subcultures, because it usually does not emphasize the voices of those involved.[15]

According to *Participant Observation: A Guide for Fieldworkers*, this method is one where "the researcher takes part in the daily activities, rituals, interactions, and events of a group of people as one of the means of learning the explicit and tacit aspects of their routines and culture." During my year in Germany I observed "explicit" aspects of German Mod culture—such as how many Mod girls at the Aachen Casino Royale" weekender had shoes, coats, and purses that were color coordinated (with a different color choice each night). The Mods I spent time with at this event, even while in "daytime casual wear," still looked more dressed-up than the non-Mod people surrounding them. However, it is even more the "tacit" aspects that inform this study in a way that no other methodology can. Participant observation al-

lowed me, for instance, to recognize the barely hidden look of contempt given to me by a DJ—one I had already befriended—for requesting a Yardbirds song (which, given the music at other events I had visited, was clearly "too-mainstream-60s" to be played). Moreover, my frustration at putting together just the right outfits to blend in with the women at events, proved more time consuming and frustrating than I could have ever imagined. It made me understand the "work" (and expense) involved in this lifestyle. Inserting myself into German Mod culture for a year allowed me to get to know it as an "insider."[16]

My "undercover" work allowed me to understand what kind of communicative slippage can occur when mainstream media try reporting on Mods today. As a television crew entered Hamburg's Prinzenbar to film, presumably, a segment on "the Hamburg Mods and what they do," Mod Harry Vogel told me he hated when mass media try and explain what Mod is because they always seem to get it "wrong." While it is contestable whether mass media reports of Mod are *always* off-target or not, I can verify that while doing my best to look 60s-ish in a green mini-dress and sporting a beehive, the Norddeutsche Rundfunk (NDR) camera crew shot a lot of footage of me (an American and not self-identified as a Mod) and my friend Bettina Peter (from Cologne) as "Hamburg Mods" for a June 2007 episode of *Rund um den Michel* (*Around the Michel*)— a nationally broadcast show about the city's cultural life.[17] By visually associating Bettina and me with "Mod," or Hamburg's Mod scene, the television crew was, albeit inadvertently, misinforming the German public on the topic. One could argue that such mediated accounts help in assessing how Mod may come across, and hence, change, via these interpretations.

While participant observation privileges the researcher with a simultaneous insider-outsider position, oral history interviews summon the voices of actual participants, foregrounding memories of lived experiences. Their stories create a lively and comprehensive composite image of cultural phenomena. In my study it is not primarily celebrity voices who, for instance, discuss the role of the Beatles in Germany, but ordinary folks who were vital in making Hamburg the Beatmusik capital of their country.

Despite Mod style's continuing existence both in commercial and subcultural forms, an obvious gap still exists between scholarship on its origins and its subsequent manifestations. The study of Mod stands to benefit from my close scrutiny of the historically contingent processes of production, dissemination, and reception with the new historicism in cultural analysis.[18] It is my sincerest hope that this book will be a welcome addition to a broader scholarship on late-twentieth-century international youth culture.

The Mod youth culture of the mid-1960s emerged from what British historian Arthur Marwick describes as a "unique era." The decade's significance is bound to distinct and rapid cultural transformations. Key changes included more ubiquitous use of technology such as color television and affordable jet travel, new concepts of identity formation via fashion, and, most importantly, the growing cultural influence of young people.[19] More so than youth of previous decades, Mods consciously and deftly galvanized the quickly accelerating communication technologies to transmit their style around the world. Between 1964 and 1967 a transnational flow of youth-oriented television shows, films, print media, and commodities such as records and clothes globally united young people. Mod's innovative and androgynous fashion sense raised questions about gender aesthetics and sexuality, while the style's global reach expressed a desire for international openness among youths. Fueled by the marriage of expansive media technologies and utopian, generation-specific impulses, Mod's international impact on youth during the mid-60s was unprecedented and foreshadowed the international sweep of the late 60s counterculture. While the original wave of Mod peaked for just a few years (early 1964 to mid-1967), its adoption by youth in succeeding generations suggests an enduring cultural journey.

The study of subcultures remains a cross-disciplinary subfield in the humanities. The scholarship exemplifies the diverse range of disciplines within the humanities and social sciences: literature, history, American studies, geography, communication, and sociology, for instance. Born out of an international fusion of theories, youth culture studies continue to be a transnational project with scholarship focused on (and emerging from) various countries around the globe. Given the speed-up of technology and scholarly discussions of globalization for some time now, it is no wonder that current scholars are turning to discussions of a global or international youth culture. Even if this may seem something pertaining only to the current era, it is actually a theme that can be traced back to the postwar period. Arthur Marwick, author of *The Sixties*, finds the connection between youth culture and technology as the locus for discussions of an internationalized culture today. According to him, technologies such as television, transistor radios, modernized telephone systems, expanded jet travel, long playing records, and the pill all contributed to shaping the youth culture of the 1960s. In his list of reasons why the 1960s were important, his culminating reason is that this period aspired to define the "ideal of a multicultural future world." As a geographer, Anoop Nayak sees the importance of technology's connection to youth vis-à-vis the definition of globalization, whereby the "world is crystallized into one space." In this compression of space, various nationalities of

youth potentially can communicate ideas and styles more effectively. None-theless, Nayak's study of youth culture in Newcastle, England, asserts that global influence can only be measured within local space. No matter how "small" the world may feel, it might be more useful to see how global influences play out "on the ground" one community at a time.

Communication scholar Charles R. Acland's essay "Fresh Contacts: Global Culture and the Concept of Generation" describes today's youth as that of the "global teen." In his estimation, "cultural forms and practices have created a transnational and cosmopolitan youth sphere."[20] He notes that this is particularly evident in the exchange of ideas via new technologies. This notion has been further explored by Richard A. Peterson, Andy Bennett, and the contributors to their anthology, *Music Scenes: Local, Translocal and Virtual.* Also important to this discourse is *The Post-Subcultures Reader* edited by David Muggleton and Rupert Weinzierl. It is comprised of essays that de-scribe contemporary youth culture as no longer bounded (à la the Birming-ham School) by national borders. According to most of the anthology's authors, technology's erosion of nation-specific youth culture discourse re-quires a global perspective in all forthcoming scholarship.[21]

As it plays now, the interdisciplinary nature of youth culture studies fits well into the heterogeneous field of communication. While previous work on youth has come from disciplines such as sociology, anthropology, and his-tory, my focus as a media scholar has been, to paraphrase James W. Carey, to elaborate upon the "transmission" and "ritual" aspects of Mod youth culture as an international phenomenon.[22] More generally, the blossoming subfield of subcultural or youth culture studies within communication will no doubt benefit from generational turnover, which offers an endless progression of unfolding narratives to be told and analyzed by this scholarly community.

This work critically engages past and present conceptualizations of mod-ernity through "Mod culture." This book's primary argument is that Mod's forward-thinking sensibility allowed young people in the 1960s and since to reevaluate personal meanings of "being modern." The primary question that drives this argument is: What is it about Mod culture and its aesthetics that still bespeak a contemporaneity despite its being a more than forty-year-old style and way of life? Beyond grounding the discussion in Mod's initial emergence in the 1960s, the book broadens the cultural history of Mod by asking current participants—in four different cultural contexts—how they have come to understand and/or reconceptualize Mod's original 1960s view of "modernity."

The ordering of the chapters underscores the actual chronology of the culture's temporal and geographic movement. The first chapter starts in Brit-

ain, because this is where Mod began. The second chapter looks at Germany as one of the first countries to be exposed to this sensibility through the Beatles and "Beat" bands from England. The next chapter is about Mod-influenced gender aesthetics in the United States, since the 1964 "British Invasion" brought this style there. Finally, Japan is both the farthest geographical point from Britain and, also, where Mod did not fully take root until 1966. Thus, the structure of the book parallels the historical trajectory of Mod culture.

In the first chapter, "Whose Modern World?: Mod Culture in Britain," I analyze the historical origins of this subculture. Every cultural phenomenon has its start somewhere, and Mod began in Britain—but *why*? Answering this question requires a brief look back into the Victorian period. This chapter opens with the idea that subjects of the first industrialized nation had an initially problematic relationship with modernity. If industry and urbanization made life for the working classes miserable in the 1860s, how would the same resources create a new and jubilant lifestyle in the 1960s? Through the voices of British Mods past and present, I examine how postwar aspirations for a "new and improved" modernity—something well beyond the confines of industry and warfare—have influenced different facets of contemporary enthusiasts' lives and what the particularly British legacy of this youth culture is.

While scholarship on postwar youth cultures has often focused on the threat of "Americanization" to other cultures worldwide, this chapter turns that notion on its head by acknowledging the impact of the Mod-influenced "British Invasion" of the mid-60s and its enduring aftermath. Mod did start in Britain for a reason, and this chapter explores the key issues as to why it did. I suggest that the British Mod identity arose not only from the eradication of National Service (hence, giving more leisure time to youth) or the influence of American music such as Modern Jazz and Rhythm and Blues, but from the country's specific struggle to redefine itself as "modern" after World War II. With the British Empire's decline, decolonization, and a lingering and problematic preoccupation with "class," young Britons were in a position to challenge these increasingly outmoded connotations of what "Modern Britain" or "British subjects" had evolved into since the Industrial Revolution. In utilizing fashion and music culled from diverse social actors—whether British or foreign—and a historical context in which the country's Prime Minister Harold Wilson would call upon British youth to be a part of the "white heat" of a new, technological age, I situate Mod's initial emergence within this era.[23] In this period, Mods granted themselves the agency to run as fast as they could from dour Dickensian stereotypes of modernity to

something more positive and democratic. In rethinking British narratives of modernity during the 1960s, the original British Mods set the tone.

In Chapter Two, "The Young Idea: Cosmopolitanism, Youth, and Mod-ernity in Germany," I look at socio-historical circumstances that may have laid the groundwork for Mod there. Long before Mod fashion and music were adopted by young people in 1960s Germany, the concept of "youth" as fostering modernity's "progress" had been established there. By briefly examining earlier twentieth-century German youth movements, I position Mod's appearance in the 1960s within an ongoing national debate about youth's influence on culture. Furthermore, Mod's appearance in post–World War II Germany was imbued with meaning specific to that time. Young Germans in the early 1960s were still struggling with National Socialism's legacy. If young people in Germany could not respect the parent generation and its heavily varnished fascist past, youths sought models from outside their cultural frame of reference. With British and American military forces' presence still palpable, young Germans were exposed to the emergent Mod culture of England through interpersonal and mediated communications.

The oral history accounts at the chapter's conclusion, from Mods within the current scene, show how the subsequent generations of Mods—separated as they are by one or two generations from the Third Reich—understand the cosmopolitan aspect of this subculture within the current realities of the European Union. Does today's Mod scene mirror this initially attractive element of internationalism that it held for German youth of the mid-60s?

In the third chapter, "Mop-Tops, Miniskirts, and Other Misdemeanors: Mod as 'Gender Trouble' in the U.S.A.," the story of American Mod starts with the Beatles' February 1964 arrival in the U.S. The band's televised appearances on *The Ed Sullivan Show* soon triggered a youthful enthusiasm for all things British. Beyond the Beatles' style—which was also influenced by the original Mods—and their music, young Americans were soon introduced to Mary Quant and Carnaby Street fashions, "Mod versus Rocker" seaside battles in Britain, British pop and op art, and bands like Gerry and the Pacemakers and the Rolling Stones—all of which were conceptualized as "Mod."

While acknowledging all these aspects of U.S. Mod, the chapter particularly focuses on how Mod fashions were stigmatized there and what historical context influenced this reception. This chapter traces American gender stereotypes back to the late-nineteenth century. I examine how what I call "gender aesthetics" among middle-class Americans were determined through prescribed fashion and appearance. How did their lingering influences determine mainstream America's attitude toward Mod by the time of this mid-

60s "British Invasion?" Mod male fashions were read as effete by many adults (and some youths) while the subculture's girlish or androgynous female fashions caused a similarly disquieting response. At this time, male teenagers with "long hair" were being suspended from classes, or in extreme cases, expelled from school. Mod girls were often chastised for wearing short skirts, or seen as in a state of prolonged immaturity for wearing "Mary Jane" shoes and baby doll dresses. Since much of the American trade and academic literature available on Mod focuses on the sensibility as a fashion of the 1960s, I examine, through oral history and personal correspondence with American Mods, how this relationship between gender identity formation, fashion, and mediated images of 1960s Mod has influenced contemporary American enthusiasts' understanding of the lifestyle.

In the fourth chapter, "Japan's 'Cult of Mod,'" I suggest that the country is—though the most far-removed from the subculture's British origins—in some ways, the most Mod. How so?: In its modern urban spaces, consumer practices, and the Mod scene itself. As in the other chapters, I situate Japanese Mod in a historical context. I first examine the idea of a lengthy history of mimetic cultural practices, such as the adoption of Chinese ideographs in the sixth century and American baseball in the nineteenth. Second, I describe the rebuilding of postwar Japan in trying to understand how Mod designs are part of the country's cityscapes. Finally, I examine the arrival and adoption of the already hybrid culture of Mod from the 1960s onward. For this final chapter, I revisit the themes of modernity, cosmopolitanism, and gender to examine how the only non-Western (if Westernized) country in this book has become, ostensibly, the premiere "Mod nation" today. The Mod phenomenon was and is a forward-thinking one: one that has embraced different strands of modernity. In analyzing the "look" and visual language of Mod— from fashion to graphics to architecture—the study of Mod visuals in Japan is especially provocative.

The conclusion of *"We Are the Mods"* reaffirms that the adoption of this self-reflexively "modern" youth culture has cultivated identities of young people in the U.K., Germany, the U.S., and Japan who want to live in a more active, progressive, and self-aware way apart from mainstream culture. This principle was true in the 1960s and remains true for today's Mods. Whether discussing changing perspectives of youth, gender, or visual spaces, nation-specific reconceptualizations of "modernity" in these various aspects of culture can be historically attributed to the Mod phenomenon. I truly hope that readers will, by the end of this book, be able to say to themselves, "So, *these* are the Mods. Now I know what all the fuss is about!"

Whose Modern World?
Mod Culture in Britain

"You'll hear my children say, all or nothing for me." –The Small Faces, 1966

"I am not a number, I am a free man." –*The Prisoner* TV show, 1967

After a day reading about English Mod culture in the British Library, I went to meet Eddie Piller at an East End pub near his office. I was pleased he had agreed to an interview, because I had come across issues of his former fanzine, *Extraordinary Sensations*, at the library. He had been part of the London Mod Revival in the late 70s, his mother ran the Small Faces Fanclub in the mid-60s, and he DJed in many parts of the world—now occasionally for the BBC.[1] I found Eddie at a typical pub—still quiet, since it was only four o'clock. After I introduced myself, we talked for over an hour about "Mod and the world." He told me about what he had learned from his parents about Mod, the violence between Mods and Skinheads in the late 70s, and the difference between "Mod" and the "Mod Scene." Later, upon reading the initial manuscript of this publication, Eddie would tell me he thought my interpretation of the interview "too literal." Nonetheless, the excerpts highlighted here offer readers a solid testimonial as to how the subculture may have come to be.

As he spoke, Eddie's distinctive, gravely voice and Cockney accent expressed varying emotions. At one point, he derided what he saw as near-fascistic attitudes in the current British Mod scene. He touched my hand reassuringly and said, "Anyway, I've lost me temper," and then continued. Involved with Mod—one way or another—since age fourteen, Eddie had clearly thought about this topic. I finally came to my main question: If Mod was initially about working-class kids in London searching for something better, why had the term also attached itself to the Beatles and the "Swinging London" phenomenon? I feared this question because some Mods vehemently separated the two: the Beatles and Swinging London were "60s Pop," and the Rhythm and Blues/Soul, working-class underground was "Mod." However, Eddie's not so black-and-white answer surprised me.

> The first thing was the Jazz thing in London, where these guys were living the life… wearing great clothes… into bebop. Then kids…15, 14 years old saw them and thought,

'Fuck me, they're cool. I aspire to that.' These kids were the first to be influenced by things like advertising…American concepts in advertising sales or in the concepts of advertising development were affecting these kids. These kids saw Mod as a way out of their boring, humdrum working-class lives, and they grasped the elements of Mod that [were] attractive… so they looked at the old Jazzers, or the youngish Jazzers. They got into that and they looked at the boss at work and thought, 'You know, I don't want to work in a factory. I want to work in an advertising agency and places like that.'

Eddie emphasized several important points. The influence of Jazz and advertising were linked to Americanization. In their attraction to both this music genre and American advertising, working-class kids found both figurative (the free-sounding rhythms of Jazz) and literal (better work) means of escape.

And all these things led to the creation and the concept of two men: Andrew Loog Oldham and Peter Meaden, who collectively and separately arrived at the concept of youth culture as commodity. Youth culture as art *as* commodity—i.e., 'I'm gonna sell this.' And, in order to increase its selling it has to come overground. It's been underground, but these kids have distilled it—they've taken the old Jazz thing and improved it. They've set new rules, new kinds of concepts as to what it is to be a Mod and then they'd gone and thought, 'Right. I wanna sell this to people. To do that, I'm gonna get the Rolling Stones and and I'm gonna get the High Numbers [the Who's name while with Meaden] and on the back of that I'm gonna get John Stephen and Carnaby Street and I'm gonna make Mary Quant the Mod shop. And I'm gonna charge for my services to do this, because I want everyone in the world to think like I do.' And so, for the first time ever you have the concept of youth culture sold as commodity.

I was intrigued by Eddie's story of how Mod evolved from an underground scene to a full-blown, media-saturated phenomenon. Suddenly it included bands like the Rolling Stones and the Who (managed initially by Oldham and Meaden, respectively) and designers Quant and Stephen. It suggested that an essential part of Mod, even if not present from day one, was a sense of entrepreneurship. Since working-class kids were trying to find a way "out" of factory jobs, why not "sell" what they knew best and had the most fun with? Young men like Oldham and Meaden reconfigured a working life that was creative and fulfilling financially and personally.

Now, by the time [Mod] gets away from its roots of Soho—you're in America—it's a target T-shirt, it's… Mary Quant. Mary Quant's logo was a target with a flower around it—for God's sake. You're left with the bite-size elements of commodity. And maybe it's divorced from the elements of the actual culture that went behind it, but that doesn't mean it's any less Mod. The British Invasion, the Remains [an American garage band]…were no less Mod than Herbie Goins and the Night-Timers. And the Who were copying Wilson Pickett, you know? The whole thing is mixed up and stirred. We ripped off your music and sold it back to you. You sold it back to us…. I mean, you can't say 'the first bit's not cool, the second bit is.' We can mix old and new and create these scenes and we

do it *very fuckin' well*. We're the best in the world at doing it. But it all comes down to 1960 and that decision between Andrew Loog Oldham and Peter Meaden to sell Mod.

The last part of Eddie's answer surprised me most. He was not making a typical "authenticity argument"—that *true* Mod culture was tainted and, eventually, killed off by commercialization. Rather, the whole concept of Mod was a continual remixing of Anglo-American sensibilities, of which marketing and selling were integral parts. Here, Englishmen Oldham and Meaden, not Americans, were those who first marketed Mod.

Though he mentioned the Rolling Stones and Mary Quant, he still did not name the Beatles. I asked him again about their role in the Mod story. He smiled and responded: "Are you a Mod or a Rocker? I'm a Mocker...that's a good answer," if you don't want to choose sides. He continued, "Some things John Lennon would say—totally Mod— political things... serious political issues. Ringo wasn't necessarily Mod, but he was a very funny guy. George Harrison—king of the fuckin' Mods—I mean, come on!" As he said this, I laughed and suddenly imagined a scene in *A Hard Day's Night* (1964) in which George Harrison dismissed a TV executive for asking him to represent a line of teen-oriented and, in Harrison's mind "grotesque," clothes (what he calls "grotty"). In this part of the interview Eddie continually referred to Mod as a "broad church," that has woven together at least "fifteen different strands" of Modernist ideas. Trying to visualize what "strands" he might have meant—I summoned a wide mélange of images. It was not just the Who's Pete Townshend sporting a Union Jack jacket while smashing his Rickenbacker guitar or Parka-clad teenagers on Italian Vespas cruising through London streets. I pictured everything from curvilinear, white furniture made in Scandinavia and boxy-looking buildings designed by continental New Brutalists to French op-art mini dresses and the helium-filled silver balloons at Pittsburgh's Warhol Museum. These varied images and artifacts were not solely of one nation, but all belonged to a vision of "the modern" that came to fruition in the 60s. Since Britain is geographically positioned between continental Europe and the Americas, it became a space where ideas from both cultures could commingle. Though of mixed parentage, Mod was born in England, which made Eddie's claim that the British "invented it" legitimate.

Why Britain?

Most accounts of Mod's initial appearance in England link it to undreamed-of consumer possibilities afforded youths by the postwar period. However, if

this were the sole reason, the subculture could have just as easily evolved in the U.S. or Western Europe. Mod began in Britain because it was the first industrialized and, arguably, "modern" nation.[2]

This industrialized world was such that "class" became a stereotypically British problem, even a "national obsession."[3] Since the first Mods were from working-class backgrounds, the issue most relevant here is the way in which earlier modernity—that of the Victorian era—created extreme economic disparity among the classes. In Victorian times, it was not uncommon for working-class men to pawn their good "Sunday clothes" (if they had them) every Monday and collect them from the pawnbrokers the following Friday, their payday. In factory neighborhoods large families were crowded into grimy cellar dwellings with little or no furnishings. Thus it was not just horrific housing or back-breaking work that belittled workers' lives, but also the lack of good clothing. While the story of Mod culture is not necessarily a "rags to riches" story, the desire and ability of working-class teenagers to dress more stylishly is an essential facet of Mod's vision of modernity. It is thus clearer how descendents of "Dickensian" urchins of the 1860s eventually became the impeccably groomed Mods of the same East End streets by the 1960s.[4]

World War II proved an exceptionally strong catalyst for Britons to re-evaluate what modernity had wrought. In its aftermath came bankruptcy and a greatly downsized Empire. Simply put, Great Britain was no longer a superpower. The war also affected many civilians. Not only did many British combatants die, but mothers and children met their end trying to survive German bombings.[5] Wartime destruction, moreover, had disillusioned the populace. Although the brutality of World War I had created a "lost generation" of young bohemians, the destruction of World War II was unprecedented. The atomic bomb could not only destroy nations, but the world itself, and the Holocaust showed how millions could be killed by prejudice combined with a modern "production line" mentality. These mass-produced slaughters psychologically affected citizens around the world.[6]

Despite the decline in world power for Britain, an economic upswing by the mid-50s allowed the working class more participation in economic and social life than ever.[7] This trend enabled young people of different classes to reconceptualize modernity. This new vision emphasized leisure over work and youth over class. Mod culture also found ways to add beauty and color to too often ugly and monotonous urban space and technology. If London's working-class neighborhoods were especially unattractive, blackened by industry and then World War II, they would be micro-gentrified by the Mods through their aesthetic choices of clothing, transportation, and collectables.

In the shadow of technology as life-destroying, Mods' use of scooters, electric guitars, records, stereos systems, and transistor radios showed it could be life-enhancing as well.

From Modernists to Mods

Prior to the full-blown birth of Mod culture in 1963, working-class youths started experimenting with fashions. In the 50s, Rock and Roll, Skiffle (a mixture of Folk and Blues), and Trad ("Dixieland") Jazz offered teenagers fresh audioscapes. With these different musical genres came distinct "looks." For instance, Rock and Rollers tried to imitate the pompadour and leather-clad style of Elvis Presley or Gene Vincent. Their girlfriends adopted a complementary style.[8]

Modern Jazz provided a new guiding light for and is the most "direct ancestor" of Mod culture. "Modern Jazz" in effect asked youth to reconsider what being modern meant. No wonder "Mod" would remain the moniker for the progressive youth style of the mid-60s. The followers of this music, the "Modernists," embraced the esoteric "bop" sounds of trumpeter Miles Davis, saxophonist John Coltrane, and pianist Thelonius Monk.[9]

What further set the Modernists apart from the Teds, Rockers, Trads, or "Skifflers" were its participants. Unlike the British-born, mostly white Trad bands, Modern Jazzers were primarily African Americans who came to play for World War II G.I.s stationed in England. There were also Jewish Modernists with tailors as parents who found a turned-out appearance easier to come by. Many newly immigrated West Indians joined the crowd, feeling some solidarity with the black Americans onstage. The most frequented Modernist nightclubs in London were in Soho, a district where many West Indians, by the 1950s, had also settled. The neighborhood also supported the then-underground queer culture, making overlaps between the two subcultures possible.[10] The Soho of the late 1950s to early 60s had the kind of bohemian reputation that Paris's Left Bank had enjoyed in the 1920s. It was a place where everybody was welcome to "join the party." While Jazz had historically symbolized the "New World" of the United States, this modern variation, full of experimentation, called for a "new human being...a sophisticated world citizen who simply did not fit into old racial [or other established] patterns."[11] Joining the Modernist scene implied a common bond through lifestyle-based interests rather than race, religion, nationality, or class.

The working-class Modernists, having left school at fifteen, cultivated an image of upward mobility. The males' Italian-cut mohair suits—complete with narrow jackets and tight-fitting trousers, pointed shoes or boots,

"French Crew" (a shaggier crew cut) hairstyles, and sometimes an overall American "Ivy League Look"—mimicked bourgeois intellectual or jet set refinement.[12] Their style was underscored by their use of Italian Vespa or Lambretta scooters. Eddie Piller's father was a Modernist: "He had a Lambretta and... he was very smart, but he didn't like the music that came after '64. He wasn't into Soul, he was into Jazz." Modernist girls were more modest in appearance, with short haircuts that may have been homage to the flappers of the 1920s.[13] They often wore simple outfits in muted or neutral colors. A former London scene member described most Mod girls as "fairly unattractive," and suggested it perhaps "was a relief for them not to be feminine or painted up."[14]

While different youth "sects" sought music-oriented spaces distinctively their own, there was inevitably some overlap. Italian-style cafés with authentic espresso machines opened nationwide. Teenagers frequented these alcohol-free haunts such as the Soho's 2is, Manchester's 700 Club, or Liverpool's Casbah. Some teenagers experimented with drugs before going out, usually amphetamines because Modernists like the amped-up feeling of "speed."[15] At the same time, many Jazz cellars opened. The club that would later become synonymous with the Beatles—Liverpool's Cavern Club—opened as a Jazz venue in 1957.[16]

Trying to hear new kinds of music outside a coffeehouse or nightclub was not easy. Before the mass distribution of records, teens relied on local resources: American servicemen and, for port-city residents in Liverpool and Newcastle, what was found at the docks.[17] Gibson Kemp (b. 1945), a Beatles-era Liverpool drummer, related memories of this phenomenon to me:

> I think, the resounding musical influence was the fact that [Liverpool] was a port and lots of people went to sea—particularly a guy in the next road whose name escapes me—his father was a captain on a ship and used to like music and he brought, like, all the Rock and Roll records back before anyone else had imported them, so every time a ship came into port, we'd roll 'round to his house to listen to them. And I remember that being quite a [to do]...and it wasn't just me... that was happening all over the place.

Due to BBC's conservative programming, A.F.N. (American Forces Network) and Radio Luxembourg easily captured an enthusiastic youth following. One West Midlands native "from a very poor family" remembered, "So in 1955 I was 13 yrs. old... and saved up my money from my newspaper round to buy a 'Crystal Set' Kit which you assembled yourself c/w headphones!! On this I would tune in to R.Lx. I used to listen in to the Top Twenty every week." A "Luxy" listener from Coventry recalled the "days of coffee bars, feeding the juke box with what loose change we had... These

were the days when music was music." Here, adolescents and teens alike huddled under bedcovers listening to the station on transistor radios late into the evening.[18]

Many teens embraced American music styles and matching wardrobes. In this sense, postwar youth implied that interest-based allegiances might become stronger than the traditional ones connected of "class, job, family, or neighborhood."[19] Although various youth cliques added variety to British cities, the Modernists would prove the most influential. In the mid-60s, Cathy McGowan, hostess of the popular music TV show *Ready, Steady, Go!* (1963–1966), declared that "the Mods [had] won" the hearts and minds of young people across the country.[20]

By 1960 several key events would further enable Mod culture to come into its own. National [military] Service was discontinued, thus allowing young men to enjoy youth culture without interruption. The year also saw the national ban on D.H. Lawrence's 1928 novel *Lady Chatterley's Lover* re-pealed, albeit through a highly publicized court case. The book's controver-sially explicit language was only surpassed by the upper-class heroine's sex scenes with a working-class man—a tribute to Mod's ethic of classlessness.[21]

Modernist Evolution: 1961-1963

While the Soviet Union and the United States both launched men into space, the U.K.'s forward thrust remained earthbound. The films *A Taste of Honey* and *Victim* showcased northern working-class accents, interracial ro-mance, unplanned pregnancy, and homosexual characters. These films' "kitchen sink realism," as the genre was dubbed, brought "marginal" social actors into the public eye.[22]

In 1961 Modernists seemed to be shifting musical allegiances from Modern Jazz to London-born electrified Blues and Liverpool-based "Beat Music." In London, a group called Blues Incorporated began crafting what would become known as "British Rhythm and Blues (R&B)." Concurrently, the Beatles debut at Liverpool's Cavern Club ignited the ascendancy of "Beat Music." It was also during the early 60s that many working-class youth en-rolled in art schools and increasingly saw the world in artistic terms. In this sense, 1961 saw a new kind of British Empire being constructed from the ground up.[23]

During this year, London's nascent R&B scene mushroomed. These musicians wanted to mimic the larger-than-life image of the traveling Afri-can-American Blues musicians. According to an interview with the Who's Roger Daltrey, this music "emanated from struggle and the English work-ing-class totally identified with black America. The Blues had that element

of rage from the underground."[24] Two of the scene's pioneers, former Jazz musicians, guitarist Alexis Korner and harmonica player Cyril Davies, founded Blues Incorporated in 1961, the first British band playing electrified Blues. Their performances attracted many young, aspiring musicians—several of whom eventually played in the Rolling Stones and the Yardbirds.[25]

British R&B offered an environment that countered that of Modern Jazz's. Unlike bebop's complex sounds and hip posturing, Blues connected musicians and listeners through accessible, repetitive rhythms (the twelve-bar blues) accompanied by engaging lyrics laying bare life's gritty realities. Dick Heckstall-Smith, Blues Incorporated's saxophonist, remarked: "I began to feel that [Modern Jazz] audiences and musicians... somehow [had] been browbeaten into believing that it wasn't quite right to enjoy themselves too openly."[26] For these teenage R&B fans, this emotional music provided an ebullient way of "being cool." This scene created an important stream of Mod culture because it suggested that while the modern world was not always good or just, room for joyful expression could still be had.

Youthful but no longer strictly working-class followers frequented the R&B nights hosted by Blues Incorporated. Here they learned musical techniques and had opportunities to sing or play. The Rolling Stones' Mick Jagger remembers aspiring singers doing versions of Muddy Waters's "I've Got My Mojo Working." Participants of every social class received a non-traditional education while escaping from mundane careers. These nights proved that what had been mere hobbies might now become paid work.[27]

Soho's Flamingo club supported this turn toward R&B while showing Mod's hybrid roots—with African-American, Jewish, and Caribbean influences present. Originally a Jewish social club and Jazz club, the Flamingo was housed in the basement of the Whiskey A-Go-Go. An early favorite of G.I.s, it became "the place" for R&B "All-Nighters" running from midnight to dawn.[28] At the Flamingo, East End Mods saw, perhaps for the first time, Caribbean men wearing their short brimmed, pork-pie hats—yet another accessory to appropriate.[29]

The Beatles meanwhile began playing at the Cavern, where they would play over 250 times by 1963. The group covered a wide variety of black American hits such as "Kansas City," "Money," and "Boys." These selections pointed to the growing influence of R&B and Soul on British artists and the soon-to-be named "Mods." At this time, R&B was still performed predominantly by blacks. Recordings by R&B's Willie Dixon, John Lee Hooker, Muddy Waters as well as Soul's Booker T. and the M.G.s, Wilson Pickett, and Otis Redding also made their way to Britain by the early 60s.

In Soul music—a spiritually charged blend of R&B, Gospel, and Blues—the role of the "outsider" was visible and valued. Young fans found it true to "the immediacy of lived experience."[30] In this way, being an outsider was deemed a more authentic experience of individuality, since being on the "inside" connoted capitulation to authority and conformity.[31]

While a new "British R&B" was born in worldly London, even youths of a seemingly dismal and backwater city like Liverpool felt the spirit of change. In fact, Liverpool became a "swinging city" before London—a testament to the tenacity of Merseyside's youth. A key player in making "Merseybeat" a household word nationwide was Bill Harry. He attended the Liverpool College of Art and, by 1958, had become a journalist. Jazz aficionado Harry soon became aware of the burgeoning music scene locally through his classmate, John Lennon. To promote this growing local phenomenon, he issued a new magazine, *Mersey Beat* (1961), and distributed 5,000 copies to 28 local shops. The magazine featured reviews of music events and up-and-coming bands plus advertisements for local shows and stage costumes ("gear"). At the height of the weekly's run (ca. 1964), it circulated throughout the northwest of the U.K. and inspired publications like the *Western Scene* and *Midlands Beat*.[32]

Harry soon received submissions from Brian Epstein, manager of his family's North End Music Stores (NEMS). Born in 1934 to an upper-middle-class Jewish family, Epstein was several years older than Liverpool's rock musicians and not particularly a fan. As a businessman, however, he noticed the enthusiasm of his young clientele for the new homegrown music. In November 1961 he first saw the Beatles play at the Cavern. As Epstein pondered managing the group, he was struck by their catchy melodies, "beat...and personal charm" but worried about their onstage appearance.[33] When he took control, their look evolved from Rocker-style leather outfits to fitted, elegant suits. According to Jonathan Gould, "It wasn't as if Brian Epstein meant to fit [the Beatles] out as a collection of singing stockbrokers.... While making the rounds of the record companies in the winter of 1962, Brian glimpsed the future, and seen that it was Mod." Epstein eventually got the Beatles signed to EMI in 1962. The band's first nationwide single, "Love Me Do," was released in December, eventually making it to #17 on the British charts later that month anu paving the way for higher-charting hits in 1963 and after.[34] Teenagers from Edinburgh to Southampton were now dancing to sounds shaped on the "provincial" banks of the River Mersey.[35]

Another educational venue for the working classes during this period was art school. Like the Vespas that Modernists rode and the espressos they consumed, "Art School" smacked of continental élan in a way that factory work

or a trade apprenticeship never could. While the older working class saw art-ists as indulgent do-nothings, many of their progeny saw art school—like playing music—as a way to escape unrewarding work.[36] It fostered the same mix of personal expression and entrepreneurial know-how that Eddie Piller identified as important to Mod culture.

"5-4-3-2-1": 1963-1964

The years 1963 and 1964 were key in Mod culture's development. In fact, one could say that what happened then is at the core of everything else that has developed since. In August 1963, the music showcase *Ready, Steady, Go!* [*RSG!*] debuted on ITV and would run until 1966. With the show's infec-tious theme song "5-4-3-2-1" by the London band Manfred Mann, the pro-gram's opening byline, "The weekend starts here," suggested the importance of leisure versus work. Also by this time, Merseybeat artists had not only "made it" onto the national charts, but the Beatles' Stateside success in Feb-ruary 1964 signaled the dawn of British-born Mod culture's international recognition. No wonder London's fortieth-anniversary festival of Mod cul-ture, "Modstock," took place in 2004.[37]

By this year, preceding cultural trends had converged to make Mod *the* youth culture of the mid-60s. Mod blended the continental style of bebop-loving Modernists, the showmanship of American Rock and Roll and Soul performers, the expressive energies of R&B, the enterprising spirit of the lower-middle class, and the Art School–influenced aesthetization of everyday life. As these elements coalesced, many young people started calling them-selves "Mods." In carving out spaces for self-expression, youth sought to overhaul how one *should* or *could* live. Their modern-world-in-the-making included energetic music, eye-catching spaces, experimental fashion, and a slang-filled patois. No lifestyle detail was too minute to be "Mod-ified."[38]

This trend was not lost on teenager Leslie Hornby—soon to be known internationally as "Twiggy." The future model commuted from her suburban home into the city to experience the Mod scene. London's West End radi-ated a kinetic energy she had not yet encountered. Saturday afternoons, with either the TV program *Dr. Who* or a rock record on in the background, she and her girlfriends labored over what to wear for their night out in Mod's urban epicenter. She remembered thinking "anything modern was wonder-ful, and anything old was terrible… everything up to date, up to the minute, brand new and streamlined and contemporary—that's what everything [had] to be—houses, home décor, ornaments, clothes!" Prior to gracing magazine covers and even her own eponymous teen magazine, Hornby's first media appearance was as a dancer on *RSG!*[39]

Hornby was one of many teens creating and enjoying this new Mod world. The 8 percent of the British population between fifteen and nineteen became targets for media producers. There were niche publications (*The Mod's Monthly* which became *The Mod*, fig. 1), teen magazines (*Honey, Petticoat, Fabulous, Rave,* and *Boyfriend*), radio ("Luxy" and soon offshore "Pirate stations"), and television programs like *RSG!* and *Top of the Pops* (1964–2006). These Mod offerings helped teens visualize and understand this new cultural phenomenon better.[40]

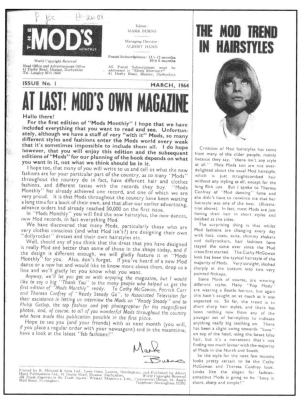

Figure 1. The first issue of the *Mod's Monthly,* 1964 (British Library)

Unlike previous working-class generations, Mod teens believed their snappy dressing gave them entrée everywhere. Though youth worldwide may have felt disempowered prior to "official" adulthood, British teens felt a special lack of agency if they were lower class. Having a sense of personal aesthetic choice thus empowered them.

Many young males wore sharply designed suits like those of the Modernists. A myriad of men's boutiques like John Stephen's Mod Male opened

in Carnaby Street. According to Stephen, "There [was] no longer a class thing any more about clothes. In a pub or a dance hall you [couldn't] tell what strata of society people belong[ed] to by the way they dress[ed]." For Mods, the blurring of class boundaries remained essential to their scene.[41] I asked Liverpudlian Gibson Kemp (b. 1945) why he thought the "look" of this period has remained recognizable:

Fashion was something you created…. You had to create it yourself. So, putting a holey, long sweater on you was instantly recognizable…. I used to take my school trousers on a Friday and sew them, turn them inside-out and sew up the seam and then iron them again so they were really, really slim…. I'm sure I wasn't allowed to…like lots of kids, and they all tried to make some sort of fashion statement without having the money to do it with. It was like mini-industry in creating fashion. Even when I was married to Astrid [Kirchherr] we used to get ordinary stuff and embellish it with stuff. Add different buttons or take a bit in, or… 'cause she created those trousers by accident, probably. You know the ones very tight…Hipsters, I suppose they're called. I'd buy normal jeans and sew up the seam just like that and that's how I guess you had hipsters.

For Kemp Mod's do-it-yourself inventiveness made the look distinctive.

Androgyny was also a characteristic of Mod male fashion. London's Scene Club crowd circa 1964 was, according to one observer, composed mostly of boys who "wore eye makeup which they carried around in small, plain purses and who danced together in groups."[42] While Mod fashions may have been influenced by the gay subculture of the period, there is nonetheless a near-homophobic defensiveness in some literature about Mod. These chroniclers have attributed the homosocial component of Mod culture to the fact that the group's males preferred spending money on clothes and accessories rather than on dates. One Mod, however, declared that "his circle of friends included a number of homosexuals," but "it was really a hush-hush thing then. Nobody talked about being gay."[43] Given the new choices of male style and behavior appropriated by Mod males, relaxed gender boundaries blurred aesthetics between gay and heterosexual subcultures.

The female fashions that appeared in boutiques like Mary Quant's Bazaar and Barbara Hulanicki's Biba *and* mainstream department stores began reflecting pop art colors and op art patterns and took on a girlish look.[44] One young Londoner of the era remembers her increasingly dyanamic wardrobe reflecting the times:

I worked for a theatrical agency in Soho in 1963. I often wore a mini kilt, I adored this fashion. I owned three kilts, one a pale lilac tweed, a black cashmere and wool mix and a black-watch tartan. The black kilt was my favorite for evenings out at the discos. I teamed it with various glamorous tops mostly bought at Biba, together with pull-on stretchy white or black boots. Mary Quant cosmetics created the pale lipped, panda eyes look, plus a geometric hairstyle.[45]

Similar to male Mod fashions, what did this "girlish gear" suggest about mid-60s sexuality?

With the recent *Lady Chatterley* trial and the arrival of the birth-control pill, British society was *just starting* to discuss heterosexuality more openly. It is not surprising, then, that alternative sexualities remained closeted.[46] However, just as Mod clothing softened the lines between "masculine" and "feminine," Mod culture less strenuously demarcated heterosexual and homosexual identities. Singer Marianne Faithfull and Kinks' guitarist Dave Davies have both chronicled their sexual experimentation during this period. In his autobiography Davies discusses his homosexual affairs during his time as an eminent, mid-60s guitar hero and notorious "ladies' man." According to Davies, "While I enjoyed experimenting sexually, I never really considered myself gay. It was fashionable at the time... and there was never any stigma attached to my interest in other young men. I've always felt that if you have a genuine respect and love for another person, who gives a shit if the partner is a boy or a girl?"[47] Thus Mod culture predated and heralded the queer theory and politics of the later twentieth century, which moved beyond seemingly inflexible straight/gay or inside/outside subject positions.[48]

The boutiques catering to this new flexibility also showcased Mod's entrepreneurialism through the youthful, sometimes androgynous, managers and teenage staff. Further, there was a commercial reciprocity between music and media in these shops. Barbara Hulanicki remembers playing the *With the Beatles* album as customers shopped in her Biba boutique assisted by Mod sales girls with "round dolly eyes." In John Stephen's Mod Male, staff would "smoke and lean against the wall and put records on," while the "walls [were] pasted with pop stars, and on the record player the Stones roll[ed] on." Bands also appeared on record covers, in magazine spreads, or on *RSG!* in clothes purchased in these boutiques. Not surprisingly, teenagers sought out the boutiques where their heroes shopped.[49]

Many of these "media personalities" were band members. By this time, Mod musical heroes were playing a variety of R&B and Beat. Two such bands were London's Rolling Stones and the Kinks. The suburbanite Stones started their career in April 1963 as the recurring act at the Crawdaddy Club in Richmond, southwest London. After gaining a Mod following for their R&B sound, they had their first #1 in 1964 with Willie Dixon's "Little Red Rooster." Their first album, *12 X 5*, released that year, also contained mainly covers. Their manager, Andrew Loog Oldham soon encouraged vocalist Mick Jagger and guitarist Keith Richards's songwriting à la the Beatles who had proved the profitability of songwriting. It was not until 1965's "The Last Time," though, that the Stones charted with a self-penned song.[50]

As Eddie Piller discussed earlier in this chapter, Oldham was a wily manager determined to see his group become leading members of the Mod phenomenon. His marketing savvy can be detected in the February 29, 1964 issue of *Boyfriend* that ran a feature called "It's a Mod, Mod World... *Boyfriend's* New Column Written by Five Top Mods (the Stones!) for You." Jagger introduced the feature: "Each week we're going to take turns to tell you all about the mod world, what's happening, what we're buying, saying and thinking."[51] Whether the column was "hosted" by Jagger, Richards, or the other three Stones, the content remained focused on their style: newly purchased clothes or musings about their "long hair." Only a column from April referred to any recording-studio experiences. Oldham also contributed semi-regularly to the *Mod's Monthly*: a magazine "for Mods, by Mods." In March 1964, he wrote, "The Mods decided that the Beatles were becoming too popular, and so discarded them for another group—the Rolling Stones."[52]

The other major group vying for Mod leadership with the Beatles and the Stones was also from London: the Kinks. Like the Stones, they too started with covers. Their American producer, Shel Talmy, goaded them to write originals, which led to their initial commercial success, the 1964 hit "You Really Got Me," by Ray Davies. While their music was up-to-the-minute modern, the Kinks toyed with images of England's past by wearing, say, red-velvet hunting jackets atop of white, ruffled shirts. As Ray Davies remembered, "During the [first 1964] tour we had started to get a reputation as Dickensian-type characters. [Mick] Avory [their drummer] was called Bill Sikes, Dave [Davies] was the Artful Dodger, I was Smike from Nicholas Nicholby [sic, Nickleby] and [Pete] Quaife [the bassist] insisted on being Pip from *Great Expectations*, even though his manner suggested that he was more like Mr. Micawber."[53] Hence, for the Kinks Victorian modernity was definitely something to be reinvented.

If their look bespoke Dickens, their music evoked the urban, emotive energy of the moment. Early Kinks' songs conjure up the whirling noise of England's motorways. "You Really Got Me" and "All Day and All of the Night" were punctuated by Dave Davies's distorted guitar sound. He experimented with various amplifiers but achieved this clang by slicing into the back of his El Pico amp that functioned as a pre-amp and then ran to his Vox AC 30 amplifier.[54] Despite the machine-like qualities of the group's music, lyrics of later songs such as "Dead End Street" and "A Well-Respected Man" (1966) reflected class issues. As one critic suggested, the Kinks "embody the contradictions, or love-hate, relationship of this generation with their country's past."[55] Thus of all Mod-era bands, the Kinks showcased most openly the classic British struggle with modernity.

The kinetic sounds of the Kinks, Stones, and Beatles provided portable soundscapes for Mods. While seeing bands play live remained important, dancing to records spun by DJs in dance clubs also became increasingly popular. Soon cellars of sound, like those of Liverpool's Merseybeat scene, cropped up all over Britain.[56] Many letters to the *Mod Monthly's* editor, for instance, were from teenagers around the country bragging that hip clubs *certainly did exist* outside of London. A female Mod from Banbury described "The Gaff" as a "real gear club." A Sheffield native wrote about the city's Mojo Club and that they, too, had "some fab groups" playing there. Similar letters from diverse locales appeared in subsequent issues en masse.[57] Though not all these clubs were beneath former factories, the fact that many were suggested another inversion of work and leisure.[58]

Aside from the material aspects of Mod, there was also a philosophical side. As Twiggy recounted, being modern meant having every aspect of one-self and one's surroundings up to date. Beyond fashion, music, and space, this also had to do with how Mods interacted with each other, with those outside of the scene, and, also, how they thought about moving through the world. In sum: their attitude. Mancunian Steve Plant (b. 1948) recounted that Mod culture opened up new horizons for him. He saw this as a time when working-class teenagers were "not only listening to music, but... started to read... they started to look at art. We started to see ourselves not only dressing smart, listening to great music, but we saw ourselves... we viewed ourselves as being intellectual." They were literally *smarter* in all re-spects.

Steve first became aware of Mod through the Beatles: "At the age of fif-teen the Beatles... the whole Merseybeat-thing had just started. And it de-veloped from that. I remember being at school and the first time we actually saw the Beatles was on a northwest evening news program and they played 'Love Me Do,' and we went to school the next day and this was a revelation. We'd never seen anything like this...it was an epiphany, really. We knew then that this was ours... And this...*this* was going to be our world." For Steve, the Beatles' first self-penned hit symbolized the transition from an imitative youth culture to one created in Britain for the British—"our world" in his words.

Steve grew up in Manchester's postwar-built council estates in Wythen-shawe and remembered being surprised that Mod culture existed outside his hometown. "We just thought [Mod] was Mancunian, as far as we were con-cerned. I mean, you know...we started to be aware of clubs in London like the Marquee and stuff like that. You were aware—from the very beginning you were aware—but we thought *we* were doing it and *we* were doing our

own thing. That this was happening simultaneously in London and Man-
chester—why that is—I've never been able to figure out." Steve's involve-
ment in Manchester's mid-60s Mod scene underscored that the culture had
mesmerized youths throughout the country—not just in England's metropo-
lis.

Also from Manchester, Phil Saxe (b. 1951) remembered encountering
Mod style as an avenue for reinventing and expanding his social world.

> Nineteen sixty-four was probably the first time I heard ["Mod"]. I was probably twelve...
> and then, I don't know, it's a strange thing. I had a bit of an epiphany when I became a
> Mod. I'm Jewish, right... but I grew up in a non-Jewish area: Stretford. I used to get
> dragged to the center of Manchester to youth clubs and stuff, Jewish youth clubs, by my
> parents, you know? And we were in this non-Jewish area, so I always felt a little bit odd.
> Two things stick in my mind. One is... I must have been just fourteen—no, maybe thir-
> teen, almost fourteen—in the summer. It must have been '64...'65 and I went into Man-
> chester and I went to the Jewish youth club and I walked a girl to a bus station... and I
> saw these two lads come out of the public toilets and they looked completely different
> from everybody else. They had short hair. They had what we used to call 'parallels'...
> wider sort of trousers... mohair, braces, polo shirts on. And I thought, 'Wow!' I was
> really impressed and I wanted to be like them. And, at the same time, someone used to
> walk past my house quite a lot and he must have been about 16...17... and he had a suit
> and everything and looked really great and I used to want to be like him.

In Phil's account, the distinctive Mod look offered an alternative identity to
being Jewish. Ironically, since many early Mods were Jewish, gentiles associ-
ated the two. Steve Plant remembered looking at what the Jewish teens were
wearing because he assumed they had more money and, therefore, better
clothes.

As much as Mod culture offered transcendence of ethnic identity, it
could challenge gender-role limitations. Some young women sensed that this
youth culture offered them something beyond the expected progression from
student to worker to wife. In a February 1964 issue of *Boyfriend*, two teenag-
ers debated whether being a Mod was a positive identity. The Mod one
rested her case on a new vision of women's potential as free human beings:

> I've been called a mod. I'm supposed to dress like a mod. It's another label in a world full
> of labels. I'm not really interested in wearing a 'uniform' and belonging to a group in that
> sense. But there is something I agree with the mods about, and that is—what is all the
> excitement about life? I find it all pretty cool so far. And that takes in about 18 years.

> Some girls have one long ball in life:

> 1. Getting all excited about weddings and dressing up like fruit cakes to be brides-
> maids, etc.

> 2. Talking breathlessly about so-and-so getting engaged and crying out in wonderment
> when the ring is produced.

3. Getting dressed up like a painting on the front of a chocolate box to go to some dance with a chinless wonder who spills drinks all over you!

4. Preparing for birthdays and Christmas in the same way year after year.

5. Saving up and going with the rest of the girls to see a London show. Goody goody gumdrops! Something snappy like Gilbert and Sullivan!

6. Mummy. All they talk about is Mummy. It's Mummy this and Mummy that. Ugh!

These are the highlights of their dull little lives. They stagger breathlessly from one peak of enjoyment (someone's engagement) to the next (an actual marriage!) and their eyes become all shiny as they tell you about it…. What are we looking for? I wish I knew. Something really exciting. Something really thrilling. We'll know when it comes. Right now will someone please tell me—what is there to get excited about?[59]

Her analysis of why being a conventional girl was boring thus underscored her choice of identifying as a Mod. Even if the Mod lifestyle was not yet offering "something really exciting" to counteract her youthful cynicism, at least it licensed her to reject putting a premium upon "getting all excited about weddings and dressing up like fruit cakes to be bridesmaids" as the best one could hope for. In an August 1964 report about Mods in the *Sunday Times Colour Supplement*, one Mod girl commented, "'My dad's trying to get me to join the Young Conservatives… but I like this set. They're nice, and they say what they mean.'" In her view, the Mod scene offered alternatives beyond Tory constrictions.[60]

As Mod became popular among many British youths, it morphed into a multidimensional, multifaceted phenomenon. With so many self-identified Mods, varying ways of experiencing the culture emerged. Some Mods started calling themselves "Individualists," suggesting that those who adopted this ethos were apt to be daring and try new things. Some loved the Beatles while others refused to acknowledge them as Mod. As much as youthful optimism drove the culture, pockets of pessimists persisted. Some Mods were simply high on their scene, while others popped pills. Some enthusiasts were rule-oriented and constantly felt the need to strictly regulate what Mod *should* be.[61] One notorious "Mod faction" rioted in the streets of British coastal resorts, punched-up "Rocker" rivals, and smashed storefront windows in late spring and summer 1964.

The book *Generation X* was published just after these riots. Sociologists Charles Hamblett and Jane Deverson asked: "What's behind the rebellious anger of Britain's untamed youth?" One answer came from an eighteen-year-old London mechanic: "Yes, I am a Mod and I was at Margate [a riot site]… I'm not ashamed of it—I wasn't the only one. I joined in a few fights. It was a laugh…. I haven't enjoyed myself so much in a long time… the beach was

like a battlefield. It was like we were taking over the country." Although the researchers described his opinions as "an extreme case," the idea of Mods as being one of two hooligan tribes still left a strong impression.[62]

The press sensationalized the riots. Many Mods however bemoaned this association with violent behavior. Their refined image was tarnished with the old stereotype of the working classes as an unruly mob. For one Mod this "wasn't Modernism anymore... it was more towards being a member of a gang and that's not what we were about. We were about style, fashion and lifestyle and the next thing." The press's "Mods and Rockers" obsession obscured the fact that the majority of Mods had none of the rioters' violent tendencies.

Little wonder, then, that the Beatles' 1964 film *A Hard Day's Night*, released not long after the conflicts, contained the line "Are You a Mod or a Rocker?" Ringo's answer "I'm a Mocker" may have not only inadvertently expressed the Beatles' witty take on the subject, but also reflected the fact that the majority of young people were both non-violent and capable of critiquing modern life sartorially *and* satirically.

All Over Now? 1965-1967

Starting in 1965, Mod went mainstream. The flow of the culture's imagery escalated and Mod was everywhere. Journalist Christopher Booker observed the city scene that summer:

> Men in shoulder-length hair, girls, in skirts for the first time eye-catchingly shorter than even the shortest skirts worn in the nineteen-Twenties, clad from top to toe in the shiny surfaces and violent colours of plastic PVC or the dazzling blacks and whites of Op Art... Down Carnaby Street and the King's Road the first of a flood of foreign tourists had already been drawn to gaze in awe at this thing which had happened to Old England—picking their bemused way past the little 'boutiques' which were springing up almost day to day, with names like 430 and Avant Garde and Count Down and Donis and Domino Male, with their weird décor of garish paintings, cardboard Gothic arches, huge photographic blow-ups of pin up girls and space rockets—and everywhere the omnipresent blare of pop music.[63]

It seemed that wherever one turned, people, places, and things were "going Mod." An editorial in *The Mod* (formerly *Mod's Monthly*) asked "Where Have All the Mods Gone?" What the editor actually meant was that Mod had become so co-opted by the mainstream that it was increasingly difficult to discern who was or was not Mod: "We see... young executives in big corporations with hair styles that would have got them shown the door but a year or two ago... company directors... asking their Savile Row tailors to make them their next suit just like the one the Beatles wore." While this cre-

ated a very vibrant overall environment, not all Mods were happy seeing "women in their fifties wearing the latest 'Mod' gear."[64]

Meanwhile, youth-oriented films like *A Hard Day's Night* paved the way for a stream of movies starring the latest music stars like *Ferry across the Mersey* (1965, starring Gerry and the Pacemakers) and *Having a Wild Weekend* (1965, the Dave Clark Five). Other movies like *The Knack... and How to Get It* (1965), *Blow-Up* (1966), and *Alfie* (1966) showcased Mod fashions and/or attitudes. *Darling* (1965) and *Georgy Girl* (1966) had female protagonists struggling to discover what made life exciting: whether through a career, sexual freedom, wealth, or marriage and family. Mod traces appeared in TV shows, too. *The Avengers* (1965-67), for example, starred a very fashionable female spy named Emma Peel (Diana Rigg). She fought villains in form-fitting catsuits, black leather knee-length boots, and other Mod fashions.[65]

Since style was so important to Mod culture, it is fitting that some fashion photographers became celebrities. Many of them, like David Bailey, also had working-class roots.[66] With its Bailey-esque, photographer protagonist, Antonioni's 1966 film *Blow-Up* captured the Mod moment at its pinnacle. The movie featured Mod fashions and a Yardbirds performance. According to the film's press release, *Blow-Up* showcased a world "where teenage pop singing groups have their records sold in shops owned by people their own age, and photographers who have barely started showing drive Rolls Royces with radio telephones."[67] The film underscored the period's fascination with documenting the Mod phenomenon.

Despite later claims that Mod's mid-decade commercialization caused it to have "lost all meaning and relevance," it was in fact the intended outcome of top "Mod publicist" Pete Meaden. According to the Who's Pete Townshend, Meaden had hoped Mod would become "the new ethos, the new art form, the new everything."[68] By 1965 his dream appeared to have come true. The mass production of Mod-styled products democratized the culture. For instance, inexpensive clothing available at chain stores was a way for more young people (and interested adults) to participate in a modern world that the first Mods had envisioned.

While male fashions remained important, female fashions were to change greatly between 1965 and 1966. Up to this point Mod girls often had been described as drab and intentionally unglamorous. A journalist explained, "They got their name, Tickets, because they look as if some machine made them at six pence a time."[69] By 1965, though, a new playfulness emerged. The earlier androgynous look gave way to fashions celebrating girlishness, as seen in Mary Quant's boutique couture. Quant's fashions celebrated femininity in a new way. She used lots of bright hues, atypical color

combinations, and unusual materials, while the skirts she designed became increasingly shorter. Quant's dresses were worn with "Mary Janes," child-like, rounded-toe, low-heeled shoes, with a strap going across the instep. Quant's style suggested a Peter Pan-like desire to never grow old. According to her, "Adult appearance was very unattractive… it was something I knew I didn't want to grow into. I saw no reason why childhood could not last for-ever."[70] Her attitude suggested rejecting traditional notions of womanhood for an eternal girlhood. "Whatever [the female Mod] is going to be," one observer of the scene claimed, "She is not going to be a woman in the tradi-tional sense…. She seems the face of the teenage revolution."[71] In this re-spect, this new wave of Mod female fashions visually symbolized an alternative to female adulthood—one that saw slim, mobile bodies as liberat-ing.

Just as this new gamine figure evoked streamlined machinery (fitting in with the aesthetic of Modernist design), feminine allure fused technology with the female body. As the space race took off, designers like André Cour-règes and Pierre Cardin created clothing with new materials like PVC (polyvinyl chloride) to accord with a "future of moon missions and space sta-tions."[72] The "space age look" of silver, white, and transparent plastic ap-peared alongside op and pop art dresses. A designer named Michael English created "superman capes over transparent PVC shortie coats, emblazoned with supersonic motifs worn over mono cat-suits [with] headgear [that was] helmeted, sometimes with transistor radios set in." In describing why he de-signed women's clothes in this way, English told *Honey* magazine, "Ten years ago we laughed at the science-fiction writers, but now everything they fore-saw is coming true! So why don't we live up to these scientific facts in the fashion world? I'm sick of looking backwards."[73] These otherworldly vest-ments signified yet another way for Mods to reconceptualize modernity—with females playing a starring role.

The pop aesthetic also began influencing male sensibilites. This was most noticeable in the look, sound, and presence of London band, the Who. A famous promotional photo of the group from this period shows them posed in front of a wall-size Union Jack. Guitarist and songwriter Pete Townshend is seated wearing a jacket made out of the British flag. His arms are crossed in front of him while his luminous blue eyes stare defiantly at the camera. Behind him stand drummer Keith Moon, bassist John Entwistle, and Roger Daltrey also outfitted in "Mod gear." Moon is wearing a white T-shirt with an op art design on it, Entwistle a diamond pattern jacket, and Daltrey is clad in a powder blue-and-white striped shirt with a long, pointy collar. Townshend's art college training encouraged him to see the spectacu-

lar in the most mundane objects or experiences. In his words, people would come to "see the group because of various things people in the group wear such as John's jacket and medals and my jacket made out of flags and Keith—who sort of wears fab gear: pop art t-shirts made out of targets and hearts and things like this. Because a group is a fairly simple form of pop art, we get a lot of audience this way."[74]

In terms of their first appearances within the Mod subculture—as logo patches of the British flag and Air Force targets affixed to Mods' parka jackets (taken from American G.I.s) and scooters—these traditional British symbols implied a love/hate dialectic between Mod and its parent culture.[75] The Mods deployed the flag, a symbol of imperialism, ironically as a way to unite individuals who did not necessarily feel patriotic in the usual sense. Similarly, the Royal Air Force's red, white, and blue target, which first appeared on British planes during World War I, became a pop art logo worn by Mods. The use of these symbols implied a longing for an England where working-class youth felt included. In adopting these symbols, the Mods declared, "Your England is *my* England, too—but *my* England is more fun!"[76]

The Who's pop art sensibility went beyond what they literally wore. Their first hit, "Can't Explain" (1965), was akin to pop art in that it sounded like a commercial jingle with a hyped-up tempo and rough-edge inspired by the early Kinks' records.[77] The group already had a loyal following in West London, where their performances had underscored their larger-than-life pop-art message. Soon they were a regular act at Soho's most desired venue, the Marquee. Their onstage presence featured a gangster-tough, posing Daltrey, windmilling arms and smashed guitars by Townshend, and, eventually, a kicked-over drum kit courtesy of Moon. Seemingly unaffected by the fray was bassist Entwistle.

Though the Who's stage shows could be read as a pop-art "happening," I see the band members' individual performances as more emblematic of various visual forms of Modernism. Former sheet-metal worker Daltrey's bravado seemed cut of the same Italian cloth as the Futurists, whose manifesto included the statement, "We want to sing the love of danger, the habit of energy and rashness."[78] Townshend's destruction of guitars may have resulted from Gustav Metzger's lecture on "Autodestructive Art" at his art college, but it also embodied the aggressive, yet playful, exercises of the Dadaists. Keith Moon's ecstatic drumming, which had him seemingly moving in all directions at once, was almost Cubist. Meanwhile, John Entwistle's unwavering cool amid the chaos whirling around him, evoked the monolithic strength of Brutalist architecture. Their look, sound, and performative energies captured the essence of British Mod-ernity for mid-60s youth. Appro-

priately titled, their biggest hit was "My Generation," which peaked at #2 on the charts.[79]

Similarly, East-End London band the Small Faces embodied another kind of modernity. Steve Marriott, the group's leader, had played various roles in West End productions of the musical *Oliver!* and had sung the Artful Dodger's songs on the cast album. By 1965, the eighteen-year-old had traded in his Cockney vocal stylings for soulful wailings reminiscent of Sam Cooke. The Small Faces had the raw energy of the Who crossed with the rhythmic cool of Booker T. and the M.G.s. In June, they had their first national hit ("Whatcha Gonna Do about It?"), followed the next year by a string of hits, including their first #1, "All or Nothing." The original song seemed to lay bare the attitudes of working-class kids with ambition.[80] Marriott's biographers write, "You are eighteen years old. You are a Mod and you are in band. You have just done something many of your schoolmates never will: you have escaped the factory line."[81] Still, the music of the Small Faces could inspire fellow East Enders in their quest for upward mobility.

The chart success of the Who, the Small Faces, and, also, the Yardbirds points to Mod culture's acceptance by the mid-60s, with London rather than Liverpool now the center of activity. Nonetheless, Mod scenes continued to exist elsewhere.[82] In February 1965, an article in *Honey* called "No Quiet on the Northern Front" describes an experience in Leeds: "Some people said they had to go to Liverpool or Manchester for entertainment. But if you get in with the university crowd there's lots going on in term time. We struck lucky at once—bumped into a group of students at Schofields who dragged us off to the art college rave...and it was! A huge rather bleak hall, overflowing with noisy colourful students.... Many of the girls look terrific in way-out gear they'd knocked up themselves—could be some trend-setters here."[83] This "report" also illustrated how Mod gathering spaces were not just about seeing live bands, but also involved dancing. The French "discotheque" certainly had its British versions. At Manchester's Twisted Wheel—where all-night parties were hosted initially by DJ Roger Eagle—girls with geometric hairstyles and long-haired boys shook their "mops" doing anything from the "Hitchhiker" to the "Hully Gully."[84] Unlike seeing live bands, the music played by Eagle and other DJs elsewhere was mostly comprised of older and contemporary R&B and Soul singles. Though some Mods came to the scene through the music of Merseybeat or British R&B bands, the songs heard while dancing at clubs led these adherents to a new appreciation of the musical roots of these British bands.

Still, Mod culture was becoming equated with "Swinging London," a tag created by American journalist Piri Halasz in her now-infamous April 1966

Time magazine article.[85] As Welshman and longtime Birmingham resident Spencer Davis described it, "London was the known center of the universe as far as the 60s were concerned. I don't mean that in a conceited manner at all. It's where the fashion was emanating from [and] politics were unfolding." Though young people enjoyed their local scenes in Newcastle or Portsmouth, curiosity about Mod London incited many a youth to take the train or bus into the city center. "Carnaby Street was—for the kids coming in on the tube—to think they were buying what Londoners were buying. If Eric Clapton [The Yardbirds, Cream] wore wide lapels, like a Georgian suit, it quickly appeared in Carnaby Street."[86] Shopping in Soho was usually followed by "raving" at clubs all night long. One journalist remembered encountering Mods hanging out at Piccadilly Circus's Eros fountain at dawn happily awaiting the morning's first trains.[87] Because of "Swinging London," the former stereotypical images of England and London—Dickens's grimy urchins or humorless, bowler-hatted men—were being replaced by a cheerful atmosphere of witty young men in pin-striped hipster pants and pudding-bowl haircuts.

Between late 1966 and mid-1967 Mod culture began to change. Thanks to the escalating Vietnam conflict, being "modern" in every sense of the word was being questioned. Unlike the reactions after World War II, when young people sought to disarm technology from its more nefarious connotations, the era of psychedelia and "flower power" relinquished this ideal and increasingly summoned the "natural" to critique the malevolent man-made, high-tech "plastic world."

Given the world situation, was it not a near-crime to *just* be concerned about clothes and bands? Even teen magazines presented articles that questioned the meaning of apparently self-absorbed stylistics. An article called "Pop Thinks" observed,

> Something's happened to pop these days: pop singers are thinking. Yes, especially those getting to the top of the hit parade. They're talking about war, draggy suburban life, news on radio.... And even when they're talking about the most ordinary things, somewhere in the song there'll be a thought to get hold of.... Perhaps the pop world is becoming less adolescent, and growing up? Or is it becoming intellectual?[88]

The Hippie aesthetic, antimodern in outlook, was now usurping Mod. The American scene emanating from San Francisco seemed to prefer a softer, more organic sensibility that was visually represented by velvet, flared trousers, Indian print clothing, and the folk-influenced music of the Grateful Dead and Jefferson Airplane. These Bay Area hipsters, soon called "Hippies," took everything easy. Their aesthetic was soon visible in the U.K. and elsewhere. The "Hippie Trail" encouraged youths to travel to destinations

like Morocco and Kathmandu. The drugs now predominantly used offered hallucinogenic "trips." They were not, like amphetamines, meant to inspire fast-paced interaction with the world.[89] Instead of dancing in clubs all night, Hippies "crashed" on soft, paisley pillows and sought to "expand their minds." English Mods tried to understand this new aesthetic. Would they be willing to give up their artfully crafted world for beanbag chairs or songs about San Francisco? The author of a 1967 *Honey* article wrote,

> Psychedelic! Wot's that? It's the new kind of music. When you hear it, you're meant to 'Freak Out' and that means have a spontaneous reaction, only we aren't quite sure what. Still, 'Freak Out' parties are held, but we can't say exactly what happens because it all depends how the 'Freak Out people' react to Psychedelic music. Although the idea came from America, three British groups are currently playing psychedelic music: the Yardbirds, John's Children and the Fingers.[90]

Many Mods were nonetheless adopting this new aesthetic. In their 1967 album *Sgt. Pepper's Lonely Heartsclub Band*, the Beatles are pictured with moustaches, thick sideburns, and in faux military satin suits. John Lennon looked especially changed—now even donning a pair of National Health Service eyeglasses. As if witnessing their own funeral as Mod-era icons on the LP's cover, mop-topped and suit-wearing wax figures of the group appeared alongside the real and "new" Beatles.[91]

The Yardbirds had already achieved fame for their snappy R&B-influenced songs, but by 1967 they started experimenting with "trippy" lyrical content, as evident on some tracks for their *Little Games* album. Meanwhile, John's Children, featuring former teenage Mod and future Glam Rocker (with band T-Rex) Marc Bolan on guitar, created rambling, disjointed-sounding songs like "Smashed! Blocked!"—a style that Pink Floyd eventually popularized.[92] Even the Small Faces got into the act. In their biggest 1967 hit (and their only charting song in the U.S.), Steve Marriott sang not-so-ambiguously about "getting high" in the single's titular "Itchycoo Park."[93]

To a certain extent, the Who's 1967 album *The Who Sell Out*, is a kind of requiem for Mod's cultural heyday. Visually, the cover celebrated the marketing ethos that was integral to Mod's sensibility. The cover photos of band members promoting fictional and real products like Odorono deodorant and Heinz's baked beans illustrated pop art's appropriation of advertising. According to Townshend, the project idea had come to him because "Pete Meaden taught me to look at the audience, watch what they're wearing, bring it on stage, and then the audience thinks you're the ones leading them… and it's actually the other way around," he said. "It's a cheap trick and it worked for us for a while."[94] Here, Townshend saw the trendy aspect

inherent to the Mod scene and toyed with this idea for criticizing while appropriating commercial culture.

Although Mod was no longer mainstream, smaller cliques of self-identified Mods would continue experimenting within the culture. The clothing and design created during the mid-60s could also still be seen in various aspects of popular culture. The sci-fi program *UFO* (ITV, 1970) featured female characters in miniskirts who sported bobbed, albeit "futuristic" purple, hair, while the male leads wore mid-60s styles too. Mod(ernist) furniture and fashion design also appeared in another depiction of a space-age future, Stanley Kubrick's film *2001: A Space Odyssey* (1968). As the culture evolved into various youth phenomena through the late 60s into the 70s and beyond, various elements could be found and adopted by anyone desiring to carry on Mod's dream of idealized modernity.

Mod in the 1970s and 80s

By the late 60s, the cheerful optimism of the earlier part of the decade was barely palpable. Mod no longer fully fit the times. No matter, there were those who would always be Mods whether it was a "trend" or not. However, Mod was no longer at the center of youth culture. With no vision to guide it from mid-1967 onward, Mods started following divergent paths. Some became Hippies. Others started the Ska-oriented Skinhead culture. Many youths in northern England focused on dancing to rare Soul records at discos. These subgroups of Mod carried on for nearly a decade. Suddenly, in 1976, Punk Rock—with its riotous music and fashions made up of safety pins, ripped T-shirts, and bondage gear—became England's latest youth trend. Its brash sound also influenced a new generation of Mod bands.

Amid mass inflation and unemployment in Britain, the Punk revolution made it difficult to remember the time of Mod idealism. In 1976, the year that the Sex Pistols debuted, the pound was quickly losing value, causing a national economic crisis. But perhaps this is why the "Mod Revival" *needed* to happen by the late 70s.[95]

In 2007, when I asked British Mods to recall their initial associations with the word "Mod," I discovered that there were as many references to the late 1970s—the Mod Revival—as to the mid-1960s era of Mod culture. This kind of recall raises issues surrounding selective, collective, historical, or generational memory.[96] Colin Fribbens (b. 1964), who grew up in the southeast of England, told me this when I asked him what initial associations he had with the term "Mod":

Well, the Mod-thing was brand new in 1978 in England, ok? There were bands called, like, the Pleasers and the Boyfriends and I really liked the Beatles at the time. I was, like, fourteen or something and the Pleasers looked like the Beatles. They had suits and ties on and I thought, 'Wow, they look really good.' They were really good, ok? I was at school and the Mod...there used to be a television program on called, um, *The London Weekend Show*... and they said, that "Mods are back" and they had pictures of Carnaby Street and Mods with scooters and parkas on—wearing parkas and everything—and I thought, "That's me. That's me, that."

Colin saying that "the Mod-thing was brand new in 1978" is true in the sense that for him and all those Mods born too late to experience 60s' culture, this phenomenon was "new" *to them*. Also, his interest in the Mod scene that was happening in "real time" circa 1978 ran concurrently with media images of the mid-60s as presented through televised images of Carnaby Street and "Mods with scooters and parkas on." It was thus a combination of mediated past and lived present that allowed the possibility of Colin becoming a Mod in the first place. He continued:

So, I went out and bought a parka. All me mates went out and bought parkas and we were all in the same year in school and that was the start of the Mod scene here. What is very interesting is that when the Rude Boy-thing come on... Madness, Specials, Bodysnatchers, etc. The Beat. We were all walking along with our parkas on... and we said, 'Rude Boys? Who wants to be called that?' You know, 'That's not gonna work. We're Mods.' And we liked, at the time, the Jam, Secret Affair, Purple Hearts... you know? And we thought the Rude Boy-thing would be rubbish and wouldn't last five minutes. And we all know it took over—it took over completely. So, when I went to see Madness, which I did in 1981, it was full of Skinheads and Mods in parkas.

Here Colin's memories showed in more detail how Mod changed from the 60s original during the revival period. He cited a more visible presence of Skinheads and Mods who were not so super-stylish and just wore parkas to signify their Mod pretenses. Colin and his friends heard that the "Rude Boy-thing" was all the rage, but did not necessarily want to incorporate that as part of *their version* of Mod.

Dick Hebdige describes Rude Boys as Caribbean immigrants who had a gangster-like "flashy, urban, 'rough and tough'" image. They listened to Jamaican-born "Bluebeat." First introduced in 60s Britain, the genre became more prominent by the 70s.[97] The bands Colin mentioned in conjunction with this influence—particularly Madness, the Specials, and the Beat—wrote songs indebted to these Caribbean sounds. When he described this music as "taking over," he referred to the fact that this development in 70s' Mod culture became incredibly popular in the scene. The new English Punk bands were also, by 1979, commercially successful and remained so until 1982.[98]

On the other side of the musical coin, the Jam, the Secret Affair, and the Purple Hearts— those groups who were actually categorized as "Mod Revival" bands—affected a look more in line with the British R&B bands of the 60s, were not biracial in their lineup, and had a musical style that combined Punk sounds with those of the British Rock and Soul of the original Mod years.[99] Finally, Colin mentioned the Skinhead presence at these events. Today the word "Skinhead" is so laden with right-wing and racist connotations that it is hard to believe that they would have had anything to do with Mod culture.[100]

Nonetheless, the truth is that some Mods became Skinheads as San Francisco-based psychedelia became increasingly popular by late 1967. Those who did not either joined in with the Folk/Country/Pop Hippie aesthetic or became "Soulies" in what was soon known as the Northern Soul scene. If Mod by the late 70s had branched out in these three different directions, how did these subgroups contribute to the evolution of this youth culture?

Skinheads

Skinheads emerged from the Mod scene with a look that countered the majority of Mods' super-stylish appearance. Before they were known as Skinheads (or "Skins"), this group was known as "Hard Mods," implying an unrefined aspect to their look.[101] Skinheads either had very short hair, or, later on, completely shaved their heads. In this way, it was a direct response to how "effeminate" the Mods had become. Skinheads celebrated what was thought to be a hypermasculine working man's look. They suggested that working-class men should not aspire to adopt an upper-class look, as the Mods had done, but dress in a way that proudly showed one's true background. Skinheads exchanged suits for jeans or plain-looking pants with button-up shirts and suspenders and work or army boots. The girls who participated also wore their hair very short, sometimes with long bangs in front. They also reverted to the "drab" casual wear sported by the earliest Mod girls.[102]

This group enthusiastically embraced Jamaican Ska and Reggae music by black artists. By the late 70s many of them would also become staunch fans of 2 Tone bands like the Specials and the Beat. Despite their musical allegiance and given England's lackluster economy by this time, some Skinheads were attracted to the hateful rhetoric of ultra-right-wing politicians such as MP Enoch Powell or the radical group the British National Front. Powell openly spoke in racist terms, believing that the continued influx of black immigrants, mostly from former British Colonies, would lead to the death of British culture.[103] The National Front (NF) took an even more openly racist

stance. This fear-laden rhetoric, aimed at the less-educated, found receptive ears among some Skins. From this time forward there would always remain a distinction between Skinheads and "Nazi Skinheads," which explains why black Skinheads existed at all.[104]

There are still male Mods in England (and some women) who cultivate a casual Skinhead look yet are peaceful members of the scene. However in the 1970s, teenage riots occurred between Mods and Skinheads. Eddie Piller recounts his experience:

> We had a fight… in the South End in August 1979 and after that it was war. It was complete war. Up 'til then it was Punks, Mods, Skins, everyone apart from Teddy Boys were part of the same alternative lifestyle. Then, the split started coming this summer and then by August we had fights with them.… And then, from then, it was just mass, gang warfare. They used to beat up Mod kids all the time. 'Cause Mod kids were like fourteen, fifteen, sixteen. Skinheads were seventeen, eighteen, nineteen.… And we grew to hate them.

Given the disparity in age and probably physical strength between these Mods and Skinheads, Eddie told me how he set up a gang-like "self protection group."

> There'd be twenty of them and four of us and they'd really beat us. And we were just little kids, you know. When we became mature men—seventeen, eighteen—for example, the Bow Street Runners, which was a Mod club I was in, set up as a self-protection group, where to join you had to be proposed by two members and then you had to go and do something…in public where you could be judged on how you did. So our favorite thing would be we'd go to a Skinhead pub in Shepherd's Bush and we'd go, 'Right, your turn' and the kid would have to go and find four Skinheads and beat 'em up. If he didn't do that, he couldn't be in the gang. And by the time the gang reached its peak of about fifty people, we were fuckin' hot.

The aggressive actions of the late-70s Skinheads prompted an equally violent retaliation among Revival-era Mods. Eddie added that, "People forget about the violence." Unfortunately this late-70s generation of Skinheads crafted an image of alcohol-induced aggression that had little to do with the original Mod ethos. Luckily, violent clashes are no longer part and parcel of the contemporary British Mod scene.

Northern Soul

Meanwhile, clubs in northern cities began playing more recorded Soul music. This scene was another option for Mods uninterested in the Hippie aesthetic. "Soulies" seemed to tap into the exclusivity of the bebop-influenced Modernists. They believed that what they listened to was just a little too complex for the general public to understand or appreciate.[105] Not satisfied

with playing the better-known hits of Motown or Stax, DJs began searching for lesser-known American Soul recordings. This was possible due to "the arrival of [more] imports in 1969. Now the DJs and collectors had access to many brightly coloured and fascinating American labels" that had never been available in Britain before.[106] Northern Soul's focus was on collecting and playing hard-to-find singles rather than chart hits. Rarity became the rule in Northern Soul. DJs like Ian Levine, Roger Eagle, and Russ Winstanley became celebrities. The height of Northern Soul's popularity peaked in the mid-to-late 70s, but the scene's music and its obsession with rare recordings have remained recognizable elements within Mod culture.[107]

Spinning records at Manchester's Twisted Wheel from 1969 to 1971, Phil Saxe remembered this shift, and liked many aspects. However, he was not a fan of the fashion: "We began playing faster and faster music and that became Northern Soul... [but] the Northern Soul scene was not a Mod scene. The dress code was different. I didn't like that: the tattoos and the badges and all that stuff. It wasn't me." Northern Soul did not retain the tailored look of 60s Mod. Like the Skinheads, this group wore casual clothing like wider flared pants and vests bedecked with pins and iron-on badges. Some former Soulies recalled, "All the DJs played to the dancers who had a big input into the success of a New Spin. Great dance floor, DJs and music."[108] While the original, cooler-than-thou Jazz-loving Modernists had ignored any kind of dancefloor, these descendents loved showing off near-acrobatic dancing chops.

The Mod Revival

While Soulies created new dance moves and Skinheads listened to Ska records, Mod Revivalists focused on live music and the fashion of the mid-60s. Influenced by the aggressive sound and stage antics of Punk bands like the Sex Pistols, the Clash, and the Damned, these bands nonetheless wore clothes like the Beatles or Kinks. This raised the question: What images, ideas, sounds did one draw on as a Mod circa 1977?

The Revivalists sought to get back to Mod's roots. In doing so, a kind of "storytelling culture" evolved, from which imitation ensued. For instance, the wearing of white socks became big in the Mod Revival because it was a trend the 2 Tone bands started. Paul Lyons remembered his dad thinking this was ridiculous.

> It's funny remembering my dad telling my mum not to buy me any more white socks as he felt the whole thing was getting out of hand.... He sat down with me one time, attempting the matey 'father to son' chat about the dreaded foot attire that I wore and even went as far as going into detail about the 60s mod scene that he was part of. 'We never

looked like that' he said. He picked up my Richard Barnes book that I had only recently purchased from Carnaby St's Rockafellas [shop] and said: 'Paul, you show me one group of Mods in there that wore what you have on your feet.'[109]

For Stuart Whitman (b. 1965, Ipswich, Kent, fig. 2), who cited 60s band the Small Faces as his favorite, Mod images came from exposure to parental stories and photos, 60s LPs, and also through the Jam:

> I'd seen old pictures of my mother when she was younger with her beehive haircut and stuff. Um, my dad actually met Dusty Springfield on two occasions when she played in Ipswich in the 60s.... I first really became interested in... I heard, obviously, the Beatles and the Stones and groups like that when I was sort of really young and growing up... but when the Jam come out of the Punk thing in the late 70s... I quite liked it at the time. I was young, but it was the new thing at the time.... And the Jam come out of that in a way—out of that period—and then I heard Paul Weller sayin' what groups... he was influenced by when he was a child, you know? And I sort of started to dig deeper and get involved with these bands that he liked when he was younger and it sort of springboarded from there, really.

Though Stuart had a family history that was "touched by the hand of Mod," TV encounters also played a role in his interest in Mod: "When I was younger I was into the 60s TV programmes stuff like *The Prisoner*... and you know, stuff like that.... I love all them 60s cult things." Nottingham area native Peter "Speed" Wild (b. 1965), who now runs the Circle record label and still regularly spins 60s Beat and R&B for *New Untouchables* (*NUTS*) Mod weekenders in the U.K.—and sometimes also in Europe and Japan—gave me a similar account: "I... used to see on the TV like...on documentaries and things like that like with the Mods and Rockers fighting in Brighton or things like that and I used to be fascinated with them. That would have been in the early 70s or something, when I was about seven or eight, or something like that."

The 1979 film *Quadrophenia* also played a vital role at this time. It offered a stirring portrait of teen angst and a search for identity through the eyes of a Mod named Jimmy Cooper. The sets, costumes, accessories, and soundtrack also gave an impression of what the London scene at the time may have been like. The film opens with Jimmy meeting friends at the Goldhawk Social Club—where the Who had often played. Jimmy and his friends wear smart suits and ties, ride Lambrettas and Vespas, while period-appropriate music is played in the background. Yet Jimmy feels increasingly misunderstood by his Mod friends, who see him as a volatile personality. The film, meanwhile, focuses on those Mods who were eager to fight Rockers at seaside resorts like Brighton. Under Franc Roddam's direction, *Quadrophenia* circulated a seemingly boisterous, delinquent image of Mod culture overall.

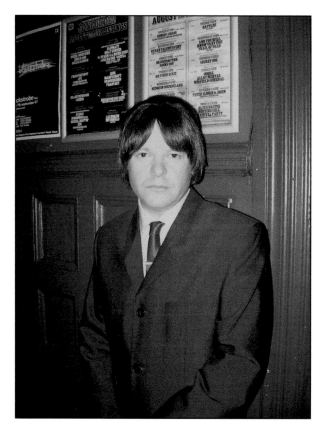

Figure 2. Stuart Whitman (Photo by author).

Given that a Mod Revival was already underway by 1977, *Quadrophenia* came out at the perfect time. This "second generation" of Mods even participated as extras in various scenes. As Des Mannay recalled, the film gave a big assist to the growth of the Mod Revival:

> It completely exploded then. You were virtually on your own at the beginning of the year; maybe you would bump into somebody who had similar taste, but you didn't hang around in a group or anything. By the end of the year it completely changed. It's difficult when you look back at it, the late-70s, early-80s Mods; it's like looking back at the 60s in reverse, because as soon as *Quadrophenia* came along you had the gang-Mod image, which was the main image: Sta-Prest and Fred Perry top, hanging around in a big gang and going to the seaside. But when the 80s progressed, it went further back into its original roots.[110]

As Mannay's comments show, Mods who were exposed to the film first encountered a thuggish, "gang-like" image, but many chose to investigate other aspects of the culture after this first impression. According to the film's di-

rector, "People say that *Quadrophenia* still plays all over the world. It's still got a big following... it still opens in cinemas. And, I think, you know, I think it's because of this drug-taking, this fighting... this search for sexual adventure. It happens to every generation... it's obviously frowned upon by society as a whole, but it's inevitable that people are going to do that."[111] Certainly, the "sex, drugs, and rock and roll" stereotype of rebellious teenagers is what Roddam was tapping into. By the 2000s, though, most Mods were not teenagers, but in their late-twenties to early forties. Thus, "teenage rebellion," was no longer a visceral aspect of the culture. However, *Quadrophenia*'s influence remained important.

Another aspect of the film's influence in Britain was that it elicited a revival of interest in "Mod products." One revivalist remembers, "With *Quadrophenia*, it [Mod] became the look of the year; you had *Quadrophenia* labeled suits and shirts. This was a line of clothing produced by Satchi and backed by the Who. It wasn't just the badge! In some ways it was good for people who couldn't find the right clothes. Eventually that stuff appeared in shops like Burton's by the early 1980s."[112] While some found these packaged Mod clothes a good deal, a lot of teenagers looked instead for secondhand bargains to capture the look they sought: "Saturdays would be spent trawling the second hand shops for clothing, shirts, ties...from Oxfam my first suit for I think £8.00. Yes I was getting there. By the end of '79 I had my suit, Parka, my first pair of Loafers, I was feeling the business but in early '80 everything would change. By the end of '79 there were around 20 Mods in my school."[113] Similar to the Mods of the mid-60s, late-70s Mods tried to create a distinct look.

Some late-70s Mods, though, seemed to fear that followers were being drawn to the culture via *Quadrophenia* for all the wrong reasons. For instance, by August 1979, journalist Gary Bushnell was worried about the growing commercialization of Mod:

> Just six months on from the happy hectic birth of New Mod as a bona fide movement and we've got a different animal on our hands.... Mod fills the London clubs, all the major groups have singles in the pipeline, Lyndall Hobbs imports poseurs for her 'mod documentary,' the first official Mod single 'You Need Wheels' is appalling and has undeservedly charted, David Essex records a single called 'M.O.D' to the delight of ugly, jealous, chinless has-beens everywhere, powerpop phonies and session men start donning parkas, the price of clothes sky-rocket, little kids at Merton Parkas gigs have never heard of The Purple Hearts, *Quadrophenia* approaches with the promise of thousands of Quadmods.... The Mod Renewal is at a crossroads in its short existence.[114]

However, as Speed told me more about how mediated images played a role in his becoming a Mod by the late 70s, it was clear that screening *Quadrophenia* (1979) had played an incredibly formative role:

It was around that time that *Quadrophenia* came out, nearly everybody at your school or friends of yours, they were all—they all felt a bit the same. They got excited by the Mod image and the film itself and everything to do with it and rediscovered the Who, of course, through that, first and foremost. The Jam were about… who were a band that was very much like a very Mod-type-of-thing through Paul Weller anyway…and more or less had been since 1977. So we liked them already. And, uh, it was like a mass popular thing. It became a big craze amongst youngsters, so it wasn't hard to meet people who liked it. [One's] dismay over Mod's commercialization due to the film aside, given the fact that to there was not as much access to specifically "Mod" images in 1979 as compared today, the movie became a generational touchstone.

As Speed further attested:

> When *Quadrophenia* came out with the Mod Revival of course, a lot of groups were playing Mod music, dressing that way, and what have you. And young kids were like, 'Yeah, we'll buy their records.' Like the Purple Hearts, the Chords, and people like that. And also we listened to a bit of the 60s music when it came out on the *Quadrophenia* soundtrack album. There was like a whole disc of like 60s originals on there… it was a double album.

In the interest of realism, the director did not want only Who songs on the reissued *Quadrophenia* album. After all, Mods listened to other artists too. Mods who saw the film and bought the soundtrack were exposed to tracks such as James Brown's "Night Train," Booker T. and the M.G.s' "Green Onions," and the Crystals' "Da Doo Ron Ron." As Speed explained, this was an educational soundtrack for him:

> …And we kind of took inspiration from there. A lot of us started collecting the originals… the Kinks and the Who… a bit of Soul, a bit of Atlantic and Motown, and what have you. So even in the places we used to go… the youth club-type of places and what have you in the Midlands, and even in some of the pubs, they were playing Soul and those sort of things—things that fitted with the Mod thing anyway, because, uh, it was very much loved in my area, and still is. So, it was easy to hear things that you liked that you could associate with Mod.

According to Speed, becoming a Mod after its original heyday required some (pop) cultural "archaeology." Once he heard these vintage tracks, he was anxious to hear more mid-60s artists.

Mods in the late 70s also listened to contemporary groups who were part of the "Mod Revival." Out these, the Jam became the most beloved to the present day. The look and soun.! of the group was and still is a way for scene participants born in the 1960s and beyond to learn about Mod. Looking back at this period, author David Lines writes that from the first time he saw Mods sporting "The Jam" on their parkas, "all I cared about was becoming part of that gang of mods. What I didn't know then was that it wasn't a gang—it was a way of life."[115]

The Jam's quoting of Mod style was evident from their first album, *In the City* (March 1977). It featured a black-and-white cover showing the three band members—Paul Weller, Bruce Foxton, and Rick Buckler—in suits and ties peering arrogantly out at the world, while "the Jam" is spray-painted in black behind them on a white-tiled wall. Their next album, *This Is the Modern World* (November 1977), exhibited a color photograph on its cover. The shot posed the group in what looks like a highway underpass—with postwar "Tower Block" architecture looming in the background. Wearing Ivy League-type casual wear, Weller's sweater is emblazoned with pop art arrows going up and down. Much like the Kinks before them, the Jam's lyrical content was often quintessentially "English." Lyricist Paul Weller's song texts often referred to Anglo- or London-centric subjects such as Eton (public school), art school, Wormwood Scrubs (a London prison), the tube, and Soho's Wardour Street. The band also paid homage to Mod culture by covering the Kinks' "David Watts" (1967) and the Beatles' "And Your Bird Can Sing" (1966).

Mod Revivalists, like the original Mods, sought spaces to see and hear their bands play. They objected to the now-corporate atmosphere of rock culture, with its large-scale, decadent arena rock scene. Mod Revival events took place in more intimate venues—like those in the mid-60s. According to an October 1979 *Los Angeles Times* article, "the hangout for the neo-Mods and the post-punkers is a nightclub called Blitz, where every Tuesday is '60s night and the getups range from boys wearing makeup and big pompadours to girls in tight, short dresses and high heels." Punk had already challenged the by-then established rock hierarchy of Led Zeppelin, Pink Floyd, and even the Who, who played impersonal concerts to thousands. Now the Revival scene followed suit.[116] Barring the massive success that the Jam had between 1979 and 1982 requiring them to play larger venues, Revival concerts were usually in more intimate.[117] Speed recalled how the Revival flew in the face of conventional music in the later 70s and was therefore attractive to him. It was not only arena rock, but the disco craze that offended him. In this way Mod, like Punk, rebelled against the mainstream:

> It was escaping the 70s. You know, we... there was something more vital, more sharp, and what have you, than what was happening at the time. Nowadays, ironically, I appreciate what was happening in the 70s and probably dress more like that... probably... but, at the time, it was square. You hated it. You hated flare trousers, you hated big lapels, you hated shoulder-length hair, because it just seemed like fashion had lost its way and culture had lost its way. I think the Punks started that where they looked at what was happening in the 70s...full of Hippies and people...very drab...very boring in a lot of ways. Glam Rock was the only exciting spark that was happening then and that soon died. And by about '75, that sort of time, it was a sort of nowhere-land. British culture

was like...seemed to have lost its way, and I think, the people who got Punk together understood that. They took a lot of 60s influences and so did we several years later. We thought, 'Yeah, we agree,' cause we were on the tail-end of when Punk happened and bands like Buzzcocks and what have you. They, to us, were quite next-door to Mod.

When Speed said culture had "lost its way," he was referring to what youth culture offerings were available at that time. As opposed to the constant, quick-paced innovations of Mod culture, the early-to-mid 70s had become a period of complacency. Punk tried to shatter that.

> We liked bands like that 'cause they were different. They had shorter hair, they had fast songs, quick songs and things, and that was the way ahead that we developed on. There were things that those bands were doing that all the people of my era were a bit too young to be Punks, but the next best thing was to smarten the Punk stuff up and grab onto it in the way of the Mod Revival. And some of your favorite bands that we liked from the Punk era that were cheerful and fit together nicely, but it was all to escape the 70s, really...to not be some long-haired guy in drape coat carrying a Yes album or something... going to a festival smoking dope, or whatever.

Some of Britain's 1977 chart-topping groups included Abba, the Eagles, Fleetwood Mac, and Boney M—all groups with ultra-slick sounds— seemingly produced with the intention to *be* chart-toppers. Both Punk and the Mod Revival challenged this perceived stagnation.[118]

Overall, the Revival made such a big impact on current conceptions of Mod that even younger members of the subculture cite the Jam and/or Paul Weller as much as, or more than, 60s-era Mod. Alan "Chalky" Smith (b. 1969, Manchester/Leeds) got into the Jam through some Mod acquaintances: "It was just those one or two people who were into the Jam. I mean, I got heavily into them. It was the same year that the Jam split—it was late '82 when the Jam split—December '82 and it was early '83 that I actually got into them, so I just missed out... started listening to the Jam, started listening to other people—got in with people... who were a year ahead of me in school. They were all wearing parkas." Chalky's friend Neil Lee (b. 1978, Liverpool/Leeds) came to Mod through a Jam video on MTV.

> [The] first image of Mod that I had was on an MTV program called *Greatest Hits* where they played the Jam 'A Town Called Malice.' Eh...and just when I heard that record I was like... I knew that I was an Indie kid. I was into Blur—those kinds of bands...Menswear...and then just seeing that image of Paul Weller in a suit, pink collar shirt, and I realized...[it] clicked into my head what Mod was. From then on, I was like, 'That's what I want to be. That's what I want to be into. That's what I like.' And then, from there, I just sort of discovered the other aspects of Mod.

Current Liverpool resident Michelle Gibson (b. 1969) told me that as a ten-year-old she and her friends attended Mod-themed dances Sunday afternoons in her hometown, Glasgow. She was not sure who organized these

events, but as we spoke, she realized they must have been put together by young adults who were part of the Mod Revival:

> Every Sunday we went to the Whiteinch Community Centre in the afternoons. There would be a disco and our disco would be Mod music... I remember dancing to, um, 'Tainted Love' [the original by Gloria Jones, 1964]...and then, 'Green Onions' by Booker T. and the MGs and there was a dance to it that we did...basically it was just the Mashed Potato one and it was intricate and you kept changing it.... The whole week was geared towards what you were going to wear to that disco. And all my little boyfriends were dressed like Mods. [They wore] parkas and Sta-Prest trousers and...you took it really, really seriously.

These examples show how Mod culture kept getting passed down to younger generations—whether through lived or mediated experiences.

By the early 1980s, running counter to mainstream music papers like *New Musical Express* (NME) or *Melody Maker*, members of the community developed fanzines. Fanzines gave Mods a voice to talk about their own culture and connect with other Mods. Fanzines of this period were of varying quality but were usually low-tech, homemade mini-magazines. Stapled together by hand, they were either typed, employed Letraset letters, or written in pen or marker. Eddie Piller told me, "I suppose my fanzine [*Extraordinary Sensations*]'s rise coincided with the decline of Mod's popularity in the music industry because of the backlash caused by the massiveness of Mod at the time." As theirs was not a high-returns commercial venture, with limited editions and each issue selling for usually less than a pound, fanzine producers ignored copyright laws and lifted appropriately Mod images whenever they liked. These handmade publications including *Extraordinary Sensations* were produced nationwide—from Cardiff, Wales to the Channel Islands. Yet another way to circulate and create Mod culture—fanzines' popularity continued up until the advent of the Internet in the mid-90s.[119]

Typical of such scene-centered micro-media, there was generally more focus on local events, clubs, and bands. However, there was some interest in Mod activities beyond England's shores. Prior to the Internet and social networking websites like My Space or Facebook in the 2000s, fanzines did their best to "spread the word" that there were others with similar interests. For instance, in the Christmas 1982 issues of *Extraordinary Sensations*, Eddie Piller writes, "recent investigations have revealed loads and loads of MOD bands all over the world... who would have believed that what started as a handful of kids following the Jam about and going up [to] West Ham in parkas in 1978 would result in something as widespread as it is now."

By this time it was clear that Mod had become an unofficial national institution like pubs, afternoon tea, and the works of Charles Dickens. Inter-

viewing London-based DJ Rob Bailey (b. 1970) at a Berlin Mod event in fall 2006, I asked him if he thought Mod was "British." He said,

> The unique thing about the U.K. is that even if you've never been a Mod, ordinary people in the street know what a Mod is. There are certain things they will always associate with it. Whereas if you're in Italy or Spain or somewhere else, you ask someone in the street what Mod is, they would look at you like you're from outerspace. So, this is the thing that makes the U.K. unique. It's [Mod] part of our...very much a part of our culture and heritage. Yeah, like everyone knows what a Punk is, don't they? So it's the same thing. Bar kind of Rock and Roll, Mod was the first...first scene to do all these things, I mean, taking pills and staying up all night dancing, you know? Which Rave/Dance culture nicked twenty years later on. The Mods were the first people to do this, you know? They had their own clubs, transport, their own talk, their own walk...the first young independent people.

Ironically, Mod culture's innovation had become so celebrated by the 80s that even though it stemmed from the past, it appeared more modern than many other contemporary youth culture offerings.

Cool Britannia: Mod in the 1990s

As *Time* magazine's 1966 article praised the hip London of the first Mod period, *Vanity Fair*'s 1997 cover story, "London Swings! Again!" attested that Mod had not lost its currency. In fact, the images and ideas from the mid-60s seemed just as exciting as they were then. According to the article's author,

> Any mental images we have of a 'swinging' London, of a city in glorious thrall to a thriving youth culture, are indelibly 60s ones: dolly birds in miniskirts; Paul McCartney walking out with Jane Asher; the designer Mary Quant and her geometric Vidal Sassoon haircut; Terence Stamp hand in hand with Jean Shrimpton; the photographer David Bailey in his canary-yellow Rolls-Royce; the actor David Hemmings pretending to be David Bailey in Antonioni's *Blow-Up*. But suddenly a whole new set of tableaux has arisen, and London finds itself cast once again as the Futura 2000 of cities, the place to which we must all look to learn how to act, think, and dress.[120]

The cover of this issue featured actress Patsy Kensit and Liam Gallagher, lead singer of the then enormously popular Manchester band, Oasis, lying on a bed with a Union Jack comforter draped over them and matching pillows.

Not only did this use of the Union Jack reference its ubiquitous use within Mod culture, but the whole idea behind the imagery and the article suggested that for Britain to return to some sort of pop cultural renaissance required a revisiting of Mod. As the title of John Harris's book *The Last Party: Britpop, Blair, and the Demise of English Rock* demonstrates, the emergence of mid-60s-sounding and looking "Britpop" bands such as Oasis (and Blur, Pulp, Suede, the Stone Roses, and so on) were, according to the au-

thor, the "last stand" of British Mod culture. Harris clearly makes a connection between the return of Labour government (albeit the more middle-of-the-road "New Labour") and a newly hip neo-Mod culture. Like Harold Wilson's election in 1964, the then forty-three-year-old Prime Minister Tony Blair was expected to reset the British clock to run at a more youthful speed.[121] What became known as "Cool Britannia," was another way of connecting to Mod culture—and often led new Mods, like those in the late 70s and 80s, to find out more about the 1960s. An increasingly popular way to do this was through a new medium—the Internet.

Like Mod culture itself, the Internet was not really new in 1997 but was also a product of the 1960s. It was originally devised as an alternative way for U.S. military personnel to communicate in case of (nuclear) war-related damage.[122] However, by the mid-90s, more people had access to both personal computers and Internet technology. This was not lost on Mod enthusiasts. Mod Culture: The Mod Scene Online (www.modculture.co.uk), one of the leading sites for Mods in Britain and around the world, was founded in the mid-90s by David Walker, then living in Sheffield.

Through seeing Internet images from Mod's past, Post-Mods have become self-proclaimed authorities. These Internet sources combine texts in an endless cycle of Mod reconstructions. In sections such as "News," "Events," "Clubbing," "Books," or "Art Design," veterans and newcomers can read about such things as where to go for a Mod night out in Brighton, Bristol, or Birmingham, as well as 60s-themed art exhibitions, clothing, furniture, or magazines.

Mod Culture has published articles such as "The Real *Quadrophenia*," a Mod's remembrance of a trip to a Mod rally in Southport, England, and another piece written by a thirtysomething woman who wondered if she was "Too Old to Be a Mod?"[123] This is a pertinent question in that by the 2000s most Mods were no longer teenagers or "young." In fact, many whom I met came to the scene through the Mod Revival and were in their early forties. As Phil Saxe and Steve Plant have shown, there were even Mods from the 60s who still participated in this form of "youth culture."

> Phil: It was only in 1999, a guy named Ian Levine was making a film about Northern Soul called *The Strange World of Northern Soul* and contacted me and my friend Brian (who's here now) and we were the DJs at the Wheel and he contacted us about this Northern Soul-thing. So, I went along, did the interview, and got invited to a night and thought, 'I can't believe it's still going on. There's old people here—still dancing, taking drugs, and stuff.'...So when I found out about that and the Hideaway, [and] met Big Steve [Plant], that was it really: became a Mod again.

Steve: It's the only genre I know where you can get a club as you can tonight where there's a dance floor with guys who are fifty-eight and people at twenty years of age dancing on the dance floor and there's no nastiness.... Everyone's nice.

This was definitely the case at the Manchester event I attended in September 2007. I interviewed the youngest Mod there—Anthony Doggett (b. 1987)—and asked him how he became interested in the scene and if he thought he was part of a "retro" movement:

Well—I got into—when I was younger, I was into, like, Indie bands—the Strokes and, um, the Libertines, and that kind of Indie stuff. And then I liked the Jam and then it just kind of led on from there. And then I started going out to things like Mod 'dos and then just got more into it, got into more, like, say, 'Mod music'—music that's to do with the Mod scene.

...From speaking to...other Mods like Steve Plant, who's one of the original ones, you can see that it's a lot different and, you know... it still seems quite fresh and...quite lively, so I wouldn't say it's a 'retro-thing,' 'cause that makes it sound really dated. I think you...have to be a certain type of person to appreciate it, as well. I suppose in answer to your question, I suppose it is like looking back, but it's looking forward as well.

My interviews and observations in Manchester showed how many varied experiential and generational views can contribute to contemporary Mod culture.

This generational aspect of Mod culture was certainly not lost on Mod website creators. A former feature of the Mod Culture site, circa 2003, showed an interest in tracking where and when contemporary Mods first got involved in this subculture. At the time, the home page featured a poll with the caption: "I entered the Mod scene in...." It gave the user the options of the 1960s, the Mod Revival era, early 90's Britpop, or the last few years. In March 2003 the results of this poll had 53.5 percent saying the Mod Revival, 21.3 percent early 90s Britpop, 16.9 percent in the last few years, and 8.3 percent in the 1960s.[124] Mod Culture also acknowledged different aspects of Mod's history with content that varyingly focused on merchandising, collecting, music, fashion, or lifestyle. It was not uncommon to see photos of angry "*Quad*-Mods," in parkas juxtaposed with more colorful images of Italian design on this site.

Doing my fieldwork, I sent emails to self-identified Mods via *Myspace* to set up interviews in Brighton and Manchester prior to my arrival in the U.K. It was also how I found out about events in both those cities. This was what some Mods had to say about the Internet as a networking tool within the scene:

Mark Perryman (b. 1980, West Sussex): The Internet is such a powerful thing—that you can buy stuff and get stuff you want without really leaving your house. So it wasn't too

bad and obviously there's the few odd shops. There's one here in Brighton. Again, it was really just stuff like search on the Internet for "Mod" or "Mod suit" and anything like that and see what came up. You slowly start to collect a little bit of stuff and you can still pick up the few odd few things on the High Street for the kind of look that you want. So, I found that that was quite easy to sort of move into and get the sort of look that I wanted.

While Mark saw the Internet as the best resource to start collecting Mod "gear," Chalky in Manchester praised Internet radio:

As a Mod growing up and listening to music and going out to the clubs and all that, you kind of think...you never get your own music played on the radio... I'm talking before the Internet. If you listen to Radio One, Radio Two and that's all you had. You had four or five radio stations—medium wave, long wave and that sort of thing—and you'd get Radio Luxembourg and stuff like that. Apart from that, you never used to get any of your—any of the music that you really loved—get played on the radio. I remember hearing 'Soul Bossanova' on the radio in about 1989 and thinking, 'Wow! What are they doing playing this? That's fantastic!' And apart from that, that was it. You know, you kind of wished you had your own radio station where you could just tune in and just listen to your own stuff. With the Internet you can do that which is absolutely fantastic.

Jonathan Marsden (b. 1979, Leeds) believed that websites are the heir apparent to fanzines, but clearly more interactive: "There are a lot of Internet Mods, if you will. People you never knew, but spoke to, online. It's created a whole new way of introducing people to the Mod scene via the Internet. In the past, in the 80s, it was all fanzines...and they might all be several weeks, several months behind...Someone says they're putting on a 'do that very same day...the whole world, even, can know." In this sense, the Mod scene from the mid-90s onward has been more international in scope. As we shall see in the next chapters, Mod has existed elsewhere in the world since the 1960s, but the Internet as well as cheaper travel (especially within Europe) has underscored the transnational aspect of the culture that was always there, but, perhaps, not as robust as in the 2000s.[125]

New-Millennium Mods

For the *New Untouchables'* (a.k.a. *NUTS*) August Bank Holiday Weekender, everyone who could do it traveled to Brighton. This was an event planned primarily by Rob Bailey, whom I had met in Berlin the year before. His website, (www.newuntouchables.com), proved a successful way to attract Mods from throughout both the U.K. and Europe to England's southern coast. The weekender lasted from Friday evening until Monday morning. Saturday afternoon I meet two friendly Greek girls who had taken vacation to come to the event. For some reason, one of the girls told me in an unsolicited aside, "Some of my Greek friends asked me if this was a gay thing. I do think a lot of the Mods are gay." This struck me as rather funny, as I had, at this point,

already noticed the level of flirting between men and women here much more rampant than what I had witnessed in other Mod communities. The other Greek girl busily photographed the scene around her. Through them I met several other people including a spirited nineteen-year-old Londoner named Sasha Hopkinson (b. 1988) and her boyfriend Sam Waller (b. 1981). Sasha was the youngest Mod I had met, though the next afternoon I ran into a group of twelve- and thirteen-year-olds boys—including one who bore a striking resemblance to a young Pete Townshend—who told me of their love of Mod (fig. 3).

Talking with Sasha, I was curious to know how she became interested in this lifestyle. First she told me that she was from the Shepherd's Bush neighborhood, "a proper Mod little sort of hang-out." As a student at the London College of Fashion, she had been influenced by Mod in some of her designs. Her dad made her watch *Quadrophenia*, about which she said,

> I don't like to admit it, but the thing with like the target—I'd seen it before—and Oasis, Paul Weller...but, I never really got on board, but the minute I saw *Quadrophenia*—I don't like to say it, but it did influence me in a way and a lot of people don't like saying that. A lot of people don't like admitting [it] are like, 'No, *Quadrophenia*'s shit—blah, blah, blah,' but yeah, we took influence from that film. And [the film's]...it's not the purist Mod, it's more the Revival.

For her, the Internet was important, too, both for personal and academic reasons. For a school project she found the Mod Culture website helpful:

> I went onto Mod Culture... and I started getting into what actually... a Mod would listen to. And I thought... 'this is good music.' So I read books. I read *Soul Stylists*. Um, I read one called *The Ben Sherman Book*, the *Mods!* I read Terry Rawlings....I read quite a few little books...

> I also sort of started downloading stuff—other music myself. ...I...went onto *Mod Culture* and sites and [asked myself] 'What's this? What's that?'... What is that tune? Little Willie Jones's 'Shakin', – oh, my Days! You know, 'I've got to get that.'

She told me her boyfriend's parents had been Mods in the 60s, when they saw the Who play in Shepherd's Bush. So I asked him, Sam Waller (fig. 4), if his parents thought it was interesting that he could be a Mod in the 2000s:

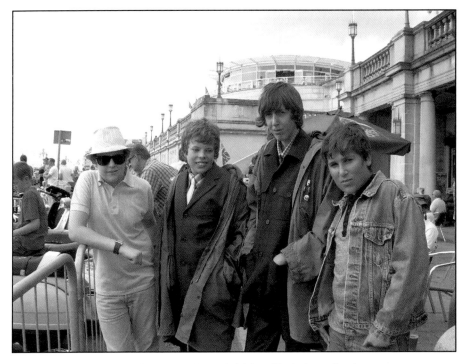

Figure 3. Preteen Mods, Brighton (Photo by author).

Sam: My dad more than my mum. My mum didn't really understand it, at first, why I wanted to get into it, you know? And she is still convinced now that I'll probably grow out of it… that it's just a phase, you know? My dad more so, kind of obviously understood where I was coming from: that I was into smart clothes and music. Even before I got into the Mod scene, I was playing guitar and I was listening to a lot of Blues anyway— a lot of Blues and Soul music. And then I suddenly realized that what I was listening to was, like, proper Mod music, anyway. And, I just took it from there, really. I started listening to the usual stuff: the Jam, Paul Weller, The Who, Small Faces, and then I started getting back into the proper roots of Mod music—R&B, Soul, Ska, Jazz… and that was like ten years ago.

Sam DJed that afternoon and did something I noticed many Mod DJs did— which must stem from Northern Soul—he played many ultra-rare singles. So, even though the musical genre was familiar (he favored late-50s to early-60s R&B), the songs were often not. I was interested in why he thought playing rare tracks was more common than playing Mod "chart hits" of the 60s.

As far as the records go, I think that's moving on—because, well, my dad was quite surprised that the records we listen to now were not the stuff they listened to in the 60s: a

lot of the R&B tunes and not the Motown Sound and stuff like that. The whole thing about the modern Soul scene now is that it's seeking out new tunes, but obviously, tunes that fit in with the whole Mod philosophy—the R&B and Soul—the stuff I played earlier. Not a big hit of the 60s, 'cause nobody knew anything about it. Nobody knew half the labels existed…. They'd probably get about a hundred copies sold. The artist probably never did another hit in his life, you know? And the whole thing is seeking out these tunes that you don't know. That's moving on.

Christine: Yeah, and that's what's moving on…because you're sort of creating new club hits, as it were, that are from…[the 60s].

Sam: …Club hits for today's Mods, yeah.

I found this interesting because it was another way to reimagine the original Mod era. Since DJs are collectors looking for "their 60s," it was not about hits but their personal playlist that could create new dancefloor sensations.

On Saturday night, at the Komedia Club in Gardner Street, there was a huge crowd of colorfully dressed female Mods and suited-up male Mods milling about outside the theater. Nearby, people gathered for pre-party drinks at the Hart and Hands. Due to the no-smoking laws, many people stood outside while drinking their pints. Some people I met earlier that afternoon were there. In the small, European "Mod world" I was not surprised to run into Matthias from Berlin (who looked a bit like a young Mick Jagger). I had met him in Bad Breisig, Germany, at the "Two Men from Linz" weekender in May 2007. He was not totally surprised to see me, either. I guess he knew more than I did how small Europe can be for travel-happy Mods. In a mixture of German and English, he told me, "Yeah, I wondered who I might run into here." He then introduced me to his friend who was living in London. Matthias had just visited him there and then they found out that this event was going on in Brighton. "We are living our teenage *Quadrophenia* fantasies," said Matthias. The boys planned to stay up all night and then head back to London on a morning train. I ended up walking with them to Komedia where they still managed to get tickets to the nearly sold-out Little Barrie concert and subsequent all-nighter.

Inside there was the usual crowding around the bar prior to the band's performance. I circulated around the crowd looking for familiar faces. The venue was a large theater space with a low, flat stage at the front. It had the feel of a discotheque rather than either a theater or nightclub. The music was already blaring with a DJ playing records stage right. I squinted through the crowd to see if I recognized anyone from earlier in the day. Despite the darkness, I saw several Mods I recognized.

The daytime activities took place at the Volks Pub by Brighton Pier, where I met and interviewed a few Mods. Entrepreneurs sold vintage

clothes, rare 45s, and various Union–Jack–emblazoned trinkets, while the rest of the crowd relaxed with a few pints in the welcome sunshine. Parked Vespas and Lambrettas were visible nearby. Back at the Komedia, I soon spotted Paul, whom I had met earlier that day. In our conversation, he told me he grew up on London's East End, studied fine arts, and was now a carpenter. His parents were both art teachers. He looked and sounded like a young Michael Caine with a modified Prince-Valiant-by-way-of-George-Harrison hairdo and sported a sharp, charcoal-gray suit with a silver paisley tie. Paul was accompanied by Stuart (Whitman), who looked every inch a Small Faces fan that night with his perfectly aped Steve Marriott hairstyle. They had just come from the Sussex Arts Center where the competing "Mojo2Gogo" event had begun earlier in the evening.

Figure 4. Sam Waller (Photo by author).

I then saw four Mods from Southampton, whom I had met the night before. We talked informally. They asked me about the States and whether I was *alone*. I was used to this question by now.[126] As I looked around, it did appear that many women in attendance were in groups of friends or with boyfriends. Apparently, most women in this Mod scene did not attend events solo. Soon I told these four about my research project. They found it interesting that an American should be writing about Mod. The next night,

already feeling well acquainted, two of the Southampton boys told me they worked in construction. We also talked about the Beatles. A few of these Mods from southern England had told me that it would be untrue to say that the Beatles had nothing to do with Mod culture. A friendly, sun-tanned brunette with a spiky mop of hair (also from Southhampton) told me that, at the end of the day, you could not exclude the Beatles in the story of how Mod style and music took over 60s youth culture. The night before, Paul had also said that without the success of the Beatles many other Mod favorites such as the Small Faces, the Spencer Davis Group, or even the Animals would never have become so well known in England.

As we have seen, Liverpool and London had been home to many bands, fashions, and hip spaces in the Mod 60s. However, thanks mainly to *Quadrophenia*, Brighton might be called the subculture's "spiritual home." Though the city was linked to the clashes there between Mods and Rockers, these images have nonetheless created a solid connection between the city and Mod itself, something which has made the city a preferred venue for weekend-long Mod events.[127]

In this way, Brighton, like Mod, represents the search for another England away from the frantic pace of everyday life—whether in London or elsewhere. Brighton is and has been a locus of both departure and return. As a coastal city and resort it is literally on "the edge" of England—allowing for cultural edginess.[128] Like the docks of London's East End or Liverpool's port, a seaside city like Brighton was yet another space for a confluence of different ideas and people where one could cast away what was one's normal routine and embrace another kind of persona. However, it was also an illusionary situation—the weekend would eventually come to an end and one would return to "real life." In *Quadrophenia*, Jimmy's illusion is shattered when he realizes the "Ace Face" of the Mod weekender he was just at is in fact "only a bellboy" at a Brighton hotel. As another song on the soundtrack states, Jimmy is a Mod because he is on a quest for who his "real me" is. The opening scene of the iconic film (which is really the ending) shows Jimmy walking away from a cliff as the sun goes down. It is not clear why, but at the end of the film, we learn he has thrown his Vespa over the cliff—walking away with his life while saying a symbolic final good-bye to his life as a Mod. Though a fitting ending for a film about teenage angst cloaked in Mod gear, this chapter has shown that the sun has not yet set on the Empire of Mod. Even in the new millennium, it has inhabited live and media youth spaces that allow new generations to breathe life into it and, inevitably, change it. It was clear to me that British Mods in 2007 embraced an idealized modernity

conceptualized by their parents or grandparents but continued making it a vibrant scene for themselves in the twenty-first century. *Rule Mod-tannia!*

The Young Idea
Cosmopolitanism, Youth, and Mod-ernity in Germany

In the city there's a thousand men in uniforms
And I hope they never have the right to kill a man
We wanna say, we gonna tell ya
About the young idea
And if it don't work, at least we said we'd tried.
—The Jam, 1977

In March 2007, as I sat in my train compartment headed for a small Bavarian town on the shores of Lake Starnberg, I felt a nervousness I had not yet experienced in the six months I had conducted oral history research in Germany. I was going to interview Klaus Voormann—someone about whom I had read about since childhood—from the first time I paged through a book about the Beatles. It was then that I first understood the band's development was affected greatly by their time in Germany. Growing up in a German-American home, I was intrigued that the most popular rock band ever had played its first overseas shows in Hamburg. At the time, this newfound knowledge made Germany seem exciting to me in a way it never had before. Before this occurrence, recognizing my German heritage had meant coming to terms with some difficult truths. Throughout my childhood my mother talked openly about her family's hardships during the war.[1] In the same year, though, that I learned of the Beatles' substantial ties to my mother's native country I also saw the TV miniseries *Holocaust*. This dramatized portrayal of Germany's Final Solution made me realize that had I been born in Europe a generation or two earlier, I would have been classified as a *Mischling* (half breed) and condemned to a concentration camp because of my Jewish father. As a Lutheran-raised child who felt connected to my German heritage, it was the first time I realized that this self-identification would have meant nothing to the Nazis.[2]

Not long after seeing this miniseries I found out that two next-door neighbors survived the concentration camps. They did not need to tell me. I saw the tattooed numbers on their arms. Though my mother was initially fearful of revealing her ethnicity, they eventually learned my mother was

German, and remained kind to her. They, on several occasions, invited our
family over for Passover—some of my first experiences of a Jewish holiday.
At eight years old I felt profoundly sad for my neighbors and the family they
lost, but also for my mother and her family, who had lost much pride in their
identity. Thus Nazism continued haunting subsequent generations of Ger-
mans. How could one live with that, I wondered? How could one live with
the knowledge that parents or immediate family members had been fervent
Nazis or actual perpetrators of war crimes? And even if one's family had not
been fascist, many Germans still felt guilt by association. How would one
wear that legacy that seemed so far removed from contemporary day-to-day
life?

Given the country's reputation during and immediately following World
War II, I was surprised that Britain's Beatles had willingly spent time in
Germany only fifteen years after the war ended. British cities, especially the
Beatles' hometown, had suffered extensive bombing by the Luftwaffe and
still showed signs of damage. Yet, my encounter with the Beatles' story in
Germany made me realize that the friendships formed between the band and
a group of Hamburg art students overcame stereotypes each may have had of
"the German" or "*der Engländer.*"[3] Just as my neighbors embraced our family,
these German and British youths embraced each other. I realized individual
connections between people *can* transcend the politics of hatred. Without
expecting it, these memories came flooding back as I traveled to interview
one of those students who befriended the Beatles so long ago.

Suddenly I heard the train conductor announcing "*Nächste Halte: Tutz-
ing*" and was back in the present. Walking out of the station, I recognized
Klaus right away. He seemed friendly from the start, even greeting people
who passed by. The town we met in was typically Bavarian: wooden-frame
houses with flower boxes attached to each and every window. Klaus sported
shoulder-length white hair and a beard, looking every inch the stereotypical
artist or ex-rock star of a "certain age." His bright blue almond-shaped eyes
and manners conveyed a boyish charm despite his nearly seventy years. We
drove a short distance from the train station to a lakeside park, where the
interview took place. Giving me an interview in English, rather than his na-
tive German, allowed me to hear traces of the British lilt that he acquired
living in London during the 60s.

The regionally specific, pastoral setting in which I interviewed Klaus
struck me as a stark contrast to the urban centers where he has lived most of
his life. Though originally from Berlin, Voormann attended art school in
Hamburg by the late 50s, which is where he eventually befriended the
Beatles in 1960. By 1964 he had moved to London, working for a short time

in advertising. In 1966 he designed the Grammy-winning cover for the Beatles' 1966 album *Revolver*. After a brief stint as part of Paddy, Klaus, and Gibson, he played bass with London's Manfred Mann (fig. 5), which dissolved in 1969.

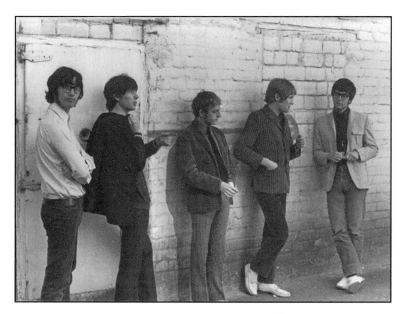

Figure 5. Klaus Voormann (second from left) with Manfred Mann, mid-60s (K&K Center-of-Beat, Hamburg).

He then recorded and toured (as bassist) with John Lennon and George Harrison, respectively, in the early-to-mid 1970s.[4] More recently, Voormann designed the sleeves of the *Beatles Anthology* albums, which were released in the mid-1990s. Though I first heard of Klaus by reading about the Beatles, I was not interested in asking questions about the Beatles per se, but rather how his friendship with these young Britons symbolized the German postwar generation's wish to move beyond the shadows of Nazism.

I asked Klaus about the early 60s in Hamburg—the years that a blossoming British Mod culture began filtering into West Germany. How did his identity as a German influence his earliest perceptions of the English? He told me that the Beatles were the first Englishmen he met. Did he have any preconceptions of what British people were like prior to meeting the young Britons? "I thought they all looked like Churchill! There was this gentleman-thing... and of course [I imagined] people like Sherlock Holmes." He explained that the difference between his preconceptions and reality had to do

with the clientele and atmosphere in Hamburg's nightclubs as well as a strong presence of Liverpool musicians:

> It's a unique situation because we had the musicians… and those were kids who had wanted to be there and dance, so this was not the normal public. This was a very selective crowd of people and they got on really well with one another. The one thing that struck me most was… about the bands from Liverpool was that they were so friendly, so funny. Ever since then I really, really love Liverpool people. They are a special breed of people. You don't find those anywhere in the world—I mean they have a little bit of Irish, Scottish, and it's all the way up north and it's a fantastic mix. I think that's the main reason that those people and those bands became so famous… because of this wit and their energy. When I first went to Liverpool it was like heaven to me.

Did the "wit and energy" that impressed and enchanted Klaus about these bands somehow influence feelings about his native land and citizenship? He told me, "I know what German qualities are, but I'm not typical. Maybe I'm not good for analyzing it and saying what German—how do you say—how it happens [that] they are the way they are starting with the Prussians. Berlin is the worst… terrible." Here, Klaus implied brusque behavior. "If you're in a supermarket or you're in a bar or standing in a row [or] trying to get on the bus it's such a hassle. It's getting better, but it's still there." I cannot but wonder if Klaus would have these feelings about being German had he not had such positive experiences with foreigners at a young age.

Though family and work (as a music producer) brought Klaus back to Germany by 1979, his words showed that it was still difficult for him to reconcile living there. "This [German] stiffness has been in the way for a long, long time," he told me. "It starts to loosen up a little now, but you see, somebody [I know] came back from holiday or something, and he said, 'When I come back and I look at these faces in the subway or in the bus… they look like they're dying.'" For Klaus inhabiting a cosmopolitan identity often has been at odds with his vision of stereotypical German "stiffness." The tension of existing both in and outside of his culture has not been Klaus's alone. As we will see, his words seemed to encapsulate sentiments of other Germans—also in his generational cohort—who have dealt with the changing attitudes surrounding national identity. Indeed, Mod culture has played an important role in new perceptions of self since Germany's postwar period.

The Mod Solution to a Fascist Past

The German adoption of Mod was not only bound to the postwar generation's desire to belong to an international youth community. It can also be examined within a longer-standing debate about nationhood and young people there. This discourse extends back to the late nineteenth century, soon

after the founding of Germany.[5] Since that time, historical documentation points to generations of adults expecting each new youth cohort to embody the national future. Youth supposedly symbolized all things progressive and new. This sentiment was so strong by the early 1900s that Germany was the only country to call the groundbreaking style of Art Nouveau *Jugendstil* (the "Young Style"). However, and not surprisingly perhaps, members of each new generation have not necessarily fulfilled that promise, and sometimes, have even rebelled actively against their predecessors' wishes. This was true even for those who came of age during the Third Reich, where resistance could mean imprisonment and/or death.[6]

In the case of Mod's postwar arrival, then, the stage was set for German youth to react against the Nazi past and to think globally versus nationalistically. National Socialism's terrifying consequences pushed many young, postwar Germans to embrace all things foreign. Starting as early as 1945, but continuing on into the 60s, German teenagers sought to escape their fascist-tainted national identity.[7] In Germany, Mod's arrival at the beginning of the 60s coincided with a need for that country's young not only to reassess what being "modern" could mean, but also what being "German" could mean after the horrors of the Third Reich were revealed. What would Mod culture, style, and music mean for their quest? The subculture's adoption in Germany thus emerged from questions about national, European, and global identity.

The relationship between generation and modern identity in Germany is especially important when placed within the context of both World Wars. Germany, a twice-defeated nation, saw the results of both wars contributing to a dynamic process whereby vibrantly progressive and "youthful" periods followed each conflict.[8] This pattern helps explain the initial adoption of the British-born Mod youth style in postwar Germany as the perfect antidote for a generation coping with the specter of their parents' Nazi past.

Mod Comes to West Germany, 1960–1967

Arguably, nowhere was it more important for young people to be considered *modern* than in postwar Germany. What good had the recent past wrought? Adolf Hitler, during his twelve-year rule, had sought to conquer Europe with an Aryan super-race, ignited World War II, and systematically killed more than six million Jews among other "traitors" to the German nation. Just as the war had changed forever the way many Britons thought about how to live in a modern world, it also made Germans rethink their identities in this same world. Furthermore, since the Third Reich had already codified most American music (like Jazz and Swing) as decadent during the 30s and 40s, the subsequent arrival, acceptance, and appreciation of

Anglo-Saxon rock music after World War II clearly challenged and "attacked" previous Nazi sensibilities. As was the case with Britain too, the "problem-solving" attitude that young Germans now had, which was influenced by the cataclysmic effects of war, also stemmed from former, seemingly soulless manifestations of modernity. German Mods would seek to transcend the nefarious reputation of their nation's Nazi past.

Germany's emergent Mod culture was helped by ties established through Allied Occupation in the immediate postwar period. The British Forces Broadcasting Service (B.F.B.S.) in northern Germany brought British accents and its accompanying culture of comedy and song to those who listened. Southern Germans who tuned in to the American Forces Network (A.F.N.) could hear Swing, Jazz, and, eventually, Rock and Roll. Meanwhile, French savoir faire was available in Berlin's French sector and to those living in the southwest occupational zone, where French commercial radio station Europe no. 1 could be heard. Just as the Third Reich tried forcing Germans to perceive their culture and identity as superior to others, the postwar occupation was a period where many young Germans saw their culture as inferior to those of the British, American, and French.[9]

Given that the Nazis created a technologically advanced nation combined with romantic attitudes that celebrated an imagined Aryan authenticity, the postwar generation sought to invent a new identity based on foreign realities. While the National Socialists would have viewed their ideology as "utopian," the original 60s Mods (as well as the subsequent generations of German Mods), strongly counteracted *reactionary modernism*, with something profoundly forward thinking.[10] As was the case with the internationally minded, free-spirited Weimar period of post–World War I, this era was also cosmopolitan in its outlook and was influenced and transformed by social outsiders.[11] As we have already seen, the origins of British Mod culture drew from the working class, Jews, Caribbean immigrants, African-American musicians and G.I.s, and homosexuals. Thus, those who adopted Mod in 1960s Germany were also, often unknowingly, reintroducing a cosmopolitanism that the Nazis had negatively linked to the Jewish community. Clearly people who were presumed to have this outlook or "nature" were seen as threats to nationalism and targeted for elimination.[12]

Mod first came to Germany in the form of Liverpool-born *Beat-Musik* through the port city of Hamburg. Like most other large cities across the country, Hamburg had been heavily bombed by the Allied Forces during World War II. Nonetheless, by the time the Beatles first arrived there in 1960, Hamburg's reconstruction was much more complete and impressive than that of their hometown. According to one Beatles biographer, after the

group saw the city's lavish townhouses and elegant church spires "what was said [in their mini-bus] that August evening would be echoed many times afterward in varying tones of disbelief: Wasn't this the country that had *lost* the war?"[13]

While Hamburg's postwar condition proved impressive, it was the British who brought with them new, dynamic sounds that would captivate local audiences. Nightclub impresarios such as Bruno Koschmider (the Indra, the Kaiserkeller), Horst Fascher (the Top Ten), and Manfred Weißleder (the Star-Club) booked British solo musicians and bands between 1960 and 1962 to play the clubs of the city's red-light district, St. Pauli—which is often (still) synonymous with its main thoroughfare—the Reeperbahn.[14] Akin to London's Soho, or the Liverpool docks, St. Pauli has a long tradition of housing all kinds of cultural outsiders. Aside from the Reeperbahn, another key street in St. Pauli is die Große Freiheit (the Great Freedom) which was so named in the seventeenth century because of the area's religious tolerance and allowance of free trade. However, given the district's lengthy history of prostitution, the street's name has often been interpreted differently.[15]

St. Pauli's streets were often dominated by sailors looking for a good time while on leave. Considered a mostly seedy, but diversely populated, area, few "respectable" Hamburgers would walk its streets. However, "intellectuals, artists, and bohemians" settled here, somehow enjoying—or not minding—the district's less-polished attributes. While St. Pauli brothels continued to thrive, some neighborhood business owners sought other ways to profit from foreign and German pleasure-seekers. Enter British rock music.[16]

Tony Sheridan, who had already achieved minor success at London's 2is coffee bar and on British TV in the late 50s, was one of the first to perform there in 1960 and quickly became a local favorite. Through the band's first manager Allan Williams's German contacts, the Beatles began playing in St. Pauli later that year. At first, the Beatles were merely one of several Liverpool bands there. The Searchers, Gerry and The Pacemakers, and King Size Taylor & the Dominoes were already featured acts. An all-female outfit called the Liverbirds also would soon attain more success in Germany than they ever would elsewhere.[17] While the presence of these bands was important to young Germans, the Beatles' eventual fame made Mod culture clearly more visible—even to mainstream youth. The relationship between the Beatles and Hamburg was also a symbiotic one. As the Beatles' sound and style matured in Germany, so did Mod youth culture in their native Britain. The group's rigorous performance schedules in Hamburg have been cited as an integral component to their later success. Additionally, the band's first

single, "My Bonnie" (with Tony Sheridan)—the same one that would soon
be popular in Brian Epstein's Liverpool music store—was recorded in Ger-
many. The impact on the group was so profound, in fact, that John Lennon
would say later, "I was born in Liverpool, but I grew up in Hamburg."[18]

The Beatles' initial concerts there took place at a small, sometime-strip
club called the Indra at a remote end of the Große Freiheit. Through three
lengthy engagements between 1960 and 1962, the Beatles usually performed
for seven hours every night. They then moved to the larger Kaiserkeller, and,
eventually, the more prestigious Top Ten Club, which was on the Reeper-
bahn. On April 13, 1962, Manfred Weißleder's Star-Club—which would
become the most well-known German club during the course of the dec-
ade—opened with the Beatles on the bill.[19] The reasoning behind the initial
influx of British, rather than American musicians was simply economic. As
English had become *the* language of rock music, it was not important where
the musicians came from, but that they could deliver the goods via the mu-
sic's lingua franca.[20] Though American acts (and even Japanese band, the
Spiders) would play the Star-Club by the mid-60s, the initial roster of per-
formers were British.

The roots of the Beatles' Mod-tinged style of collarless suits and pud-
ding-bowl haircuts circa 1963 also have been linked to their Hamburg ten-
ure. The Beatles' initial transition from Rocker-esque to Mod-ish style can
be attributed to their friendship with some German art students. Astrid
Kirchherr, Klaus Voormann, and Jürgen Vollmer, who befriended the group
during their German engagements, encapsulated all the continental flair and
élan that British Mods wished for. Unbeknownst initially to the young Liv-
erpudlians, these students were part of Hamburg's *Exi* clique. The Exis
(short for Existentialisten) were a subculture that touted existentialist lean-
ings, watched French films, wore chic, black clothing, frequented cafés, and
favored Jazz. With many similar interests, the Exis could be seen as the sty-
listic German cousins of British Modernists. Like these British hipsters, Exis
also sought and mimicked aspects of French and Italian culture alongside the
free-flowing sounds of Modern Jazz. Paul McCartney described them as
bridging Mod and Rocker style: "They weren't really Rockers or Mods—like
we'd seen. They were something in the middle…. They were art students,
really."[21]

While the U.K.'s Modernists, and later, Mods, attempted fleeing a re-
pressive class system, the Exis tried escaping a newly tainted German identity
by creating this cosmopolitan youth style. Hamburger, former Beat musician,
and current television personality Kuno Dreysse (b. 1945), remembered
thinking Exi was really the same thing as (British) Mod: "For me Mod was

more... we called it 'Exi.' Existentialist: 'Exi...' and from Jazz... 'Parka' was also a term... also short hair, actual, short hair, because there were actually already Rockers with their ducktails and pompadours... leatherjackets. Rockers were primitive and we were elite... we were secondary school students. We played Jazz... I would equate [Exi] with the Mods." Thus, the more high-brow Exis became foils to German Rockers, just as the Mods did to those in England.[22]

While Kirchherr, Voormann, and Vollmer became relatively well known, in part, due to their formative roles in Beatles lore, countless other young Germans began frequenting St. Pauli clubs to see and interact with their favorite bands. In diary excerpts from the mid-60s a young woman identified as "Gesine" documented her struggle to break free from the confines of her provincial north German town and find something more in Hamburg. She describes her town as "population 8000... fat women, workers, farmers, priests." According to her, in order to escape via the train station you "have to run the gauntlets, passing gossips dressed in aprons."[23] Gesine's jaunts in Hamburg seemed filled with experiences running opposite to those she had back home.

The city represented the new and exciting while her *Heimat* symbolized the everyday and humdrum.[24] These sentiments came across in her diary as she described seeing British and German bands playing in St. Pauli—bands like Liverpool's Remo Four, London's Kinks, and Hamburg's Rattles. Like many of her British Mod counterparts, Gesine found excitement in the era's burgeoning youth-oriented nightlife, but there was something else, too. For young Germans, listening to English-language music and spending time with British musicians, specifically, were ways to differentiate oneself from a much maligned past. To align oneself with the "British," or to identify as "continental" or "European," rather than solely as German was presumably quite attractive. As historian Axel Schildt astutely observes, "There was perhaps no other Western European country [in the postwar period] in which school children and students were as enthusiastic about Europe as in Germany."[25] For youths not yet able to travel outside of Germany, larger cities like Hamburg became gateways to greater European and cosmopolitan experiences. It was here that teenagers tried to free themselves of a German society which was still mostly made up of lace-curtained rooms, midday coffee klatches, and uncomfortable silences.

These diary entries mirror a greater trend among German postwar youths who wanted to distance themselves from a previous generation that they saw as not only stuffy or provincial due to their age or environment, but also as a group suspiciously eyed given the Nazi past. Was theirs not the gen-

eration who had either supported Adolf Hitler's anti-Semitism, militarism, genocide, and aspirations of *"Deutschland über Alles"* in young adulthood, or marched proudly as part of Hitler Youth? Thus, German teenage rebellion had an added layer of intergenerational complexity not found in other Western nations during this period. In their efforts to be, as much as possible, direct opposites of their parents, these youths felt that they had to look actively outside of their country for an antithetical future outcome.

Even if he was not always conscious of his actions' greater implications, one such teenager was Harald Mau (Hamburg, b. 1945). In broken English, but not lacking in enthusiasm, this young dockworker would always try making contact with St. Pauli's coterie of ultra-cool, near-other worldly Britons. At the Star-Club he saw performers such as the Remo Four, the Liverbirds, and his particular favorite singer Beryl Marsden. In encountering young, musical Brits, Harald related to me how this group broke stereotypes he had heard from his older coworkers:

> I tried not to bring politics up at work with my colleagues, because I had to work with them tomorrow and the day after tomorrow....But they really spoke very snidely about the English, the older people. The younger ones did not. For us... it was a departure. Everything was new to us... you can't forget that. One didn't see the English necessarily as friends, but you just accepted them. Because I think we said, even then, that we don't have anything to do with the past. Maybe one thought about it, maybe one didn't worry about it at all and just accepted things for face value: They're there and they're making nice music... they're nice people. It doesn't interest us what their parents did. I want to have fun here and now and hear good music.

Though Harald interacted with scores of Greek, Italian, and Yugoslavian *Gastarbeiter* (guest workers) on the docks, his first leisure-time encounters with foreigners were with British musicians at Hamburg clubs. These friendly meetings between young Germans and Britons did more than these youths knew in establishing amicable relationships between people from countries that, just one generation before, had been at war. In describing this dynamic, historian Gerhard Linne suggests that "The most joyful characteristic of the German postwar [youth]... is their self-evident internationalism. After twelve years of isolation within a swastika cage they finally had contact again with the outside world. It was like an epiphany. There were 'others,' and they were people like them. From a critical and sober point of view they knew that there is no such thing as conflict-free togetherness. But, there is the possibility of getting a little bit closer and... making the world a better place."[26] A similar sentiment comes across in Astrid Kirchherr's (Hamburg, b. 1938) memories of first getting to know the Beatles. In retrospect, she now understands the nature of her interactions with the young Liverpudlians in broader, historical terms:

Because it was a relatively short time after the end of the Second World War and because we were citizens of two nations that had recently been enemies, we faced each other at first with a few prejudices and misconceptions. John, Paul, George, Stu, and Pete, for example, would have been more likely to expect a strapping, red-cheeked maiden with straw-blond braids and a dirndl dress than me—a self-assured, short-haired young photographer wearing a leather suit and driving my own convertible. We, on the other hand, remembered the 'Tommies'—British soldiers—who had occupied Hamburg in 1945. These prejudices soon evaporated and led to a give-and-take that was as intense as it gets. We had so many common interests—music, literature, film, and art; we talked heatedly about God and the world.[27]

Astrid, who was engaged to "fifth Beatle" Stuart Sutcliffe before his untimely death from a brain hemorrhage in 1962, subsequently married Hamburg-based Beat drummer and Liverpudlian Gibson Kemp in 1967. Though the couple eventually divorced, they remain good friends. Astrid's pivotal role in emergent Mod culture both in the U.K. (via the Beatles' newly developed style) and in Germany has long been a story mostly only known to those familiar with Beatles history. However, a wider audience became familiar with her influential role through Iain Softley's 1994 film *Backbeat*.

Astrid's relationships with Stuart, and later with Gibson, were not the only British-German romances to blossom. Seemingly inevitable—given musicians' long-term residencies in Hamburg—at least a few friendships between British musicians and German women ended in matrimony.[28] It was another point in which generational attitudes differed. As Gibson Kemp told me, "When I rang up and said I'm getting married to a German, [my grandmother] pulled a bit of the 'Don't you remember the war?' sort of thing." The significance of these cross-cultural interactions was not lost on impresario Manfred Weißleder, who saw an even greater importance in them. Writing most of the *Star-Club News* magazine himself, he touted in the August 1964 issue that his upcoming international rock festival hoped to foster even more understanding among young people:

> Through [this festival] our intended result is that young people from different countries get to know each other, become friends, and keep in contact. Music is the ideal prerequisite for such efforts. Proof of this claim was the Hamburg visit of the Liverpool Cavern Club and the plan to follow with a trip to Liverpool. Since then, there has been a spirited letter-exchange between young people in England and their Hamburg penpals, which is dutifully being tended to. Liverpool is a city that was nearly destroyed by the German Luftwaffe in the last war. That's why is is noteworthy and satisfying to us that Liverpool's Lord Mayor said, at a reception in our honor, that this kind of acquaintance has been more effective than professional diplomacy. It is because this kind of acquaintance happens person to person and does not come about through professional obligations.[29]

As his words show, Weißleder saw diplomatic potential in the seemingly apolitical world of popular youth culture. Through common interests in music and fashion, the first transmissions of Mod culture filtered into 60s Germany.

Just as British groups, including the Beatles, learned about Exis and other aspects of German culture by spending time there, German youths began to hear about what was happening in the U.K. from the English bands. Klaus Voormann told me, "Yes, I heard [about Mod] because they [the Beatles] were saying 'Mods and Rockers' and we were saying 'Exis and Rockers.' I think the Germans were always more orientated toward France." Klaus's claim might not only be based on his involvement with Hamburg's Exis, but also as someone who grew up in Berlin's French occupational zone. However, at this time, a shifting orientation toward British music and style was becoming clear in many facets of German youth culture. By 1964, with the Beatles' momentous successes in Britain and the U.S., "Mod" became the word to describe the new youth styles in music and dress. In Germany, though, the word "Beat" was used instead. Items that were part of the country's "Beat fashion," such as *Beatstiefel* (Cuban-heeled, Chelsea boots) and *Pilzkopffrisur* (mop-top) for men—and "*charlestonähnliche Kittel*" (1920s style fashions) and "*weiße Lederstiefelchen*" (white leather go-go boots) for women—would definitely have been labeled *Mod* in Britain and the U.S.[30] The success of the Beatles and Beat music paved the way for the German marketing of the Mod lifestyle that manifested itself in these commodities, as well as in print, radio, television, and film.

In print, magazines *Ok, Musik Parade, Twen*, and to a lesser degree, the more mainstream *Bravo*, provided information on this emergent culture.[31] Strangely, considering that "Beat" simply replaced "Mod" as a style descriptor, it seems rather contradictory that many of these magazines nonetheless characterized "Mod" as something British, and thus different, from Germany's then-current youth phenomenon. One such example is a May 1964 *Spiegel* article focusing on the "Mods and Rockers" in England—featured in its "*Ausland*" (overseas) section.[32] An August 1965 *Star-Club-News* reader-written "Scene Report" of London described a mélange of youth cultures, but focusing on Mods and Rockers. Mods are described as "Modern-Boys... They are youths that separate themselves from Rockers and Jazz fans through their choice of playful, romantic, super-modern, or old-fashioned clothing, their preference of music, group mentality, etc.... Mods are truly the most unusual of the British youth cliques."[33] Fashion articles in *Bravo* between 1965 and 1966—the first featured the Rolling Stones—also mention Mod in conjunction with British fashions. A 1965 book about the

Beatles, written by a German expatriate living in Greater London, devoted a whole chapter to Mods and Rockers. She portrayed Mods as people who think of themselves as the "*Menschen von Morgen*" ("the people of tomorrow") who were ordinary, middle-class teens with avant-garde aspirations.[34]

Even so, it was also by this time, and within the pages of these very same magazines, that some young Germans began describing themselves as Mods. Starting in late 1965, issues of *OK* magazine's personals section featured readers who described themselves as Mods who were looking for like-minded pen-pals. In the October 1965 issue of *Twen* magazine a nineteen-year-old student also identified this way:

> Last summer I let my hair grow long. I like it that way. However, it's not the Beatles that I emulate, but much more so the Mods. That's why I try as much as possible to dress my best. I especially love jewelry. I always wear rings and bracelets. My school director is really against it and I often have to go see him. He calls me a complete idiot and a Neanderthal. I personally think that long hair in our age is okay. Most girls like the long hair…I'd like to study architecture later. If my work requires that I cut my hair, of course I'll cut it.[35]

The accompanying picture of this student showed him wearing light-colored, Sta-Prest-type trousers, a white shirt without a tie, and a black blazer. Here he differentiated his style from the Beatles', implying that some German Mods did not necessarily see Mod and Beat as interchangeable terms. Although these examples show that some German youths in the 60s were calling themselves Mods, participants in the 2000s did not believe this identity, as they understood it, existed in the 60s. Dietmar ("Didi") Haarcke (b. 1970), who discovered the Hamburg Mod scene in the mid-80s, has DJed events, and produced the *New Explosion* "modzine," had this to say:

> Hamburg was the Beat Mecca from the beginning to the end of the 60s. One always hears how all the bands who played here in the 60s thought Hamburg was the best, the most interesting…the most super. There was naturally a fascination. But there was no Mod scene here in the 60s. I mean, my father, who was always in the Star-Club, he was a bit more of a Rock and Roller. Not a Rocker, per se, but he had a pompadour but no leather jacket…but looked more Rock and Roll-ish. And Mods… they didn't exist then. There were the Exis (the Existentialists) who thought everything was interesting and read books. My dad told me that that existed, but the people in the Star-Club… when you see photos today… when you look at the girls in the photos… they look great. The guys are all wearing suits, so that's like a Mod event, but that was just normal for youth back then.

In Didi's estimation a proto-Mod community existed de facto because what he recognized as Mod style was present in images he had seen of Star-Club audiences. However, he did not recognize an *authentic* 60s Mod scene because he did not think most teenagers then intentionally identified them-

selves as Mods in a scene with that label. They were simply going along with the current fashion, which was—whether they called it that or not—indeed Mod.

As described so far, direct contact between young Britons and Germans through Anglo-American Rock music began primarily in Hamburg's St. Pauli. However, West Berlin also had some foreign influences on everyday life since the city remained divided into British, American, and French sectors during this time. Given more international connections in these cities, how did the rest of West Germany fare in the face of mid-60s *Mod-ification?* As it turns out, as early as 1964, with the increasing commercialization of Mod youth culture both in and outside of England, even some smaller towns witnessed stylistic changes in their youth. Though "long-haired" male teenagers, in their attempts to follow Mod fashion, were often the target of provincial attitudes, the influence of British Beat music through live or mediated encounters, could not be restrained. Nonetheless, extreme adult attitudes toward such youths could still be found. As late as 1969, a disgruntled adult from the city of Braunschweig said of long hair: "That didn't exist when Adolf was around!" In news footage from this time, some middle-aged Germans voiced similar sentiments. One man even suggested that internment in a "camp" would solve these teenagers' problems. Clearly, the denazification of *some* Germans during the Allied Occupation had never taken root.[36] Remnants of these disturbing attitudes proved all the more why the adoption of this foreign-born style was not only an appealing, but necessary way for young Germans to distance themselves from any lingering strains of fascism.

Clearly, live encounters between British and German young people were an important aspect of transmitting Mod style and culture to this country. Eventually, both foreign and local Beat bands played both large cities and small towns in Germany.[37] According to one German Beat music chronicler, over six hundred youth and Beat-oriented music venues existed in Germany by 1966. Some of the venues' names, like Duisburg-Ruhrort's "Liverpool Club" or Fürth's "Cavern Club," paid homage to the music genre's British origins. Others like Frankfurt's "Havanna Bar," Neuss's "Roma," and Weinheim's "Capri," suggested the lure of the exotic and distinctly non-German for youths perhaps not able to afford international travel.[38]

The modeling of one's identity after Anglo-American youth styles spread nationwide—from Bavaria's southern, alpine peaks to Lower Saxony's northern hinterlands. Mod boutiques cropped up around the country between 1964 and 1965 offering Beat fashions to this new and hungry market.[39] While Beat first entered the Federal Republic, even the Democratic Republic ("East Germany") tolerated their teens' answer to the Beat phenomenon un-

til 1965 with bands like the Butlers and the Sputniks on the scene. However, government officials soon decided that this new sound could incite capitalist sympathies, decadent fashion, and an interest in the *verboten* English language among its young people. From this point on, being an East German Mod in any sense was an illegal affair.[40]

Alongside this music and fashion, new attitudes underscored the postwar generation's determination to inhabit a psychology profoundly different from their predecessors. German Mods wanted to show that they had nothing in common with those adults who still either mourned the decline of Hitler's Germany openly or secretly. Nor would they find any common ground with their contemporaries, who supported the 1964-established, neo-Fascist National Democratic Party (NPD).[41] If Germany once had the reputation as the land of poets and thinkers, then postwar youth turned their thoughts to encompass the rhythmic and *poetic* language of Beat. Despite English-language lyrics, it was felt that these texts spoke for young people around the world, no matter their native tongue. Maybe *because* they were Germans they felt it was especially important to join in.[42]

Mediated aspirations for cross-cultural contact had been evident in *Bravo*, a youth-oriented entertainment magazine published since 1956. With approximately 1.6 million readers by 1960, *Bravo* made its mark on young Germans and continued to do so through the initial wave of Mod culture.[43] Starting in 1964, with the Beatles' growing international success, there was suddenly an emphasis on British Beat and Rhythm and Blues groups. This transition of content within the pages of Germany's most popular youth magazine merely reflected what was happening on that country's weekly record charts. One week before "I Want to Hold Your Hand" entered the German charts on February 22, 1964 the only British artist to appear on it was Cliff Richard—singing in German. By early 1965, the top ten looked much different, with nearly half of the hits in English by British artists.

This trend continued on. By early 1967 Dave Dee, Dozy, Beaky, Mick, and Tich ("Save Me"), David Garrick ("Dear Mrs. Applebee"), the Who ("Happy Jack"), the Kinks ("Dead End Street"), Tom Jones ("Green, Green Grass of Home"), Herman's Hermits ("No Milk Today"), and the Rolling Stones ("Let's Spend the Night Together") made up seven out of the top ten singles for one week. Aside from the most successful groups of the period like the Beatles, Rolling Stones, the Who, and Kinks, several less commercially successful English Mod acts, most notably the Creation and the Smoke, found greater chart success in Germany than elsewhere, including their homeland.[44]

British bands' commercial successes in Germany were reflected in new (yet short-lived) music-oriented, teen magazines, such *The Star-Club-News* (1964–1965, as part of Weißleder's pop empire), *OK* (1965–1967), and *Musikparade* (1965–1967), rather than *Bravo*.[45] *Star-Club-News* promoted the bands that regularly performed at Germany's now most famous nightclub. It also continued supporting Weißleder's view that Beat music was the most practical conduit to also promote understanding between German and foreign youths. *OK* and *Musikparade* were also more likely, than *Bravo*, for instance, to evoke youths' turn from the past generation and equate Beat music and, hence, Mod culture, with cultural change. The fact that *OK* and *Musikparade* focused on British and American stars during the mid-60s paralleled the ubiquitous use of English slang peppered throughout issues of these magazines. By 1966 *OK* even published a mini-dictionary translating hip, English terms into German, so young readers using "fab," "mad," and "gear" could actually know what these words meant.

In addition to the ubiquity of English in these German youth magazines, the British *New Musical Express*, *Disc Weekly*, *Fabulous*, and *Rave*, were sometimes available for purchase in larger metropolitan areas by the mid-60s.[46] Acquiring English skills through these teen magazines (lyrics of songs from favorite, British Beat bands were printed in *OK*, *Musikparade*, and *Bravo*, too), was a step towards potential communication with visiting bands, overseas penpals, or a way to write better lyrics of your own—if you happened to be a fledgling Beat musician.

For some, it also meant being able to understand more fully what was happening when traveling to one of the youth Meccas of Liverpool or London. In the July 4, 1966 issue of *Musikparade* a reader shared, "I have had two vacations staying with a penpal. She lives near Liverpool. I have spent hour upon thrilling hour in the Cavern. The atmosphere in there is really exciting. After pushing our way through the crowd and getting ourselves used to the dim lighting and deafening rhythms, bits of English suddenly caught my ear. 'Mods': girls in unusual clothes and boys with long hair."[47] Letters like this complemented articles with titles such as "Where London Teens and Twens Meet" (February 28, 1966) and "Summer-Sun Vacation Tips: London for Teenagers" (May 23, 1966), which "prepared" young readers who were able, for what a trip to England might be like.[48]

Historian Axel Schildt, drawing from his own experience, writes, "Any West German youth, who during the summer of 1966 had been to the south coast of England and had spent time in one of the beach resorts between Margate and Ramsgate to take part in language courses became immersed in a fascinating world of cinemas, gambling halls, ice cream parlors, and live

concerts by bands like the Who, the Kinks, or the Small Faces. Moreover, they had gained a reliable preview of whatever would become a trend in their own country within the next half year after their return home."[49] Even if not all German teens were able to make it to their now-beloved Britain or other desired overseas destinations, Beat musicians once again modeled this ideal of international exchange. Teen magazines ran articles between 1965 and 1966 showing Cologne's all-female Ruby Rats in London or, more exciting considering the Cold War, Berlin's Lords on tour in Poland.[50] Thus, by the peak years of German Mod culture, it may have still been British bands who led the way, but German groups adopted the best of what they had witnessed: including the desire to connect with young people outside their own country.

It was not just German print media that portrayed postwar youths' new sensibilities in a kind of bold defiance against the past, but films and TV programs as well. As in the U.K., this run of Mod, youth-oriented films began with the Beatles' 1964 feature *A Hard Day's Night*. In Germany the movie was released the same year as *Yeah! Yeah! Yeah!* The nationwide success of *A Hard Day's Night* inspired manager Manfred Weißleder to create a film project for his group the Rattles. The only German Beat-music film ever produced, *Hurra, die Rattles kommen!* which debuted in February 1966, never would receive many accolades. The film's thin plot revolved around a Rattles gig in Copenhagen. It was marred by poor acting and made worse still by overdubbing the group's voices due to their supposedly incomprehensible Hamburg accents. Though these qualities sealed the film's fate as a lackluster imitation of the Beatles' original, it was still another way in which German youth could glimpse the new culture developing around them. Additionally, many British films that had already done well with Mod teens in the U.K., such as *Ferry across the Mersey* and *Dateline Diamonds*, were released in cinemas nationwide.[51]

On the small screen, TV shows such as Radio Bremen's *Beat-Club* (1965–1972) and the A.F.N.'s *Beat! Beat! Beat!* (1966–1969) demonstrated what being a cosmopolitan German teenager could be. *Beat-Club*'s female host Uschi Nerke, whose style resembled that of *Ready, Steady, Go!*'s Cathy McGowan, was soon joined by British DJ Dave Lee Travis. Nerke's attempts to pronounce correctly English band names and their song titles were matched with Travis's eagerness to speak German—usually resulting in something like, "*Ja, Guten Tag!* We got things happening. *Bitte anschnallen, es geht los!* Groovin'!" Ultimately, Travis's announcements were just made in English.[52] Producers believed that the addition of Travis and the inclusion of English brought a higher level of "quality" to the program.[53] They also

broadcast from "Swinging London" twice during the mid-60s, with one show taped at Soho's Marquee Club.

Similarly, *Beat! Beat! Beat!*, hosted by two different A.F.N. DJs, both spoke German with American-English accents and introduced artists in both German and English since their intended audience was a mixture of American G.I.s' teenage children and German youth. Since featured bands played live versus with "playback," the hosts were more interactive with their mostly Anglo-American guests, thus necessitating the use of English more so than on *Beat-Club* where artists were simply introduced.

Another aspect to the shows' cosmopolitanism was that both *Beat-Club* and *Beat! Beat! Beat!* not only presented white, British Mod bands such as the Small Faces or the Who, but also featured artists of color such as Jimmy Cliff and biracial British band the Equals. *Beat-Club*, with its go-go dancers and cutting-edge graphic "scene breaks," was immediately successful with young viewers. It aired only once a month for half an hour in the afternoon, but when it came on, music-hungry teens did what they could to watch it.[54] Thomas Schmidt (Hamburg, b. 1969), a DJ and 60s fan who studied *Beat-Club* while at university, told me about the first time he saw the show and what fascinated him about it.

> [I saw it first] in a documentary about the 60s. One episode was about *Beat-Club* and featured twenty or thirty minutes from the show. There were also *Beat-Club* video cassettes out by 1987.... I saw how it was...with playback and announcements from Uschi Nerke and Dave Lee Travis. There were only three channels then [in the 80s]...but then, by the early 1990s there were more channels and more repeats of the show. [In the 80s] we were already in the MTV era...I knew that at the time [*Beat-Club*] was the only thing happening for Beat fans in the 60s... once a month, thirty minutes or forty-five minutes...that was it. Young people may have had to fight for the TV in order to even see it.

Though *Beat-Club* was only on for a short, half-hour burst per month, young Germans were grateful to have a TV show to call their own.

Fervor over Anglo-American popular culture may have been connected to the fact that it was seen as more free-spirited by young Germans. The love of English-language rock music, long hair, and other "foreign" fashions, seemed to challenge the national status quo linked, as it was, to stereotypical German qualities such as "orderliness." That youth gravitated toward all things British may have been related to a general culture stereotyping of Britons during this era. For instance, the nationally produced *Edgar Wallace* film cycle, which followed a Scotland Yard detective, demonstrated Germans' view of Britishness as "idiosyncratic, irreverent, and non-conformist... [that] stood in sharp contrast to the strait-laced norms and values of the Adenauerian work ethic of the postwar West German *Wirtschaftswunder*."[55]

Though some older Germans may have found such behavior amusing in films, they did not necessarily want to emulate it, while younger people may have seen it as a model of how to behave less "German." Nonetheless, it is still sometimes hard to believe that listening and enjoying music by foreign and/or black artists or wearing different-looking hairstyles or clothes was considered radical, but it was. As a letter from a former *Beat-Club* viewer to host Uschi Nerke attests to:

> We finally had a music for us, that was progressive and that expressed our mood. It was a music that really didn't have anything to do with our old culture. Even years after the end of World War II, the past was seldom discussed. There were big question marks that would never be answered. Nobody really knew what kinds of attitudes there were in one's family. A big silence encircled us, and that's why we wanted loudness, openness, and above all, everything new that came from us, that was completely different... something that had never existed before.[56]

For Mods and 60s enthusiasts today, the stylistic offenses that youth supposedly committed remain perplexing. As longtime Mod, and attorney, Christof Sonnenberg (b. 1968, Munich/Kempton) related: "One tries to understand the feeling... of the youth culture that existed then... in England and also here. One tries to understand why were people... were people bothered by this? Why was there trouble... or riots, even? Or, why was it in the newspaper that 'longhairs' were running through the streets? Of course that interested me...this power that the youth movement had despite its not being aggressive. Nonetheless, [the youth culture] was offensive to the establishment and got trouble because of it." This "affront" to adult society was evident from the first broadcast of *Beat-Club*. It was introduced by way of apology to older viewers who may have "accidentally" tuned in.[57]

This desire that the aforementioned *Beat-Club* viewer described as a longing for "loudness, openness, and above all, everything new," was also expressed by many German Beat musicians of the period. "Lord Ulli" Günther (from Berlin band, the Lords) attributed the band's adoption of Prince Valiant haircuts to his determination to bring back respect to attributes misused by the Nazis. "I was crazy about Prince Valiant [called *Prince Eisenherz*, or 'Ironhearted' in German]," writes Ulli. "These terms like bravery [and] honor, which were unfortunately robbed of their real meaning by the Nazis, made an incredible impact on me when I was a teenager."[58] As lead singer of Hamburg band the Faces and then, the Rattles, Frank Dostal saw joining the already professional Rattles as an escape route from bourgeois life:

> [The offer to sing with the Rattles] was my great rescue, because I was in the 13th grade about to complete my *Abitur* [final exams] and move on to what followed. I knew, 'You can't do it!'—this bourgeois track...The only thing I envisioned was: 'I won't take the

exam!' And I was really fed up with school, with the disguised Nazis—sexually uptight types—who were supposed to preach to us about educational ideals which they themselves couldn't live up to. Those were the ones who told us about the war as a period of great camaraderie, about their exceptional friendships where they and four hundred men bent railroad tracks in Siberia in order to make the tracks curve! It was already very clear to me then: Germany had attacked and stained the rest of the world.[59]

These accounts support the idea that this generation's initial form of protest against older Germans was expressed both through personal style, i.e., external factors of identity, and also through becoming musicians, rather than going into more conventional trades or professions.

In the spectacle of what German Mod culture had become, with its frenetic Beat music, playful fashion sense, and an overall joie de vivre, it is sometimes hard to believe it emerged so quickly on the world stage following one of the most harrowing periods of the twentieth century, if not Western civilization. Youth there struggled to come to terms with the recent past—no matter how apolitical or indirectly political their immediate surroundings may have been. The following statements from German youths of this period attested to the tensions, silences, or indifference palpable in many postwar households:

I was totally apolitical because I came from an apolitical household... actually my whole circle of friends was apolitical as well. (Kuno Dreysse, b. 1945)

The topic of politics didn't come up at all. Why? My mother, quite honestly—she worked in a laundry... she had a hard job. We were poor slobs. She worked 'round the clock and even took work home...at the time she must have been thirty-five or forty and she already had such fat, swollen legs where you could poke them and the indentation would remain. That's why she didn't have any interest in the past, or had intentionally repressed it. (Harald Mau, b. 1945)

Well I wouldn't say it [the war] was a taboo subject, but I know that whenever anything ever came up about the war my mother didn't want to hear about it because her son—my brother—was still missing in Russia. So, she knew about the cold and the terrible situation in Russia on the front and that's why she was very.... You can't show things in films. But she didn't even want to see the real film, what do you call that—[documentary]— that had been taken there. She didn't want to see it. When there was a film she didn't want to watch it, but she told us about her feelings. But we did not discuss it. She was on the road with five kids, one in a pram and it was just awful for her. It was terrible for all us. It was a hard time. (Klaus Voormann, b. 1938)

These comments from Kuno, Harald, and to a certain extent Klaus, showed a more distanced reaction to the war and what followed. They also suggested no real confrontation between children and parents, but rather an understanding for what strenuous situations their parents may have gone through as a result of the war, and thus represented an acceptance of how their par-

ents went about avoiding direct discussions about life during the Third Reich and World War II.

Not all interviews with postwar narrators, however, suggested a lack of intergenerational confrontations. The following comments from songwriter, musician, and music producer Ulf Krüger (Hamburg, b. 1947, fig. 6) and filmmaker Hans-Peter Weymar (Hamburg, b. 1947) supported the notion that questioning or critiquing the attitudes or actions of parents did arise in some families. Ulf talked about how his parents called music with African-American roots "Nigger Music." He believed that this racial-based criticism of Rock music by parents at that time was one reason it became so popular among Germans in his generation. He said the music was used as a "weapon" against Nazis past and (secretly) present.

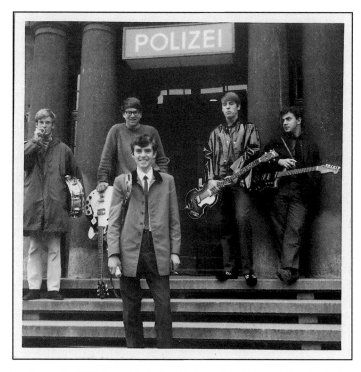

Figure 6. Ulf Krüger (far left) with his mid-60s band, the Randalls
(courtesy K&K Center-of-Beat, Hamburg).

In my interview with him he relayed to me, "Even though I believe that my parents were very loving and good people, it [the Nazi past] was still a big problem for my whole generation. We rejected everything and we showed absolutely no understanding for circumstances or nuance." Throughout this

interview and afterward, Ulf talked lovingly about his father (who had, in fact, been a Nazi Party member like many Germans of that generation), but he was able to separate easily their personal relationship from his father's Third Reich–era politics. Nonetheless, Krüger's love of Skiffle and Rock music as a teenager functioned as a way—maybe not always self-consciously— but as a way to challenge both his father's and country's political past.

Hans-Peter Weymar, who coproduced a 2006 TV documentary about the Beatles' impact on Hamburg and German youth culture in the 1960s called *Beatles, Beat, und Grosse Freiheit: Der Sound von St.Pauli*, held a slightly different view of his parents' past.[60] He told me that he could not forgive his parents' lack of self-reflexivity in terms of their support of Nazism: "Even when I could somewhat think more broadly about things, I never said, 'You awful people, you went along with it back then.' Instead, I said, 'I don't blame you, but what I expect from you, what I wish, is that you would reflect upon what happened.' And they couldn't even do that....Instead they...use this kind of 'poetry of justification' and that is so horrible... that is a situation that I just can't forgive. I'm not saying that they are really awful people, but that is something they should be dealing with." Clearly, Weymar could not understand his parents' unwillingness to reflect upon their past.

While it was undoubtedly difficult for many 60s youths to avoid asking themselves "What did my parents do during the war?" their embrace of Mod—and hence, turning to the future for a different kind of life—was a more tacit way of reconciling with the realities of the recent past. By adopting Mod, young Germans created new facets of their identity. For instance, Kuno's interest in Beat music inspired him to become the bassist for Hamburg's Rivets. Ulf, aside from his musical accomplishments, later established Hamburg's K&K photo archive and shop—specializing in Astrid Kirchherr's prints—and has produced several Beatles-themed festivals. As already introduced, Harald Mau was a regular at the Star-Club, where his eyes and ears were opened to an internationally minded youth culture.[61]

I met Harald in December 2006 at the Hamburg Museum while visiting an exhibit called *The Hamburg Sound: Beatles, Beat & Grosse Freiheit*. Cocoordinated by Ulf Krüger and historian, Utwin Pelc, the exhibit ran from June 2006 to January 2007. The show invited visitors to learn about the dynamic relationship that budded between British and German musicians and youths in the 1960s. Several events were held in conjunction with the exhibit, including an opening festival (with guests Klaus Voormann and Astrid Kirchherr) and a guitar show, where I happened to catch Spencer Davis playing "Norwegian Wood." I met Harald while paging through the exhibit's guestbook.

I saw comments such as: "I am a big fan of the Beatles and the sixties. If I could, I would travel back to this time!" Another stated: "What a neat era... I especially liked the hairstyles!" The last entry read: "Before the Beatles there was nothing!" I suddenly heard a man's voice behind me saying, "Exciting times!" We struck up a conversation and when I returned to looking through the guestbook, I continued seeing a similar enthusiasm to Mau's reflected in the words of people—whether from Hamburg or elsewhere—who did not necessarily experience those "exciting times" themselves but let the exhibit *transport* them there.[62]

On another day at the *Hamburg Sound* I saw a young woman guiding a group around the exhibit. In August 2007 I again ran into her while she was giving a Beatles walking tour through St. Pauli. I soon learned that musician and longtime 60s fan Stefanie Hempel (b. 1977, Parchim) gave Hamburg's official Beatles walking tour, which always ended with a sing-a-long at the Indra club. When I asked her what she most enjoyed about her part-time job, Stefanie told me one of the *many* highlights was encountering older people sharing stories about the "good old days." She recalled:

> The Star-Club time totally made an impact on these people and at sixty they still look like old Rockers or so... or a lot of old Exis are also there. 'We were Exis,' and then others say 'We were Rockers' and there they are at over fifty, sixty: the old rivals together [on this tour]. And this is super exciting, because I will of course say, 'Yes, I wasn't there, why don't you tell us something.'.... That is the neatest thing for me—as someone who wasn't around then—as someone who grew up in the GDR—that I can offer these people a kind of trip back in time and then, often, I'll see them standing in the Indra with tears in their eyes singing along to the old songs.

Clearly, images and stories from these times still resonate nostalgically with the postwar generation, and even with some—like the Mods—who were born later.

I asked, for instance, Jani Egloff (b. 1967, Hamburg) why she thought the postwar generation would have been attracted to non-German popular culture? She told me:

> Everything that was German was frightening, was horrid, was boring, was grim, was bombed, was destroyed, was bad...was, well, bad music and bad taste... and very traditional. And things from Italy were slim, sleek, crisp, fun... fast... mobile, and totally different.... I think they wanted to have fun. They wanted to live. They wanted to... enjoy their life at all costs, and they *didn't* want to live like their parents. For example, my mother... the first thing she did with 19 was that she married an artist. She married an actor because that was the life she wanted to live. ...These people wanted to live life to the max, to the full. They wanted to enjoy themselves and of course there was this 'live now, pay later' attitude. There was this: 'We're living for today' and everything can only get better attitude, of course, which was true.

Her words reflected the fact that some younger parents (those who were still children or teenagers after the war) did, at the very least, discuss what their attitudes were like and how they tried to enjoy life despite past hardships.

Even if family members or teachers, even, refused addressing the Nazi past, teenagers were nonetheless exposed to the Third Reich through TV, film, and print media during the 1960s. Mass media provided a depersonalized way to educate the younger generation about the National Socialist years—describing it on a national rather than local or personal context. Many of the television documentaries about Hitler, the Holocaust, and World War II shown during the early 1960s were depersonalized in the sense that Nazi crimes were blamed on a finite cast of now-dead villains. By constantly portraying Hitler, his inner circle, and SS officers, as the only guilty parties, "ordinary Germans," like one's father or grandfather, could not be seen as perpetrators of war crimes, but victims of ideological brainwashing.[63]

Obviously, a more detached recounting of Germany's role in the war located Nazis at a safe distance away from one's family or community. German television mostly addressed the recent past via documentaries and TV docudramas. According to one scholar, "Individual responsibility remained a central theme in TV shows during the 60s... it [often] had to do with the 'brown skeleton in the closet' despite the current period of economic prosperity...those who were able to hide behind a mask of a normal citizen.... Frequently the theme was framed by generational conflict between the parents who were involved [former Nazis] and insistently questioning youth" who wanted more information about what had happened.[64] Given this lack, or minimal, discussion about the recent past, the tensions between the older and younger generation continued mounting during the 1960s.

Even the Mod-styled, sci-fi TV romp—*Raumpatrouille* (*Space Patrol*)—seemingly sanitized any traces of *German-ness*. Only airing during the 1966 season, it was nonetheless popular with teenagers. Set in the year 3000, the opening sequence's narration stated that "There are no nations anymore, only the human race."[65] And yet, ironically, although the show's protagonists (much like America's contemporaneous *Star Trek*) had surnames suggesting certain national ancestry, there seemed to be no room for a character named Schmidt or Schröder. The spaceship's commander was Allister McLane and even Lieutenant *Helga Lagrelle*'s name sounded more Swiss than overtly German.[66] In *Raumpatrouille*'s universe, it seemed that much would have to change before those of German lineage deserved a place in the world of tomorrow.

While TV shows consciously or subconsciously dealt with Germany's past, even magazines *Bravo* and *Twen* addressed the issue. *Twen*, anticipat-

ing a more mature and educated readership, did not shy away from issues such as American perceptions of contemporary Germany or even the Holocaust itself, and, in fact, printed incisive articles on these subjects. A *Twen* article from January 1965 reported on a New York photography exhibit called "Germans Today" and printed some of less-than-complimentary excerpts from the show's guestbook. One commenter asserted, "Some [Germans] are o.k., but most are Nazis." Another entrant opined, "You forget to mention that the Germans are the only people in the world that have never heard of Nazism or Hitler." Finally, and one must remember that the intended audience of this magazine was "twentysomethings," another comment read, "You are not showing the problems of young Germans. They are militaristic, undemocratic in their thinking, and not unlike their parents in their mentality." It is easy to imagine young German readers coming across such an article and asking themselves, "Will there ever be a time when we are not thought of as Nazis?"[67]

While youths could not escape entirely the legacy of their ancestry, the desire for a newly modern Germany remained strong and was clearly linked to questions of identity. Postwar youth's longing to reconfigure the notion of what a modern German person could be in the still fairly new *Bundesrepublik* was most palpable in the music culture intrinsic to this era. Youths reacted enthusiastically to the British sounds that they encountered by forming Beat bands with un-Teutonic names such as the Rattles, the Rivets, the Lords, and, even, the Mods. The songs sung—whether covers like "Money" or "Gloria," or originals such as the Rattles' "Come on and Sing," or the Lords' "Poor Boy" were always delivered in English. Even Hamburg's Rattles, sometimes called "the German Beatles" due to their massive popularity nationally and, marginally, in England, wrote simple English lyrics in their top hits: "La La La" (1965) and "Come On and Sing" (1966). Very rarely would German Beat bands have band names *auf Deutsch* or sing in their native tongue. The most popular Beat performer to sing in German was Drafi Deutscher. He was nonetheless aware that singing in German was not totally "in" at the time. He has remarked that this period was one in which young Germans, and, hence, youthful musicians did not like their own language. It is probable that the manipulation of the language by Goebbels's propaganda machine during Nazi Germany, the long-standing stereotype by many foreigners that German is an "aggressive language," and the ever-growing assessment in the postwar period that English "was a symbol of globalism, of youth, [and] of progress and modernity" aided in this phenomenon.[68]

In any case, Germany's Beat-inspired Mod period was a love affair with everything English, including the language—which was connected to the

notion of the modern. The Anglo rock sounds were to become the sound-track for not only today, but also tomorrow. Mod bands the Who and the Yardbirds were even billed in *Bravo* as having the "Robot Sound." Apparently, this term was concocted to describe the bands' music as befitting the technological age in which "motors, machines, and the whirl of electronic, robot-brains belong to daily life."[69] This was meant to describe the experimental nature of the bands and did not come across as social critique à la C. Wright Mills "cheerful robot."[70] Through "rock technology," fashion, or media transmissions, Mod youths of mid-60s pictured themselves as more British than German, if only via the facade of natty clothing, the right guitars, and some ability to sing in English. If young Germans felt weighed-down by the nationalism of the Nazi past, then all things British led not only to the future, but to a visceral internationalism.

Mod's Decline and Reappearance, 1967–1989

The period from the late-60s until its revival in 1978 was a time of decreased visibility for Mod in West Germany. By mid-1967, magazines started exploring topics such as LSD and the idea of youth as a "counterculture" rather than subculture. Since Hamburg's Star-Club was the space in which Mod culture (vis-à-vis Beat music) initially came to the country, the symbolism of its closing after the New Year's Eve show on December 31, 1969 is clear.[71] Alongside the Beatles' break-up, by 1970 many German Beat bands had also disbanded.

West Germany in the late 60s, like much of the West, was a tumultuous place. Given the continued close relationship between the Federal Republic and the States, noticeable through the continued presence of American military there, many German youths began protesting the Vietnam War. An increased political activism among some university students throughout Germany influenced the era's attitudes. The students also protested what they saw as an incredibly stiff educational experience still led, in part, by former Nazis. The idea that the country's leaders had somehow seamlessly transitioned from fascism to democracy (with help, primarily from the U.S., who sought a Cold War ally) with former Nazis still in the high echelons of power, hit a nerve with these students.[72] Not surprisingly, the word "fascist" became the primary insult used by these youths against all adults whose views did not align with theirs. The mainstream press followed the young protestors' activities, often members of the Socialist German Student Union (S.D.S.) and their leader, Rudi Dutschke, to such a degree that most Germans today remember "the 60s" as truly beginning in 1968. For instance,

those young activists who continued into public life, such as former Foreign Minister Joschka Fischer, were tagged as "68-ers."[73]

By the early 70s, youth culture was transitioning. Meeting spaces were either discotheques playing proto-funk and disco or live-music clubs, like Onkel Pö in Hamburg, featuring mainly acoustic singer-songwriter acts. The British music played on German radio was often jam-oriented "progressive rock" (Yes, Genesis), which found massive audiences. German groups also became more experimental. Bands like Tangerine Dream, Can, and Amon Düül created cacophonous sounds that were seemingly the exact opposite of melodious Beat music. Tangerine Dream's Edgar Froese remembers how he responded to journalists who critiqued the inverted "foreignness" of his band's style: "We don't want to play like the English or the Americans. We play like *we* play."[74] Because Rock music had become a "youth language" in the 60s, some German musicians suddenly desired to contribute something distinctive within an ever-more-globalized youth culture.

By 1977, and parallel to nihilistic Punk's emergence, another anarchistic storm was devastating Germany. A small minority of "68-ers," with radical views, had branched off and formed the Red Army Faction (R.A.F.), sometimes known as the Baader-Meinhof Gang, after its leaders' surnames. Dissatisfied with merely protesting the continued government participation of former Nazis, the group turned violent. After a series of terrorist actions between 1968 and 1976, from torching a department store in Frankfurt to highjacking a Lufthansa flight, the so-called "German Autumn" of terror climaxed with the kidnapping and murder of former S.S. officer and political insider, Hanns-Martin Schleyer, in late 1977.[75] In these young people's attempts to be different from the previous generation, they actually wound up behaving similarly.[76] Unlike Mod culture in the extreme, this severe outlet of generational frustration had led back to a focus on national malaise and division among the young, rather than joyful expressions of a more internationally minded youth culture.

While domestic terrorism reminded Germans of their horrific past, Germany's broadcast of the American miniseries *Holocaust* (1979) a few years later prompted intergenerational dialogue at school and at home. According to one journalist, "Young people are asking the older ones how Auschwitz was possible in a world that, despite the conformity of a totalitarian regime, still protected forms of bourgeois, affluent society." More than in the 60s, teenagers asked direct questions about their family's involvement in National Socialism and what knowledge they had had of the government's genocidal plans.[77] With the upbeat and economically stable mid-60s a fading memory as well, national commentators looked at young people with greater caution

and concern. Meanwhile, disco hits like Donna Summer's "Hot Stuff" and M's "Pop Music" raced up the German pop charts.[78]

This, then, was the cultural climate in which Punk came to Germany and brought a new version of Mod with it. While this era's Mod culture will be described below, some attention must be paid to German, as opposed to British, Skinhead culture, which arrived concurrently with Mod. By the time of its arrival, "Skinhead" was already associated with racism and hooliganism. While some early Skinheads understood the subculture's Mod roots and nonracist attitudes, by the early 80s, many of them were right-wing. While Skinheads hated Punks, intense acts of violence were directed mostly, like in Britain, against "foreigners." When, in 1985, Hamburg Skinheads killed two Turks, many nonracists left the subculture. At this time it was not uncommon to see Skinheads at Mod events.

Based on my observations of Germany's Mod scene between 2006 and 2007, there were some people at Mod events who, stylistically, at least, could be described as Skins. These mostly non-racist Skinheads were, however, thin on the ground and usually attended events highlighting Ska, Reggae, and Soul, versus those that mixed Soul with Beat, Psychedelic Freakbeat, or Garage.[79] A Skinhead since 1984 and a frequenter of Mod events in the Ruhr Valley—Markus "Wodka" (Vodka) Schultz (b. 1969, Düsseldorf) told me how he viewed politics within subcultures and also how he had reacted to right-wing Skinheads he had encountered over the years:

> Politics do not belong in subcultures. Naturally, politics try to worm their way in— whether left, right, or some other direction. I have always said that I'm neutral [about politics], but I would say if someone came to me... seventeen, with five Böhsen Onkelz [a right-wing Skinhead band] albums, and in a bomber jacket...I would say, 'No, listen to this and this...Sham 69...and these other things. You will see that it has nothing to do with politics.' Unfortunately, politics always finds some takers and I've run into enough people who have said to me, 'Hey, you listen to Ska. I like it too, but only white Ska.'...I've said, 'Ska and being right wing have absolutely nothing to do with one another. Ska came from Reggae and Reggae is black [music]. There is only nonpolitical or anti-racist Reggae.'

Wodka believed since Skins tended to be more tradition-oriented than Mods, older members of the community should help educate newcomers to its origins and detach the right-wing associations that have long persisted in Germany's scene.

While some German Skins acknowledged the culture's Mod roots, England's "Mod Revival" bands and their neo-60s fashions also attracted followers there by the late 1970s. Though I have argued that Mod culture was very much present in mid-60s' Germany, the Revival era, more so than the original era, has laid the groundwork for manifestations of Mod culture well into

the 2000s.[80] In a period during which many youth "tribes" existed, self-identifing as "Mod" was an alternative to being an *Öko* ("Green"), a Punk, a Skinhead, or, simply, a preppy, proto-Yuppie member of the German bour-geoisie.[81] From this time onward, more German youths consciously self-identified as Mods if they liked the music and style of early-to-mid 60s cul-ture. This was a change from the 60s, when "Beat," rather than "Mod," was *the* word. Unlike the Beat-music-fixated 60s generation, these new Mods drew from a wider palate of music genres: embracing Soul and Northern Soul, Mod Revival bands from England like the Jam and Secret Affair, Ska (through 2 Tone bands), and Reggae. Jani Egloff, who became a Mod in 1980 (fig.7) has often wondered why it was that Mod should have been one of many youth cultures for young Germans to choose from during this pe-riod.

Figure 7. Jani Egloff (Photo by author).

If 60s Mods had turned to it as a cosmopolitan solution to a nationalistic past, what did this recurrence of Mod in the 1980s potentially signify?

Why was it after Punk rock that there were so many subcultural tribes or so many subcultures re-evolving? Why did it happen in the 80s? What was the climate in the 80s that these things happened? Part was Punk was the first subculture and then there was the Skins and then the Ska and Mod revival, even Ted revival...I don't know... the 80s were pretty conservative. The 80s in Germany were conservative as well. We're getting even more conservative in the mid-80s and, in the U.K. it was Thatcherism. So, perhaps that was the climate that was necessary to bring up these subcultures. And of course there were these '68... these people in Germany who were against everything from the past [esp. before the late 60s...the early 60s- I interject]—that was petit bourgeois, that was *spiesig*. It was petit bourgeois to run around in a crisp suit. You were thought to be either a fascist or said to belong to a stupid sect or whatever—and they didn't, well they didn't—these people, these teachers, for example, they tried to dominate us, and they tried to tell us that it was "uncool" to wear suits and to wear dresses and to look like that because we looked like their older sisters or whatever. They wore their stupid wool sweaters and idiotic Birkenstocks... and I hated them. I hated these people and thought, 'Na, you're not hip... you're lazy hippies.'

According to Jani, it was both the overtly conservative milieu both in and outside of Germany and, ironically, the "68-er" Hippie ethos that carried over from the late 60s that these Mods were rebelling against. Jani's sentiments belied the idea that the once "hip" late-60s aesthetic was considered passé by the 80s, while the earlier 60s, Mod style was further removed (or absent) from contemporary culture and, therefore, seemed fresher and more rebellious. What her Hippie-ish teachers saw as conservative, Jani and other Mods read as the apex of radical, underground style.

Hamburg and Düsseldorf were the first two hubs of Mod activity from the late-70s onward.[82] While the cosmopolitan aspect of this culture was still present for the earliest group of second-wave German Mods in the 80s, there was much more emphasis on building up local "scenes" that would attract Mods from around the country and, then, eventually, outside of Germany. Sarah Cohen has described how local interactions can generate excitement for a scene that eventually can take on global implications. Local scenes "involve a regular circulation and exchange of: information, advice, and gossip; instruments, technical support, and additional services; music recordings, journals, and other products...through them, knowledge about music and the scene is generated, distinctions are made between being inside or outside the scene, and the boundaries of the scene are thus marked."[83] Once local participants have established preferred spaces and media for circulation, they become known to those outside initial geographic boundaries.

As in Britain, specialty music and culture magazines like *Spex*, *Prinz*, *Wiener*, and *Tempo* occasionally reported on Mod and other youth scenes, while a fanzine such as *Hi Fab!*, directly catered to Mods, first in Hamburg, and then elsewhere.[84] By the early-80s Mod events began being organized at

smaller, Hamburg clubs like KIR, while scene participants also attended concerts by British bands at the larger *Markthalle*.[85] At this point attendance for Mod events were mainly local—while organized weekend-long events would prove to be more geographically diverse in the years to come. Unlike in the 1960s, the St. Pauli district was not the hub of youth activities. In the early 70s, the neighborhood fell into a downward spiral, making it feel more seedy and dangerous than it had in a very long time.[86]

Mod in 80s Germany was heavily influenced by the U.K.'s Mod Revival with its bands the Jam, Secret Affair, and the Purple Hearts. As the narrators below explain, the concept of Mod was again aided by its circulation in various media such as *Bravo*, the (still on-air) British Forces Broadcasting Service, and especially, *Quadrophenia* (1979). Harry Vogel (b. 1963, Munich) distinctly remembered this period of discovery and the role of the film in his introduction to Mod.

> It was either 1978 or 1979, around the time that *Quadrophenia* was playing at the cinema, that I heard [the word] *Mod* for the first time…and that's exactly what it meant to me: parkas and fights on the beach and the Who. But I also have to say that my first or second record, that I had bought with my own money when I was around ten or so, was a *Best of the Who* and had "Can't Explain" and all the stuff from '65 to '67 on it and I thought it was extremely good. I didn't know, though, that this would ('cause I was way too young)… would be described as Mod. I had already bought a Jam LP in '77 because I saw a centerfold of a bunch of guys in suits with Rickenbackers in this magazine *Bravo* and thought they looked fantastic. "That is so super—that's somehow exactly what I want," but I didn't know that that was Mod.

Jani Egloff (b. 1967), Alain Ayadi (b. 1967), and Ralf Jürgens (b. 1966), who grew up in the greater Hamburg area, had similar experiences with *Quadrophenia* and the Jam.

> Jani: That was 1980 when I first heard about Mod and, of course, everything was in connection with the film *Quadrophenia*. *Quadrophenia* came into the cinemas in 1979 and, um, Germany was a bit slower and the movie came into smaller cinemas and that was the first time I heard about it. I didn't read anything about it, but I heard about it, and the first time was when I went on the underground and saw several Mods and asked them, because it was really a pack, and I asked them, 'Well, who are you?' because they looked different, to me they looked different—they were quite loud they were shouting 'We are Mods,' so I thought, 'Oh yeah, they must be Mods, whatever that is,' and they had parkas on, fishtail parkas on. Some had porkpie hats on and it was the time of Ska revival as well, so this is how I got into contact with them and I asked them where they were going and they told me they were meeting at a café [she pronounces it as the British 'caff'] in Hamburg…and I went there.

> Alain: I think I first heard it [Mod] in connection with the Jam. At the time I was already a music fan and would regularly listen to [the program] 'John Peel's Music,' because you were able to listen to it in Lower Saxony. You could hear 'John Peel's Music' through

reception of the British Forces Broadcasting Service and he played all kinds of new music and I'm sure he played the Jam and it was there that I heard for the first time that the Jam were Mods. I liked the music and it was also around this time that I became friends with an ex-Punk, or ex-Clash fan, who had become a Mod.

Ralf: I think I [first] heard [about Mod] through the music of the late 70s, through the Jam, *Quadrophenia*, and so on...

When Ralf recalled this time, he also remembered the vastness of the local Mod gatherings:

From the beginning [to] middle 80s, the scene in Hamburg was actually quite big. There were regular meet-ups at the Markthalle every Friday, every Saturday... circa three, four hundred people would meet ... even if there was nothing going on there... and then we would go to parties afterwards.

Because of *Quadrophenia*'s impact, these Hamburg Mods all eventually took on varying participatory roles within the scene and also became interested in different branches of the ever-growing Mod family tree. Jani Egloff started singing in the 1960s-garage-influenced band Daisy Chain; Alain became an avid concertgoer supporting bands like Jani's and collecting masses of "Modzines" from Germany, England, the U.S., and Australia; Ralf eventually began playing rare Rhythm and Blues singles as a DJ (albeit much later).

A key member of the Hamburg scene, Olaf Ott (b. 1964, fig. 8) created Fab Records, which had him doing everything from managing the label's bands and tours, to promoting them and all things Mod in his *Hi Fab!* zine. Though Fab artists tended to veer toward mid-60's Beat and American garage sounds, Soul became Ott's favorite genre. In 1985 Olaf, with his friend Leif Nüske began Hamburg's "Soul Allnighter"—originally held at the aforementioned KIR nightclub has continued to be held at other locations every Easter Sunday and Christmas Eve. Olaf Ott's first brush with Mod culture came from a trip to London with his family in the summer of 1979, by way of record shops carrying 2 Tone label LPs by groups like Madness. Not yet having heard the word "Mod," though, in connection with the sounds he heard and the fashion sported on the album covers, he did not actually hear the word until his return to Hamburg:

The first time [I heard] Mod I didn't understand it. The first time I heard it was in the summer of '79 at the Markthalle at a Ska concert. I don't quite remember if it was Madness or the Specials...and there was the first little group in parkas and they sang, 'We are the Mods! We are the Mods!' I think that was even before the first German screening of *Quadrophenia*. At that time I thought 'Mods,' if I correctly remember it, was short for the German word *motzen*...when one complains about something, one *motzes*.

For Ott and the aforementioned narrators, Mod became an important aspect to their identity, not just within the subculture, but sometimes also in

the way they thought about themselves as Germans. While German press in the 1960s had associated the word "Mod" mainly with England or English youths, the word and concept was now something that could be used more readily to describe German youth as well.

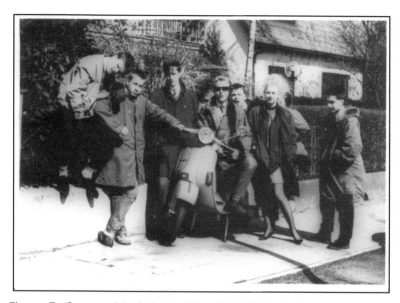

Figure 8. German Mods in the 80s. Olaf Ott far left (courtesy Ott).

Articles in various magazines tried to understand what relevance a 60s-oriented youth culture might have in the 1980s. *Der Stern's* 1984 article, "The Resurrection of the Mods," which followed the scene that Jani, Alain, and Ralf were then participating in, and in which Jani was featured, aptly captured an aspect of the fascination: "Flower Power, youth revolt, an optimistic view of the future: these times are over and have been replaced by 'No Future,' acid rain, missiles, environmental destruction, and unemployment. No wonder then, if unemployed 'youth' laugh at 'dialogue' with politicians and, instead, create another world with its own codes, symbols, and fetishes." As one of the articles' seventeen-year-old interviewees states, "Back then things were a lot more positive and not as broken-down as today. Those guys didn't look backwards or forwards—they were only living for today."[87] Interestingly, and not surprisingly, this Hamburg Mod must not have been thinking of his parents' generation at all—who still had to work out their feelings of guilt by association connected to World War II. It seemed that the refer-

ence point here became the actual British Mod subculture of the early 60s rather than the broader Mod sensibility of the mid-60s.

Two articles in youth-oriented magazines during this time, "Dandies of the Eighties" and "Mods in Germany," also ruminated on the issue at hand: How could youth be Mod or modern if they want to "live in the past?" Both articles seemed to answer the question by confirming the subculture's existence: If Mods exist in the present, not only with a fetish for the 60s, but with an ever-expanding palette of their own events and happenings, and a new crop of bands, then it *is* something contemporary, if simultaneously retrospective. The project of the Mods continued to be one of identity formation that was established by seeking out the best of an exciting and dynamic period and redefining it for current consumption. As Jens Kraft wrote in "Dandies of the Eighties," "The Mods of today are an elite and fashionable group, whose hobby it is to delve into and work through the 1960s. Their work is long from being finished...but the Mods do not just live in the past. They do not ignore new bands, but there are only a few that suit their tastes...the Times, TV Personalities, the Style Council (recently the Jam)."[88] Meanwhile, the "Mods in Germany" article recognized that Mod's "young idea" had resurfaced in its 80s version. A Düsseldorf Mod told the author, "'Mod' is something young. It is a complete self-abandonment. It is all about loving and savoring one's youth.... Mods detest the idea of growing older, and try to impede the process. They fight against it."[89] Here, as in 1960s Germany, the concept of Mod became a space where notions of modernity and generation were united, and where an ideal of progress via youth was much sought after. If the right combination of this formula could not be found in contemporary, mainstream culture (as it was during the original Mod period), then looking backward would have to become the progressive option of the moment. This key component of Mod would continue with the next wave of its adherents in the 1990s and 2000s.

Mod Youth in E.U. Germany, 1990–2008

To be a contemporary German Mod would put one in the position of potentially being labeled as *postmoderne*.[90] A 1996 magazine article called "Thank Mod," described Mod in this way: "The nineties version is no authentic revival, but in typical postmodern fashion, a case where one helps oneself to various epochs and styles of pop culture: the twenties Dandy and the sixties Mod with a shot of eighties Glam and a dash of androgyny are celebrating a rebirth."[91] The mid-90s vision of Mod was, as in the U.K., colored by the popularity of contemporary Britpop bands like Oasis and Blur. As a 2007 German *Rolling Stone* cover story had it, the Jam's Paul Weller and Oasis's

Noel Gallagher were in a "fight about Mod and the world," thus aligning "Mod heroes" of the 1970s and 1990s with the culture's continued presence.[92] It still has been easy for some to label Mod culture since the 1960s as post-modern—or as a failed attempt to "relive the 60s." This, however, was not how the participants I interviewed saw their involvement with Mod. Instead, it has been a way to evoke the essence of the Mod 60s. Some participants told me that they enjoyed attending events where everyone would be dressed in mid-60s clothing, and where music from that time was being played on 45s, because it was, in a sense, like traveling back in time,

> There was this 'Men from Unkel' Weekender and a friend from here in Hamburg was always telling me about it. And it was the case that whenever he told [me] something it was always highly exaggerated.... He was always telling me about these parties and said to me, 'You have to go there. It's like a time machine....' And then, in '98, I went there for the first time. And that's when I thought, 'Oops, he *was* telling the truth. He didn't exaggerate a thing.' And it was the absolute best. It was really a turning point for me when I walked in and no one looked as if it was the 90s. They were all completely styled [Mod] from head to toe. (Ben "Jones" Nickel, b. 1977, Hamburg)

> If it [Mod] could only be tied to the 60s, then you couldn't live it out today.... Naturally you can project it into current times as a lifestyle, as a way to differentiate yourself from the masses and listen to music that is well-crafted... In any case, one can live it like this even with different [socio-] political circumstances. (Nicole Benesch b. 1973, Hamburg)

For these two narrators, this "time travel" has been a means to provide a more satisfying parallel to often mundane, *adult* life. Though Mod started as a youth culture, the German scene has become—not unlike those in other countries—one increasingly populated by people who think and act youth-fully, even if they are no longer young. *Gymnasium* German and Philosophy teacher Bettina Peter (b. 1970, Cologne) described it thus:

> It's the wish to cultivate things that people have rights to... even as adults. There are things which trap you. You have to work so that you can afford to buy clothes... that it's a necessary evil. Jimmy [from *Quadrophenia*] already showed us that. If you want to have fun on the weekends you have to set your nose to the grindstone and live with that. That's how it is. And recognizing that this is the way it is means that I can allow myself to go crazy on the weekends, because I'll still have to set my nose to the grindstone on Monday.... Life is no joyride, and when one understands that, one can establish a really nice kind of escape. I very much understand it. 'The 60s? I'm addicted to the 60s,' be-cause it speaks to me... the aesthetic... and much more. It's a flight from the everyday.... It's a very endearing escape, too. I think it is, for instance, better than running around costumed as a dwarf at live [role-playing] conventions [Laughs].

For Bettina, this lifestyle is not only an escape into an idealization of the 1960s, but what adult life *could* be, but seldom is not.

Bettina introduced me to her hairdresser Arthur Wynandz back in Cologne. Arthur was apparently not only highly knowledgeable when it came to giving local Mods the French crew and geometric cuts they desired, but had also observed closely subcultures in general. His clientele included not only Mods, but also Punks, Goths, Rockabillys, and so on. Similar to Bettina, Arthur believed that Mod was a style that did not just cater to teenagers, but just as easily to people in their twenties and thirties. Part of his opinion had to do with the actual stylishness of the Mod look as compared to those of other subcultures: It's a style "that doesn't have to be rude or severe. It can be something nice where one recognizes oneself [within it], right? Where one says, 'Oh, I am rebelling through my appearance, but it doesn't have to be in a severe manner... [It can be] in a more graceful one.'" This may be one of the key reasons why Mod has lasted as long as it has. It has opposed the conventional *not* by embodying society's (supposedly) denied "ugliness," but instead has flaunted what the world could look like through rose-colored glasses. Mod has been a rebellion that uses elegance as defiance.[93]

As the above statements have shown, Mod culture can be a way for young people today to tap into an "authenticity" missing from mainstream, contemporary life.[94] Two of my narrators located this quality not just in mid-60s music and fashion, but in the eventual political activism of the later 60s. One of these narrators, Susanne ("Susi") Reimann (b. 1980, Berlin, fig. 9), saw this as an intrinsic part (or, at least, an outgrowth) of what she understood as Mod culture:

> I don't just like music from [the 60s], but everything. I think the 60s was simply an incredibly exciting decade where a lot happened. There was recognition that this was a period of change. It was the next generation, the so-called postwar generation and it was through them that these [various] movements came to be... things like the student revolt and so on. It's impressive to me when people change things; when they mobilize themselves for things. The way it is now, I really think it's unfortunate somehow, because I don't have the feeling that people fight for their rights.... I think it's time again for people to say, 'Hey, Hello... we are the people and you won't trivialize us again.' I think that people accept a lot of things [that they shouldn't] and that was not just shown in the student movement, but it affected everything [then]. It was mirrored in the music and fashion. Everything was very innovative. It was simply a great big, new direction.

Another narrator believed that Mod style served as a portal to understanding deeper dimensions of the original mid-60s period, as well as post-1967—which some Mods have started to include within contemporary expressions of the culture.[95] She thought this was true for her generation as well as for "twens and teens" who have entered the scene more recently:

Figure 9. Susanne Reimann (Photo by author).

They may think, 'Oh, that dress is cool,' and then they realize at some point, 'Oh these fashions have existed back then [in the 60s]... and what was that time like?' And I think it's the same with music. If they know the Beatles, they might wonder, 'What else was going on?' Then they discover the Kinks... and *then* they realize there was even wilder stuff. And, for me, I think the late 60s had this political angle. I'm not sure how much of a role that plays [for young people] these days, but that was very important to me... this idea that in those days people had reasons to take to the streets. These days people are happy when they have a video recorder or a CD player. People live for themselves. In those days people still fought to make society better. 'It isn't necessary anymore.' I think people today have great individual freedoms, so you can convince yourself that you are free. Today when you fight for things they seem abstract or far away... in other countries. Concerns like Global warming, for instance, are not as concrete as things back them. Back then one fought for women's rights and the civil rights for blacks in the U.S., which felt like more immediate concerns. (Dani Schwämmlein, b. 1972, Nuremburg/Berlin)

In Dani's estimation, an affinity for late-60s culture can also be a gateway for eventual participation in Mod culture.

However, not everyone I interviewed would have actually liked living in the 1960s as they were, not when they think about how they really could have been:

I don't try to live in the 60s. I don't want to live like they did back then. I'm not trying to travel back in time, but rather have a little bit of the feeling and style—the style of clothing and music [of then]. (Christoph Sonnenberg, b. 1968, Munich/Kempton)

Honestly, I have to say that I wouldn't want to go back and live in the 60s, because I think that nowadays, especially as a woman, you can enjoy the benefits of what women in that era fought so hard for. [These things] are just understood as a given now... that I am unmarried at my age... [for example]. I really don't think I would have necessarily loved the 60s. (Anja Beckmann, b. 1973, Ruhr Valley/Bremen)

...Old objects... an old record, old clothes... they have a history that you really cannot imagine. I find that very attractive. You 'see' in these things how other people lived... That is what I think is simply charming... [But] it was only for a very short time that I thought that I would have liked to have lived in that time... Sure, when I was fourteen I thought, 'Man, I could have been living in my parents' generation.' In 1969 my parents were eighteen, so they just barely experienced that [time]. I really don't want that, because today you have a lot more choices... and one can try out many different things. (Manuel Sureck, b. 1977, Düsseldorf/Trier)

These three examples show that although one can adopt the best of Mod 60s style and culture into the contemporary moment, one would not necessarily want to live in the past. It works instead, as a gateway for the aestheticization of everyday life. Cologne DJ Andi Schultz (one of the "Two Men from Linz"—nee "Unkel"—organizers) and owner of Mod-themed Hammond Bar, thought traditionally Mod sounds from the 60s could easily be mixed with newer Anglo-American pop music. He believed some of his events have been important in this way:

At some point I began my event called 'Pop Vibrations,' and, at that time, there were Britpop and Indie scenes and there was a 60s scene. And, to a certain degree, the music was super similar, but no one from these scenes managed to dance to the music of the other. Then, every now and then, I would mix the music together... simply to show that there are actually no big differences sometimes, and that you can have a good time together. And that's important for my events... that [people] realize that it's not limited to a certain time period, but rather that other genres count. And, in the meantime, a lot of Indie and Britpop people come to 60s parties... and vice versa that 60s people sometimes come to other parties.

In Andi's view, today's Mod scene can be more inclusive and expansive than some other participants are willing to acknowledge. The songs played at his events, then, do not have to be strictly "60s only." As he said this, I remem-

bered my trip to his "Pop Vibrations" Halloween party where the Kinks' "She's Got Everything" was played in the same set as Pulp's 90s hit "Common People."

As illustrated in this chapter's sections on German Mod from the 1960s to the 1980s, the culture's presence and evolution has been wed to sociohistoric circumstances. The same has remained true from the key year of 1989 onward. Since the country's split between East and West was the result of Germany's defeat, occupation, and the Cold War, when the Berlin Wall came down on November 11, 1989, so did the most symbolic vestige of Germany's postwar fate. Previously, the Wall and all it stood for had been more directly ominous to Generation X Germans than the remaining ghosts of the country's Nazi past. Though the Nazi past was not forgotten by this cohort, it did not have the same kind of immediacy that it had had to their parents: It was their grandparents, rather than parents, who had potentially been "Party Members" or worse.[96] As one historian writes, "Germans born since the 1960s probably have no compelling psychological reason to engage with the legacy of the Third Reich in an intensive, sustained, and self-critical fashion." Thus, in terms of understanding "Gen X" German Mods' interest in the culture's cosmopolitan possibilities, this desire has more likely to do with newfound travel possibilities afforded by the European Union and the end of the Cold War, rather than a wish for one's actions to counteract the Nazi past.[97]

The reunification of Germany in 1990 also raised old issues dating back to the original unification of 1871. Namely, how could one integrate and unify *different* kinds of Germans? Palpable feelings of fraternity between West and East Germans were immediately evident, but disintegrated quickly. Similar to the original unification of Germany in 1871, the coming together of East and West—which can be argued was the West merely incorporating the "failed" East—required a subsuming of another (i.e., less desirable) kind of Germanness. By 1989, at least two generations of East Germans had come of age in a Communist state, and though a pre-1945 past and common language connected the Democratic and Federal Republics, the two countries were as different as could be by 1990. Unfortunately, as "Wessis" and "Ossis" (slang for westerners and easterners) sized one another up, they sometimes did not really like what they saw.[98] Reunification was situated also within the new Republic of Germany's participation in the European Union—even trading in Deutschmarks for euros. Though many Germans were initially upset about the change in currency, the currently strong euro has made it easier than ever for young people to be even more mobile than in decades past. However, not all German youths necessarily

take advantage of this benefit of E.U. status by traveling or working outside of Germany. Nor do they necessarily identify as "Europeans" instead of Germans. Though Germans were initially considered the most enthusiastic E.U. participants (at least through the voice of their government) and called "the most European of Europeans," many citizens have tended to feel disconnected from the principles of the E.U. In this way, Mods are different. Given the history I have outlined here, as well as the culture's continued attitudes of cosmopolitanism, I suggest that today's Mods are "the most European of Germans."[99]

Though travel is something that appeals to more than just Mod youth, I found it striking how many Mods I interviewed saw the scene's internationally visited events as *essential* to its appeal and what keeps them involved even as adults.

> [Travel and the international aspect of Mod] are super important. Because... well, I know it from two different perspectives. Earlier, when I was relatively young, I didn't have the money or opportunities to somehow travel outside the country. I stayed pretty close to my hometown of Münster and around there. Later, when I went to my first foreign weekender...I think it was in France...that was fabulous. [It was] 1993? 1994? The lovely thing is that you get to know people. When you get along with people, it's like 'Hey, come to Stockholm!' 'Ok, I'll come to Stockholm!'...And that is what's so lovely... just getting to know a lot of new people and realizing you're on the same wavelength... even if you don't see one another so often...maybe only two, three times a year or even if you just write emails [to each other]. When you see each other at the next weekender, then it's... simply lovely. And that's exactly the attraction of it...getting to know lots of people all around Europe. (Carina Marrder, b. 1974, Munich/Münster)

> It's fun. Most Mods speak a little bit of English... or you find a translator. You usually chat with the people you already now... more with other Germans or Brits. There are always national cliques... but you are together. There are always people who approach each other [from various countries]... or things you have to sort out. It's a change; it's a vacation... you do get to know a few people. (Achim Jürgens, b. 1969, Hamburg)

> I think the scene is definitely cosmopolitan. Especially a lot of English, Italians, and Spaniards came to 'Unkel.' A few from France, Belgian, Poland, and even the U.S.A. showed up. German Mods who can afford it travel to international weekenders like the ones in Rimini [Italy], Gijon [Spain], Great Britain, etc. The quality of the weekenders is also measured by their internationalism. Mods who travel internationally are greatly respected. (Ania Marx, b. 1969, Bonn)

In Carina's estimation, meeting Mods from other countries has allowed potential new travel possibilites through cross-cultural friendships established at events. Achim's comments attested to the fact that though there were some nation-specific cliques at Mod weekenders, part of the fun was knowing that you were likely to meet someone from another country. Finally, in Ania's view, the caliber of an event corrolated to the ratio of its

international guests. Clearly, if someone has taken the time to travel great distances to an event, the event *must* be good.

As with Mod culture from the 60s to 90s, most events in the 2000 still took place in larger urban areas. Some of the contemporary scene's participants, though, came to the culture despite a small-town upbringing. Hans Eiglsperger (b. 1972) who eventually moved to Munich for university, was proud of the fact that his small Bavarian hometown of Pfarrkirchen— with around 10,000 inhabitants—boasted a large subcultural youth scene when he was a teenager. Though he was one of less than a handful of Mods at the time, he would hang out with Punks, Skins, Rockabillys, and other kids who dressed alternatively. With so much going on locally, he did not meet a lot of other Mods until much later. "We actually didn't know much of what there was elsewhere... or maybe one knew, of course, that [Mod] was in England. But we did not have any idea that it was in Germany. Years later we got to know people from [another town] that started around the same time as we did. We had done the same thing for ten years and didn't know each other."

Another southern German who now lives in Munich, though originally from near Stuttgart, Michael Süß (b. 1967, Tuttlingen) remembered traveling relatively far the first time he met people who had similar interests. "Actually, where you met other people, in the summer of course, was when you took drives [like] over the weekend down to Lake Constance." Here, Michael says, he and a few friends from his town would not necessarily meet stereotypical Mods, but what he called "Scooter Gangsters"— a kind of cruder Mod-ish type obsessed with scooters. Scooters were an attractive point of entry for some male Mods I talked to. Despite growing up in a bigger city (Cologne) than Michael did, Volker von Reth (b. 1972) nonetheless felt the scooter component of Mod culture offered something different from other subcultures. "On your scooter, you were often on the go. You could really get away from home. So, with your scooter you went to England or God knows where else... and that did not exist in other subcultures. They just went to discos or clubs and that was it." As in the U.K., scooters have continued to be very much part of the culture, though not everyone rides them. As symbols of mobility, sleek design, and internationalism, the Italian-made Vespas and Lambrettas are easily spotted at German events.

The means by which young people can find like-minded others has certainly expanded through the Internet. This was also another way to identify cosmopolitanism in the German scene. The many German-specific websites and fanzines have created networks of friendships and acquaintanceships from Hamburg to Munich and the rural hinterlands in

between. Journalist and member of Hamburg's *Biff! Bang! Pow!* DJ
collective, Gregor Kessler (b. 1971, Saarbrücken/Hamburg) had these
thoughts about the subject:

> I am convinced that without the Internet, Mod would be pretty much dead in Germany.
> The 60s scene has reached such a small level that you cannot get in touch with it by coin-
> cidence if you live in a smaller city or in the countryside. In the 80s you found one or two
> Mods in most German schools, these days you'd be hard pressed to find one in all of
> Hamburg's schools. That means even if you have a faint interest in 60s culture you'd feel
> extremely isolated and probably give up your passion to focus on more socially accepted
> preferences. However with the Internet it's easy to find out even about the most special-
> ized sub-scenes. It allows you to exchange opinions with 60s fans from another city, learn
> about upcoming gigs and nighters, see photos of past events—and by doing this you de-
> velop the sense of being part of a national or even international scene. I am sure that
> without this feeling a lot of people would have lost interest long ago.

Though the aforementioned Harry Vogel has been involved in the Munich
and national scene since the late 70s, he has contined to be an active member
of the community and does not dismiss the Internet's role. Now a *Gymna-
sium* teacher of English, Politics, and *Informatik* (basic computer science), he
believed that this technology has aided the scene. Internationalism was again
at the heart of his perspective.

> I think I almost have to say that the Mod scene wouldn't exist anymore without the
> Internet. In the end, the Mod scene only can function because it *is* international. If I
> were to talk about the German Mod scene, I could just as easily talk about my group of
> friends. There are about thirty or forty people and I know them all personally. This
> international scene stays together through the Internet, because everything is spread
> through the Internet. There is a forum and so on... email contact with people regardless
> where they are. I think that without the Internet [the Mod scene] would not be possible.

Many other Mods I spoke with held similar attitudes toward the Internet
and its role in globalizing effects on both their local—whether Hamburg,
Munich, Cologne, Berlin—and national scene. Here the Internet once again
played a role that it has been so good at: that of "glocalization," or merging
immediate experiences with those that are distant or worldwide.[100] The
metaphor of the computer screen as a window is certainly clichéd by now,
but it bears repeating that in discussions of global-networking subcultures
like the Mods, that it can function as a window opening to a greater world. It
has allowed users "the illusion of navigating through virtual spaces, of being
physically present somewhere else."[101] In this way, the wish for cosmopolitan-
ism already inherent in German Mod culture is underscored in the possibili-
ties of online communication with like-minded people worldwide.

　　This internationalist attitude and aesthetic has been evident in many of
the websites created by Mods in Germany. Of the seven Mod websites that I

initially discovered, almost all used English-language text—clearly inviting non-German speakers to join the fun.[102] This was especially true of those sites related to events, such as those for *The Hip Cat Club* and *Biff! Bang! Pow!*, which were both monthly Mod events in Hamburg during my stay there. On *Hip Cat*'s homepage, the site's creator had this to say to the public: "Hey Swinger! Know where the action is? Come on in! Get along with the hippest cats and grooviest birds at Hamburg's monthly vintage-underground club-night! With resident and top international DJs and live acts playing high class 60s and early 70s sounds from real vinyl." Meanwhile, *Biff! Bang! Pow!* marketed itself to both local and potential foreign guests in this way: "With a broad selection of smart 'n' groovy dance tunes, Hamburg's 6T-Night-Club won't tell you what's Mod and what's not. We simply want you to enjoy yourself, have a few drinks and dance your socks off!" In the case of both websites, promoting these events in English, rather than German, heightened the probability that Mods traveling from outside Germany to Hamburg would be able to read about these events and connect with this local scene.[103]

While *Hip Cat Club* opens its site mentioning the fact that international DJs frequently spin at its events (for instance, a July 2006 event featured London DJ Rob Bailey, introduced in Chapter One), *Biff! Bang! Pow!* has billed its stable of DJs as worldly jet-setters well-versed in Mod around the world. For instance, Jani Egloff's alter-ego "Dr. Mod" "oscillates between the Mod nightlife of Munich, Hamburg, New York City, and a lot in between." Ralf (Jürgens) "embraces the joys of the modernistic party-jet-set and chances are high you've met him along the way in Stockholm, London, or somewhere in between." Meanwhile, Alex Copasetic (a.k.a Giamlich) "when not spinning records on the 6Ts-Partys circuit between Paris, Berlin, Barcelona and Leipzig... runs the Copasetic mail order and Copasedisques label."[104] In these two examples of Mod websites, evoking international élan is important to those writing them and clearly sends the message that German Mods are well connected to the sights, sounds, and scenes within its global community. Interestingly, when attending these Hamburg events, it was only rarely that I encountered other foreigners. Thus, it seemed to me that evoking cosmopolitanism and a well-traveled coterie of locals was important in and of itself—even if the Hamburg Mod scene has not been necessarily international in its makeup.

My year of fieldwork observing German Mods and their events between 2006 and 2007 also took me to Berlin, Cologne, Munich, and Aachen. The events ranged from those that were elaborately planned and weekend-long such as Aachen's "Casino Royale" and the "Two Men from Linz," held along

the Rhine River outside Bonn—to casual gatherings and parties at people's homes. Again and again, as I met and interviewed Mods, I was continually struck by this theme of internationalism or the way in which traveling to other Mod scenes was integral to one's experience in the scene. Dietmar "Didi" Haarcke told me, "There used to be a big [scooter] run in Sweden over Pentecost [weekend]. It was always Pentecost...that was extremely fun and Sweden is simply....how should I say it...simply a brilliant country. It was just fun and you also got to see a bit of the countryside." Jani Egloff said:

> I always found it fascinating to look at how people from other countries identified with Mod and how they explained the concept to themselves and how they adopted Mod for themselves. For example, in Italy it's different, you ... it was very funny when I was in Milan and talked to the Milano Mods because they were somehow separate and they were... and there were two... not tribes, but two threads, that didn't like each other and one was apolitical and the other were socialists and thought Mod is a socialist thing. And I thought, 'Aha, okay, Mod is socialist.'

Meanwhile, Lena Dehnärt (b. 1981, Darmstadt/Cologne), whom I met at the 2007 Two Men from Linz gathering, told me that experiences outside of Germany were what first made her aware that Mod scenes actually existed.

> Before I actually got to know the [Mod] scene...I had a boyfriend who, in retrospect, I now realize was a Mod [laughs] who, like I said, played soul music and is how I was able to travel all around Europe and meet lots of different people who played music. So it was already at that time that I arrived in Spain and there were people dressed in 60s-style clothes and I thought, 'Wow! Hot! You're here...but where are you in Germany?' I had already met people in all possible countries who liked this music....through my ex-boyfriend...and through the tours and concerts and everything. But I didn't know this scene at all. So when I did happen upon these people in Germany, that was the first time I thought, 'Oh, the people back then were also Mods.'

In Dietmar, Jani, and Lena's comments, elements of difference and/or similarity as compared to Mod culture outside of Germany have played roles in understanding what the culture is about both locally and in a bigger-picture-sense through travel. Instead of focusing on the fact that Mod initially came from Great Britain, the voices of these German narrators suggested instead that *their* Mod culture was central to their experience as Europeans, rather than Germans. The narrators' voices echoed what I observed in Germany. There were many non-Germans in attendance at weekend events such as Aachen's "Casino Royale" (2007) and "The Two Men from Linz" weekender (2007, 2008). The events welcomed DJs and guests from Italy, Spain, Britain, Sweden, and Greece. Strewn on tables throughout the events' venues were many pop art–style handbills advertising events in other countries such as Spain's "10th Magic Soul Weekender" (Madrid) or Italy's 15th annual "All Saints Mod Holiday" (in Lavarone and featuring a photo of the Small Faces

on it) or "Hot Mod Summer on the Lake" (in Perugia).[105] The creation and attendance of events and parties around Germany and Europe for those who have identified with the culture's 60s-influenced trademark style has been integral to the longevity and continuation of Mod there.

For participants in the scene, this heterogeneous and international community has been where the *soul* of their *mod-ernity* lies. In her description of the German Ruhr Valley Mod scene (or as she alternatively calls it, a retro-oriented "60s scene") anthropologist Heike Jenß has suggested that the diminishing number of German Mods in the 2000s has necessitated more and more international gatherings.[106] Although the mere existence of a Mod scene in Germany (or elsewhere) in the twenty-first century, and not the number of participants, has been a stunning achievement, the international *Weltanschauung* and accompanying travel habits of many German Mods is one that has been cultivated since the 1960s and remains one of its most noticeable features. One interview in particular, with Alain Ayadi, also reminded me of the importance of national versus international identity politics at play. Alain relayed why Mod was initially so appealing: "To me, Mod seemed elite... something special, something apart. It was nothing mainstream. And for me, someone who isn't German (my mother is Dutch and my father is French-Algerian)...it was a way out of German culture... where different rules and different aesthetics applied. What was 'German': garden gnomes, Bratwurst, and potato salad...wasn't important anymore. [Mod] was a kind of escapism." For Alain, who grew up in Germany but is a French citizen, and whose parents are not German, Mod gave him a sense of identity that superseded what he saw as stereotypically German means of cultural belonging.

This chapter on German Mod culture began in Bavaria and it shall end there, too. In the same week that I interviewed Klaus Voormann, I was also invited to a dinner party thrown by Harry Vogel and his wife Annette Hutt (fig. 10).

Figure 10. Harry Vogel and Annette Hutt (Courtesy Vogel).

Harry told me that the others coming were the core of Munich's Mod scene. As I entered their fantastically decorated "pad," with its brightly colored walls (the living room was painted orange), geometrically-patterned curtains, a collapsible egg-shaped chair, and white bookshelves, I immediately met a group of very nice people—most of whom were between their mid-twenties and late-thirties. First I talked with Claudia and Silvia. Claudia was a petite brunette with bobbed hair and big, blue eyes. Silvia was Italian and married to Hans (Eiglsperger). She had long black hair and was dressed in a black turtleneck and pants. Carina and her boyfriend, Thomas arrived a short while later. Carina was a tall girl with pixie-ish short hair and wore an outfit combining hip hugger pants with a thick belt and a dark blue collared shirt with a vest. Thomas sported a prematurely gray, cropped haircut with sideburns and his fashion evoked the Ivy League look. Thomas asked me about my work and we then discussed German movies from the 60s such as *Engelchen* (1968) and *Mord and Totschlag* (1967).

Later that evening, Harry pointed out something on his book shelf. It was a silver object that looked like a cross between a robotic spider and a rocket. He asked me if I knew what it was, but I had no idea. It turned out to be a lemon press. He went on to explain how something like this was Mod… because the concept and form of it were both much more interesting than the function or the sum of its parts. He told me that something so cool looking could not be used simply in the way it was intended to be, because its decora-

tive function was much more riveting. It was the design of it that deserved attention. This brief interlude drove home the fact that no facet in living as a Mod was too small for one's attention. It was not just the idea of living life surrounded and connected with like-minded people locally and globally. Every commodity with which one surrounded oneself could be an object of beauty to enhance one's life.[107] Later that evening, I thanked Annette for co-hosting such a nice party and how good it was to have met her. I was moved to see tears welling up in her eyes. She told me that this is what she thought was so wonderful about the Mod scene—how you get to know people from all around the world.

Several months later, in June 2007, I made my next and final visit to Munich. Harry Vogel was hosting a summer barbecue at his parents' home in a leafy, residential part of town. I saw once again many of the people I had met at Harry and Annette's party in March. Soon after arriving, I was greeted by Thomas and Carina.

Since my initial interview with Thomas was cut short when I saw him at the "Casino Royale" event in Aachen, I would conduct a second part of it tonight. This time, I would find out one of the main reasons he enjoyed identifying with this culture.

> I do think that we [Mods] *are* the Europeans, actually. Everyone is always talking about it, but we are living it. Some of us travel more than others, but even when we can't always be everywhere at once, there's always the telephone and the Internet where you can get in contact with other 'cultures' or people from throughout Europe or worldwide. There are a lot of people even in our generation who think, 'Sure, a united Europe is here, but what's the point?' But I *know* what the point is. I think that's very positive, actually, that we are living as Europeans.

I immediately got goose bumps as I heard him say this. Thomas's words attested to the fact that he and many of his contemporaries were now experiencing what those in the 60s envisioned for the future. A German Mod could now indeed inhabit a lifestyle unbounded by the artificial confines of national identity. Mod had become a truly cosmopolitan phenomenon.

Mop-Tops, Miniskirts, and Other Misdemeanors
Mod as "Gender Trouble" in the U.S.A.[1]

I let my hair grow long like his
Pretended I was in showbiz
They called my mother up at school
They said I must have blown my cool
They said your son is acting bad
He thinks he is the English lad
But I didn't care about disgrace
If only I could take the place of Ringo.

—"Like Ringo," American novelty record (1964)

The first U.S. interview that I conducted was, appropriately enough, held in New York City. After all, this is where Mod culture literally "landed" with the Beatles on February 7, 1964 at Kennedy Airport. Just as Hamburg became the literal *port-al* for Mod style via the city's docks, the airport's landing strip served as the point of entry for a look and sound that would rattle American popular culture in unprecedented ways. As one U.S. author has it, Mod "started with the Beatles."[2] This chapter will examine how Mod, as first introduced through the Beatles, caused crises surrounding *gender aesthetics* in middle-class American culture. Here, I define gender aesthetics as the physical and accessorized attributes of men or women and how they have related to socio-historical constructions of masculinity and femininity.

In trying to uncover if these subversive energies of 1960s Mod still held sway over new-millennium Mods, I began seeking answers in 2002. I soon discovered the short film *American Mod*—produced and filmed in New York—had debuted the previous year. Through the Internet, I contacted Charles Wallace, a musician whose band Headquarters was featured in the film (fig. 11).

On the afternoon that I met Charles in New York's Greenwich Village the winds were so intense that my occasion-appropriate, if too tiny, Union Jack umbrella broke a few minutes after emerging from the subway. As I soldiered along trying to find our meeting spot—an old-school, Italian café—I tried imagining Mod culture in Manhattan. Given the rain and small, wind-

ing streets, the setting reminded me of Mod's birthplace: London's Soho. Soon, I hoped, Charles would tell me how this 60s-oriented subculture might be different here. My mind suddenly flashed back to my recent viewing of the film that brought Charles and his neo-60s band to my attention.

Figure 11. Charles Wallace (courtesy Wallace).

Kolton Lee's *American Mod* is a fictionalized account of three friends within the New York Mod scene. These characters are pretty boy Chester, his buddy, Max, and their female sidekick, Sandy. Chester chases after a long-legged blonde beauty, but it is the petite, black-bobbed Sandy who wants him as more than a friend. The film is also noteworthy for the late British gay icon Quentin Crisp's cross-dressing role as a drug dealer's "Grandma," which was also his last film role.[3] The film debuted in an East Village theater in March of 2001 with two sold-out screenings. When Headquarters toured the U.S. and Europe, Charles often showed *American Mod* as part of the evening's events. The film also aired on the U.S. Sundance cable channel and was, at least in the early 2000s, available through Internet purchase. A graphic designer, Charles further helped the director promote the film through a website, which featured links to other sites, such as those for his band Headquarters and for Mod-themed events happening in New York such as "Smashed! Blocked!" and "'Tiswas."[4] When I eventually

talked to Charles, he told me, though, that New York's Mod scene was fairly small, "with the same thousand or so people interchanged throughout these clubs. It sounds like a lot, but in New York that is very underground." If Charles's estimates were accurate, I still wondered what youthful New York Mods would find fascinating about this culture and aesthetic.

Having worn a chic, Mod-ish minidress to meet Charles, but having also just drudged through wet weather, I did not think, at that particular moment, that I looked very Mod. Instead, I looked and felt like a drowned rat and quickly bolted to the ladies room to freshen up. When I emerged a few minutes later, I saw Charles (b. 1971) walk through the doors. I recognized him from the film and his band's website. He looked like a very tall version of Steve Marriott—the exceptionally petit lead singer of 60s Mod band the Small Faces. Later that night, at Headquarters' performance in the West Village, I saw him mimic all the 60s' "greats" (Marriott included) as both frontman and guitarist. For the interview he showed up wearing white pants and a button-up paisley shirt. Sporting a mop-top-type hairstyle, as dark-blond bangs splayed across his forehead, Charles was well spoken, with hints of a Midwestern accent that underscored his Michigan roots. His distinctively arched eyebrows and eyes were expressive as he talked. He first gave off an air of detached cool, but came across friendlier and more open as we talked. The questions I had for him were myriad: How did he get into Mod culture? What was the current New York scene like? Why were the 60s interesting to him? I listened closely to Charles's erudite answers and found my mind creeping towards an initial understanding of what may have brought him (and other New Yorkers) to the city's Mod community. It was the excitement associated with the "1960s" whether in fashion, in art, or in the decade's idealized vision of "progress" and "modernity."

I was struck by two of Wallace's comments regarding the Mod lifestyle and, in particular, what they suggested to me about gender aesthetics and American society from the mid-60s onward. First, when I asked him why he thought Mod (male) style stood out in 2002, he said, "I think it's pretty radical to wear a suit and a tie. You walk into a club nowadays with all these Grunge people and Rock people…. People just drop their jaws. 'This guy is obviously not a businessman because the suit is just too weird, but it's like completely radical.' The Mods went against the early pre-Hippie, Beatnik style." In this sense, what Wallace saw as subversive about this male style was its formality. Because many male youths belonging to subcultures in the early 2000s wore casual clothing (baggy jeans, T-shirts, etc.), the supposedly "conservative" appearance of a suit and tie was also paradoxically cutting edge. When I asked him the broader question of why this 60s-born style would

appeal to someone who came of age in the 1980s, Wallace explained, "I don't like 60s music because [to like it now] is ironic. It's a sentence that still has to be finished. [There was] racism and sexism and social change and breaking boundaries of clichés and opening people's mind. In the 60s a lot changed, but a lot of it reversed—or at least it stopped in the 70s. All the Hippies got old and had kids and went back to the 50s styles." Here, Wallace observed that though "a lot changed" in the 1960s these were, by and large, changes that were subdued by the 1970s. He assumed that many people who were involved with those changes gave up on them and went back to more traditional lifestyles and roles such as marriage and family; husband and father, wife and mother.

I begin this chapter with these comments from Wallace because Mod has been historicized and arguably still is understood in the U.S. as a fashion that *visually suggested* social transformations on all fronts—but especially in terms of gender. As Wallace's words implied, though Mod emerged in an era of change, radical departures in appearance did not always mean transformations in Mods' actual lifestyles or habits over the long term. Despite now-familiar mid-60s imagery depicting young men wearing their hair longer or young women wearing daringly short skirts, not all who partook in those trends would become less conventional adults. And also despite the exploration of "alternatives" in the 60s, cultural hegemony of the nuclear family, marriage, and aspirations to conventional middle-class life, did actually not alter drastically after decade's end.[5]

My conversation with Charles led me to investigate further how gender issues played out in the subculture's U.S. manifestation. I also soon recognized that I could not examine Mod gender aesthetics without thinking about class also. Unlike British Mod's original associations with working-class youth, American Mod was tied primarily to middle-class teenagers. As might be guessed, this disparity had to do with the way class was, and still is, viewed in Britain versus in the U.S. The primary, American postwar ideal was that everyone was or could be middle class. Many citizens self-identified as middle class and the term itself became the yardstick for measuring the "American way of life" starting in postwar society.[6] The middle class has historically "established the patterns for many of our dominant clothing and gender traditions."[7] It is in this context that I focus on how Mod style upset middle-class society in the postwar United States.

Mod in the U.S. invited animated discourse about changing aesthetics in male and female appearances which hinted at changing sex roles during the mid-1960s. Thus, it is important to understand how middle-class gender issues had been historicized in the years leading up to Mod's arrival. It is only

then that one can see how Mod style was as shocking as it was. Much An-glo-American scholarship on gender and/or appearance (including analyses of fashion) underscores the social significance of the connection between ex-pectations of masculine and feminine appearance and greater cultural changes. Judith Butler, for instance, is well known for her theory that gender is "performed" through one's looks, gestures, and mannerisms. If being mas-culine or feminine is a role versus an immutable, natural state, there is no reason, then, why the "costumes," let alone behaviors, of these social actors cannot be changed. In this chapter, a closer look at American Mod culture will illuminate gender concerns surrounding mostly straight and middle-class youths, asking the question: Did Mod act as a potential change agent that "queered" notions of gender aesthetics in the 1960s that continue to influ-ence the identity of American youths today—especially those in Mod com-munities?[8]

American Gender Roles and Aesthetics Before Mod

Understanding Mod's initial reception in the U.S. requires a look back at earlier gender aesthetics and roles of the middle classes. Why some Ameri-cans would eventually read Mod male fashions as feminine, and therefore even, at times, tacitly "homosexual," stemmed from earlier points in the country's history. This was equally true for Mod female styles of the 60s, which were often seen as fostering "inappropriate" adult, female identities.

Ostensibly, American men have sought to distance themselves from "British decadence" (read: effeteness) since the Revolutionary War. In one historian's words, "American soldiers [were] to look formidable, but not too foppish... it would not do for them to appear too fashionable," like the Red-coats. The even more over-the-top British stylists of the eighteenth century, the Macaronis, known for wearing massive and accessorized wigs, were also mocked—eventually earning an unflattering mention in the popular Ameri-can song "Yankee Doodle."[9]

By the 1890s, the contrast between American and British masculinity was much starker. The closing of the American frontier not only cultivated nostalgia for the country's "Old West," but a rough-hewn masculinity associ-ated with it. This era also saw unprecedented urban growth, creating a new kind of competitive environment requiring men to be more "civilized" in their choices of work, attire, and attitudes. Genteel office work started re-placing more vigorous or agrarian labor on a massive scale. As a cultural re-sponse to this, images of hulking and rugged frontiersmen in buckskin clothes suddenly were romanticized greatly. In 1901, the newly elected President Theodore Roosevelt, who had, several years earlier, left New York

for a time to live in the Dakotas (eventually penning the multivolume *Winning of the West*, 1885–1894), embodied this dominant male ideal. This image further distinguished American men from their "English gentlemen" cousins who instead aspired to refined, gentle, and, sometimes, urbane manner.[10] Thus, the "civilized" urbanites who favored a more debonair style, were not seen as sufficiently "American" but somehow sissified through "excessive [read: European] cosmopolitanism."[11]

This prevailing vision of American manhood seemingly had no room for those who, either by birth of lifestyle did not somehow "fit." Native American, black, Jewish, working-class, and homosexual men were noticeably absent from this formulation of the male experience. More recent scholarship, however, has uncovered "alternative masculinities" challenging this period's stereotypical image. Gay and black cowboys coexisted with their heterosexual counterparts, though in the former's case, this difference could be more easily hidden. Urban centers also had thriving, if underground, gay scenes that cultivated distinct fashions and slang. Though homosexuality has been practiced by traditionally "masculine-looking" men, too, some chose feminine dress or style. These effeminate homosexuals were not usually transvestites but often simply adopted particularly ostentatious accessories or details to their dress— signaling their orientation to likeminded others. Given the otherwise mostly monotone clothing choices for men (black suits, more black suits, and hats) during this time, outfits that appeared a little too conscientiously assembled became identifiable markers of queerness. Pockets of the working class and petit bourgeois, including straight men, however, had a similar eye for fashion detail. Many department store clerks were depicted as overly concerned with their appearance. Hangers-on of the New York theatre scene, known as "Mashers" were also known for their flamboyant dress.[12]

Middle-class women's lives during this time were also more complex and multifaceted than at first glance. However, the image of the middle-class woman as homemaker and mother—a holdover from the "cult of true womanhood"—tended to prevail.[13] While only a small percentage of married women worked outside the home circa 1900, many males feared their increasing social power, which was connected to concepts of the so-called "New Woman." These women ranged from office workers to Gibson Girls; from Greenwich Village Bohemians to Suffragists.[14]

American women won the right to vote by 1920—further liberating them through their inclusion in this vital political process.[15] With more open views of sexuality and an increasingly urbane lifestyle, this period's young women symbolized for many a traditional thinker "the end of civilization as he had known it." The joviality of the 20s was not only because of Jazz, but

due in great part to these (mostly) college-educated, usually rail-thin young women with trendy "bob" haircuts. They were Charleston-dancing party girls whose "uniform" was a "short dress, roll-top silk stockings, girdle-bra that bound the breasts and minimized the hips, handbag, makeup." Though fashion conscious to their cores, these so-called "Flappers" eventually left the dance floors to "settle down."[16]

By 1941, as the U.S. entered World War II, women took "traditionally male" jobs while men joined the armed forces. Norman Rockwell's famous depiction of "Rosie the Riveter," shows a muscular woman wearing overalls, thick-soled shoes, and goggles atop her head, with a large riveting machine laid across her lap. This "industrial strength" woman wore clothing that was, in no way, coded as feminine at the time.[17] During the War, more women inhabited "masculine" spaces, work, and dress. Certainly, there had always been a minority of women who chose unconventional paths. For the majority of middle-class women, though, traditional division of labor resumed at war's end. Men took back their jobs while most women returned to conventional roles as homemakers, mothers, and wives.[18]

With the defeat of the Axis powers, and the economic disaster facing Britain and France, the U.S. soon symbolized postwar might. The role of women in the postwar, nuclear family was to serve a specific purpose in creating this strength. As for their husbands, American men were expected to embody the vim and vigor that both media and government projected as the U.S.'s image in the world.

Though the immediate postwar years often have been portrayed as an unadventurous period, it was actually an important, transitional time in American popular culture. Similar to reactions in Britain and Germany, World War II's end—with its exploding nuclear bombs, profoundly changed the way Americans, especially young people, envisioned the future. The ensuing Cold War prompted an unprecedented fear of Communism among many Americans, which sometimes led to ultra-conformist behavior.[19] Those who succumbed to this fear clung to the certainties of traditional lifestyles, while others, again by birth or choice, sought out something more. The postwar dawning and subsequent evolution of teenage culture was increasingly media influenced. Through movies, Beat literature, and Rock and Roll music, young people were exposed to a diverse group of mediated "role models."[20] Many in this populous, postwar group wanted, like those in England and Germany, to cultivate a new culture. In doing so, teenagers also looked for different expressions of manhood and womanhood.

Despite the now-stereotypical 50s imagery of middle-class and middle-aged "organization men" and their happy homemaker wives, the mediated

exposure to different "types" of men and women alerted teenagers to new behavioral and sartorial possibilities. Nontraditional masculinities appeared in the mid-50s thorough Rock and Roll's Elvis Presley and Buddy Holly, as well as by up-and-coming Hollywood stars such as Marlon Brando, James Dean, and Montgomery Clift. These unconventional males, who often conveyed anti-authoritarian sentiments and unrestrained pathos while usually donning blue jeans and other casual fashions, appealed to many male war babies languishing in a hat-and-suit-clad suburbia. That Brando or Clift showed more varied emotions than established leading men like "cowboy" John Wayne or the mustachioed Clark Gable led to some critics' readings of the new stars' personae as boyish, and, thus, also not fully masculine. They were performing manhood but were not truly men themselves. Meanwhile, Presley, a working-class Southerner who had reworked "race music" (read: Rock and Roll) initially for white audiences, had a hip-swiveling, raw sexuality. Another alternative hero was the bespectacled Rocker Buddy Holly, whose romanticism carried with it a more subdued sensuality. Whether criticized by their parents or not for such role models, male, teenage fans of such figures simply saw these men as more interestingly complex then their seemingly one-dimensional, middle-class contemporaries.[21]

It is also important not to forget that Beat writers, many of whom happened to be gay or bisexual, such as Allan Ginsburg and William S. Burroughs were highly influential, too. In creating a poetic, black-turtleneck-wearing, "hip" world, this clique thrived in their self-proclaimed apartness from the lemming-like masses. The Beats' "howl" against an increasingly affluent, consumer-driven society was meant to highlight "America's other appetite, not for wealth, but for autonomy... the purest form of which is freedom from the demands of money."[22] While male Beats showed a more avant-garde way for male teens to escape from the mainstream, their equally hip female counterparts underscored that not all young women of the period aspired to be contented suburbanites, either.[23]

By the early 1960s more gender-specific changes were afoot. Akin to former president Theodore Roosevelt's mirroring of masculine trends in the 1890s, the 1960-elected President, John F. ("Jack") Kennedy, seemed to do something similar. Though already in their forties and thirties, respectively, President Kennedy and First Lady Jacqueline ("Jackie") brought a youthful liveliness to early 60s culture. This was also evident in their personal style. The attention paid to Kennedy's lustrous hair, which he often showed off—countering the hat-wearing majority—predated the interest in the Beatles' "controversial" mop-tops. Young women around the country started mimicking Jackie's less-is-more fashions (A-line cuts and sleeveless shift dresses)

and her "flip" hairstyle. In the twentieth-century, certainly, Kennedy was perhaps the first president to be seen as inherently youthful—even "boy-ish"—and not less manly for it. Jackie, meanwhile, paved the way for baby boomer girls' eventual love of the more minimalist look of Mod.[24]

Another expression of changing femininity was found in the songs of "Girl Groups." For instance, the Shirelles' "Will You Still Love Me Tomor-row" (penned by Carole King and Gerry Goffin) depicted female desire, sexuality, and the guilt that often accompanied them. The Ronettes' "Be My Baby," expressed the vocalists' determination to "get their man."[25] While Jackie Kennedy was often portrayed as the stylish power behind the presi-dent, Girl Groups vocally embodied a similar panache. They made strong statements about modern womanhood, yet still worked within a traditionally heteronormative context.

Kennedy's assassination in November 1963 dashed the dreams that many Americans had projected onto both the President and First Lady. Though Kennedy was not the only example of early 1960s masculinity, his image was a difficult one to think of losing or trying to replace. Where would this gen-eration of Americans—especially young men—turn next for inspiration?

The British Invasion, 1964–1965

From an American perspective, the Beatles and other "British Invasion" groups clearly have impacted the U.S. conceptualization of Mod culture. Ac-tor Alex Baker (b. 1970, San Francisco/Los Angeles)—who discovered Mod as a teenager—told me, "The world moving into the 60s and coming out of it was dramatically different. There was this sense of revolution that was touched off by the Beatles in fashion and music and culture." Meanwhile, Bay Area musician Paul Bertolino (b. 1969, San Francisco) recalled:

> I didn't realize until much later that Soul music was such a major part of the whole Mod scene.... My aunt introduced me to the Beatles via 'The Beatles' Second Album' when I was probably around two years old. When I was three or four I actually imagined what it would be like to be at High School dances in the early to mid-60s. I had vivid pictures in my head of girls with Patty Duke hair and guys in suits and I loved it. I wanted to be there even then. My obsession with the Who and the Kinks, which started when I was 12, is what introduced me to slightly more authentic Mod music and culture.

Similarly, when I asked Dan Melendez (b. 1974, Los Angeles) what songs he would define as "Mod," he cited several by British Invasion groups, like "Zoot Suit," by the Who as the High Numbers and "Just Out of Reach," by the Zombies. For these narrators, the British Invasion was intrinsic to Mod's U.S. roots.

If Mod came to the U.S. via the Beatles then the subculture's initial arrival was greeted with "screams heard round the world."[26] Elizabeth Levine (b. 1952, New York) recalled Beatlemania's impact on her adolescent life:

> [My friends and I] formed a Beatles Club. We hung out in each others rooms listening to the radio, fantasizing about what we would do when we met them. In 1965, my best friend had a very serious surgery, which required her to be flat in bed, in a body cast for six months. Her aunt wrote to the Beatles explaining my friend's dire circumstances. She got a letter back, signed by them all, wishing her a speedy recovery. But the best part was that a swatch of fabric from Paul's suit was attached. How we loved to stroke that piece of fabric!

Despite youthful enthusiasm such as this, and even prior to the Beatles' U.S. arrival, the American press's coverage tended towards a dismissive attitude. According to *Time*, British youth had already succumbed to a "new madness" called Beatlemania. The article's somewhat mocking tone suggested that American teens would remain immune to it—unlike their less sensible British cousins. The author of a *Newsweek* article tried feminizing the group, stating, "They prance, skip, and turn in circles" when performing.[27] Despite the tenor of these articles, the initial reception of the group was nothing less than exuberant. On February 9, 1964 many American teens were likely part of the record-breaking, 73-million-person audience witnessing the Beatles on *The Ed Sullivan Show.*[28]

In the early days of jet travel, these "long-haired" Liverpudlians must have appeared beyond foreign. As one author observed, "given how rarefied foreign travel was then, England might as well have been in a different galaxy."[29] Later reflecting on this stylistic culture clash, John Lennon remarked about Americans, "You were all walking around in fuckin' Bermuda shorts and Boston crew cuts and stuff on your teeth."[30] Needless to say, the intercultural criticism flowed both ways. Nonetheless, the Beatles' mop-top would become more than just a teenage fad; it became symbolic of changing masculine aesthetics during the 1960s—part of what had already, by 1963, been codified as "Mod" in their native Britain.

While the mop-top hairstyle still caused consternation in the Beatles' native Britain, it was read as even more effeminate in the U.S. than in the U.K. Since American perceptions of British foppery can be traced back to the Revolutionary War, it is no wonder that this influx of U.K. music and fashion was soon coined the "British Invasion."[31] If Americans first saw the Beatles' haircuts as odd, they would soon also read them as distinctively "Mod," because of the mainstream press's increasing coverage of British style. Regardless of its popularity in the U.K., Mod offended many older, middle-class Americans with its presumed effeminacy. The Beatles' de facto affilia-

tion with this new flavor of Britishness marked the group as queerly mascu-
line in the U.S.[32]

Because of this perception by many in the older generation, Beatlemania
was studied by a slew of American psychologists and sociologists trying to
understand the female hysteria surrounding these foppish musicians. One
psychologist claimed that the Beatles' supposed "femininity" was integral to
the mania they inspired. He suggested that the group's success symbolized a
cultural shift whereby Western culture was transitioning "from excessive pa-
ternalism to an era of semi-maternalism."[33] As history attests to, homosexual-
ity and effeminacy can be mutually exclusive. However, "queerness" can
challenge normative gender aesthetics. Nonetheless, homosexuality, already
outside of the mainstream, has allowed for broader identity play in which
some gay men may adopt traditionally feminine traits if they so choose. In
describing gender-bending rock artists, queerness is, according to one
scholar, "more about confusion and subversion on all available levels than
about having an explicit, fixed sexual identity." Given this definition, a
"queer" reading of the Beatles circa 1964 seems plausible.[34]

In an article printed several months after Beatlemania first hit the States,
a journalist opined that though the Beatles were being blamed "for every-
thing with the exception of the climate," their style was actually nothing
compared to other British bands soon making their way to across the Atlan-
tic. This article juxtaposed a photo of the longer-haired Rolling Stone Brian
Jones against that of Beatle John Lennon. The layout of the piece suggested
that more extreme sartorial decadence would come with another battalion of
British invaders.[35]

More British Are Coming: 1964–1965

In 1775, when Paul Revere warned colonials of the King's approaching army,
young revolutionaries were ready to fight the power of the crown. In 1964,
young Americans—already enchanted by the Beatles—were happy to surren-
der to the British. It was not just the bands, but anything connected to the
British Isles, that intrigued U.S. youth. In these teenagers' eyes, Liverpool
and, soon, London more so, was a "continuous space-age funfair, one endless
parade of boutiques and discotheques and hip trattorias, Carnaby Streets and
King's Roads.... England became the epitome of everything elegant, enlight-
ened, deeply switched-on, and its exports became automatic triumphs."[36]
With this willing audience, bands making up the "British Invasion" were
those who were already successful at home—either through Liverpool's Mer-
seybeat phenomenon or London's R&B scene.[37]

The Beatles' success and the subsequent British Invasion have been portrayed as lacking support from African-American teenagers. A binary portrait of 60s popular culture has emerged depicting white teens listening only to English groups, while black youths exclusively spun Motown singles on their turntables.[38] I was able to gain a more nuanced view about the relationship between black teens and the British Invasion from Robert "Leroy" Fields (b. 1952, Chicago). Already an equal-opportunity fan of Tamla-Motown *and* the Beach Boys by 1964, he told me:

> One of the things that the British Invasion did for me was opening up my mind to the fact that a white artist's 'cover' version of an R&B or Blues tune could be more than passable…. You see, up to this point, I hated most white artists' versions of American R&B songs. Now, if you know me at all you know that I am not a person who sees people according to their race. When I heard the Beatles singing "Please Mr. Postman" and the Rolling Stones' version of Willie Dixon's "I Just Want to Make Love to You" in 1964, I realized that I actually liked cover versions of American Soul when performed by [some] white artist[s]. This was big news for me as it opened my mind to this new way of thinking and simultaneously piqued my curiosity about other groups emanating from England.

Mostly through the radio, Leroy was soon exposed to bands like the Animals, Wayne Fontana and the Mindbenders, and Gerry and the Pacemakers.

Whether playing covers or originals, many of the British groups' melodic recordings made it onto the U.S. charts. Londoners the Rolling Stones and the Kinks represented the rawer, R&B sounds radiating from Britain's capital. Poppy Londoners the Dave Clark Five, the next British rock band to appear on *The Ed Sullivan Show* after the Beatles, were also enormously popular on the U.S. charts with hits like "Glad All Over" and "Bits and Pieces."[39] Meanwhile, Newcastle's Animals impressed audiences with their version of the American folk ballad "House of the Rising Sun," which made it to #1. The Zombies, from St. Albans (near London) also charted with "She's Not There." Thus, what the Beatles had started with their first U.S. hit single, "I Want to Hold Your Hand," became a near domination of the American Top Forty charts within a year.[40] As was the case with the Beatles, the bands who flourished in 1964 and 1965 brought a specific style sense with them. Like John, Paul, George, and Ringo, their hair was longer than was currently acceptable in the U.S., and they usually wore matching outfits consisting of suits and ties. Of these groups, only the Kinks evoked a "truly British," (i.e., foppish), stereotype.

The teen-oriented pop music shows that began broadcasting on U.S. television by late 1964 were another means for young Americans to catch glimpses of Mod styles. The Kinks as well as female singers Sandie Shaw or Dusty Springfield soon made appearances. However, *Shindig!* and *Hullabaloo* were not nearly as cutting edge as England's *Ready, Steady, Go!* While the

British show took its cues from London's Mod underground, the American equivalents could not help but be influenced by the glitzy and unapologetically commercial Hollywood environment in which they were produced. Nonetheless, *Shindig!*, originally conceptualized by an Englishman, tried to transmit Mod not only through sounds and fashions, but also via its set design. The sensibility was evident by "liberal use of geometric shapes in backdrops as well as on platforms used by the shows performers."[41]

Like its forerunner, the long-running *American Bandstand, Shindig!* not only showed bands performing (usually lip synching) their current hits, but also featured its youthful participants. This virtual teen clique included a house band called the Shindogs, house dancers named the Shin-Diggers, and an all-girl vocal/back up group called the Blossoms (featuring former Girl Group singer Darlene Love). With an all-male band, a mixed boy-girl dance troupe, and an all-girl singing group, *Shindig!*'s Mod aspirations were thus undercut by normative gender roles. Was this at least partially due to who was producing the program? In American teen magazine *Hit Parader*, one writer suggested that Britain's *Ready, Steady, Go!* was more innovative because "there are lots of young people in charge, but even the older technicians seem more open-minded than their American counterparts. Creative ideas are developed quickly without being bogged down in dreary conferences."[42]

Meanwhile, producers of teen magazines, keen to shore up the commercial potential of this musical and stylistic invasion, published numerous articles about the British influence on teen culture and continued, in over-the-top fashion, to allude to the colonial past. A 1964 *Dig* magazine article exemplified this style of marketing: "Almost two hundred years ago, the British invaded American shores and set about to conquer our struggling young country. Their attempt wasn't much of a success...but England never gives up, and two hundred years later, their never-say-die attitude has finally paid up.... Here's hoping England's battle won makes up for her long ago battle lost. Here's hoping the hits keep coming. Roll on, Britainica [sic] Long may you rave." Similarly themed articles followed even until 1966, and, while the term "British Invasion" was not always used, articles featuring British bands and performers proliferated. Whether subscribing to '*Teen, Tiger Beat,* or *16,* youths were more likely to read about British rather than American acts.[43] This onset of teenage Anglophilia transformed some young people's attitudes about not just themselves, but the world. This is exemplified in the following, written by a reader to '*Teen* magazine's editors. "1964 was a really wonderful year. I was introduced to a new way of life: Beatlemania. Every day was like a new year in itself. The world was uplifted as people began to real-

ize that we teenagers aren't as bad as some think. We care about world af-
fairs—Vietnam, the Cold War...Who says we have one-track minds? Just
last night, after watching *Shindig* and writing Japanese Haiku poetry for
school, I went into my room to read 'The Making of a President...' the ac-
companying music [was] a Rolling Stones album. Can you top that?" Here, a
young fan of British Invasion sounds equated traditional education with a
new kind of "pop cultural" edification.[44]

If Boys Will Be Girls, Will Girls Be Boys?

"All I know is, these English matching boy-girl hairdos turn my tum,"
opined a *Mademoiselle* writer after a fall 1964 assignment in London. With
some exceptions, long hair on males has been primarily coded as rebellious
and/or feminine throughout Western history.[45] Notably, this stylistic change
was a direct reaction to the styles that had been mainstreamed in the previous
decades, where men did indeed, wear their hair shorter—sometimes in mili-
taristic crew cuts—and women usually wore their hair longer. This switch in
the mid-60s implied that men with "long" hair and women with "short"
styles were both doing something that could be seen as culturally threatening
at the time. Soon after Beatlemania hit stateside, the June 1964 *Teen* maga-
zine's cover featured a look-a-like male-female couple with Beatles hairstyles
with a bold caption of "Everything's coming up Beatles!" (fig.12). Inside the
issue, one article's author begged the magazine's mostly female readers that if
they have to "go Beatle," that they should choose a flattering bob haircut.[46]

Beyond these Beatles–related articles, a few stories published in 1964
tried to show more specifically who the British Mods were. *Life* magazine
depicted Mods as a stylish youth gang battling it out with Greaser-type
"Rockers" in towns along the southern, British coast. A U.K. journalist, writ-
ing an exposé on the subculture for *Vogue*, alerted interested readers to a styl-
ish, media-savvy band of teenagers who overturned traditional gender
aesthetics—even those in supposedly foppish England.[47]

During the course of 1965 Mod's meaning expanded from that of the
year before. More than just aligning it to a British phenomenon associated
with the Beatles or U.K. hooligans called "Mods and Rockers," it became
even more allied with trendy and youthful clothing from Britain. As this
transformation of meaning occurred, there were increasing concerns of how
this trend was affecting gender identity. Primarily, the press reflected a grow-
ing distress that this effete, British style was feminizing young American
men while also destabilizing female ("feminine") aesthetics. In a *Look* article
entitled "The Minneapolis Mods," the author explains that the Mod fashions
of London's Carnaby Street had "hit America's theoretically ultraconservative

farmland." As this piece demonstrated, Mod styles were no longer just worn by cosmopolitan, New York teens, but also by youth in the stereotypically behind-the-times Midwest. This journalist also introduced the idea that American parents negatively associated Mod with a "creeping feminization" within teenage culture. The author, however, described this as a "needless worry" and saw Mod's effeminacy as merely "shock value" whereby male teens empowered themselves in the one area they felt they had control: their clothing.[48]

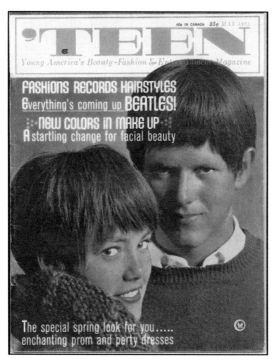

Figure 12. *Teen* magazine, May 1964 (Popular Culture Library, BGSU, Ohio).

A concern over an increasingly "effeminate" generation of males was nonetheless expressed elsewhere. In a recurring *Mademoiselle* piece called "Man Talk," the September 1965 offering boldly suggested that cultural feminization was an insidious form of female revenge. According to the two authors, this supposed societal shift was happening due to women's failure to "gain total entry into the man's world." Because full female participation had been barred, the authors believed women were now "forc[ing] men to worry about things like fashion and dancing...this is a 'woman's world': fashion, fad culture, music, art, pop movements, [and] publications." In this view, women wanted control over men. In contrast to the violent mobs described as bat-

tling it out in Brighton, Mod men were here described as more androgynous, pliable, and, therefore, less threatening.[49]

While this article was unusually severe in its attitudes toward men's fashions and a woman's "place," it was not singular in content. Also featured in *Mademoiselle* that year, the article "Pop Sex: Some Sex Symbols of the Sixties" contained similar sentiments. This piece also linked Mod male fashions to this notion of a "creeping feminization" of American style. Still blaming the Beatles for these changes, the author complained about how difficult it was to differentiate between "the New Young Man and the New Mod Girl," both of whom apparently always sported identical hairstyles and clothes.[50] Another angle on this burgeoning "unisex" phenomenon was provided to me by Pennsylvanian Karen Henry (b. 1952, Shippensburg, PA). Though she did not remember how she came upon the idea (a magazine, she wondered?), Henry and her girlfriends thought it was extremely cool to wear men's cologne. Her scent of choice was Canoe, but she remembered that British Sterling and English Leather were popular with her friends.

But the question remains: Did Mod style really come across as "queer" to American *youth*? A series of three articles published in *'Teen* during 1965 further attempted to plumb this issue by more closely examining a London group of female Mods. The American journalist observing these girls emphasized that, despite appearances to the contrary, both female and male Mods adopted more traditional rather than iconoclastic roles.[51] Here, Mod's "gender play," was really only seen as cosmetic.

Meanwhile, back in the U.S., teenage girls began writing letters to *'Teen* and other similar magazines communicating various levels of comfort (or lack thereof) with Mod's influence on American gender aesthetics. On the positive side, a reader from New Jersey wrote, "We'll take the pompadour and the adorable Beatle cut any day. If you ask me, a boy with a crew cut looks like he's bald." After a vacation to Mod's homeland, one girl even felt, "English males to be infinitely superior to their American counterparts. English boys are much more masculine and also more mature." Not all teenagers, however, were of the same mind. A letter titled by the editors, "Likes Masculine Boys," asked if "We girls should form an organization called 'Let's Stamp Out Short Pants & Shaggy Haired Boys'?" Yet another letter writer chided young men for "becoming carbon copies of the female sex."[52] Despite some jabs at the new male gender aesthetics teen critiques were not normally as harsh as those featured in adult-oriented, mainstream publications. Perhaps this was because, per Naomi Klein's assessment of teen idols, that "showing overt signs of traditional masculinity" (such as hairy chests) was "too scary" for adolescent female audiences.[53] Nonetheless, despite the fact

that teen magazines tended to be more "open-minded"—and to be fair, this was probably just in order to cash in on the latest youth tastes—this did not mean that all articles, images, or even responses from readers were uniformly supportive of such trends.

If the content in newspapers and both mainstream and niche magazines suggested fears that the new Mod boy was sissified, then other stories' authors worried equally as much that Mod style was changing girls from organic and curvy beings to ones made up of geometric angles and near-mechanical limbs. A parallel fear was that she was remaining a little girl rather than growing up. In 1965 both childlike baby-doll dresses worn with buckled Mary Jane shoes and robot-like silver and plastic mini-dresses dominated the pages of various publications.[54]

Already starting a few years before, a "juvenile look" has become trendy in Mod female fashion. By 1965, more articles appeared showing that clothing for girls veered toward this ultra-childish trend. The prepubescent attributes of this style—already obvious—was underscored by advertisements for similar "Mod" dresses for six-to-ten-year-olds.[55] Many teenage girls wanted to continue looking young for as long as possible. They falsely assumed that if they avoided growing up, they never had to grow old. I would argue that much of this reluctance to look "older" had to do with connotations of potential burdens associated with domestic work and motherhood. To those girls who really embraced this Mod style, the very thought of motherhood appeared unfathomable. Motherhood was not fun or cool.[56] The idea of being and looking like a woman would have meant that girls had to exchange playful freedoms for the responsibilties of being mothers and caretakers.

Clearly, the word and idea "woman," scared some female teenagers into "prolonging" adolescence—a space where more options actually existed. Feminist icon Simone de Beauvoir even proposed that girlhood was a more nurturing, freeing, and creative space for females— and one that allowed for more equality between the sexes.[57] When viewed in this light, the seemingly schoolgirl looks of Mary Quant's Mod designs could not have been meant to demean or infantilize women, but rather allowed them to reconnect with the gleeful liberties associated with girlhood.

In comparison to the charcoal grays, off-whites, camels, and brick reds which were often seen in female fashion pre–Jackie Kennedy, the usually bright colors of Mod clothing seemed to evoke juvenility over maturity. The word "girl" itself was freely and positively used even when referring to women in their twenties and thirties.[58] The hip, Quant-outfitted, single *girl* was the direct opposite of the sadsacks that Betty Friedan had described just a few years earlier in *The Feminine Mystique* (1963) who were unable to

imagine their lives past marriage or the age of twenty-one. Hilary Radner has posited that this newfound love for the "girl within" allowed single women in the 60s much more agency despite an "immature" appearance. The girlish persona "present[ed] a utopian fantasy of a woman free from the constraints that appeared to limit her mother."[59]

Parallel to these girlish styles, a strangely "mechanical" or "futuristic" look was also part of mid-60s female fashions. In a May 1965 issue of *Life*, French designer Courrèges, already beloved by the Mod set, was called "Lord of the Space ladies" and "the couturier of space age clothes."[60] Space exploration had clearly fired the imagination of European fashion designers.[61] One female reader felt obliged to respond to Courrèges's unusual style. She wrote that "the mental midget of feminine fashion…is designing under the delusion that he is dressing a Pythagorean Theorem."[62] Courrèges was not the only one "guilty" of wanting to merge the female body with technology. Later that year, the *Life* article "I Was a Teen-Age Computer" discussed computerized predictions of female fashions designed by the Bobby Brooks Company. The fashions touted were described as "a cross section of current preferences…English Mod dresses, smock shapes, pop art, football stripes and jazzy stockings."[63] While this did not imply a computerization of women's bodies themselves, it exemplified the idea that women's fashions were being dictated in an automated manner and not dependent on traditional values of femininity.

Distaste for this "fashion machine" came in the form of angry letters a few weeks later. According to one *Life* reader, "If this mode of dress is going to continue, I am glad I can sew." Another letter from a male teenager opined that this phenomenon should be blamed on a teenage market that demands such quick turnover of fashions: "The teen-ager [sic] (and I am one) is certainly a phenomenon that is wielding a psychotic affliction on our society. Combining [teenager and computer] doesn't help matters much."[64] These letters again suggested that objections to these emerging gender aesthetics were not always limited to adults. No matter whether focusing on young men or women, gender issues remained at the forefront of the Mod discourse throughout 1965.

1966–1967

In May 1966 *Life* featured a cover story about men's Mod fashions. By that July, *Look* also featured a lengthy article about Mod fashions for both men and women called "Mod in America: High Gear… Low Gear."[65] *Life*'s cover story byline read, "Face It! Revolution in Male Clothes" and featured Chicago rather than London teens. In the article, the issue of effeminacy re-

mained a primary concern and dandified styles, such as shirts with ruffles, were shown within the pages of the article. *Look*'s article suggested, "From Maine to California, teen-agers have gone mad for mod." The author correctly correlated the popularity of Mod fashions with that of Rock music. "Credit for the quick catch-on of mod is due to those pied pipers of fashion—the rock-and-roll combos. Their unsquare outfits mesmerized youthful followers as much as their far-out rhythms."[66] Though the author never mentions gender, the photos that accompany the story, depicted a lone teenage girl among many boys. Was this suggesting that Mod was really a male-dominated and homosocial—albeit flamboyantly costumed—subculture after all?

Both these stories on Mod male fashion received plentiful and varied feedback from their readers.[67] This was the first time in either magazine that American responses to the concept of Mod had been so richly documented. Though not all letters contained a negative response, a recurring theme in these letters—seemingly from "the older generation"—reconfirmed how upset people were by the effeminacy they blamed Mod for creating. Responding to *Life*'s article, a woman from Maine wrote, "During my teens...when I walked down the street with my date I was the one with the long hair, high heels, and ruffles." An Atlanta-based *Look* reader wrote that even *traditional* military units may not be of help anymore. "Uncle Sam has some adorable styles that he will furnish for free, with choice of design: Army, Navy, Marine Corps, Air Force, and Coast Guard," he wrote, and then added: "I'm referring to the WAC and WAVE [female] branches of above services, of course." The most severe denouncement of Mod came from a reverend in York, Pennsylvania. He compared Mod fashion to the unwanted and highly taxed tea that the British army forced upon American colonists in 1774: He suggested that this "British import...should be accorded the same treatment as was a load of tea they once sent here."[68] Despite these negative responses, some readers were more positive. "I feel that the public shouldn't be so alarmed and ready to criticize the way boys are dressing and instead should give them credit for this change," wrote a woman from New York. A Pittsburgher said his initially cynical view of the style changed the minute he wore a pair of hip-huggers. "The difference in comfort amazed me. So whoopee for John Stephen and Pierre Cardin—the revolution is here to stay."[69]

Teen magazines continued to be part of this discourse. In the January 1966 issue of *Tiger Beat*, editors asked their readers: "Is It a Boy or a Girl?" which accompanied a photo of boys and girls taken from the back. Many letters about the Beatles and long hair also continued to fill *Tiger Beat*'s

mailbox. Some were even from young men. "A Long Hair" from Scranton, Pennsylvania wrote, "Why is it that some girls don't like long hair on boys? My steady loves my long hair... she often washes and sets it with her hair rollers and clips." Another male reader, advocating for boys wearing earrings (a new trend, he wrote), supported the blurring of gender lines. "Who is to say what belongs to girls or boys exclusively?" the Philadelphian asked.[70] Thus, teen magazines continued to be a venue for young people of both sexes to ponder questions that were mostly analyzed from one perspective by mainstream magazines and their primarily adult audiences.

While Mod fashions for men continued to ignite masculinity debates, the style more easily integrated into the mainstream, female fashion world. Despite some "outrageous" Mod manifestations such as disposable paper dresses and Courregès's spacey, silver clothing, the word Mod was soon used to market rather mundane and less trendy-looking products. In July's issue of *Mademoiselle* the Shapely Classics Company offered a dress called "Carnaby Street" that was ecstatically described as "Madly Mod!" The Stanley Wyllins group ran an advertisement in the magazine's August issues for their Watermill jumper that read, "You think you're smart...you are, in a Watermill jumper! Marvelous and a bit mod-y." Life Stride Shoes also touted their "London Look Suede" which was comprised of "Pantsuited perfection in delicious thick-wale corduroy... picking up more Mod fashion from the bright-striped poor boy, the big-buckled belt, the racing gloves." By November 1966, even a "granny gown" was described as Mod by LeVoy's of Salt Lake City: "Mod in design, the square neck and double-flounced sleeves are beautifully accented with fabulous white Cluny lace." These examples demonstrate that in terms of fashion, Mod was becoming a marketing cliché.[71]

In the case of both the aforementioned *Life* and *Look* articles, and based on the advertisements in *Mademoiselle*, it appeared 1966 was the year that—for better or worse—Mod was more fully incorporated into American popular culture. As discussed in Chapter One, quite a few scholars have believed that once a phenomenon has reached commercial saturation that the trend has officially died—that obsolescence is part and parcel of pop culture. After all, it must have been an affront to Mod enthusiasts to see the Mattel toy company launch their new Barbie doll, Francie—"Barbie's Mod Cousin"—in fall 1966.[72]

As longer hair became more prevalent and "accepted," members of the older generation did not always de facto view it negatively. Instead, some tried to understand the underlying issues that may have been afoot. In a 1967 *Look* magazine article, communication scholar Marshall McLuhan and writer George B. Leonard maintained that though the industrial age divided mas-

culine and feminine, the future required more diffusion of qualities between the sexes. McLuhan and Leonard predicted that the macho John Waynes of the world would be replaced by a new breed of sensitive Paul McCartneys. The authors saw the current style of young men as testament to feminine, rather than masculine, logic. McLuhan's reading of the feminine was bound to sensitivity and receptivity. In analyzing the young, McLuhan read long hair on men as saying, "We are no longer afraid to display what [society] may call feminine. We are willing to reveal that we have feelings, weaknesses, tenderness—that we are human. And, by the way, we just may be ridiculing all of those uptight movie males with cropped hair and unflinching eyes."[73] Indeed, some more nuanced readings of, specifically, male, Mod style were beginning to emerge.

Per McLuhan and Leonard's vision, embracing a supposedly feminine style—namely long hair, but also a dandified style of dress, Mods attempted to broker a different vision of masculinity: one that described them as human first and male second. According to some of McLuhan's theories on modern society, it appeared that an industrialized, capitalist state had ignored man's humanity in exchange for alienated labor, and then, falsely wed the notion of privileged masculinity to this labor. Also, in connecting technology, masculinity, and war, it seemed logical that these über-masculine projects should be questioned. In a 1966 *Mademoiselle* column, a British journalist also connected this questioning to Mod fashion. He described the style as "a kind of oriflamme, a rallying point for the forces of optimism in a world increasingly drab… one day Vietnam, the next Rhodesia; one day troubles at home, the next, a still darker cloud over the rest of the world. But still trousers get tighter, ties dizzier, sideburns bushier."[74] Both these articles suggest that some older men during the mid-60s *were* aware that Mod fashion meant more than what first met the eye.

Nineteen sixty-seven also saw the last big pop cultural import of "Mod" embodied in a tiny model named Twiggy. Growing up in small, western Pennsylvania steel town, Mary Michael Tribone (b. 1953, Burgettstown/Pittsburgh), recollected, "Twiggy and Jean Shrimpton were two of the fashion models that I remember seeing in the magazines a lot… Peggy Moffitt, too. I was skinny so I tried to emulate Twiggy's style." Already famous in the U.K., Twiggy became the leading female face of Mod style in the U.S. that year. Just seventeen, Twiggy had an impossibly thin frame, huge eyes, and a boyish haircut. Twiggy both embodied and parodied certain aspects of what Mod had been understood to be: androgyny, youth, and all things British. Twiggy's extreme looks—especially her large eyes—made her look like a living (Mod) doll. Just as many adolescent boys had mimicked the

Beatles' hair and outfits, scores of young girls wanted "to be" Twiggy. Eliza-
beth Levine remembered, "I was clearly influenced by Twiggy. At age 13, I
weighed a mere 79 pounds! Thin was in!" From a male perspective, Leroy
Fields fondly recalled the petite supermodel and her influence on his female
peers: "Who can forget Twiggy (the first English 'bird' I ever had a crush on)
in one of her brightly striped miniskirts... her slim (most would say skinny,
but not me) legs looking so perfect! The miniskirt was indeed the uniform of
a 'cool chick' back in high school."

Twiggy was literally such a hot commodity among many young Ameri-
cans that a string of Twiggy products ensued. Already a "living doll," Mattel
nonetheless produced a Barbie in her image. Twiggy lunch boxes, tote bags,
and false eyelash sets soon followed.[75] In the one-off special magazine about
her produced in the U.S., called *Twiggy: Her Mod Mod Teen World*, some of
the language used firmly positioned her not only as the new face of Mod
("She's doing for Mod fashions what the Beatles did for the Mod Sound in
music"), but also continued couching Mod within the U.S.'s colonial past
("Twiggy has claimed the colonies for the Crown.")[76] *Life* also ran two arti-
cles on Twiggy during this year. "In the swift-moving teeny-mod-mini-
world of British fashion, Twiggy now strides ahead of the pack," read the
first article entitled "The Arrival of Twiggy." The second article, April's
"Twiggy Makes U.S. Styles Swing Too" presented Twiggy's shape as feeding
into the gender concerns that surrounded Mod starting in 1965. The authors
wrote, "Twiggy, with hair shorter than most boys and eyes bigger than most
girls, and a shape that is no shape at all, is apt to set the cause of female
curves back for year to come."[77] Yet again, American gender norms were
challenged by Mod style, and this time, in the guise of a tiny teenage Lon-
doner.

Responses to Twiggy by *Life* magazine readers were primarily negative
and again pigeonholed Twiggy's style as something offensive from England.
"Send that leggy ironing board back to Britain," suggested one male Colo-
radan. Even more incendiary was this man's letter: "History shows that you
can measure a nation's strength by the principles of its females. Britain and
France, once great, are now noted for nothing much but unkempt hair and
short skirts." While both these letters appeared to be written by older men,
the following complaint was written by a young woman. "Many of my
friends are bringing out their sewing machines because most of these fash-
ions from England are too ugly to even consider wearing," wrote Mary
Staudinger of Minneapolis.[78] Clearly these *Life* readers were desirous of see-
ing Mod return from whence it came.

While these readers were outraged at the way Twiggy continued to "bother" decent Americans with another wave of Mod style, the groundwork of what would become the American "Counterculture" of the late 60s was already being laid. What became known as the "Hippie" look included many young men with much longer hair and an overall more casual—if not downright sloppy—dress style. In hindsight, Mod would seem quaint by comparison. Young Americans began longing less for Mod England and turned their gaze to the emerging scenes in Los Angeles's West Hollywood ("the Sunset Strip") and San Francisco ("Haight Ashbury"). Even the most (arguably) Mod of Mod bands, the Who, only had their first American hit ("Happy Jack") in 1967, and toured the U.S. for the first time that year sporting more psychedelic than Mod fashions.[79] Though the band continued to smash their instruments as they had done in England and the Continent since 1964, they appeared on American stages not in their pop-art "gear," but bedecked in psychedelic, satin, rococo-style outfits more akin to what the Beatles had recently modeled on the cover of their *Sgt. Pepper's Lonely Heartsclub Band* album.

Beyond the Mod 60s

Since Mod did not fully become a household word in U.S. pop culture until 1966, it is interesting that its subsequent dissipation should have happened so quickly. At the beginning of 1967 Mod still appeared attractive as an international youth and pop culture style. However, the truth was that the *height* of Mod had already passed and was soon eclipsed by the psychedelic styles emanating from San Francisco. One magazine article from March, referring mainly to the fashions associated with it, went so far as to ask, "Is Mod Dead?"[80] While the term had come to garner more press attention in the previous year, Mod had become a parody of itself at the start of 1967. Not only was Barbie's "Mod Cousin" Francie in little girls' playrooms, now with an African-American version of the doll available, but the near-cartoonish Twiggy became the "it girl" of Mod's final months as the premier youth style. By mid-1967, after the cancellation of the last remaining music and teen-oriented TV show—*Where the Action Is!*—there were less visual means of seeing Mod performers and their fashions.[81]

Probably the closest approximation to televised Mod culture left on TV was *The Monkees* (NBC, 1966–1968). The Monkees was a musical group put together by TV producers explicitly for the show. Looking every part the "British Invasion" band in the first season—and even with an Englishman in the group—by the show's second season, the Monkees had traded in their tailored, matching outfits for Hippie-ish "ethnic" print clothing and wider-

legged pants. Monkee Mickey Dolenz even stopped straightening his curly hair to look like Mod band members and began wearing a proto-afro instead.[82] Prefabricated or not, the Monkees' stylistic shift on television helped indicate that the heyday of U.S. Mod culture was on the wane. Soon the sleek lines of Mod would be replaced by the casual anti-fashions of the American-born Hippie counterculture. Though the popular sitcoms *I Dream of Jeannie* and *That Girl* would air specifically Mod-themed episodes that year, the truly hip, youth set had now moved on to greater and groovier things.[83]

In 1967 *Look* magazine's parent company Cowles Publishing decided to publish a book called *Youthquake*, which, in some ways, exemplified the switch from Mod to Hippie aesthetics. Based on a full-page advertisement in *Look* that first appeared in May 1967, it seems that this book was to serve as a guide for the older generation in understanding an increasingly "alien" youth culture. The ad displayed the book's cover, which contained a lengthy heading at the top of it. This heading started with the term "What's Happening" and combined many supposedly trendy slang terms. Noticeably, the word "Hippies" appeared toward the beginning of this heading and "Mod" toward the end. This ordering of terms is symbolic of how the year evolved. By mid-1967, American parents were probably more concerned with why young people thought they were "turned on and tuned in" rather than why they listened to the Beatles or wore Mod fashions.[84] The "Summer of Love" in 1967 is said to have started by June.[85] Was Mod still a buzz word by this time, or had "Mod" become so overused that its cachet had completely dwindled? Despite Mod's strong presence in 1966, it was still primarily used to describe British rather than American things. In contrast, the laid-back Hippie was homegrown, a group whose origins historian Arthur Marwick links to the American Beatniks of the 1950s.[86]

This transitional period can be seen as starting during the Summer of Love and continuing with heightened youth activism in response to the Vietnam War.[87] The protests that abounded in 1968 reflected both youth discontent with America's policy in Vietnam and an overall frustration with the government. However, the focus on this later period has diminished the importance of the earlier, *other* "60s." Though Mod had actually set into motion discourse about gender roles in early to mid-60s U.S. culture—both overtly and tacitly—the main way "The 60s" has been historicized by American scholars and journalists alike seems to, for the most part, either downplay or ignore the Mod period. Nonetheless, Mod played a vital part in making the late 60s possible, because, according to one historian, Hippies "took a latent, implicit Mod critique of adult society, maturity, and the life cycle and

politicized it." It was a "shift from attitude to ideology, from posture to provocation."[88] In this way, Mod truly paved the way for greater social changes attributed to the United States of the late 60s.

Thus, Americans young and old mostly came to define Mod through its commercial aspects: the Beatles and the British Invasion, Carnaby Street fashions, and Twiggy. Contrastingly, the whole Hippie phenomenon of the 60s counterculture was a grassroots youth movement developed in the U.S *by* U.S. teens. Looking back, then, the most underground or rebellious aspect of Mod to be adopted in the United States during the 1960s would be that surrounding gender aesthetics. If this was the case, would gender continue to be an important thread in Mod as it returned and continued to evolve in the United States?

The 1970s and 1980s: Mod and Paisley Undergrounds

More similar in its evolution to Germany's than Mod's native Britain, strains of this subculture were noticeably absent in the U.S. until the late 1970s. Unlike the Northern Soul or Skinhead scenes in the U.K., which were direct offshoots of 60s Mod, American music and youth culture of the early to mid-70s emerged more so from the Hippie-era 60s. Bands like Jefferson Airplane and the Grateful Dead, with their free-and-easy California sounds, continued to find fans in the early 1970s. The British-born Glam Rock movement also did not carry as much weight as it did in the U.K. Although former Mod David Bowie's androgynous alien stage persona Ziggy Stardust made waves stateside, as did the flamboyantly dressed Elton John, any kind of "British Invasion" on the scale of 1964 to 1965 was a thing of the past. More so than any of these makeup-laden Brit musicians, many American teens who craved rock theatrics rallied around groups like Detroit's Stooges, whose lead singer Iggy Pop combined certain femme elements of Glam with a harder-edged, traditionally "American" machismo.[89]

U.S. youths would not really revive Mod until the late-70s, when the subculture was couched within a discourse of Punk and a "New Wave" of music from both England and the States. While the U.K. would produce Punk heroes the Sex Pistols and the Clash, the U.S. also had their own cavalcade of underground Punk bands. The New York Dolls and the Ramones (founded in 1971 and 1974, respectively) both existed before the Sex Pistols unleashed Punk on Britain, and sometimes usurp the title of "first Punk bands." The New York Dolls started as a Glam band, and like Bowie and others of his ilk, wore makeup and some women's clothing. The Ramones had a uniform look with matching hairstyles (extra-long, black Prince Valiant cuts) and usually wore matching ensembles of T-shirts, jeans, and

leather jackets. By the late 70s Los Angeles and San Francisco soon had several Punk bands, too, including the Germs (L.A.) and the Dead Kennedys (San Francisco). The former scene was such a phenomenon that filmmaker Penelope Spheeris's first feature-length film, *The Decline of Western Civilization* (1981) attempted to tell the story of the Punk scene which had evolved in southern California.[90]

As was the case in the U.K. and Germany, the American Mod Revival was sparked by the initial screenings of the Who's *Quadrophenia* (1979). For a new generation of Americans, this film was, for many, the first impression of what the initial British subculture of Mod may have looked like. The film also informed those who had missed recognizing Mod culture's underground beginnings the first time around. By the late-70s, the Who—like Led Zeppelin—was performing in massive, sold-out arenas. Thus, the film brought to light the band's Mod origins. As mentioned earlier in this chapter, the American public of the mid-to-late 1960s was only vaguely aware of the Who's Mod roots. Since the American interpretation of Mod was more closely connected to the earlier British Invasion groups and Carnaby Street fashions, the Who's American success was instead due to their performance at Woodstock (1969) and the band's subsequent "rock opera" album *Tommy*.[91]

The *Los Angeles Times'* review of *Quadrophenia* described it as "the British *American Graffiti*"—the 1973 George Lucas film that glorified U.S. youth culture circa 1962. The reviewer's main commentary highlighted that while the American film was a "sunny, nostalgic look at innocence," *Quadrophenia* "threatens to explode at every turn. Given the limited social mobility in Britain, the future promised only more of the same frustration." The *New York Times'* review of the film opined that the teens featured in the film "speak with such thick accents that American audiences may find their conversation indecipherable. For this and other reasons, the film—which was a hit in England—hasn't traveled well." The Who's Roger Daltrey also worried that suburban, car-driving American kids would have a hard time relating to British teens who rode around on vehicles that must have "look[ed] like hairdryers" to them. Despite what these film critics saw as too Anglo-idiosyncratic, the movie did excite some American teens to investigate what this even more British version of the Mod aesthetic was all about.[92] Both of the above reviewers, as well as Daltrey, underestimated the appeal something like Mod would have for American audiences at this time.

One newspaper article from 1982 described a San Diego Mod: "He prefers listening to the Kinks and the Zombies rather than Ted Nugent or Judas Priest and claims he wouldn't be caught dead wearing an AC/DC T-shirt

and faded blue jeans."[93] For American youths of the 80s, Hard Rock and Metal, which had up to this point never been noncommercial, now represented the status quo just as much as conservative "Preppies" or athletic "Jocks."[94] Occasional rereleases of *Quadrophenia* in theaters throughout the 1980s proved popular with teens—even those who identified with Punk. As one L.A. girl attested, the film "was sort of about our lives. Their lives in the film...were kind of, like, Punk." If young people wanted to break away from more accepted teen identities, Mod offered a valid alternative for this new generation.[95]

The relatively early explosion of Punk in California also opened up the possibility for this second wave of Mod to succeed there. Kevin Long, who was in one of the first L.A. Mod bands, the Untouchables, witnessed the birth of this scene and has described it in an online essay. According to his observations, the main venue for the burgeoning Mod scene circa 1980 was the O.N. Klub in the then downtrodden neighborhood of Silverlake. Long describes the activities and interests of those at the club as "an odd amalgamation of sorts, combining the sound and style of 1960's swinging London with the music of original and second-wave Jamaican and English Ska, the danceable grooves of American 60s soul and R&B, while tapping into the DIY spirit and independence of late 70s Punk rock." Additionally, this veteran of the L.A. scene described the young people in attendance as diverse at the city itself. L.A. Mods of the early 1980s were not just white (as media images of 60s Mods have suggested), but African American, Latino, and Asian American.

This inclusiveness extended beyond ethnic minorities, but also to a healthy population of women, and those of varying "socio-economic standing, education [and] sexual orientation... this scene was broader, deeper and more expansive than any other local music scene at the time. What united these otherwise disparate forces was its passion for R&B, Soul, and Ska music."[96] In a newspaper article from 1982, the input of male versus female scene participants was described in this way: "The men are the peacocks in this bunch. The guys own the scooters and clothes, but the girls contribute to new ideas in dance."[97] Even if the focus of the 80s scene was yet again on the boys, it was clear that girls were still in on the action. Though mimicking the British Mod Revival was their goal, this portrait of L.A.'s early-80s Mod scene clearly reflected the diversity of the city and served as a microcosm of idealized American multiculturalism as well as California's reputation as one of the most progressive states in the country.

The Mod Revival played out differently in the States, because while the British enacted a history familiar to them, the way the word "Mod" had

evolved in the U.S. bore little relation to this part of its British origins. Thus, this "Revival" was elemental rather than fully imitative. These Mods were actually creating something altogether new while referencing the old. One big difference, too, was that British Mod Revival bands of the late 70s did not do as well in the U.S. as they did at home. Though the Jam toured the U.S. several times in the early 80s, their following was laughably small as compared to in England. As one newspaper writer reported in 1980, "The British rock trio fell several hundred tickets short of a 3,500-seat sellout," while two years later, the *Los Angeles Times* stated once again that "In their native England, the Jam are monsters," but still remained only marginally well known in the States.[98] If Britain's most successful Mod Revival band had received this kind of reception in the States, then it is more than surprising that even one review of a Secret Affair concert exists at all. In this sole article, the group is primarily used as an excuse to talk about the L.A. Mods in attendance: "Suitable attire for the young men in the movement is literally suit and tie—the thin-lapelled, straightlegged, '60s variety. The ladies opt for miniskirts, Cilla Black bobs and dark eye makeup. Suitable music is British: contemporary groups which would not have been out of place at Liverpool's Cavern Club or London's Marquee in 1964—the Jam, the Lambrettas, and of course, Secret Affair." The American understanding of the "original" Mod period, still couched as it is in the British Invasion narrative, was clearly underscored here, by mentioning Liverpool's Cilla Black and the Cavern Club.[99]

Tandem to these U.K. Revival-inspired activities was another Mod scene that fused British Invasion sounds and sensibilities with American 60s bands who could have been described as psychedelic. Thus, the discussion of "Punks in parkas" that followed the Mod Revival scene in the U.K. was supplemented by the idea of "Punks in paisleys" in the U.S. Though similar bands were emerging on the East Coast such as Pittsburgh's Cynics, New Jersey's Mod Fun, and Rochester's Chesterfield Kings, southern California's so-called "Paisley Underground" was quickly attached to this musical and sartorial style and was the 80s manifestation of Mod which received more media attention than American interpretations of the Mod Revival. Though most of the L.A. bands who were a part of this scene—like the Three O'Clock and the Dream Syndicate—received mainly critical accolades, the all-girl Bangles (formerly the Bangs) would go on to win international commercial favor.[100] Given the attention paid to the Paisley Underground, even retrospectively, Los Angeles (and arguably all of California) remained a key location for Mod culture's post-60s existence in the United States.[101]

The 1980s, in general, was a period nostalgic for the 1960s. Miniskirts were just as popular among fashion designers as they were to newly Mod teenagers who scoured secondhand stores for tossed-out originals.[102] Those Mods today who grew up in the 1970s and 1980s were weaned on syndicated reruns of many TV shows from the 1960s that introduced them to the mass circulated sights and sounds of Mod style. Generally speaking, though, the 1980s was a decade of not just (retooled) miniskirts, but mini-scenes. Groups of Preppies, Jocks, Punks, Goths, Hippies, Rappers, and Metalheads could be found alongside Mods in many cities, suburbs, and towns across the country.[103] Equally "mini" or "micro-mini" were the underground music scenes such as those of the aforementioned Mod Revival and Paisley Underground, as well as, for instance, the one in Athens, Georgia, which spawned many 60s-inspired groups such as the B52s and REM.[104] As was the case with the 1980s Mod scenes in Britain and Germany, fanzines proved invaluable sources of information for this pre-Internet generation of participants.

Though interviews or record reviews covered British bands, a lot of the zines' content focused on the 60s-inspired sounds chiming throughout the underground. One could learn about an all-girl garage band from Portland, Maine called the Brood or catch up with news from the Manhattan Mod scene, for instance.[105] As in the U.K. and Germany, these low-fi media sources were crucial to the American Mod scene of the 1980s. As musician Bart Davenport (b. 1969, San Francisco, fig.13) remembers,

> For the most part, in America in the 1980s you couldn't find ANYTHING remotely Mod looking a store where new clothes were sold. You had to hunt! Nowadays, one only has to go online and mail order brand new Mod clothes designed by Paul Weller himself. We also had to seek out the obscure 60s bands that we slowly found out about through fanzines and rock books. Today, all you have to do is go down to Virgin Megastore and buy the second *Nuggets* box [a compilation box set of songs by British bands of the mid-60s] and you are set. There was no e-mail then either. We found Mods in other cities and countries through a complex web of pen pals whose addresses were made public in xeroxed, little zines… We made mix-tapes for each other. We invented our own dances or rented VHS tapes of *Ready Steady Go!* and copied moves we saw the original Mods doing there.

While this independent network served as a portal to Mod identity, the only truly mainstream, mediated outlet that an emergent Mod may have utilized were the then-newly dubbed "classic rock" or "Oldies" radio stations.[106]

By the mid-to-late 1980s, many of my American narrators sought out, or accidentally happened upon Mod scenes already in progress. Bart Davenport continued, in his correspondence with me, to describe the heady atmosphere of the Bay Area Mod scene at this time:

Figure 13. Bart Davenport, 1988 (courtesy Davenport).

Figure 14. Berkeley Mods, 1988 (courtesy Davenport).

The real heavy Mod years for me and Xan [his friend and bandmate] were '87, '88, '89. At that time, we were in the Birminghams, a rough, garage R&B quintet that played almost exclusively to Mods and 60s scensters at scooter rallies, all-ages gigs and house parties…the late 80s Berkeley Mod scene was INTENSE! We felt like we were the coolest people on planet earth. And maybe we were. Our house parties were out of control and our sense of style was probably the most flamboyant of any American Mods. The girls wore miniskirts and go-go boots and had amazing hair. They all knew about Mary Quant and all that. Some of them even made their own clothes. The guys wore eyeliner, hair spray, tight-as-hell flared trousers and…WHITE BELTS…ages before the emo-indie kids [of the 90s and 00s] appropriated them.

In further describing the scene, Bart discussed the male-female dynamic among the Bay Area Mods (fig. 14). In doing so, he underscored the fact that the Mod scene mimicked the greater hetereonormative culture. Nowhere in my correspondence with Bart did he say that openly gay, bisexual, or lesbian Mods existed—at least at this time. I am not implying here that they never existed, but in Bart's and other narrators' memories, it is a point that rarely comes up.

The social scene of parties and gigs where there were ONLY Mods would ever be there eventually took its toll. There was a lot of incest going on. There was some boyfriend-stealing, girlfriend-stealing, secret blowjobs, hidden cassette recorders taping certain females while having sex…scooters were set on fire by jealous boyfriends etc. etc. etc. Many of us would agree now that the small-town incest of it all eventually became our downfall. That, and let's face it; they weren't all Mods for life. Some of them grew up, got married and had kids. I didn't.

Here, Bart's words suggested that being a "Mod for life," did not fit within the stereotypical matrix of growing up. That is, in order to be a true Mod forever, one would probably not marry and/or have children, because that would surely stifle the ability to truly take part in such a leisure-oriented lifestyle. If you were at home with kids, it would be difficult to also be on the go.

Unlike Mod in 1960s America, in which the culture's rebellious nature was linked to gender aesthetics and an especially strong fear of "creeping feminization," the 1980s incarnation of the subculture, or any media cover-age surrounding it, was noticeably lacking such critique. Perhaps because Mod in the 80s was a shoring up of a now older, and thus, more established youth culture, such moral panic around gender was linked instead to Punk, New Wave, Goth, and Heavy Metal: the more contemporary and, arguably, confrontational, youth culture styles of the time.

Instead, the Mod scene's subversiveness during the 80s laid in the fact that it was an underground that existed parallel with the commercialization of Rock music and youth culture that sometimes even had Mod origins (the

Who, Jimmy Page of Led Zeppelin was in the Yardbirds, David Bowie). That being said, there were some gender issues in this Rock scene that Mods may have been reacting to. The arena Rock stars of the 70s and 80s had spun a severely homosocial web, such that not only was their style sometimes known as "Cock Rock," but their audiences were predominantly made up of male adolescents and grown men. Some would even argue that Hard Rock and Heavy Metal *always already* had been commercial.[107] Thus, for this new generation, embracing Mod sensibilities was getting back to something deemed authentic and inclusive: an identity not connected *solely* to bloated, commercial aspirations and one that allowed more participation for young women as well. One California Mod musician neatly summed up this attitude: "These [arena rock bands] took themselves too seriously; they saw themselves as the object of all the excitement, instead of pointing to the excitement through their music. That's what the British Invasion bands did, and that's why they came off as so sincere, so unpretentious. That's what we're trying to do, too."[108] It was this feeling of excitement through music— enough excitement to choose an underground subculture rather than follow the pack—that allowed Mod to blossom in 1980s America.

The 1990s to 2008: Engendering Mod America

It was a cold, snowy, slushy January evening in Pittsburgh and of the possibilities for an evening out, a crowd of people—both young and not so young—had braved their way to the Rex Theatre to attend a rare Mod night in the Steel City. Unlike many other Mod-themed events I had attended that focused on DJ-spun music from the 1960s, this evening featured live music. A local band named Camera headlined the show, while Charles Wallace, whom you met at the beginning of this chapter, and his New York-based band Headquarters, were the opening act. In between, Wallace showed the *American Mod* film.

The venue was decorated with both Union Jacks and "Old Glory," symbolizing the evening's theme: a joining of British and American sensibilities. A Vespa sat in the lobby of the theater. At one point, two young women posed for pictures atop of it—both modeling dresses from Luxx—a now-defunct boutique which was one of the few in town to sell contemporary, locally designed Mod outfits. Similar to my other excursions into Pittsburgh's nightlife, I noticed most of those in attendance were just wearing what they normally would, i.e., not necessarily dressed up or wearing Mod styles. This made the few exceptions stand out. A college student named Corey with a dark brown mop-top wore a sharp, gray suit jacket, a black

shirt, and skinny, striped tie. His girlfriend Cindy sported a black bob and wore a black mini dress with white accents (fig. 15).

Figure 15. Corey Wittig and Cindy Yogmas (Photo by author).

Most people arrived in couples. This seemed a very straight scene. A few other women in attendance wore 60s-style dresses, but their hairstyles and accessories did not match that look. More common, among the crowd, though, were fellows with trendily disheveled hair wearing rock T-shirts (someone had a Who T-shirt on) and jeans. It made those dressed Mod stand out even more. Pittsburgh circa 2004 was apparently not quite used to such fancy sartorial sights. While enjoying this scene, I noticed amused looks on the faces of some of the plainly dressed guests. Did those dressed Mod— mostly in couples—appear to them incredibly fashionable or *old-fashioned*? To gain some kind of understanding, it was helpful to look at what led up to the point where Mod in the U.S.—both in terms of fashion and gender— could have been potentially seen as either conventional or, as Charles Wallace mentioned in the opening of this chapter, confrontational.

If one were to read Mod culture as conventional, it may have to do with the fact that unlike other more recent subcultures, such as those of the Punks, Goths, or Ravers, for instance, a gay presence is rare. Considering that it has become relatively more acceptable for Americans to come out as gay, lesbian, or bisexual since the 1990s—certainly more so than in the 1960s—twenty-first-century Mod culture, given its past associations with gender and sexuality, is surprisingly unreflective of these social changes.[109] The scene at this particular Pittsburgh event continued to be more heterosexual, with many girlfriend-boyfriend or wife-husband couples in attendance. With some exceptions, this is usually the case. Based on my narrators' comments, as well as from my own observations, I contend that Mod events attract straight couples, or those looking to date someone of the opposite sex. In this sense, there is nothing very radical about current Mod culture.

Chicago Mod Eric Reidelberger (a.k.a "Eric Colin," b. 1970) told me, "I think a fair majority of people in the Mod scene are straight… at least that's my experience," adding that it was "probably because a person can only handle one subculture at a time." In saying this, Eric alluded to the difference between being a part of a definitive gay subculture versus one that may or may not be (but probably is) mostly heterosexual. Alex Baker concurred: "Most Mod scenes are overwhelmingly straight. My impression is that it always has been. In Berkeley in the 80s there were no gays in our scene. In S.F. during the height of 90s Britpop/Mod/Lounge/Mocker chic clubs there were more gays around. They tended to cultivate flamboyant 'Z Man' [a character from the 1970 film *Beyond the Valley of the Dolls*] type personas. In the L.A. Mod scene currently there are a few of them on the fringe as well, but the major players are all pretty much straight lads trying to pull the birds and vice versa."

Interestingly, in terms of gender aesthetics, Pittsburgh DJ Justin "Juddy" Hopper (b. 1972) related to me that several of the super-stylish Mod girls at his "Viper Soul Lounge" events are lesbians. Apparently they sport the more girlish, rather than tomboyish, Mod style. This fits with another observation of Alex Baker's—that "the Mod look on girls is such a cornerstone of what we think of as high fashion now," so these women could not be read as butch in the least. Baker's view is supported by the issues of *W*, *Vogue*, and *Allure* magazines, which, in 2003, featured Mod photo essays promoting this "latest hot look" back from the past. As an exception to the rule, a 2008 *New York Times Style Magazine* recently devoted a fashion spread to Hard Mod/Skinhead-style clothing for men.[110] In this sense, the presence of Mods wearing suits and their girlfriends or wives wearing vintage dresses, is not so much conservative, as it is distinctly nonqueer. Perhaps after over thirty years

of establishing the aesthetics of a gay and lesbian culture—with its own sty-
listic markers—it has become difficult, if not impossible—to make the argu-
ments that were made in the mid-60s about Mod's androgynous nature.
Compared to subcultural styles that emerged later, Mod was, by this period,
not "winning awards" for flamboyance or queerness. The trendy, early 00s
term "Metrosexual," described men who were fashion and style-conscious.
Much like Mods past and present, this group was "just gay enough" in their
grooming habits. Even though times had changed, too much interest in one's
appearance was still somehow linked to gay male culture. Nonetheless, this
moniker played upon the fact that this new, urban male was still indisputably
heterosexual.[111]

If Mod was seen as controversial, it was only in contrast to other youth
subculture styles from the 1990s onward. Nineties youth had, in many re-
spects, reached the apex of an androgynous look. However, the way it played
out had little to do with a feminization of American culture that mid-60s
fear mongers had prophesized. If anything, the casual and bland nature of
most mainstream, youth fashions had nothing either extremely feminine or
masculine about it. It *was* unisex. Ushering in the final decade of the last
century and millennium, ripped jeans—or extremely baggy ones that revealed
intimate apparel beneath—T-shirts, chunky-heeled shoes and work-style
boots, and khaki-colored clothing became the preferred fashion for young
adults. It was also not uncommon to walk across a college campus and see
students of both sexes wearing athletic garb as day wear—a trend that had
continued from the late 1980s. Given this backdrop, it has become more ap-
parent why wearing a crisp, Continental-looking suit or an ultra-girlish pop
art dress could challenge the status quo.[112]

Accompanying these 1990s fashions were the thrashing power chords of
Seattle-born "Grunge," which became a major commercial trend in 1991
with the chart success of the band Nirvana. For most youths of color, as well
an increasingly ardent white posse of fans, the aural collages of black Amer-
ica that made up Hip Hop supplied the other prominent sounds of the dec-
ade.[113] Clearly, it could be argued that this casual, unisex style *is* what
differentiated the 1990s from previous decades. However, it also mirrored
the notion that perhaps young people who came of age at this time lacked a
distinctive and attractive youth culture style to rally around. Those dissatis-
fied with this mainstream, as in the decade before, continued splintering off
into various subcultures like those of Punk, Mod, Goth, Skinhead, or Hip
Hop to find a community that, to them, offered that "little something extra."
This seemingly lackluster generation of youth was not just guilty of boring or

derivative fashions, but was also accused of being somewhat identity-less in general.[114]

Mods of the 90s and the 00s tended to believe, not unlike their contemporaries in the U.K. and Germany that their lifestyle, while drawing from the Mod era of the 60s was very much of the present. If they looked back to this "other 60s," it was a period of style and savoir faire that remained somehow coolly detached from what the baby boomers would become by the late 60s and beyond. Though it is likely that many American Mods of the 1960s became Hippies later on, this was not a point that latter-day Mods tended to focus on. For the culture's more contemporary adherents, Mod youth were seemingly frozen in time and often, through media images—whether in films, on album sleeves and CD covers, on TV, or on the Internet—had become role models.[115]

As far as Mod female style was concerned, the legacy of Mary Quant's enthusiastically girly pop designs remained alive and well. Just as Quant nostalgically attached her designs to the past freedoms of girlhood, such fashions offered a similar comfort to Mod women of the 90s and 00s.[116] The Minneapolis-based designer Jessika Madison, drawn to the ideals of Mod fashions, created remakes of famous 60s dress styles often made with dead stock materials from that decade. She started her business, Dada Die Brucke in the late 1990s because "original items of 60's clothing are scarcer to find and are increasingly in a sorry condition."[117] Her website advertised "Style A-Go-Go for Young Moderns" and became a vital outlet for female Mods to purchase authentically girlish-looking, 60s-style dresses. In 2007 designer and 60s culture afficianado Lisa Perry launched an upscale line of Mod-inspired clothing for clients who are mostly not Mods, but simply appreciate mid-60s style.[118]

For Francing Edralin (b. 1975, Sacramento) however, her Mod style owed more to male peers: "From very early on, in my experiences in the Mod scene, my fashion idols were always the men around me. I basically copied their style because it was so smart, yet a bit flashy... specifically the 1965 Mod look. Looking up to the stereotypical Mod-girl idols was quite foreign to me. I was never into Twiggy. If I was into any girl, it was the ever-so-smart Mary Quant, and that was it." Francing's interest in Mod, male style echoed back to some of the "gender-bending" aesthetics of the subculture's original 60s era.

Some male Mods I interviewed in the 2000s saw Mod style as more typically masculine than effeminate. According to Alex Baker, Mod "always seemed to have a slightly macho cool element to it. At first it was because of spy shows like *Man from Uncle*, *I Spy*, and *The Prisoner*: tough secret agents

shooting and kicking ass, while wearing very Mod outfits." Justin Hopper (Pittsburgh, b. 1972, fig. 16), who came to Mod through the second Ska revival of the early 1990s, also told me he recognized some Alpha-male aspects of dressing Mod:

> This girl I was dating sort of started dating a guy I was really good friends with. This is 1990, 1991, or something, and, I remember distinctly I was going to a party where I knew he would be, and I…and this never ended up happening… but I remember having just seen *Quadrophenia* for the first or second time, which I can't even count the times I've seen it now, but, I remember getting dressed thinking…putting on jeans and Clarks and a Ben Sherman and a suit jacket thinking, 'Well, I'm gonna have to beat the fuck out of this guy and I'm gonna wear a suit while I do it.' [Laughs] And it was somehow important to me… the idea that I wasn't gonna just be some dickhead beating some guy up because of my girlfriend—who wasn't—you know, you're 19 years old and you don't know what the fuck's going on, but… I felt empowered by the idea of doing it while, sort of, looking good, you know? I thought there was something really tough about being a skinny little kid in a suit when no one else was wearing a suit.

Figure 16. Justin Hopper, early 1990s (courtesy Hopper).

With a different socio-historical context in which to explore Mod style, Alex and Justin were able to recognize more bravado aspects to Mod masculinity, those which had been mostly ignored in 60s.

This also has come through in a certain comic book artist's work—wherein Mod femininity has also been reconceptualized. Though Chynna Clugston-Major's comic series *Blue Monday* (2000–2001) and *Scooter Girl* (2004) have depicted Mod males as Vespa-riding machos—despite their dandified clothes—the comics' female heroines perpetually seek to overthrow Mod's supposedly homosocial order. Clugston-Major's stories follow a group of high school students who listen to Blur, the Jam, and the Kinks—a fact that instantly signifies Mod style in its 90s, 70s, and 60s musical incarnations.[119]

Set in the early 90s, Clugston-Major's characters, especially her *Blue Monday* female protagonist Bleu L. Finnegan, are unexpectedly wise to 60s Mod culture. Bleu runs around in miniskirts and target emblem T-shirts, while the boys who torment Bleu and her friends at school are parka-wearing thugs who ride scooters. Bleu fantasizes about pop stars, which is not unusual for a teenage girl, but the cartoonist makes sure they are mostly retro-stars. A cartoon version of the Jam's Paul Weller makes his first appearance on the first page, with Bleu eventually shouting out to the 90s world, "Where's that handsome Mod dream on a Lambretta?"[120] Though the Mod boys at school continue to pester her and her butch and Punk best friend Clover through pranks, the girls often get back at them, coming out on top.

Unlike *Blue Monday*, where Mod symbols and characters are peppered throughout, Clugston-Major's *Scooter Girl* takes place in a contemporary Mod scene. Protagonist Margaret Sheldon, who of course wears her hair in a bob, is "scooter girl," the cool, Mod chick whose nemesis is Ashton Archer. At the start of the comic Ashton has it all: good looks, fabulously sharp clothes, a hip DJ-ing gig, and a bevy of girls whom he woos and discards. He is caricaturized as a womanizing, arrogant Mod who is too attractive for his own good. However, things change when he sees Margaret on her scooter for the first time and becomes instantly smitten with her. "This girl on a silver special… her eyes seemed to burn through me, and sure enough I felt like lightning had hit my spine with a vengeance. It was simultaneously exhilarating and creepy, somehow, and I knew right then that I had to talk to her."[121] As the story progresses, Margaret's Mod coolness and disinterest in Ashton seemingly zaps him of his "powers" and he begins to hate her. They end up getting into a Mod-style battles of the sexes, as a "competition of cool" ensues, that Ashton eventually loses—though the story does conclude with

them as a couple. Though male and female roles are shaken up within the plot, the story's "happy ending" is nothing if not traditional.

The gender issues of Mod from the 1960s to the present are woven from a complex combination of threads. The cultural history of American gender aesthetics since the late nineteenth century helped create a society in which the original reception of Mod style disturbed middle-class visions of masculinity and femininity. By the 1980s, but especially in the 1990s and beyond, this no longer has been the case. As Chicagoan Eric Reidelsberger explained, "I would imagine in some circles in the 60s [Mod] was looked upon like that but it's never struck me as extremely androgynous, the women always looked like women and the men always looked like men." Instead, these later Mods have looked to the original mid-60s style for an ethos that has promoted the possibility of a society with a different look to it: one in which experimentation with appearance could potentially mean more experimentation on other social fronts.

The British novelist L.P. Hartley once wrote, "The past is foreign country." For Mods, then, living at least part time as "expatriates" is an extremely attractive lifestyle option. As a Pittsburgh fashion writer recently stated, "In the tiresome world of 21st century hipsterdom, the past—irresistibly authentic in comparison to the banal present—is regularly raided for ironic incorporation into our daily wardrobes."[122] I would argue, though, that in the Mods' case, it has not become necessarily ironic. The fashions, instead, have become a portal to lauded images of a preferred youth culture.

However, it is important to remember that Mod also happened the first time in conjunction with the postwar generation and prior to the escalation in Vietnam and the consequences of this war. In 1968 youths went "wild in the streets" because of social injustices while in 1964 teenagers reveled because of perceived social progress. If the late 60s was the less optimistic part of the decade, then the era in which Mod culture blossomed in the U.S. also gave young men and women a glimpse of innovation, newness, and—just maybe—new opportunities for self-expression. As Donna Gaines has said, "The Mod scene has an upbeat tempo about it. It gives people a sense of forward motion while having roots in the past, a simpler time." It was and is upbeat and *fun*: both for men and women.

Walking into a Mod club circa 2009, you would have probably seen male *and* female DJs spinning vinyl. Mod girls would have been found atop scooters zipping through city streets with the guys. If bands played at Mod events most of them would be all-male, but with some notable exceptions. The scene had become more "straight" than "queer," but adherents still stepped outside the norm through their unswerving love of Mod style. Some things

may have changed, but some things have not. If you had entered L.A.'s Club Satisfaction in the mid 00s you would have likely seen "doe-eyed girls in polyester A-line dresses and bobbed hair shimmy[ing] and shak[ing] along-side boys in three-button suits and Beatle boots."[123] By this time, the styles remained while the "gender trouble" had passed.

Japan's "Cult of Mod"

"I love the retro-future atmosphere of plastic."

—Female Mod quoted in *Girls 60s* magazine, 2004[1]

The inexpensive and uncomfortable bus journey from Tokyo to Kyoto took all night. My travel companion, photographer Corey LeChat, and I awoke as the coach rounded a city corner. We decided we must already be in Kyoto. Gazing out the window, our eyes were met with a sight we probably expected to see—a grand temple—whose grounds seemed to go on and on for many blocks. After two weeks staying in the neon-saturated Shinjuku district of Tokyo—seeing more malls, shops, and fast food restaurants than shrines or temples—this vision was a welcome one. Minutes later, the coach pulled in and parked in front of the train station. This glimpse of the temple—of what I thought of as a more traditional view of Japan—quickly disappeared. I was now curious if this juxtaposition between old and new Japan would be more obvious in the coming days?[2] As we disembarked from the bus, the ultra-modern Kyoto central train station stood monolithically before us. Despite our tiredness, Corey and I decided to look around the station prior to taking a taxi to our hotel. As we stepped inside, we saw on either side of us stair-cases and escalators that seemingly ascended into the heavens. They went so high, it was nearly impossible to see where they stopped. We would later read in our guide book that this "sweeping steel-and-glass structure whose sheer size boggles the mind" was designed by Hiroshi Hara who won a na-tional competition for it.[3] Exploring Kyōto Eki further, we saw one part of the station had a multimedia exhibit devoted to Japan's original king of *anime* (animation) Osamu Tezuka.[4] Looking up, over, and around, endless streams of shops and restaurants that dotted each level of the station-cum-mall, the overall feeling of the place exuded was one of light, endless space, and, in my mind, at least, "the future." In this respect, the station was noth-ing short of Mod.

In the moments that had passed between our initial arrival into Kyoto and our walk though the train station, we had witnessed the juxtaposition of tradition and innovation that has become increasingly typical of the city-scapes of Japan since the postwar period. As mentioned in Chapter One, if British and European designers of the Mod 60s vividly imagined and tried to incorporate conceptions of the ultramodern or futuristic into the contempo-

rary, it was, in many ways, a reaction to the depressing shades of the war years not long behind them. Here, in Kyoto, one of the only Japanese cities to be spared bombing during World War II, the near-futurism of Kyoto's train terminus was mere blocks away from the Higashi Hongan-Ji, a seventeenth-century Buddhist temple that draws one into Kyoto's past. It was at this temple, just a few days into our stay, that I saw the following quote (translated into English) posted on one of the temple's inner walls: "The future comes when it is an extension of the present. The future will not come when we disconnect ourselves from the present." The British conception of Mod was to reconceive modernity in the present despite the aspects of Victorian modernity that remained—miniskirts versus bowler hats, so to speak. Japan may just have proved the most Mod of countries in this manner, especially in the new millennium.

Every May for the last twenty-five years Japanese Mods from Sapporo to Nagasaki have gathered in Tokyo for the annual "Mods Mayday" scooter run—speeding by structures of the city's past and present. Riding Vespas or Lambrettas, mop-topped men and miniskirted women reenact an originally British event of 1960s vintage. In response to photos documenting this event on the Uppers Organization website, a site user identified only as Benji G. commented, "Keeping up with the definition of modernism, I believe Japan is now one of the leaders....As of right now there is no country so cutting edge in art and contempo [sic] culture than Japan. We as an enduring mod subculture, and especially the youth, like me, have to evolve along with the times and the changing contempo, and that is becoming Japan."[5] If, as we have seen, Mod is tied to the contemporary as well as the mid-60s period, it is also connected to the futuristic visions promised by modernist design. More so than elsewhere, the digitally fast pace of Japanese cities and the mass of neon that illuminates them seem to fulfill this promise.[6]

Akin to latter-day Mods in Britain, Germany, and the United States, Japanese enthusiasts have recreated this mid-60s style with both local and contemporary inflections. In the words of a 1964 *Life* magazine article describing Japan's past use of Western imports, it was "as if by magic, the foreign seed bore characteristically Japanese flowers."[7] In recurrent phases since 1964, Mod style has been translated into Japanese. In the myriad of youth culture fads to be embraced, discarded, and recycled by Japan's youth since the postwar period, Mod still appears in many ways as fresh and innovative as when it first blossomed internationally during the mid-60s.[8] The first chapter of this book explored Mod culture's relationship to modernity and class in Britain, while the last two chapters have examined Germany and the United States' adoption and adaptation of Mod as related to specific cultural

issues in those countries. In both the cases of Germany and the U.S., however, this youth culture was interpreted by other Western cultures, which, historically, already had much more contact with the U.K. and, thus, more familiarity with British culture.

When I first told people that I was going to study Mod in Japan, a typical response was, "Oh, the Japanese really get into their subcultures 150% percent, don't they?" Having already looked at books like *Fruits*, which consists of a photographic essay of young people in Tokyo's Harajuku neighborhood sporting their current favorite fashions, I tended to agree with this statement even before stepping onto Japanese soil. As another Western observer of Japanese Mods has stated, they are "very different, quite extreme and eccentric." It seemed to me that Japanese Mods would strive fervently for the most perceived authenticity possible—even trying to out-Mod the British themselves. This idea reminded me of a scene in the 2003 film *Lost in Translation*, where the Japanese director of a *Santory* whiskey commercial asks American actor Bob Harris (played by Bill Murray) to talk about the product with "more intensity."[9] Indeed, since Japan's emergence as the most "Western" of Asian nations since the postwar period, the country has excelled in almost every aspect of socioeconomic endeavor it has taken on. And, as in the past, this intensity and drive has shone through a fusion of global and local ideas.[10]

Japanese Hybridity

During the early part of the Edo period (1603–1868), starting in 1638, the government chose to isolate itself from Europeans. Because this had come, at least in part, from anti-Catholic sentiments (Catholic missionaries sought to convert the Japanese en masse), the only contact with Westerners for over two hundred years was with Protestant Dutch traders. It was not until after trade treaties were signed with many Western countries in 1858 that more cultural exchange took place between the Japanese East and European (and now North American) West. Nonetheless, even prior to the 1853 appearance of American Commodore Matthew Perry's so-called "black ships" in Edo (now Tokyo) Bay and the Meiji Restoration of 1868, which renewed contact to more of the outside world, some European goods had been available to Japanese via the Dutch. While imports like woolen textiles or more "far out" technologies like clocks and microscopes became tangible ways to conceive of the West, they were also embraced with the little contextual knowledge about the places from whence they came or the people who produced them.[11]

However, Japan already had a long-standing practice of appropriating and incorporating foreign traits, symbols, and ideas—many of them from

China—into their country's way of life.[12] The prime example of this was Japan's sixth-century adoption of Chinese ideographs for constructing their own written language, which is phonetically foreign to the original. After Japan opened itself to the world, other imports, such as the "American pastime" of baseball (*yakyū*), which was first played there in 1872, also became a favorite leisure activity in Japan. The Japanese version of this "U.S." sport is said to reflect a nationally-defined, group-oriented mentality. As one author puts it, players are expected to "'follow the rule of sameness… 'recognize and respect the team pecking order'; and, finally, must strive for *wa*—'team harmony and unity,'" rather than individual members trying to win the game by any means possible.[13] In a big-picture sense, Japan's translation of Mod culture from the 1960s forward is not only contextualized within a national tradition of mimesis and hybridity par excellence, but as we shall see, is mirrored in the collectivist, group dynamics of the Mods there as well.[14]

Since Mod has itself been a hybrid culture from the very beginning—mixing American, Caribbean, and British music, French, Italian, and British fashions, and Italian and Scandinavian design—I suggest this is a doubly fitting subculture for those Japanese who have chosen to identify with it. In terms of examining Mod culture's historical and geographical trajectory, it only seems appropriate, then, that this study of the "Mod Diaspora" ends in Japan.

In the following pages we will look first at how Mod came to Japan in the postwar period. Further, this chapter examines how contemporary Mod culture has continued working as an agent of modernity, cosmopolitanism, and gender identity within a country whose culture has been greatly influenced by the creative implementation of foreign ideas. Here, special focus will be placed on how these three concepts have been incorporated visually into the Japanese Mod scenes from the 1960s to the present, as symbolic language has been the most easily translatable into this non-Western culture. In the case of Japan, I have looked at Mod's adoption and, to quote John Fiske, the translation of its "semiotic power" through fashion, accessories, community events, and mediated artifacts.[15] When asked why he thought Mod had become such a transnational phenomenon, a contemporary Mod from Canada replied, "It's the graphic language and music that appeals visually and socially to most people. It is a very aesthetic thing… people come to me for mod hairstyles who can't even speak English."[16] Although the barriers of spoken and written language have often kept Westerners and Japanese apart, it appears Mod's unique dialect has united young people through fashion, design, and musical style for over forty years.[17]

After the Bomb

Sitting on the front steps outside the Rosa Fiesta Casa Grande club in Roppongi, Tokyo, prior to the "French Blue" Mod event in June 2004, I struck up a conversation with a man in his twenties. We were waiting for the club's doors to open and the rest of the Mods to arrive from their scooter run from Shibuya. When I asked him if he was from Tokyo, he said, "No, Hiroshima. Americans have heard of this city?" I could not quite read the expression on his face, but the moment was uncomfortable. I quickly said, "Of course." Though my response seemed lacking, I was not really sure what to say.

It is impossible to talk about Japan in the postwar period without talking about Hiroshima or Nagasaki. The August 1945 atomic bombings may have launched the world into the stark realities of the "Nuclear Age," but they affected the Japanese in ways that no other nation's citizens could begin to understand. The explosions above Hiroshima and Nagasaki, which literally vaporized human beings, were not just the culmination of a lost war, but events that had a profound psychological impact on the Japanese. As one scholar describes it, the aftermath of the war hit many Japanese (especially the younger generation) with a sense of meaninglessness. The loss of World War II "discredited the institutions and values for which millions of Japanese had just given their lives, in particular, the emperor system, its institutional expressions, and the philosophical and mythological systems of thought that informed it. Henceforth, what should the Japanese live and die for? It was a question not easily answered."[18] The fact that atomic weapons were used on Japan continues to raise questions. Primarily, several historians have argued that Americans' racism toward the Japanese during the war was so intense that it impacted the decision to use atomic weapons on Japan. The country's wartime activities were, in many respects, quite similar to those of the Germans, especially with their annexation and brutal subjugation of neighboring lands and people. Nonetheless, the German enemy was not demonized by Americans because of their race as the Japanese were. The Germans were called many things, but they were not called "back-stabbing monkeys" or "vermin in need of extinction." Some propaganda even questioned if "the barbaric Japanese were... members of the same species as the rest of the world's people." Given this backdrop of accelerated, World War II–era racism, the postwar relationship between U.S. occupiers and the Japanese occupied was ostensibly a harder emotional bridge for those in Japan to cross than for the Germans.[19]

This underlying tension could be seen in the youth of the immediate postwar years. Unlike German postwar youths, many younger Japanese felt more ambivalence than cynicism about what had happened. They were confused, and depending on whom they hung out with or what they read, their sociopolitical views continued to span from left to right. Had not the beloved emperor—a true living god—sanctioned this war? Was their nation and all it stood for not worth fighting for? And, most importantly, why had the Japanese paid such a dear price for their efforts? A fog of confusion descended over the land and its people for several years.[20]

Rebuilding Urban Japan: 1946–1964

As the only country to be attacked by nuclear weapons, and only one of a few nations subject to Allied carpet and fire bombs, Japan had truly suffered huge losses by the end of World War II. Cities large and small were in ruins. Indeed, much of urban Japan had simply disintegrated into rubble and ash and many people were starving or on the brink of starvation. Although Americans were behind the horrific bombings of Japan during the war, they were also equally responsible for helping rebuild the country afterward during an occupation starting in 1946 and lasting until 1952. With the Supreme Commander of Allied Powers (SCAP), American General Douglas McArthur at the helm, the ultimate goal of the Allies was, of course, to democratize a recently fascist country and dissuade movement toward communism.[21] Just as had been the case in Germany, the presence of the U.S. forces had piqued the curiosity, if nothing else, of the occupied Japanese.

By the mid-1950s, a few years after the occupation had ended, more recognizable facets of Anglo-American popular culture filtered into Japan. Initially, as in the U.K. and Germany, Jazz became *the* hot music genre in Japan immediately after the war. Also, as elsewhere, this was not entirely new, but a return to the youth culture trends of 1920s modernity. It was in this earlier decade that *moga* and *mobo*—"modern girls and boys"—initially adopted Jazz as a new, hip music. After the defeat of Imperial Japan, internationally minded young men and women once again gravitated to it as they had in the 1920s. As one scholar describes it, Jazz clubs were "marked sites for Japanese cosmopolitans to experience the nation's emergent modernity."[22] However much Jazz remained an important music genre in Japan, things were soon to be shaken up.

It was only a matter of time before American Rock and Roll also became a huge hit with Japanese youth. By the mid-50s *rockabiri* (i.e., Rockabilly) bands and the "Japanese Elvis Presley," Kazuya Kosaka who even covered "Heartbreak Hotel" in 1956, emerged as the premier musical style for young

people. Another *rockabiri idoru* ("idol"), an Anglo-Japanese named Mickey Curtis, soon appeared on the scene. The year 1959 would also see the arrival of Japan's first music-oriented youth TV show, *The Hit Parade* (hosted by Curtis) featuring both Japanese rockers *and* docile pop crooners and singing actors. Soon, similar shows like *Spark Show, Hoi Hoi Music School,* and *Yume de Aimasho* (*Let's Meet in Our Dreams*) followed. Though these performers were initially seen as simply imitative of Western stars, some "Japanized" what they were doing. For instance, performer Masaaki Hirao took traditional folk songs and transformed them, giving them a Rock and Roll sound. Similar to in the newly established West Germany, this wave of popular culture came to Japan amid increasing prosperity fostered by U.S. aid. The country was experiencing its own "economic miracle."[23]

Despite the rebuilding of urban Japan from the immediate postwar years onward, greater transformations, both topographical and cultural, began in the following decade. It was during the 60s that Japanese migration from countryside to city peaked. As *Life* magazine editor-in-chief noted in 1964, "Since the end of the War, which left her devastated, Japan has grown faster than any other country in the world and is to be congratulated for working so hard and well. Her growth rate—within a capitalist framework—has been nearly 10 percent since 1954… roughly three times that of the U.S."[24] From this point onward, the modernization that had begun prior to Japan's militarization in the 30s and 40s, put the country en route to the hyper-consumer-conscious society it was to become toward the end of the twentieth century.

While the initial Western influence in postwar Japan came from the United States, it should be noted that the fascist Japanese had previously lumped the U.S. and the U.K. together in their disdain for "Anglo-American liberalism."[25] Further, Japan and Great Britain shared some things in common. On a very superficial level, one might paint them both as island nations with a penchant for drinking tea and driving on the "wrong side of the road." On a more serious level, though Britain and Japan had fought on different sides, both of these countries awoke to find their imperial might crushed at the end of the war. Japan lost Manchuria and Korea, while the U.K. lost a good portion of the planet. Just as British young people during the 1950s sought to design a new "empire of cool" in the aftermath of World War II, so did the Japanese. Prior to Mod's arrival, a proto-Mod, beatnik-ish type subculture called *Raritteru* looked to almost literally "sleep away" the disappointments of postwar life. Unlike the Mods' use of amphetamines to boost their jubilant, night-long festivities, this group of Modern Jazz lovers were "intoxicated by sleeping pills," and took them "to drowse through life, with-

drawing into nothingness"—seemingly the desired place through which to "enjoy" life.[26]

Although Britain had not suffered nuclear nightmare, it also found its cityscapes, where Mod culture would develop, in ruins. For the postwar generation, Mod's celebration of youth and a playful attitude toward consumer culture was refreshing. More importantly, its forward-looking attitude was desperately desired, not just by Britons, but also by youth around the world. Mary Quant later toasted Mods for being a "superbly international" group of young people who decried dangerous pre–World War II notions of nationalism, ethnocentrism, and xenophobia.[27] After all, these same values, whether culturally traditional or not, were those that had led to war. While Quant described Mod as facilitating camaraderie among youth in the Western world, Asian youth were also quickly attracted to this new style, what a *Look* magazine article about this region would by 1967 describe as "the cult of Mod."[28]

Even some British Mods became aware that their style of youth culture had reached Japan. As early as November 1964, the editorial page of the *Mod's Monthly* read in boldface, "Mod Scene Booming—From England to Japan," and further remarked, "We are shortly setting up centers all over the world to distribute Mod books."[29] Unlike the United States, Mod's initial impact in Japan was not directly linked to the arrival of the Beatles. Although the Beatles were introduced to Japanese youth via records and other affiliated media products, the Beatles themselves did not tour Japan until 1966. Clearly, some Mod activity was brewing prior to the Beatles' 1966 Asian tour.

Nineteen sixty-four was also a fundamentally important year for Tokyo—and by extension—Japan. By hosting the Olympics that year, there was a great push to finally revamp neighborhoods that were still in rough shape from the war. This rejuvenating project also extended nationwide, especially in the implementation of new expressways. Everything was to look spectacular and, of course, highly up to date. One Japanese chronicler of the 1960s explains it this way, "It was like being able to engineer a 'future city' from old science fiction movies one right after another… [In this way] the 60s might just be the most beautiful period in the twentieth century for cities [because of] modern design."[30] This concept of remaking urban Japan with "science fiction" in mind was taken a step further by the Metabolists—an avant-garde architectural group that came together in 1959.

To understand the importance of the Metabolists' visions, it is necessary to reflect back on merry Mod England circa 1964. The intent of the earliest British Mods was so create a total environmentally enhanced culture that

entailed their own fashion sense, favorite music, and hip hang-outs. They wanted to create and be enveloped by a totally new atmosphere. Their love of modernist design from Italy—whether in clothing or products (suits or Vespas)—shaped their visual realm. Although quickly built sterile postwar building facades dotted urban Britain, interior spaces could be reinvented to be more playful, colorful, and *très moderne*. The boutiques that began to thrive in Carnaby Street often reflected the ideals of what could be done to mod-ify one's self and one's surroundings. The spaces themselves were also meant to serve as examples of the culture though they reflected various nuanced readings of Mod. One boutique might be decorated in pop art, while another looked like the latest discotheque, and still another aspired for a space age aesthetic. Thus, young Mods not only went to these stores in search of fab, new, gear, but also the experience of stepping into a differently imagined world.[31]

The Metabolist architects dreamed of more outrageous spaces than they actually ended up building, but their legacy lives on. The group was committed to the idea that "life, design, and building share a dynamic process of change," hence their name. These exceptional innovators had a view of Modernist design that mixed organicism, traditionally Japanese architectural forms, and science fiction fantasies. The "organic" and "Japanese" aspect of the group's work mirrored earlier adaptations of Modernist design and architecture in Japan during the 1920s, and especially in the rebuilding after Tokyo's 1923 earthquake.[32] Metabolists such as Kisho Kurokawa and Arata Isozaki had an uncanny way of mixing Japanese tradition and a form of British modernism. One scholar links the group's dynamism not only to the pop idea of manufactured obsolescence, but also to an aspect of Shinto. The Metabolists' "concept of change also involved a certain traditionalism, a faithfulness to Japanese history and religion that resulted in efforts to echo symbolic shapes like roofs in their designs; to follow the tradition of the Shinto shrine involves periodic demolition and rebuilding which in turn echoes the obsolescence principle of the British Archigram group by which the Japanese were considerably influenced." The idea of "change" and a new look for urban Japan also inspired the group to sketch out and create models of floating cities or towering buildings made of interconnected capsule-like structures. Though structures designed by the group were primarily constructed starting in the early 1970s, their influential ideas would remain and eventually help create snapshots of an overall more Mod Japan in the 1990s and 2000s.[33]

The Beatles and Mod in 60s Japan

A September 1964 issue of *Life* magazine dedicated an entire issue to the Western perspective of postwar Japan. The issue examined changes resulting from the war and the American occupation. As youth culture was then a topic of great interest, a large part of the magazine focused on intergenerational tensions. *Life* magazine reported that Beatles records had already made their mark in the form of the Tokyo Beatles. The article observes "Many youths running away from the old traditions, go western with a vengeance. Hardly had the British Beatles hit the Tokyo record shops than the Japanese had Beatles of their own. In a matter of weeks Tokyo youngsters were gyrating to 'I Want to Hold Your Hand' by Beatles with names like Jiro Ichikawa and Takashi Saito." However, *Life*'s American reporter probably made the group sound more popular than they actually were. Though they delivered Beatles songs like "Please Please Me" in Japanese, teenagers soon became much more interested in the English-language originals. In 1966, when the Beatles finally did arrive, they were slated to perform at Tokyo's famed Budokan Hall. Because of this, a tension between East and West was almost immediately palpable.[34]

Designed for the 1964 Olympic Games, the Budokan had been meant for traditional Japanese martial arts like judo, certainly not pop or Western events. Members of the older generation displayed "Beatles Go Home" banners upon the band's arrival while a group of militant right-wing students objected to the Beatles' influence on Japanese youth.[35] In a press conference prior to their performances, a Japanese reporter posed the following question: "Some Japanese say that your performances will violate the Budokan, which is devoted to traditional martial arts, and that you set a bad example for Japanese youth by leading them astray from traditional Japanese values. What do you think of all that?" In answering the reporter, Paul McCartney turned the situation around by saying that a touring Japanese dancing troupe would not insult British values and that the Beatles were "traditional," too. In the terse and clever style John Lennon was known for, his reply unfortunately proved less diplomatic: "It's better to watch singing than wrestling, anyway." Being blind to their own country's history of imperialist tendencies and the way the West had long fetishized, feminized, and controlled parts of the "Orient," the group could not understand why they were poorly received by a faction of nationalistic Japanese. By the end of the tour, the Beatles received multiple death threats and were only too happy to leave Japan immediately following their last performance.[36]

Despite the controversial visit, there were still many Japanese youth who *did* respond favorably to the Beatles tour of Japan. As current Japanologist

and former Teardrop Explodes front man Julian Cope explains, "If early July 1966 was a cool time to be English in Japan, then late '66 was even better, as the England football team won the World Cup... [There were] Carnaby Street threads, Union Jack prints, Swinging London and the fabulous four were all the Japanese could think about." The so-called "Beatles Typhoon" was what the Japanese called *their* British Invasion.[37] In its wake, a plethora of Beat-style combos with names like the Tigers, the Tempters, and the Carnabeats adopted a Mod look and musical style under the banner of "Group Sounds" ("G.S.") shortly after the Beatles' departure and remained active into the early 1970s.

According to a 1969 *Rolling Stone* article on the Japanese rock scene, the term "Group Sounds" was devised because the two r's and two l's in Rock and Roll made the English word too difficult for most Japanese to pronounce. In imitating British bands, and often even covering their songs, bands like the Tigers and the Spiders attempted to be just as media-savvy as their Western counterparts. While published during the height of the Hippie-influenced "flower power" aesthetic in the United States and Europe, *Rolling Stone*'s 1969 report of Japanese G.S. bands describes a scene that is still in awe of mid-60s Mod style. According to the article's author, "Right now, in early 1969, much of the clothing, the long hair, and music, is early Beatles, meticulously neat, well-combed, and copied note for note." Record covers and promotional photographs of many G.S. bands show them in matching, uniform-like outfits comparable to those worn by the Beatles during the early phase of their fame.[38]

Like the Beatles or the Stones, several of these groups benefited from savvy management. Unlike an initially more youthful, underground, and/or hip command of the emerging "youth market" that a Brian Epstein or an Andrew Loog Oldham gave their groups, many G.S. bands were managed by two huge corporations. Watanabe Productions and Asuka Pro immediately groomed G.S. outfits for mass consumption. The Mod look, already successful with the Beatles and other British bands, for instance, became a safe style strategy to promote these groups. The Tigers, for instance, not only played this promotional game, but also appeared in completely different (matching) outfits for each new single that came out. They were also the first G.S. band to play the once-verboten Bukodan, which the Beatles had, of course, already "christened." This intentional corporate "makeover" could be read as more Monkees-than-Beatles, as management tried to censor any signs of truly rebellious behavior among their groups. For instance, The Golden Cups were required to play more staid songs on their TV appearances, while their live shows tended to be raucous, feedback-drenched rave-

ups.[39] As Daisuke Usui (b. 1971, Nagoya) would tell me in 2004 when I asked him about G.S. bands: "The Golden Cups were the rebels, bad boys: taking drugs, having fights." Apparently, any attempts to truly hide this reputation by Watanabe or Asuka ultimately failed. Almost forty years later, the reputation that has persisted is evident from Usui's words.

The Spiders were an exception to the rule and were not under corporate management. They were diligent in seeking and achieving national success, but also sought acknowledgment from the West. Up until that time, the only Japanese to have had a hit in the West was Kyu Sakamoto with the song "Sukiyaki" (1963). In fall 1966, the group toured Europe, playing, among other locales, the famed Hamburg Star-Club, the venue for many of their musical heroes (fig.17).

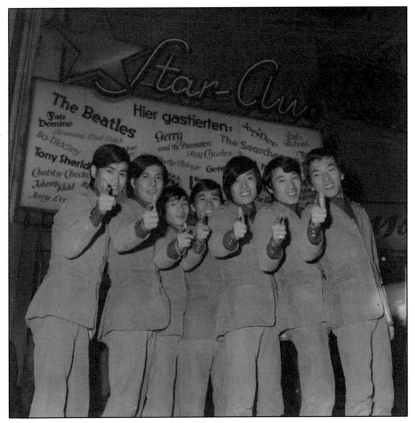

Figure 17. The Spiders at the Star-Club (courtesy K&K Center-of-Beat, Hamburg).

The Spiders also starred in several movies: *Wild Scheme A-Go-Go* (1967), which featured the group doing what was called their "Monkey Dance," and

Go Forward! (1968), a rock-meets-espionage film, were intentional nods to the Beatles films *A Hard Day's Night* (1964) and *Help!* (1965), respectively. The G.S. bands adopted Mod style in the hopes that a Beatles-like charisma and, maybe even, international success would follow. Nonetheless, neither the Spiders, nor any of their rival bands, ever became big names outside their native Japan during the 1960s or 1970s.[40]

The mania which followed the fashionable and charismatic Beatles around the globe took on a near-religious tint. At least one scholar argues that in contemporary mass society, fandom around popular culture phenomena has replaced religion as a "unifying element." Though John Lennon's now-infamous remark of the same year (1966), about the Beatles being more popular than Jesus, had caused the group's albums to be burned in some U.S. states, this probably had little resonance with the mostly non-Christian Japanese.[41] Instead, in a similar-yet-different vein, traditionally minded Japanese worried the Beatles embodied a way in which Western popular culture was treated as god-like and all-encompassing. Even a playwright who was part of the post-*shingeki* (postmodern) theatre movement of the 1960s "cast" the group as transformative characters in his production *Atashi no Beatles* (*My Beatles*, 1967), where they were meant to symbolize how ancient gods would return to Earth in contemporary form.[42]

This linkage also reflects what more recently has been written about the religious aspects of fan culture surrounding rock stars in Japan. Writing about this phenomenon, Hiroshi Aoyagi believes that the continued influence of Shinto in Japan manifests as a blending of religious rituals with day-to-day life: the ancient and the modern.[43] I posit this is reflective not just in pop idol worship, but in the subcultural affiliations there, too. As British Mod Stuart Whitman recounted, "I can remember going to *Modstock*, which was about four years ago at the Rocket in Holloway Road [London]. We got there and there was loads of Japanese people taking photographs of everybody... You know how Japanese people get into everything so big? And they're really obsessed with it, you know?" A near-zealous devotion to being every stitch a Mod, for instance, is perhaps why the Japanese stand out among this transnational youth culture.

"For many fans of popular culture," Michael Indra writes, "organized religion seems less relevant, partly because they perceive it as backward looking rather than forward looking."[44] As we have seen in previous chapters, the idea of Mod is a celebration of innovation, contemporaneity, and what a truly "modern future" could be. This paradoxically holds true for Mod today. Another astute view of this intense connection to Mod may be provided by re-

ligion scholar Richard B. Pilgrim. He has described Japanese culture as one in which "artistic form and aesthetic sensibility become synonymous with religious form and religious (or spiritual) sensibility." Since Mod is also a lifestyle that is especially concerned about the aesthetic details of everyday consumer goods—a way to make the ordinary special—this subculture theoretically is a perfect fit for Japan.[45]

Another aspect of the Shinto religion is the search for purity. In 1964, psychologist Robert Jay Lifton described a "special intensity" that some postwar political movements and ideologies had. Those involved "deplore[d]… impurity in the world around [them]—the threat of war—and [sought] out, however theoretically, a universal symbol of peace." In the initial wave of Mod in Japan, young people there, not dissimilar to Mods in the U.K., Germany, or the U.S. saw "impurity" in the sterile, adult world around them. They had not witnessed war as their parents and grandparents had, but they did not see the *sarariman* (salaried man) and dedication to work and corporate progress as highlights of modern life. This Japanese version of the "organization man" was "the personification of impure self-betrayal, of rote, purposeless subservience both to his immediate superiors and the overall social and economic system."[46]

If emperor worship had ceased once the Japanese lost the war, and many of the (mostly male) adults around them found satisfaction in "working for the man," then young people gravitated to a less sterile form of achievement and materialism through a strange hybrid form of consumerism and spirituality. Is it really so strange? After all, as one scholar has it, "Religion is a repertoire of cultural practices and performances, of human relations and exchanges, in which people conduct symbolic negotiations over material objects and material negotiations over sacred symbols."[47] With the ever-circulating and contested stories about what Mod culture is or can be (among Mods themselves), there is a great amount of seriousness attributed to youth culture allegiance in general, and this quality, as we shall see, is more than evident in Japan.

Japan's Mod Scene Circa 2004

I first became aware of a Japanese Mod scene through the Internet in late 2002. From looking at the Uppers Organization website's "city guide" web pages for Japan, I discovered there were regular Mod-themed events in Tokyo and Nagoya. I also learned of a bar dedicated to the Jam's Paul Weller in Kyoto, which I knew I had to see with my own eyes to believe.[48] When I journeyed to Japan in summer 2004 to observe the Mod scene there, I traveled to these three cities. I also added Osaka to my list in order to interview a member of Sho-

nen Knife, an alternative band whose matching, onstage outfits often quote
the 1960s. Aside from the continued existence of Mod culture in Japan, it
was possible, at times, to glimpse 60s icons and motifs in more mainstream
spaces. For instance, in 1999, images of the Beatles and the 60s era Ameri-
can TV show *Bewitched* appeared in Television commercials there.[49] Dinner
theatre–type venues in Tokyo and Osaka (and probably in other Japanese
cities, though I was not able to see them myself) hosted Beatles look-and-
sound-alike bands, while Mary Quant products were available at department
stores. The host of *Matthew's Best Hit TV* sported a blonde, mop-topped wig
and wore many fitted and brightly colored suits—not unlike fictional 60s spy,
Austin Powers.[50]

From Tokyo to Nagoya, aspects of Japanese commercial culture today
embraced icons of the Mod era such as Twiggy, Mary Quant, and the
Beatles. For instance, a female Mod living in Tokyo today could easily find
Mary Quant cosmetics and accessories via its many kiosks throughout the
city's department stores. This same woman may also buy a reissued Twiggy
CD and Twiggy doll with her Twiggy-branded Japan Credit Bank (JCB)
"Linda" credit card. At the end of a long day of shopping, she might then
take in a show at Roppongi's re-created Cavern Club to see a Japanese
Beatles tribute band perform for three thousand yen.[51]

Clearly, though, I was more curious to see the Japanese Mod scene in ac-
tion, than how aspects of the culture have been commercialized. I attended
two smaller Mod events in the Shinjuku and Roppongi neighborhoods
("Facing Facts" and "French Blue") and one larger event in Shibuya ("Friday
on My Mind"), held at Tokyo's Club Quattro. "Facing Facts" was a dance
event featuring five different DJs spinning primarily American R&B and
Soul from the late 50s to early 60s. One DJ whom I talked to there wore a
flat cap and jeans and told me his favorite bands were American garage-type
groups like the Sonics. Another DJ in his mid-twenties, who played in a
band called Big Fanny and the Sharps, told me his favorite performer was
James Brown and that he loved the Blues. He, too, was wearing a flat cap
and jeans. At one point, two rows of girls wearing more 1950s-versus 1960s-
style dresses dance in synchronized, Motownesque steps as if they had al-
ready practiced beforehand.

"French Blue" took place on a Sunday afternoon into early evening and
incorporated a scooter rally (from Shibuya to Roppongi) that turned into a
multiband concert and DJ event at a nightclub. As a cavalcade of Vespas and
Lambrettas roared down a Shibuya side street, I noticed that many of the
girls riding these scooters were wearing black helmets that looked similar to
those jockeys would wear, which was a Mod fashion accessory I had not seen

elsewhere. Overall, the scene was vibrant: young women in bright green, red, and purple dresses; young men in brightly striped shirts and sharply tailored jackets. After the scooter run—at the nightclub—bands with names like the Outs and Boy Friends hit the stage, with the Marquee as one of the headliners. Appearing onstage in Italian-style suits and with tricked-out, expensive-looking equipment, I paid special attention to the bassist, who was holding his teardrop-shaped bass almost vertically à la the Stones' Bill Wyman. The DJs spun a potpourri of different styles—from Northern Soul to Beat—and the ratio of male to female DJs was nearly equal.

The next event I attended, "Friday on My Mind" (named after the mid-60s hit by Australian band, the Easybeats), featured the Japanese band The Collectors—a Tokyo-based Mod rock group who have been together since the early 1980s. They have since achieved mainstream, commercial success in Japan, but still employ Mod imagery such as targets and British flags in their press and CD designs.[52] At this event, and through the event's co-coordinator, Kotaro Furuta, I was able to meet two early members of the 1980s Tokyo Mod scene, Manabu "Modfather" Kuroda and Masami "The Mod" Murano. Also in attendance at the venue were some staff members of *Girls 60s* magazine Mizuki Ishikawa, art editor and Eri Nishimura, writer and editor—who sold copies of the magazine in the venue's foyer.

In Kyoto I spent time at the Weller's Club. It was a shrine-like nightclub dedicated to British Mod icon Paul Weller. After having seen a bar in the Shinjuku neighborhood of Tokyo dedicated to the Small Faces' Steve Marriott called "Feels So Marriott: Heartful Rockland," I was starting to wonder if such "tribute clubs" were commonplace. Tadashi Yamamoto's club was dimly lit and had minimal furnishings, but what *was* there was definitively of mid-century design: white, round, and low-to-the ground, pod-like chairs. Days in Kyoto were spent walking through covered shopping arcades, where I found vintage clothing stores such as Eve and Emu & Stag where many 60s fashions were available, if relatively expensive compared to U.S. prices. Also in Kyoto was Happy Jack, a record store that was named after a mid-60s' song by the Who, and was a shop that primarily, if appropriately, dealt in vinyl versus CDs. In the store there were separate sections for Mod music as well as British Beat, and a few English-language books available about Mod.

There were similar stores in Osaka, though more plentiful there were Mod-style furniture stores. The most impressive of these was called Spiral in the Trip—which looked like a warehouse full of movie set pieces from the 1968 film *2001* (fig. 18).

Figure 18. Spiral in the Trip, Osaka, 2004 (Photo by Corey LeChat).

In fact, the store actually sold recreations of French designer Olivier Mourgue's Djinn chairs (1965), which were featured in the movie. A virtual sea of these chairs appear in a scene from the film that takes place in the lobby of a rotating, Hilton Hotel, which was located en route to the moon.[53] Not so ironically, perhaps, the store itself opened in 2001, which by 2004 evoked a double nostalgia—both for director Stanley Kubrick's 1960s vision of a full-tilt space age and the fact that the "futuristic" year of 2001 was already three years past.[54] Large, white, and orb-like TVs and record players dominated the store's interior and window display, as did Italian-designed chairs, coffee tables, and mini-sofas. The store's 60s-design theme was clear from the moment I saw it. The items that populated the store fit what art historian Lesley Jackson has described as an important aspect of 60s design. He writes that by the early 1960s "spheres, domes, and discs, while the pattern design in the circle itself [were] the most dominant images." These shapes were integral to the curvilinear design of mid-60s Mod style. By the decade's end the first spherical television was also designed and is now included in what Mods consider part of the design style today. When I talked with the store's owner she proudly showed me how her shop was recently featured in the latest issue of *Girls 60s* magazine, garnering both the Mod community's stamp of approval and patronage.[55]

Traveling out of the Kansai region of Japan and onward to Nagoya, I was impressed with the vibrant Mod scene there. For instance, there were two

events being held on the night of July 24, 2004 and both were attended by between sixty to eighty people in rather small venues. The Osu Kannon shopping district of Nagoya also had at least three distinctively Mod-oriented clothing shops including the Other, His Clothes, and Métropolitain. Besides this, there were other vintage shops that carried Mod 60s styles with those of other eras. In particular The Other served as ground zero for a wealth of Mod activity. The store sponsored music events in Nagoya two or three times a year and also produced a limited amount of 60s-influenced music CDs under the store's name.

Niche media also contributed to the sense of identity formation among contemporary Japanese Mods. What was foregrounded here was a definite "group mentality," that suggested that if one followed a few simple steps, you could be "in" with the Mod crowd. Editors of *Girls 60s*, which was first published in 2004, proclaimed on its cover that it was a "Real 60s Fashion and Lifestyle" magazine for women interested in Mod style. Though its fashion spreads and shopping tips were formatted similarly to both mainstream and underground Western fashion and lifestyle magazines such as *Vogue* or *Bust*, the content and look was focused on the niche audience of Japanese Mod girls. Based in Tokyo, but covering the Mod scene throughout the country, the magazine acted as a guide to the Mod lifestyle and advised young women what to wear and where to shop if they wanted to be part of the "60s scene." In this sense, niche media as embodied by *Girls 60s* magazine functioned similarly to Japan's "manual books" popularized in the 1980s and 1990s. These books gave detailed instructions on specific hobby or lifestyle choices and how to fully incorporate them in one's everyday life.[56]

Three articles were extremely telling of various aspects of Japan's adoption and adaptation of Mod in the early twenty-first century. An article in the spring issue of the magazine featured the lead singer of the Collectors, Hisashi Katoh, advising readers, "The Mod culture is boys' culture. So Mod girls (also called Modettes) are, in some ways, the best accessories of cool Mods," and then gave Mick Jagger's 60s-era girlfriend Marianne Faithfull as a shining example. The article continued to say that Mod girls may never be more stylish than male Mods and, further, because of her "B-grade" attractiveness (and singing chops), Lulu was the prime example of Mod-60s girlhood. Unfortunately, it may be that Katoh's male-centric reading of Mod—and especially because he was a lauded Mod "rock star"—could have negatively impacted a female Mod's sense of true belonging. In this reading, the "Modette" was a prized accessory that was both needed to reinforce the heteronormativity of the culture and also the superior attractiveness of the males in the scene. She should be smartly dressed and "with it," but also unobtru-

sive in this Mod, male world.[57] Despite an article such as this one, and a few odd looks given to me by some of the male Mods I tried to interview there, I am still reluctant to assess Japan's Mod scene as potentially "more sexist" than those in the U.K., Germany, or the U.S., especially since the only overt sexism I experienced was from an expatriate—an English teacher living in Japan. For some reason, he refused to acknowledge that I (and not my male travel companion, Corey) was the one studying the Japanese Mod scene and avoided eye contact with me during the whole of our conversation.

Thus, while such observations *may* have led readers to think that Mod lends itself (yet again) to some kind of gendered hierarchy in Japan, several other articles in this and another issue contradicted this sentiment. A review of the 2004 Ryuichi Honda film *Pussycat! Go! Go! Go!* revealed the young director's desire to recreate the 1965 Russ Meyer film *Faster, Pussycat! Kill! Kill!* The original featured buxom, strong, and, for lack of a better term, "ass-kicking," women in hip clothing who got into all sorts of trouble. Unlike the Meyer film, though, where the leads sported tight-fitting, black and Rockabilly-ish attire, Honda's heroines were cloaked in go-go boots and floral mini-dresses. Their toughness was thus counteracted by more visually playful, Mod fashions. Another "pro girl" article was called "Mod Girl Group: That's a NoNo!" The piece chronicled the rise of a Tokyo-based, 60s-inspired female band. The members met in the city's Mod scene and appeared equally serious about their music *and* style. They related to the article's author that their next gig had them wearing "garage fashion," but the one after that would have them wearing something "bright and cute." What they said about their love of R&B music, though, is endlessly fascinating—especially in terms of Mod's transnationalism. One of the band members mused, "[we] admire white R&B groups who admire black R&B... we love the primitive rhythm unique to whites who cannot express blackness completely." She then opined that they are putting a "yellow" spin on this white interpretation of black music. If that is not a truly transnational statement about Mod's peculiar relationship to race and style, then I do not know what is. Then, it can be truly said, that while *Girls 60s* was a way to "train" women to be Mod consumers, it was a source that could also make readers reflect about which qualities of Mod were lost or gained in Japanese translation.[58]

The Scooter, Modernity, and the Vespa in Japan

Since Mod is primarily an urban phenomenon, and Tokyo remains one of the world's most populous cities, it is no surprise that the city is one of Mod culture's twenty-first-century hubs. Given their style consciousness, young

Japanese have been as concerned with keeping up their image as the original British Mods were, no matter which fashion allegiances have been made. Borrowing from Roland Barthes's *Empire of Signs*, sociologist John Clammer describes contemporary urban Japan as a "sign saturated society," whereby citizens "consume a particular product primarily for its symbolic value." Clammer characterizes urban Japan's "centerlessness, neon saturated streets, temporary looking buildings, and simulational zones [as] both sites of consumption and sites/sights to be consumed." In creating Mod communities, new millennium Japanese Mods have helped determine the look of their urban terrain. They have become "urban images makers" because they have designed spaces or sites for consumption, such as their events and stores, and also have visually consumed a myriad of traditionally Mod images in constructing their lifestyle. And, though the Metabolist architects did not end up constructing as many actual futuristic-looking structures as they designed, space-aged themed "Love" and, especially, "Capsule" hotels, reflect some of their aspirations. As an important model for Ridley Scott's set-in-the-future film *Blade Runner* (1982), with Corbusian-style buildings and neon-dominated streets, contemporary, urban Japan has become, in this way, a highly Mod place.[59]

As the previous chapters have already shown, Mod has used many material symbols to express its ideological bent. If one were to think of a single, metaphorical object from the archive of images that has existed to describe Mod's past and present incarnations, it would also be the Italian scooter. In 1997 the San Francisco, all-female pop-rock outfit, the Kirby Grips, recorded a song called "Mod Boy" as an ode to the latter-day Mods that lyricist China Tamblyn had encountered in the 1980s and 90s. "Mod Boy," she sings, "Meet me in Brighton and bring your Lambretta." Invoking the Lambretta in a British setting, Tamblyn touched upon what has remained the premiere image associated with Mod style: the Italian scooter. The sleek and stylish Lambretta or Vespa favored by Mods symbolize youth and forward movement. As both consumer goods and objects coveted by a particular group, scooters, like Mod, are about the brokering between commercial and subcultural style. And, as mirrored in the sprightly speed of the scooter, Mod represents a playful spin on a fast-paced, urban-centered world.

Looking even further beyond these interpretations, though, there was something else valuable to be gleaned from the idea of Mods and their scooters. Rushing by on their Vespas at feverishly fast speeds, the Mods took in a great mass of images that blurred together within their vision. What was understood through this visual montage? Was it similar to Wolfgang Shivelbusch's observations on early-twentieth-century train travel where "speed

causes objects to escape from one's gaze, but one nevertheless keeps on trying to grasp them?"[60] Similar to contemporary media-driven experiences, with their constant glut and rapidity of images, it was often hard to discern how one picture connected to the next. We have been nonetheless required to make sense of them. The pace of the scooter in conjunction with these images mirrors this identifiable modern reality where we are expected to make quicker connections between the things we see.

In its signification of movement, it has been the scooter that embodies Mod's urgent *nowness*, whereby a moving panorama of past and future visions is visible together in one glimpse. Taking in many visuals at once, Mods on their scooters were somehow simultaneously aware both of what lay behind and ahead of them. Mods today see and interpret a mix of signifiers and images as if they were spread across a wide horizon; where a re-vision of history is juxtaposed with future possibilities. American Alex Baker touched on this metaphor: "The thing about the [original] Mods was that they were actually embracing newness [...] they were *scanning the horizon* and looked beyond where they were. [They thought:] 'We like these suits and scooters from Italy.' They were trying to invent their own little culture and they were very in tune with things that were going on." It has been this concept that has remained true to Mod today: the culture has become a mixing and matching of the most visionary ideas and styles assembled—not just from disparate locations—but moments in time.

Taking this metaphor one step further, imagine a group of Mods speeding on their Vespas going from club to club or party to party. Amid all the comings and goings there is a palpable anticipation that the next party should be better than the last—but would it *really* be? Would it not just be more of the same—with all the recognizably familiar signs of their culture? As I have touched upon throughout this book, an essential part of the Mod narrative has been that excitement for the present can be combined with expectations of an even more exciting, more modern future. However, there has always been tension inherent even in that sentiment as expressed by the Who lyrics "Hope I die before I get old." As much as the earliest Mods embraced modernity and all the trappings of contemporary life, there was still some doubt as to whether the future would indeed be better, or even as good as "the now." Perhaps this was as good as it would get. Besides, the future also meant an end to youth. Would idealism fade as they got older?

As I have indicated, Mod idealizes modernity so that it can be a route to transcendence. On a visceral level, perhaps the scooter has worked as a conduit for this. Umberto Eco recognizes the vehicle's transformational powers: "The Vespa came to be linked in my eyes with [...] the subtle seduction of

faraway places where [it] was the only means for transport."[61] If a post-60s recall of Mod—imbued as it can be with nostalgic, wishful thinking—can transport us back to a better version of modernity, then it is the Vespa that can take us there. The Vespa has become symbolic of people and places continually longing to move forward, yet also looking back. Eco's words are certainly suggestive of the way contemporary Mods have nostalgically painted the 60s: no matter how fast you have driven, you have inevitably missed the *actual* party—but why not try to throw another one? In embracing the scooter, and therefore, Mod, later Mods have attempted to find a new kind of party invoking memories of the last one.

As already shown, popular notions of *60s* Mods today have been linked to images of Mods on scooters racing down the highways of southern England in the 1979 film *Quadrophenia*. It has become evident that this was a film which first introduced many of today's Mods to the culture. It also etched the scooter into people's minds as an important part of this scene. In fact, the film goes so far as to make the scooter synonymous with the Mod's sense of identity. When the film's protagonist Jimmy Cooper no longer wants to be a Mod, the only solution was the destruction of his scooter and all it symbolized. One song featured on the soundtrack is called "The Real Me," so the issue of Jimmy's identity is central to the film. In *Quadrophenia* the scooter had become an extension of who Jimmy was, or at least, who he had been trying to be. In this identification between the Mod and his scooter, Jimmy projected all that he desired to be onto a mechanically precise machine.

Like Jimmy, the first subcultural Mods strove for an excessively perfect appearance and the affect of upward mobility. The Vespa was symbolic of both these aspirations. As Dick Hebdige explains, "The Mods converted themselves into objects, they 'chose' to make themselves Mods, attempting to impose systematic control over the narrow domain which was 'theirs,' and within which they saw their 'real selves' invested."[62] With all its streamlined perfection the Vespa symbolized a type of soulful materialism to the Mods. It was more than just machinery—it was instead a metaphor for what kind of person they sought to be: urban and sophisticated, modern and well traveled.

Based on their consumer rationale, Mods assumed this personal excellence—and therefore happiness—could be bought. In Mod style, with its emphasis on image and consumer culture, there was a sense that happiness could indeed be purchased. It is then not altogether unsurprising that the scooter, as the ultimate symbol for dreams that money *can* buy, has made a rather pronounced appearance in Japan's contemporary Mod scene. Though Japan's rise to becoming a consumer utopia accelerated in the postwar period,

and peaked in the 1980s, this more contemporary consumption of "Mod goods" has been different in the sense that it was not automatically available within mainstream culture. It has required social networking (both on and offline) in order to find where these items can be located and purchased. It is also a consumer practice which has evolved through the empathetic appropriation of *other* cultures' nostalgic longings. This is a phenomenon some scholars see as increasingly common in contemporary Japan.[63]

The feverish use of these scooters by the original British Mods during the early 60s never fully translated into the American Mod scene, where it was not necessary to own a scooter to be a "true Mod." However, the Japanese I spoke with appeared to take the scooter as seriously, if not more seriously, than their British counterparts. British expatriate and Tokyo resident Gordon Moir (b. 1966, Birmingham) remarked on the amount of money Tokyo Mods put into the purchase and maintenance of their scooters. According to Moir, these were not just any scooters, but the best vintage Vespas and Lambrettas available anywhere. At Tokyo's French Blue scooter rally held in June 2004, Moir pointed to a gold Lambretta and said, "You're talking about over five thousand pounds (approximately $9200 in U.S. dollars based on current exchange rates). They're dream scooters... you can't even afford one of those if you re-mortgage your house these days. People of my age get one of those and put them in the living room and say, 'I'm not going to ride apart from sunny days.' To see them in the really 60s style with the extra accessories is quite unusual."

According to Kotaro Furuta (b. 1970), longtime Mod enthusiast and owner of Jungle Scooters, a Vespa and Lambretta dealership in the Setagaya district of Tokyo, scooters have played a crucial role in Tokyo's Mod scene from the late 70s onward. He described how in 1979 after a midnight viewing of the film *Quadrophenia* in Tokyo's Shinjuku district, two teenagers decided they were going to be Mods. Each of them thought that they must be the only Mod in all of Tokyo, if not Japan. One day they crossed paths while on their Vespas, suddenly realizing the possibility of many others interested in Mod style. Furuta identified these Mods as a future guitarist of Tokyo Mod band, the Collectors—Kotaro Furuichi—and Manabu "Mabo" Kuroda, future member of Tokyo Mod band I-Spy (1980–1993). Like the revered Mod musician Paul Weller, Kuroda is known in Japan's Mod circles today as "the Modfather."

Furuta also explained from personal experience why the scooter was an essential accessory for any true Japanese Mod. He became intrigued with the style while at university in Tokyo during the late 80s to early 90s. He attended his first Mod event during this time. In his words: "When I went to

club Jam in Shinjuku, I went the first time, no scooter—went by train, went
to gig. There were many Mods with scooters talking, but I have no scooter, I
cannot join them. Then I get scooter, I can join. No scooter, no Mod in To-
kyo."[64] Despite Furuta's experience, Nagoya's Daisuke Usui thought that
scooters, while important, were not the only tickets available for entry into
Japan's Mod community. He saw this strict attitude among Mods as having
been more persistent when Kotaro Furuta's story of "no scooter, no entry"
took place. While Usui enjoyed the cachet of once owning scooters, he be-
lieved that the time and cost of upkeep was ultimately not worth it. Well-
known and active in the Mod scene in both Nagoya and throughout Japan,
this choice has not held him back in any way. Thanks to his fluent English,
perfected by his time living in London, Usui was also familiar to those in-
volved in the global scene as the main Japanese correspondent and writer for
the international Mod website, the Uppers Organization.

Regardless of Furtura and Usui's slightly differing views on the role of
the scooter in the Japanese Mod scene, it is also important to note that while
scooters have a history that extends back to the early postwar period, some
Japanese Mods of Gen-X or later, have not always associated Mod with the
1960s. Although scooters, and many other Mod visual motifs, are used to
advertise Mod wares and events, these contemporary Mods have often at-
tributed the sensibility to 1970s or 1990s revivals rather than with the mid-
60s period. For instance, *Quadrophenia* came up in several interviews while in
Japan. This cinematic recreation of the earliest, subcultural Mod period has
become a touchstone for many Japanese Gen-X Mods' visual understanding
of the style. Perhaps because Mod is an imported, Western style in Japan, it
has been the case that Mod has existed outside a specific historical trajectory
linked solely to a progression from the 1960s onward. In this understanding
of Mod style, there have been many possible routes leading from mid-60s
London to twenty-first century Tokyo.

Ronnie Fujiyama (b. 1965, Tokyo) was one of several correspondents
who recalled the impression that *Quadrophenia* made. Fujiyama plays lead
guitar for the all-girl Tokyo band the 5678's. Featured in Quentin Taran-
tino's 2004 film *Kill Bill-Volume 1*, their name comes from the fact that their
sound is influenced by music from the 1950s, 60s, 70s, and 80s. While Fuji-
yama and her bandmates mix Mod and Rockabilly fashion sense, sometimes
sporting beehive hairdos and miniskirts, she first understood what Mod style
was through seeing *Quadrophenia* in the early 80s. Shonen Knife's Naoko
Yamano remembered viewing the film "four or five times... as a high school
student." A member of the band the Marquee, Fumio Nawa (b. unknown,
Tokyo), also attested to the film's influence and how it offered something

Western, but "non-American," in terms of pop culture: "The biggest reason I became a mod was after watching *Quadrophenia*. I first saw this film when I was in High school. Afterwards, I fell head over heels in love with mod. Also, because Japan is usually deeply influenced by American culture, I felt this British culture thing was so fresh and attractive. Eventually, I got a M-51 shell parka and a Lambretta and started going to nightclubs. I joined a scooter group, the High Numbers and formed a band called the Marquee. I went to the Whiskey A-Go-Go club in Tokyo every weekend and would lose myself, I would go mad every time. I've been a mod for about eight years."[65] Jungle Scooters owner Kotaro Furtura also first recognized Mod through watching the film in the late 80s. Growing up in the countryside, he did not see Mods until moving to Tokyo at age eighteen. In his words, "I saw a Vespa Mod style... I saw one Mod with a Vespa. When I saw this person I thought: 'this is Mod style.'" Had Furtura, nor any of these other Japanese Mods, not seen *Quadrophenia* prior to encountering this person, they probably would not have had as defined a frame of reference to recognize the style.

Quadrophenia could easily be read as quintessentially representative of Mod. However, as stated in previous chapters, its depiction of the lifestyle is not reflective of how it had evolved, so its view of Mod is narrow. The Mods in the film are portrayed as mostly male and working-class. Much of the film takes place in Brighton, where Jimmy and his friends partake of a mass riot between Mods and Rockers. Girls are included in the film, but take on supporting roles as love objects and hangers-on. Predominantly, these Mods are seen as the pill-popping, scooter-obsessed, angry young men that some people (not in the know) still assume all Mods are. In their exposure to this film, the Japanese I spoke with simply referred to it as a visual introduction to Mod in terms of fashion and scooters. Nothing of the violent gang mentality displayed in the film seems to have influenced the way Mod is played out in Japan today. In fact, it was not uncommon for contemporary Japanese Mod and Rockabilly ("Rocker") bands to share the billing at events—even the annual Mods Mayday.[66] However, it is also not difficult to imagine that *Quadrophenia*'s rebellious attitude may have been very attractive to my respondents when they were teenagers.

In Japan's contemporary Mod scene, participants have deftly used micro and niche media to spread concepts and products. This kind of community building connects back to the original Mods' local and transnational identity formation through locally and internationally circulating media texts such as fanzines, magazines, albums, TV shows, and films. Within the approximately ninety pieces of ephemera I collected, I gathered twenty-four handbills specifically advertising Mod DJ events and concerts, seventeen for stores

advertising Mod clothing, furniture, and other collectibles, as well as several print advertisements for Mary Quant cosmetics and the Twiggy-themed "Linda" JCB credit card. As today's Mod communities are primarily below the mass-market radar, these forms of micro-media has helped Mods create an air of distinction—what Bourdieu describes as "cultural capital."[67]

The sheer will and dedication to seek out these events and products continually creates a bond between these latter day Mods. In this scenario, those who found and made it to Mod events, bought Mod clothing, and decorated their homes in modernist furnishings and assorted curios had worked to acquire information about Mod culture, thereby validating their participation in the community. This dedicated search for and/or creation of a contemporary Mod "scene" has been key to understanding the existence of Mod communities in Japan and around the globe. These Mod scenes have created spaces for enthusiasts to "perform" Mod within a social setting through distinct choices of music and fashion. British sociologist David Muggleton, in *Inside Subculture*, asserts that micro-media "is integral to the networking process of assembling individuals as a crowd for a specific purpose and imbuing them with a particular identity."[68] For Mods searching a community of like-minded people, micro-media has been an inexpensive, but extremely effective, form of community building.

Cosmopolitanism in Mod Japan?

The clichéd image of Japanese tourists abroad is that of hordes of people traveling together in a motor coach—sticking in groups—and usually not speaking whatever native language goes along with the country they are visiting. The omnipresent camera hangs around their neck, but is then quickly utilized to capture one of many special moments occurring. Sure, it is a stereotype and a cliché. However, as we have seen in Chapter Two, because cosmopolitanism is a key attribute to Mod culture, I was curious to see how this aspect was played out in a nation with a hybrid history, a yearning to travel, and a language barrier that clearly trumps that between English and other Latin-based or European languages.[69]

While Mod has served as its own visual language in Japan, English "loanwords" are also visibly peppered throughout the country. According to James Stanilaw's *Japanese English: Language and Culture Contact*, Japanese statistics have claimed these loanwords "account for between 5 and 10 percent of the daily Japanese vocabulary."[70] English appears more generally in the romanization (rooma-ji) of subway stop names and, more specifically, in the ubiquitous use of English for Mod event names. Beyond the events I was able to attend in Japan, I collected a wide array of handbills and flyers an-

nouncing Mod dance nights and events such as Tokyo's "Uppers!" and "Shapes of Things" (fig. 19) and Osaka's "Twist & Shout," and "Readymade Weekend." Beyond, perhaps, the event's date, further details were always in Japanese characters only.[71]

Figure 19. Tokyo Mod night, summer 2004 (Collected by author).

Despite the pervasive use of English in its written and "pop cultural" forms, I found, to my surprise, that even some Mods greatly interested in the British origins of Mod—and a desire to be truly "authentic"—did not attempt to speak English. Many Mod bands that I saw, such as Tokyo's the Marquee (named, of course, after the Who's regular London venue) sang many songs in English, and yet could not speak it conversationally, nor would they use any in their on-stage patter between songs. In Osaka, Beatles tribute band, the Beatrips mimicked the Beatles lyrics, vocal delivery, and mannerisms perfectly and yet also could not speak English. This occurrence has been called "phonetic consumption," whereby "Lyrics... can be considered just as much of a consumer product, functioning in the same way to promote a song or an artist as the CD cover design would. Language, transformed from one tradition (foreign as 'authentic') to another (foreign as 'sophisticated') to yet another (English to Japanese, and back again, as fun and playful, but with a serious message)." This use of language has developed in the postwar era to reflect the way Japanese composers and audiences view

their lives against a global backdrop of these cultural industries. In this way, translations provide both evidence and counterevidence for the maintenance of a U.S./U.K. hegemony in Japanese popular music.[72]

Since Mod originated in England, I had theorized that Japanese Mods would somehow be more inclined or eager to speak English than the average Japanese, but this was not the case. Those Mods that I interviewed who did speak English well, such as Kotaro Furuta from Tokyo and Daisuke ("Dai") Usui from Nagoya, had either attended college or spent time overseas—usually in Britain. Dai, who had lived in London from 1995 to mid-1997, assessed the difference between the Japanese and British Mod scenes in this way:

> I thought it was really cool since England is the birthplace of mod, and some mods were still about. The nineties mods looked exactly the same as the people in the pictures I'd copied from 60s magazines or books. I was envious of these Brit mods because they had longer legs, those hipsters fit them so well and most of them were much taller than me! There seemed to be less unwritten rules about mod taste or sensibilities and they seemed to know how to relax and enjoy themselves as mods. I preferred dancing to good music and talking with my mates about cool gear than discussing what a mod should be. In a way, it was a lot of fun for me to be with the English Mods who took themselves less seriously.[73]

While Dai's comment about English Mods implied that Japan's scene may be more "rule oriented," British expatriate and Tokyo resident Gordon Moir saw things in exactly the opposite light. "One thing that is better here than in the U.K., I think… I wear 60s-style suits to work, but I can dress as a scooter boy one day, casual the next day, and Mod the next and they don't criticize you. I haven't noticed any bitchiness… [it's] all really friendly and nice." Perhaps both these statements refer to the notion that it might be easier to be forgiving when outside one's own cultural context.

From the 1960s onward Mod has been an international movement, and, indeed some Japanese Mods I talked to had traveled to the Western hubs of the culture. However, the majority of those with whom I talked expressed that they did not have ongoing contact with Mods in England, Europe, or the United States. Despite Mods' international modus operandi, or even signs of mainstream globalization in 2004 Japan such as Starbucks and the now defunct Tower Records, I found that enthusiasm for foreign pop culture did not necessarily translate into an enthusiasm for all things international or foreign—such as the English language itself.

Based on this observation, the English strewn throughout Japanese, particularly in printed form, took on a more fetishistic feel than a practical one.[74] It appeared a big draw in advertising, whether for Mod things or not. Many magazines, for instance, do at least have some English words on their cov-

ers.[75] Alongside the British flag and pop art designs, the English language, then, has become yet another set of symbols for the Japanese to use and modify. For instance, *Girls 60s* magazine has practically no English or romanization within its pages, but runs the English phrase "Real 60s Fashion and Lifestyle Magazine" at the top of its cover. Similarly, Kyoto's Mitsuba coffee shop advertised itself in its handbills as "50s-70s Modern! Interior-Fashion-Music-Art," but the store's proprietor did not speak English either. In examining this recurrent use of English by non-English-speaking Japanese, I wondered to whose benefit this kind of English-language advertising exists? Given the nature of my inquiry, and the emphasis on Japanese appropriation of Mod symbols, I found that my lack of fluency in Japanese was not a disadvantage, but rather proved beneficial. Conversing through Mod symbols rather than (always) through English or minimal Japanese seemed to underscore Mod's communicative power despite linguistic and other cultural obstacles.

Gendering Mod: Mod versus "60s" Style

In 2004, Kyoto's Weller's Club hosted "Girls Go On!," a semi-monthly event featuring all-female DJs spinning many Mod-era hits. At the night I attended, the DJs played a mix of mid-60s music from different parts of the globe such as France's Françoise Hardy, Britain's Kinks, America's Beach Boys, and Japan's Tigers. One of the DJs, Kazuyo Ikeda, a.k.a "DJ Stereo," (b. 1974, Kyoto), who at time of interviewing worked as a video game designer for Nintendo, did not fully identify with Mod because she perceived it as a male style (fig. 20). "I like 60s culture, but not only Mod culture. Mod culture is for boys. I am just interested in 60s clothes and songs." The way Ikeda talked about Mod as gendered is reminiscent of the androcentric way the Birmingham School scholars—barring Angela McRobbie and Jenny Garber—originally portrayed the culture.[76]

In Nagoya, Mod impresario and musician (leader of the band, the Absolude, fig. 21), Daisuke Usui maintained that there were more men involved with the Nagoya Mod scene, and that the women involved were distinctly less visible. He also saw a gender division between those aligned with the originally British, Mod music and those more interested in the Japanese Group Sounds style.

He described the Group Sounds scene as more "psychedelic" than "Mod," with more brightly colored fashion attracting women, thereby making the scene "more unisex." I later read another interview with Dai about this phenomenon, where he explained this "other Mod scene" in more detail

Figure 20. "DJ Stereo" far right, Weller's Club, Kyoto (Photo by Corey LeChat).

Figure 21. Daisuke Usui and the Absolude (Photo by Corey LeChat).

There is also a big Japanese sixties and seventies crossover scene that branched off in the mid-nineties. More people especially ex-mods became interested in a Japanese culture sixties movement called G.S. (Group Sounds). This scene has been steadily growing and it has become bigger than the mod scene especially in Nagoya. There is a clothing shop called the Other (Osu, Nagoya) run by ex-faces of the Nagoya mod scene, Hata and Takahiro Suzuki. They also have a small indie record label called the *Other* label. Their charismatic drive has made the Japanese sixties and seventies scene bigger and they are also highly respected by mods here too.[77]

This viewpoint was supported by the fact that Osaka native and current Tokyo resident, Kae Doi (b. 1970) first became interested in Mod through what she described as a "neo-psychedelic" Japanese band called the Hair. Furthermore, a commercially successful group called Love Psychedelico (with a female lead singer) have been described as not just influenced by the Beatles and the Kinks, but Bob Dylan, too. It has been suggested that Love Psychedelico's commercial success has been contingent on that fact that 1960s-tinged music sounds fresh to people used to a music industry which mostly promotes "soft hip-hip, R&B, and dance music." I believe this holds true for more mainstream-crossover bands like Love Psychedelico and the Collectors as well as groups like the Marquee, who truly belong to Japan's underground Mod scene.[78]

While some Japanese Mods differentiated between "Mod" and "60s style" via gender more than their current American or British counterparts, some predominantly female, contemporary, and internationally acclaimed rock bands from Japan utilize Mod imagery to market themselves. Shonen Knife has been the most globally renowned of these groups, due in part to touring with Nirvana during the band's last international tour in 1994. Known for often wearing matching, 60s-style dresses and outfits, and covering songs like the Kinks' 1965 hit "Till the End of the Day," the all-female Osaka trio has adopted Mod style while not always sounding like mid-60s rock. Asked about how the band came upon the Mod band "uniforms," lead singer and guitarist Naoko Yamano (b. 1961) replied, "Our mother liked to make dresses and she bought many 60s fashion magazines. Atsuko [Naoko's bandmate and sister] saw a book and was inspired by the 60s clothing and fashion and then she made Pierre Cardin or Mondrian, 60s style dresses." Another (now-defunct) Japanese group with a female singer, Pizzicato Five (P5), once released an album called *On Her Majesty's Secret Service* (1989) and one of their most popular songs is called "Twiggy Twiggy." One music writer described them as former "luminaries of the much-hyped *Shibuya-kei* scene... [Their] music combine[d] Burt Bacharach songcraft with go-go kitsch; chanteusy murmurings backed by an updated pastiche of everything that was fabulous about the 60s."[79] However, with a more digitized versus

guitar-based sound, they would also probably not have described themselves as a Mod band, but rather, one that was obsessed with the 60s. Finally, the fact that the Japanese magazine *Girls 60s* was not called *Girls Mod* underscored this gender division. What was presented in the magazine was visually Mod in every sense, from the miniskirted fashions to the recommended events and modernist furniture shops, to the ever-present image of the scooter. The use of these images succinctly encapsulated this gendered notion of Mod.[80] It must be, then, that if one is a female Mod, one is perhaps more appropriately described as a "60s Girl."

Is it the female population's near obsession with "cute" style that encouraged such identification? After all, the moniker "60s girl," immediately implies a girlishness that "Mod" does not. However, the phenomenon of *kawaii* or "cute culture" in Japan also parallels one of the gender identities discussed in the previous chapter. According to Peter Braunstein, Mod's "rejuvenating" sense of role playing via fashion was meant to stifle the onset of maturity.[81] In its sensibility of "thinking young" despite one's actual age, Braunstein maintained that Mod was unlike the later 60s counterculture because it asked everyone to *act* under thirty instead of *distrusting all those over this age*. The playfulness of bold colors, baby doll dresses, and Mary Jane shoes alone assured that women who desired extended girlhood could have their wish, at least on the surface. This concept of eternal girlishness is also something that has come to stereotype Japanese women. In this light, it is important to evaluate the ideal of *kawaii* and its connection to contemporary Japanese Mod culture.[82]

Though the exact meaning, like Mod itself, has been contested, *kawaii* can generally be translated as "cute." According to Japanologist Sharon Kinsella, *kawaii* has become a standard style aesthetic in Japan that can be applied to other fashions "such as [those of] preppy, punk, skater, folk, black, and French."[83] Though it has 1960s roots, too, *kawaii* became a more dominant aesthetic at the height of Japan's economic prosperity, the 1980s. It was coded as rebellious because "to be cute in this socioeconomic setting was to celebrate appearances and attitudes that are 'infantile and delicate at the same time as being pretty' and thereby participate in the creation of a utopia in the affluent environment where people could remain forever 'young,' 'playful,' 'childlike,' and thus 'liberated from the filthy world of adult politics.'" Like postwar Japanese youth, the *sarariman*, and the "mature" world he stood for, was completely unattractive, and this contrary youth style reflected this opinion.[84]

Given Mod's already recognizably youthful aesthetic, its combing with *kawaii* has created an especially sugary version of it, especially for females

involved in the subculture. This love of youthfulness and cuteness also hark-ens to the body type favored by mid-60s female fashions. Prior to one of the Tokyo Mod events I attended in June 2004, the French Blue scooter run and music showcase, Ronnie Fujiyama explained why she thought Mod fashion worked so well for Japanese women. "60s clothes… Mod… is a good look for skinny Japanese girls." In Ronnie's eyes, there was something integral to the typically svelte, Japanese female body that matched Mod's less-than-curvy designs (fig. 22).

Figure 22. Kae Doi (far left) and friends, Tokyo (Photo by Corey LeChat).

Her comment helped answer the question of why Twiggy's image abounded in twenty-first century, urban Japan and perhaps, why the former model's woman-child look resonated with Japanese women. Whether Mod or not, the connection between young Japanese women and Twiggy sug-gested a bond through girlish, pixie-like bodies. Longtime expatriate and writer Donald Richie maintains that the notion of *kawaii* in Japan is often equated with miniaturization, where "smaller—and cuter—is better" and that "cuteness is considered… to be a virtue."[85]

Beyond the aisles of *kawaii* Sanrio products and its icons such as "Hello Kitty" and "Chococat," Mod-themed or -accented toys were also available at Japanese stores. For instance, Twiggy's image did not merely adorn the ads

for the JCB "Linda" credit cards, but was made available to a potentially younger female audience through the then newly issued Twiggy Barbie-sized doll for sale at 8,300 Yen (approximately $80 U.S.). There were also mini, bendable Twiggy dolls available at 850 Yen (approximately $8 U.S.). Another doll company called Pullip (Korean, but marketed in Japan) made big-eyed dolls—not unlike the Margaret Keane paintings and prints made popular in the Mod era. These dolls were presented in 60s clothing such as go-go boots, miniskirts, and white-rimmed sunglasses selling for the equivalent of $67 US.[86]

As previously mentioned, Peter Braunstein has equated the original Mod movement with youthful optimism and exuberance. Similarly, Richie describes Japan's popular culture, one of "extended juvenility," where many young adult women still respond favorably to Hello Kitty "character goods," and even the Liberal Democratic Party once used a doll to promote their candidate for Prime Minister. Japan's love of cute seems a natural match for Mod style.[87] In the land of twenty-four-hour Pachinko parlors and rainbow-colored gaming arcades whose high winnings are usually plush toys and colorful candy, it makes sense that former teen model Twiggy and miniskirt inventor Mary Quant's products should still meet with positive reception in Japan. Mary Quant did not just invent the miniskirt; she also popularized a new way in which to be an adult woman. The 1960s are remembered as years dominated by youth and yet, based on standards of the decade, Quant was not young when her fashions became popular. Born in 1934, Quant was already thirty by the time she became famous. Despite her age, Quant not only designed fashions with a waifish, schoolgirl look, but also wore these clothes herself. [88] Quant wanted the rest of the world's female population to ignore the then-acceptable aesthetics for womanhood as well. In 2004 Japan, the girlish look was still prevalent and was a noticeable feature in many of the female Mods observed and interviewed for this study.

Modernist Japan: Final Thoughts

Over the course of forty years, Mod has woven itself into the thread of youth culture in many countries. Similar to Mods in Britain or America, contemporary Japanese Mods are looking to recapture a style that has spoken for them while also speaking of an innovative past. Unlike enthusiasts in U.S. or the U.K., my Japanese respondents conceptualized Mod much more noticeably along gender lines. In Japan distinctions were being made between what is "Mod" (mostly male) and what is "60s" (female). Some Japanese Mods did not solely see the style as linked to the mid-60s, but instead saw it as a continuous youth sensibility easily tied to the late 70s, early 80s, or mid-90s.

Comparatively, U.S. Mods placed less importance on what was "purely" Mod, and instead all things 60s were described by this word. Americans also placed little emphasis on the late-1970s revival, as it did not play as big a role in the U.S. as in England and Japan. Last, Mod female fashion is read as "*kawaii*" (cute), more so in Japan than in either the U.K. or the United States. Where Mary Quant's fashions or Mod icon Twiggy are seen as girlish, playful, or simply androgynous in the West, both reach a level of near virtuousness in Japan.

Mod is past and it is present. Mod is British and it is global. The Mod 60s view of modernity has become somehow endearingly antiquated in its retro-futurism and yet, has been deemed as more progressive and interesting than contemporary realities by many of its current adherents. Thus, Mods have continued touting the style's idealized, if not internalized, modernity. If Tokyo Mod Kae Doi confessed that she liked techno as well as Mod sounds from various decades, does that *still* make her a Mod? Right before hopping aboard her Vespa, Doi encapsulated the strange discourse that time and distance have produced when trying to conceptualize Mod today—whether in Tokyo, New York, Hamburg, or London. Doi stated, "I am a Modernist, so I like modern music.... Mod music is past music. So I am interested in Techno...more technology." Moments later Doi, dressed in a red mini-dress and go-go boots, raced off with her colorfully dressed friends. Later that night she was to spin vinyl for a Mod event in Roppongi where no techno would be played. Years later she would email me and explain further that she saw Mod as a forerunner to the Techno-oriented Rave culture: where young people took drugs and danced all night.

Mod "messages," just as in the 1960s, have continued to be transmitted through a variety of media and interpersonal forms of communication. Both in past and present incarnations, Mod can be seen as a fluid entity traveling through what anthropologist Arjun Appadurai identifies as various "scapes." In film or through the Internet, Mod transmits its ideology via a "mediascape," whereas interaction between Mods of various nationalities happens within an "ethnoscape," the commingling of mobile people.[89] Scholars such as David Muggleton, Rupert Weinzierl, and Andy Bennett have maintained that subculturalists today are more international by nature and tribal by definition.[90] One "Post-Subculture" scholar Geoff Stahl has described these "tribes" and their affiliated totems resulting from a "circulation of ideas, texts, styles, and people around the globe.... The institutional and infrastructural mechanisms that enable this mobility have produced networks, circuits, and alliances, all modes of communicative and community action, which traverses the globe."[91] Given these theorists' views, it is clear that Mod con-

tinues to exist in a form it was aspiring to in the mid-1960s. While 60s Mods looked forward to speedy and affordable international travel by supersonic jet and, hopefully at some point, space travel by rocket, the new millennium's travel and media technologies actually offer a much more diverse, well-informed, and instantly accessible international network (via digital means) of Mod peers. These contemporary flows of information and people may not be as romantic as the original mid-60s vision of supersonic or space travel, but they have allowed Mod's fantasy of international understanding through youth style, media, and technology to blossom.[92]

Is It a Mod World (After All)?

In October 1965, the American novelist James Michener was asked to judge a "battle of the bands"– type competition in suburban New York. Sitting alongside music producer Phil Spector and beloved regional radio DJ "Cousin Brucey," the author of *Hawaii* and *The Source* was asked to evaluate a bevy of Mod-influenced American teen bands. Initially surprised at the invitation, Michener nonetheless participated, even writing an article about it for the *New York Times*.

Michener stated that, though an unlikely judge for such an event, he was not "entirely a square," and "as a novelist [he] was fascinated by the sociology that accompanied the mania: the long hair, the Edwardian elegance among boys who would normally be repelled by such fashion... the phenomenon of teen-age [sic] screaming, and most important of all, the presence of great protest."[1] The way in which the famed author described his interest in this emergent youth culture is similar to the way I initially approached the intense study of the Mod subculture. Despite a lifelong interest in mid-60s culture and style, I have—much to my own astonishment—never been a Mod. However, I can honestly admit I have never been a "square," either— sampling from Goth to Riot Grrrl to Indie Rock—while a teenager and twentysomehting. More importantly, I too, often have wondered what deeper issues might be lurking behind the stylistic machinations of the Mods—past and present; American and foreign. What would have made young people in the 1960s, 1980s, or 2000s want to be Mods? Was it the melodic jingle-jangle of the guitar-based music? Was it the anti-mainstream, yet elegant, fashion? Or, was it a kind of protest? Does the adoption of the lifestyle express some deep-seated belief that all things Mod symbolize how contemporary life *could be*, rather than how it actually is?

Through the years, long before my doctoral research and this subsequent publication, I have read countless books about the 1960s in hopes of under-standing truly this idea of "Mod." Never finding a fully satisfactory answer, I felt that it was important to turn to those people who have either through coincidence of birth or later intentional "investigations," so to speak, become Mods. I believe those participants interviewed for this book offer heretofore undiscovered insights into the nuanced dimensions of what Mod culture is. It was truly these participants' personal histories that largely guided the

theme of each chapter: modernity, cosmopolitanism, gender, and how these concepts have translated in a non-Western, yet Westernized country.

As we have seen, in each decade's contemporary version of it, Mod youth have been the most optimistic of contrarians. When postwar Britain was clearly gray and class-bound, then Mods of that time envisioned and created a micro-world of colorful classlessness. Later, when 1970s Punk touted nihilism and an intentional ugliness, the Mod revivalist band the Jam channeled aggressive attitudes and music into frenetic, energizing anthems which, in turn, motivated teenagers to don once again elegant attire to counteract Punk's snarly "rattiness." Soon many young people returned to the "Mod fold" to invigorate a (by then) near-mythologized British youth identity. In the 2000s, Mod continued to be a source of national pride for current participants. These Mods have realized they are legacies of a long-standing, beloved youth movement that has stemmed from both the 60s and 70s incarnations, and has become a very international, if underground, export. Though they enthusiastically use new media to spread their sensibility, their coterie of DJs spin Soul, Rhythm and Blues, and Beat records that run contrary to the digitized "thump-thump-thumps" of the most popular of contemporary DJed music.

German Mods gladly took up the torch of reconceptualized modernity demonstrated to them by their British cousins. In the postwar period, those youths who became Mods felt truly trounced and battered by a recent fascist past that was no fault of their own. In order to show that they were wanting "in" on this emergent and progressive youth culture, and disagreed with their parents' values, young Germans eagerly adopted the spirit and style of Mod. The relatively close proximity between England and Germany allowed a faster transmission of Mod culture through, first, the Beatles, and then a myriad of other British groups. The desire to be "cosmopolitan" versus solely "German" is the strongest leitmotif inherent in Mod culture's evolution in Germany. This has continued through the many permutations of Mod— from the 1980s to the present. As many of my narrators indicated, Mod has functioned not just as an alternative to mainstream local, national, and international socio-political circumstances of the Federal Republic of Germany, but also to the humdrum aspects of bourgeois middle-class, adult life. The internationally-minded German Mod of today is ostensibly the most well-traveled and "connected" European of all.

The American discussion of Mod culture has hinged on the idea that its contrariness there since the 1960s has been connected with issues of gender identity. With Mod's seemingly "queer" connotations of masculinity and femininity, the American middle class found this new youth sensibility in-

credibly shocking and irreverent. Unlike the U.K. and Germany, where the ideas surrounding "modernity" and "cosmopolitanism" in connection with Mod have stayed relatively similar from the 60s to today, ideas surrounding the theme of gender have changed greatly. Instead of associating Mod fashions (though falsely) with effeminacy or, even, at times, homosexuality, contemporary scenes have illustrated how patently heterosexual this subculture usually is. This evidence supports the idea that a wider spectrum of gender aesthetics has become acceptable in not just middle-class American culture, but U.S. culture in general. The contrary or alternative aspect of Mod fashion today is, instead, the fact that its tailored look appears "traditional," or "old fashioned," even, in terms of male and female fashions compared to the less form-fitting, unisex look of more recent youth culture styles such as those connected to the Hip Hop and the Indie Rock scenes.

In the final chapter, Japan serves a microcosm for identifying Mod culture participants' dreams of an ultimate modern life—not just in a smaller, parallel culture to that of the mainstream—but actually in the makeup of Japan's cities themselves. This idea was then expanded upon in manifestations of cosmopolitanism and gender. Is Japan indeed the most Mod of all places today? Here, I posited that the project of postwar "modernization" there and the Mod subculture itself fused in a way that has not been as apparent in the other nations. On a more nuanced level, I also wanted to try answering why Mods in Japan are so dedicated—even though the culture's origins are so removed from their own. I wanted to emphasize that despite the limitations of distance and language, the visual rubric of Mod has been most ardently adopted and supported in the Japanese Mod scenes I observed. This simply magnified, for me, the inherent transnational appeal of all the various components of Mod identity.

I have actively sought to transcend not just geographic boundaries but intellectual ones. Just as the first wave of Mods borrowed from different nations' cultures to create what in their opinion was a kind of "ultimate modern style," I have drawn from a wide palate of scholarly work that has struggled with the tensions of identifying with a nation, age group, generation, or time period. In this sense, I have positioned Mod not just as a fashion or subcultural allegiance, but as a state of mind and lifestyle. This culture has its own complex histories, mythologies, and ideals, which have now spanned three generations. As the sources throughout this text have shown, those intellectuals who contributed to my understanding of the Mod diaspora come from not just communication studies, but also history, cultural studies, literature, sociology, cultural anthropology, urban and design history, and musicology. I realized early on that this interdisciplinary approach was necessary, since

those who adhere to the Mod way of life designate spaces, clothing, litera-
ture, music, design, modes of transport, and even hairstyles, as stamped with
their particular aesthetic. I do not believe as comprehensive a portrait of Mod
culture could have emerged without interweaving this complex network of
disciplinary viewpoints.

Overall the vision I hoped would radiate throughout this work was that
Mod was and is a youth subculture that set the tone for those to follow, yet is
clearly distinct from all the rest. For instance, like Rappers or Hip Hop art-
ists who wear lots of pricey-looking "bling" (jewelry), the earliest British
Mods showed-off expensive-looking suits and scooters. Like that of the
original working-class Mods, the favored image of current Hip Hoppers is to
wear clothing and accessories that aspires to moneyed status. The Glam
Rockers of the 1970s, many of whom had been Mods in their teenage years
(David Bowie, Marc Bolan), utilized a "queer identity," taking androgyny
several steps further. Wearing makeup, for example, was a norm for this sub-
cultural set. In the early 2000s, Indie Rock bands like the Strokes and Franz
Ferdinand began wearing suits and skinny ties, combining the look of 60s
Mod with its more "New Wave," sensibility from the late 70s and early 80s.
However, unlike these other youth cultures, the main distinction Mod con-
tinues to have is that it stemmed from a desire to create the ultimate modern
experience. Even as a supposedly "retro" lifestyle, the looking-back aspect has
more to do with roads of modernity not taken—that somehow these alterna-
tive routes may have led society to an even more satisfying and sophisticated
present-day existence. Mod is the only youth culture to valorize and embody
the hopes instilled in the modern project of "progress." The Mods I met, in-
terviewed, and observed—no matter in which country—often described the
discovery of the subculture as nothing short of an epiphany: Mod *is* energiz-
ing and youth preserving. It is also voluminous in its history and imagery. To
be a Mod is to look in the face of an often-disappointing world and still
think it is fantastic, because one has seen what is possible. One might see
Mod as an urban fairy tale come to life, which posits that once upon a time,
in the mid-60s, young people allowed their imaginations to run wild and let
those imaginings color the world. Those who continue to breathe life into
these visions and impulses of a "better modernity," believe that this is more
than a fairy story or mythology. It can be lived. To be a Mod is to "be real" in
a way that is not obvious in mainstream society. The "real" is an identity that
prefers leisure over work, for instance. That is where the authenticity of ex-
perience is found. Moreover, this reality has come from a utopian impulse to
believe that work, class, gender, and nationality do not predestine the course

of one's life. For a modern person, these traits are malleable, changeable. That is what the modern world *should be*—even if it is not.

I have attempted to make *"We Are the Mods"* as thorough as possible in my quest to carefully analyze the "hows" and "whys" of this long-standing, transnational youth culture. However, I am also of the belief that as an academic text, this should not be a stopping point—a "definitive text"—but a resource from which to draw. Just as I am indebted to scholars who have asked provocative questions and analyzed various cultural phenomena from their unique perspectives, I expect that this will function in a similar way. Hopefully, this examination of Mod will open up more dialogue and questions surrounding the difference between the ideals of modernity versus postmodernity in contemporary youth cultures. Moreover, I believe that scholars from the various disciplines I draw from will bring their own questions. I realize that this book could have been written using various methodological and theoretical frames. Future scholars of Mod and other youth cultures may want to examine further themes I did not detail, but are clearly part of Mod culture. For instance, design scholars could easily delve into more detailed readings of the symbols and signifiers of Mod. And, though, new media plays its part in describing the networking of Mod culture, it is not at the core of this text. As "new media" is on the lips of many up-and-coming communication scholars, those with that specialization could investigate more thoroughly the relationship between new media and Mod—especially in the years to come—as technological advances are sure to be forthcoming.

In the end, though, it is my greatest wish that readers are left feeling as if they can fully perceive the sights, sounds, and concepts that have made Mod culture the distinct youth culture it is. Whether enthusiastic shouts of "We Are the Mods" come with English, American, German, or Japanese accents, ultimately there is unity behind this declaration. It is more than just a call to action. It is the fervent belief that the modern world can be worth fighting for.

Notes

Introduction

1 Veloso and Dunn, "Tropicalista," 121; Denselow, *Guardian* (UK), June 11, 2004.
2 *Quadrophenia*, dir. Roddam, 1979.
3 Ehrhardt, *Die Beatles*, 102–103.
4 Refer to the bibliography for this and all subsequent interviews cited.
5 Synge, *Financial Times*, Sept. 18, 2004.
6 Savage, *Teenage*, 464.
7 Kater, *Hitler Youth*; Utley, "Radical," 207–228; Roper, "German," 499–516.
8 Hotz, "United Nation," 136.
9 Barnes, *Mods!*, 8.
10 Bourdieu, *Distinction*; Hall and Jefferson, eds., *Resistance*; Hebdige, *Subculture*.
11 Clarke, "Style," 187; Hebdige, *Subculture*, 54.
12 Ehrenreich, et al., "Beatlemania;" Kane, *Ticket*; Spizer and Cronkite, *Beatles Are Coming*.
13 Synge, *Financial Times*, Sept. 18, 2004.
14 Lummis, *Listening*, 20; Yow, *Recording*.
15 Thompson, *Voice*, 108.
16 For participant observation of subcultures, see DeWalt and DeWalt, *Participant*, 8; Lull, "Thrashing," 225–252; Fox, "Real Punks," 344–370; Drew, *Karaoke*.
17 "Hamburg-Große Wildstadt (Back to the Sixties: Hamburger Mod-Szene)," *Rund um den Michel*, NDR, Germany, June 24, 2007.
18 Much communication scholarship today tends toward the theoretical or critical, though there is a move being made by some scholars in this field to approach media studies with more of an eye toward "history as theory."
19 Marwick, *Sixties*, 16.
20 Acland, "Fresh Contacts," 44.
21 Peterson and Bennett, eds., *Music Scenes*; Muggleton and Weinzierl, *Post-Subcultures*.
22 James Carey, *Communication*, 14–22.
23 Kirby, "Blackett," 987.

Chapter One

1 For Piller's involvement with Mod, see Lentz, *Influential*, 75. For Fran Piller's running of the Small Faces Fanclub, see Hewitt and Hellier, *Steve Marriott*, 100; Lentz, *Influential*, 75. For Piller's music label and DJing, see *Acid Jazz*; "Interview with Eddie Piller."
2 Hall and Jefferson, eds., *Resistance*; Hebdige, *Subculture*; 52–54; Wiener, *English Culture*, 7, 46, 51; Giddens, *Modernity*, 14–15.
3 Ian Bradley, *British*, 7; Braunstein, *Myth of Decline*, 338; Hoggart, *Uses*; E.P. Thompson, *Working Class*; Frankel, *States of Inquiry*, 138–203; Wellhofer, "'Two Nations,'" 977–993.
4 Engels, *Condition*; F.M.L. Thompson, *Social History of Britain*, Vol. 1, 15, 33–34.Halsam, *Manchester*, xii; Burchardt, *Paradise*, 16–19; Palmer, *East End*; Hewitt and Hellier, *Steve Marriott*.
5 MacKay, *Modernism*, 5–6.
6 Savage, *Teenage*, 464.
7 Black and Pemberton, *Affluent Society?*, 187–189; Davey, *English*, 3.

8 Groom, "Rock Island Line?," 167–182; Brocken, *British Folk Revival*; De La Haye and
 Dingwall, *Subcultural Style*, 15, 38; Leese, *Britain*, 51; Boulton, *Jazz*, 145–161.
9 Leland, *Hip*, 11, 112.
10 Jonathan Green, *All Dressed-Up*, 41; Osgerby, *Youth in Britain*, 43; Houlbrook and Wa-
 ters, "Heart in Exile," 142–165; Woodbridge, *Rock 'n' Roll*, 14, 20; Curtis, "Mobile and
 Plastic," 57.
11 McKay, *Circular Breathing*, 116.
12 Barnes, *Mods!*, 1979, 8–9; Rawlings, *Mod*, 50, 53, 59; Hamblett and Deverson, *Genera-
 tion X*, 11.
13 Zdatny, *Hairstyles*, 24–26, 33; Bowen, "Three Basics."
14 Barnes, *Mods!*, 15.
15 Hebdige, *Subculture*, 44, 51, 52–3.
16 Lentz, *Influential*, 3; Wooldridge, *Rock 'n' Roll*, 16, 25, 60; DuNoyer, *Liverpool*, 18–19.
17 Halsam, *Manchester*, 85; DuNoyer, *Liverpool*, 53–54.
18 Richard Green, "Guestbook." Myra Rowe, "Guestbook."
19 Gould, *Can't Buy Me Love*, 133.
20 Qtd. in Halasz, "You Can Walk," 30.
21 Donnelly, *Sixties*, 35, 117.
22 John Hill, *Sex, Class, and Realism*.
23 Till, "Blues," 188–89; DuNoyer, *Liverpool*, 18–19; Frith and Horne, *Art*, 73; Ray Davies,
 X-Ray, 79.
24 "My Generation: The Birth of Rock," *Seven Ages of Rock*, prod. William Naylor, VH1.
25 Wilson, "Young London," 23–25; Wooldrige, *Rock 'n' Roll*, 134–36; Lentz, *Influential*,
 15–16.
26 Heckstall-Smith, *Safest Place*, 32.
27 Frith and Horne, *Art into Pop*, 35.
28 Hewitt, *Soul Stylists*, 25, 34; Rawlings, *Mod*, 11; Nowell, *Too Darn Soulful*, 15; Dave
 Davies, *Kink*, 46; Faithfull with Dalton, *Faithfull*, 16.
29 Barnes, *Mods!*, 13.
30 Merlis and Seay, *Heart and Soul*, 50–51. See also Nowell, *Too Darn Soulful*, 18; Moore,
 Rock, 65.
31 Anthony Marks, "Young," 103–104; Leland, *Hip*, 135.
32 Harry, "Mersey Beatle," 7. For examples of such articles, all by Harry, see "Newsbeat,"
 12; "Girl Group?," 16; "Meet the Girls," 4; Harry, "Giants," 12. For the paper's layout
 and advertising, see Harry, *Mersey Beat*.
33 DuNoyer, "Mr. Brian Epstein," 24–25; Levy, *Ready*, 70.
34 Jasper, *Top Twenty*, 85–88.
35 Gould, *Can't Buy Me Love*, 128; Dick Bradley, *Understanding Rock*, 12, 71, 73, 92.
36 Hoggart, *Uses*, 196.
37 Marwick, *Sixties*, 73; Levy, *Ready*, 111–113; Taylor, "Ready, Steady, Gone"; Spitz,
 Beatles, 457–485; Synge, *Financial Times*, Sept. 18, 2004.
38 Ayto, *Movers*, 144; Max the Mod, "Mods;" Cawthorne, *Sixties*, 124–129.
39 Twiggy, *Twiggy*, 12, 14, 19; *Twiggy… Mod Teen World*.
40 Whiteley, "Design Shift," 39; Rawlings, *Mod*, 64–65, 91; Cawthorne, *Sixties*, 142–143;
 Robert Chapman, "1960s Pirates," 165–178; Donnelly, *Sixties*, 82.
41 Bennett-England, *Dress Optional*, 80; Maureen Green, "£1,000,000 Mod," 32; Costan-
 tino, *Men's Fashions*, 94–98.

42 Wilson, "Young London," 26
43 Barnes, *Mods!*, 13, Hewitt, *Soul Stylists*, 30, 35; Lentz, *Influential*, 11. Qtd. in Nowell, *Too Darn Soulful*, 17.
44 Twiggy, *Twiggy*, 12; Donnelly, *Sixties*, 23.
45 "Your Sixties Memories."
46 "BBC on this Day."
47 Faithfull with Dalton, *Faithfull*, 26, 84, 75; Dave Davies, *Kink*, 52–53.
48 Namaste, "Politics," 225; Gamson, "Identity Movements?" 390–407; Adam Green, "Gay Not Queer," 521–545.
49 Hulanicki, *A to Biba*, 77, 81; "ARESGEE!," 25; Maureen Green, "The £1,000,000 Mod," 32; Rawlings, *Mod*, 59.
50 "Britain Invades," *History of Rock and Roll*, Dir. A. Solt, 1995; Perry, *London*, 7; Wooldrige, *Rock 'n' Roll*, 162; Jasper, *Top Twenty*, 101, 107.
51 "It's a Mod, Mod World," 5.
52 For Stones as "Mod," see Ravel, "Coming Mod Trends," 10; "Rolling Stones: Mod or Not?," 1.
53 Ray Davies, *X-Ray*, 120.
54 Dave Davies, *Kink*, 1–2; Hunter, "Voxes," "Britain Invades"; "My Generation."
55 Miller, *Kinks*, 5; Baxter-Moore, "Where I Belong," 145–166.
56 Donnelly, *Sixties*, 38; Wooldridge, *Rock 'n' Roll*, 134, 162–163; Fearon, "Mod Mailbag," 16; "North or South?," 12; "Night Club Listings."
57 Fearon, "Mod Mailbag," 16.
58 Epstein, *Cellarful of Noise*, 97.
59 "What Is There to Get Excited About?" 27.
60 Halton, "Changing Faces," 18.
61 "Did It Really Happen?"
62 Hamblett and Deverson, *Generation X*, 7–8.
63 Booker, *Neophiliacs*, 20.
64 Burns, "Editorial: Where?," 1.
65 Luckett, "Sensuous Women," 277–300.
66 Levy, *Ready*, 14.
67 Qtd. in Lev, "Blow-Up," 135.
68 Lentz, *Influential*, 32; *Amazing Journey: The Story of The Who*, dir. M. Lerner, 2007.
69 Laurie, *Teenage*, 7, 27.
70 "Mary Quant." Quant qtd. in Gardiner, *Bomb*, 133.
71 Laurie, *Teenage*, 7.
72 Fenichell, *Plastic*, 297.
73 "Informers: Everybody," 83.
74 *Kids Are Alright*, dir. J. Stein, 1979.
75 Hebdige, *Subculture*, 1–4, 124.
76 Goodrum, *National Fabric*, 208; 'United Kingdom, "Flag"; "MoD's Battle"; Malvern, "MoD Takes Aim."
77 *Kids Are Alright*, dir. J. Stein, 1979.
78 Marinetti, "Futurist."
79 Jasper, *Top Twenty*, 112.
80 *Small Faces under Review*; Jasper, *Top Twenty*, 118, 122, 124.
81 Hewitt and Hellier, *Steve Marriott*, 91.

82 "Clothes Shops," and "Venues," at *Manchester Beat* and *Brighton Beat*; "Your Letters," *Brum Beat.*
83 Margaret Goodman, "No Quiet," 26.
84 Cartmell, *Dances*, 1.
85 Halasz, "You Can Walk," 30.
86 "Britain Invades."
87 Henke and Puterbaugh, eds., *Take You Higher*, 28; Laurie, *Teenage*, 57.
88 Abelson, "Pop Thinks," 71.
89 Henke and Puterbaugh, eds., *Take You Higher*, 85, 103; Rozsak, *Making*, 145, 160, 161–170; McLean, *Magic Bus.*
90 "Informers: Psychedelic!" 46.
91 Muncie, "The Beatles," 48; Henke and Puterbaugh, eds., *Take You Higher*, 103; Mablen Jones, *Getting it On*, 85–6.
92 Clayson, *Yardbirds*, 110–121; Unterberger, *Unknown*, 37–43.
93 *Small Faces under Review*, Prod. Chrome Studios, 2005.
94 *Amazing Journey*; Marsh, liner notes, *The Who Sell Out*. MCA NR 11268, CD; Dougan, *Who Sell Out*; Robert Chapman, "1960s Pirates," 165–178.
95 Burk and Cairncross, *Good-Bye*; Hickson, *IMF Crisis*; Nevin, *Age of Illusions.* Mablen Jones, *Getting It On*, 137, 139; Szatmary, *Rockin' in Time*, 226–229.
96 Crane, "Writing," 1372–1385; Olick and Robbins, "Social," 105–140.
97 Hebdige, *Subculture*, 145.
98 Jasper, *Top Twenty*, 277–319.
99 Lines, *Modfather*, 40; Lentz, *Influential*, 78; Rawlings, *Mod*, 164.
100 Zuberry, "'Last Truly British,'" 539–555; Jack Moore, *Skinheads.*
101 Hebdige, *Subculture*, 55; DeWaters, "Hard Mods."
102 Brown, "Subcultures," 157–178.
103 "Brief History of Ska"; Knight, *Skinhead*, 26–36; Lentz, *Influential*, 53–4; Bernstein, *Decline*, 622–624.
104 Lentz, *Influential*, 55.
105 Leland, *Hip*, 6, 134–5.
106 Nowell, *Too Darn Soulful*, 37, 24.
107 Nowell, *Too Darn Soulful*, 40; Lentz, *Influential*, 57; Doyle, "'More Than,'" 313–332.
108 "Heart and Soul."
109 Qtd. in Verguren, *Modern Life*, 15.
110 Qtd. in Vergruen, *Modern Life*, 12.
111 Roddam, *Quadrophenia*, DVD commentary.
112 Mannay qtd. in Vergruen, *Modern Life*, 12.
113 Minty, "Mod Stories."
114 Bushnell, "Mod Squad."
115 Lines, *Modfather*, 24–26.
116 Luther, *Los Angeles Times*, Oct. 23, 1979; "Punk."
117 Walker, "Five Must-Buy Books."
118 Jasper, *Top Twenty*, 257.
119 Lentz, *Influential*, 111; *Extraordinary Sensations*; 007; *In the Crowd*; *Born in the Sixties*; *Maximum Speed.*
120 Kamp, "London Swings!"
121 Harris, *Last Party*; Fonarow, *Empire*, 41.

122 Rabinovitz and Geil, *Memory*, 10–11.
123 Ward, "Real *Quadrophenia*"; Claudia Elliott, "Too Old?"
124 "Homepage."
125 "Superbrands."
126 For female anthropologists' addressing their subject position in relation to sexuality, see Newton, "My Best Informant's Dress," 3–23; Coffey, "Sex in the Field," 66; Giovannini, "Female Anthropologist," 103–116.
127 "Mods and Rockers"; "Quadrophenia Walking Tour."
128 Gray, *Designing*, 7.

Chapter Two

1 Carr and Tyler, *Beatles*. My mother would later write her memoirs about growing up in a non-Nazi household during the Third Reich. See Feldman, *Voices*.
2 Rich, "Nazi Nightmare"; Waters and Carter, "Holocaust Fallout." See "The Nuremberg Laws." The Third Reich's Nuremberg laws unsurprisingly trumped Jewish law, where one's Judaisim is determined through the matrilineal versus the patrilineal line. Anyone with one Jewish grandparent was considered part of the Jewish "race."
3 Emig, ed., *Stereotypes*.
4 Voormann played bass on John Lennon's *Plastic Ono Band* (1970) and *Imagine* (1971) albums and George Harrison's *All Things Must Pass* (1970).
5 For conceptualizing and building Germany and a national identity, see Applegate, *Nation of Provincials*, 7–8; Stefan Berger, *Inventing the Nation*, 1, 6, 15; Kocka, "German History Before Hitler," 40–50; Grebing, "deutsche Sonderweg."
6 Koreska-Hartmann, *Jugendstil*, 18–19; Wyneken, *Jugendkultur*; Stambolis, *Mythos Jugend*; Trommler, "Mission ohne Ziel," 14–49; Ferschoff, "Jugendkulturkonzepte," 127–129; Malzacher and Dänschel, *Jugendbewegung*; Schäfer, "Bekenntnisse;" 383–385; Breyvogel, ed., *Piraten, Swings*; Balfour, *Withstanding Hitler*; Savage, *Teenage*, 375–383.
7 Youth-oriented magazines from the mid-to-late 40s often featured letters and articles from young people dealing with identity issues. I examined issues of *Das Junge Wort* and *Jugend* at the German Youth Movement Archive, Burg Ludwigstein, near Witzenhausen, Germany.
8 For the dynamic Weimar Republic and German 1920s, see Gay, *Weimar*; Lusk, ed., *Wilden Zwanziger*.
9 Siegfried, *Time*, 324–25. For German culture under the occupation, see also Clemens, *Britische Kulturpolitik*.
10 Herf, *Reactionary Modernism*, 2–3.
11 Gay, *Weimar*; Durst, *Weimar Modernism*; Weitz, *Weimar Germany*.
12 Cosmopolitanism favors internationalism over national loyalties. For reference to this definition, see Robbins, "Actually Existing Cosmopolitanism," 2. Speeches given by Hitler and Goebbels connected the Jewish Diaspora to cosmopolitanism—a worldview or lifestyle seen as anti-nationalist. Thus, this people without "a state of their own" were seen as "harming" the German state. Prange, ed., *Hitler's Words*, 76; Kallis, *Nazi Propaganda*, 93. For a celebratory perspective of "Jewish cosmopolitanism," see Slezkine, *The Jewish Century*.
13 Diefendorf, *Wake of War*, 3–17; Bahnsen and von Stürmer, *Die Stadt, die Auferstand*, 213–214; Clayson, *Hamburg*, 81; Jonathan Gould, *Can't Buy Me Love*, 79; For quote, see Norman, *Shout!*, 87.

14 Zint, *Große Freiheit 39*, 23–47; Klitsch, *Shakin' All Over*, 31–34; Krüger, "Mr. Beat," 50–55.

15 Krüger, *Beatles Guide Hamburg*, 15–16.

16 Martens and Zint, *St. Pauli*, 11.

17 "Beatles Mädchen," 52; "Liverbirds: Wir lieben die Germans," 30; "Bravo Stars von Heute: Die Liverbirds," 32–33; Klitsch, *Shakin' All Over*, 120–121.

18 Articus et al., *Beatles in Harburg*; Lennon qtd. in Nowicki, "Towns for Trying Out."

19 Krüger, "Hamburg Beat," 18; Krüger, "Beatles Venues," 27; Zint, *Große Freiheit 39*, 19–20.

20 For contemporary accounts, autobiographies, or histories addressing Beat music and style's impact on German youth during this period, see Scheler, "Beatles," 38–48; Peters, "Ein ganz neues," 373–374; Nimmermann, "Beat," 495–504; Krüger and Pelc, *Hamburg Sound*; Groessel, "Beat-Musik," 240–253; Schildt, *Rebellion and Reform*, Reichel, "Rolling Home," 125–151; Obermeier, *Wilde Leben*; Beckmann and Martens, *Starclub*; Zimt, *Große Freiheit 39*.

21 *Beatles Anthology*, dir. Geoff Wonfor and Bob Smeaton, 1996.

22 For the friendship between these art students and the Beatles, and Exi style's influence on the band, see Voormann, *"Warum,"* 35–43; Krüger, *Beatles in Hamburg*, 38–9; Clayson, *Hamburg*, 144–6; Kirchherr, "Last Word," 146; Kirchherr, "Forward," *Read the Beatles*, xv–xvi; Kirchherr, "Vorwort," *Beatles Guide*, 7–8; Krüger, "Beatles-Haarschnitt," 62–4; Vollmer, *Beatles in Hamburg*, 5–26; Ellen, "Ein, Zwei, Drei, Vier!" 15–17; Siegfried, *Time*, 219–220; "Beatles: Vier Liverpudel," 61.

23 Burkhard and Gesine, *Aftermath*, 5.

24 For more understanding of *Heimat*, see Blickle, *Heimat*; Applegate, *Nation of Provincials*.

25 Schildt, "Across the Border," 150.

26 Linne, *Jugend*, 197.

27 Kirchherr, "Forward," xv.

28 For Kirchherr's friendship with the Beatles and her relationships with Stuart Sutcliffe, and Gibson Kemp, see "Astrid weinte," 1–2; Spitz, *The Beatles*, 222; "Bravo Musik: Beat-Hochzeit," 24. Regarding international romances, see "Wie angle ich mir...?" 16–17; "Biographie;" *Rock Frauen*, 32–33.

29 Weißleder, "International,"2. A similar festival was held in 1966. See "Wilkommen," 23.

30 Klitsch, *Shakin' All Over*, 89–91. See also "Young London-Look" [Carnaby Street fashions], 28–31; "Mini-Mode & Musik" [miniskirts and dresses], 28–31; "Bravo-Modetip: Schwarz-weiser Chic," [black and white geometric, op-art clothes], 18–19; "Jetzt kommt die Op Zeit" [op art fashions], 54–55; "Top Teen Mode" [op art fashions], 43–44.

31 Siegfried, *Time*, 280–1.

32 "England: Halbstarke," 113–114.

33 "Leser-Report," 25.

34 *"Bravo* Modetip: Schicker Besuch," 64–65; "Bravo Modetip: Chic von der Alster," 30 Ehrhardt, *Die Beatles*, 102–103.

35 "Kommt der Zopf wieder?," 62–65.

36 Margarete et al., "Jugend," 545–552; "Claudia Antworte,'" 42–43.

37 Sturm, *Beat Goes On.*, 50–59, 61, 73; Mannel and Obeling, *Beat Geschichte(n)*, 54, 34, 43–47; Helfeier et al., *Wer Beatet Mehr?*, 8–9, 12–13; *Cuxhaven '66*.

38 Klitsch, *Shakin' All Over*, 95–97.

39 "Topteen Boutique," 42–43; "Boutiquen Boom," 74–75; Helfeier et al., *Wer Beatet Mehr?*; 155–159.

40 Leo, "Beatle Aufstand," 72–82; Kloos, *Pop 2000*; Grabowsky, "'Wie John, Paul, George, und Ringo,'" 49–51.

41 Several letters written to *Der Spiegel* in 1966 defended the NPD after the magazine ran a cover story of the opinion that the NPD was a latter-day NSDAP. See "Briefe," Apr. 4, 1966, 5–18.

42 For Germany as the land of poets and thinkers, see Jaimey Fisher, *Disciplining Germany*, 17.

43 "Die Beatles;" 44; "Beatles in Maß" [the Dave Clark Five], 36–37; "Häßlichkeit verkauft sich" [Rolling Stones], 52–53; "Fünf mit einem Namen" [Manfred Mann], 8–9; "*Bravo* Porträt: Nr. 1" [Georgie Fame], 42; "Musik wie Dynamit" [the Who], 20–21; Maase, *Bravo Amerika*, 104.

44 *Hit Bilanz*, 181, 204, 221, 239.For the Creation and the Smoke, see *Hit Balanz*, 243–44; "Bravo-Porträt: The Creation," 82; "Bravo-Porträt: Ein Scherz" [the Smoke], 26; Unterberger, *Unknown Legends*, 35.

45 This is based on examining all accessible 1964 to 1967 issues of *Bravo*, *OK*, *Star-Club News*, and *Musikparade* at Berlin's *Archiv der Jugendkulturen*, Leipzig's *Deutsche Bücherei*, and Ulf Krüger's personal collection of the *Star-Club News*. See also Siegfried, *Time*, 230–23; Klitsch, *Shakin' All Over*, 113.

46 "Kleines OK Wörterbuch," 11; Baacke, "Being Involved," 552–560.

47 "Von Euch: Cavern," 33.

48 Wedge, "Wo Treffen," 26–27; "Sommer-Sonne," 42–43.

49 Schildt, "Across," 155–156.

50 For the Ruby Rats, see "Von Euch: Beatbirds," 38; For the Lords in Poland, see "Liebegrüße aus Polen," 5–7.

51 Struck, *Rock Around*, 54–57; "*Hurra*" *Illustrierter*, "Hurra," 14–15; "3 Filme," 16.

52 "*Bitte anschnallen, es geht los!*" [Fasten your seatbelts, it's getting started!] Qtd. in *Beat-Club*, Episode 24, Sept. 23, 1967.

53 Siegfried, *Time*, 346–347.

54 For *Beat-Club*, see Jogschies, *Wer Zweimal*, 81; Nerke, *40 Jahre*, *Beat-Club*. See also Bush, "Biography: Equals." For *Beat!, Beat!, Beat!*, see "*Beat! Beat! Beat!*" Badurina, "*Beat! Beat! Beat!*"

55 Bergfelder, *International Adventures*, 156; Bausinger, *Typisch Deutsch*.

56 Nerke, *40 Jahre*, 64.

57 *Pop 2000: 50 Jahre Popmusik und Jugendkultur in Deutschland*, WDR Germany, 1999.

58 Qtd. in Klitsch, *Lords*.

59 Qtd. in Klitsch, *Rattles*.

60 *Beatles, Beat, und Grosse Freiheit: Der Sound von St. Pauli*. NDR Germany, Prod. by Weymar, Wernich and Goerke. Original airdate Dec. 30, 2006.

61 Sturm, *Beat Goes on*, 32.

62 *The Hamburg Sound* [Guestbook]. Several Nostalgic, 60s-centric events took place between 2006 and 2007. For examples, see "45 Jahre Star-Club"; "Hamburger Oldie Night!"

63 Goldhagen, *Hitler's Willing Executioners*; Kansteiner, *Pursuit*, 122–127; Welzer et al., *Opa war kein Nazi*.

64 Classen, *Bilder*, 156.

65 *Raumpatrouille Orion.* dir. by M. Braun and T. Mezger, ARD Germany, 1966.
66 This was the first sci-fi program on German TV and aired starting on Sept. 17, 1966.
 For its popularity, see "Mit Orion," 16–17; "MP Music," 4; "Futurology," 75; Jogschies,
 Wer Zweimal, 83; Bergfelder, *International,* 93.
67 "Deutsche Heute," 71.
68 Kloos, *Pop 2000*; Kelly-Holmes, "German Language," 47, 54, 57.
69 "Roboter Sound," 6–7; "From England: Beat-Time," 17.
70 Mills, *Sociological Imagination,* 171.
71 "Gesellschaft: Rauchgift," 104–105; "Gesellschaft: LSD," 48; "Gesellschaft: Hippies,"
 88–89; "Junge Leute," 135–141; Zint, *Große Freiheit 39,* 90–93.
72 Pells, *Not Like Us,* 43–44.
73 Klimke, "West Germany," 97–110; Mohr, *diskrete Charme der Rebellion;* Mitscherlich,
 Inability, xx; Bude, "German *Kriegskinder,*" 290–305; von Dirke, *"All Power,"* 29–66.
74 Möller, "Onkel Pö," 11–12; Avantario, "Von Krawall," 44; *Pop 2000,* Unterberger, *Un-
 known Legends,* 168–173.
75 Varon, *Bringing,* 196–253; von Dirke, *All Power,* 70–74; Stefan Klein, "Deutscher Herbst
 1977."
76 Varon, *Bringing,* 197; Becker, *Hitler's Children.*
77 Kansteiner, *German Memory,* 6; "Auschwitz," 30.
78 "Gesellschaft: Irgendwo Kaputt," 133–134; *Hit Balanz,* 457.
79 For Skinheads at Hamburg Mod events, see Avantario, "Von Krawall," 79. For a more
 recent event, see "Kings and Queens."
80 This history is also supported by Jenß, *Sixties Dress,* 170–171.
81 For "style tribes," see Polhemus, *Streetstyle.*
82 Niemczyk, "Mods," 30–34.
83 Sarah Cohen, "Scenes," 240–241.
84 Twickel, "Editorial," 7.
85 Avantario, "Von Krawall," 50–51, 79.
86 Martens and Zint, *St. Pauli,* 19, 21; Möller, "Onkel Pö," 11.
87 Bredy, "Mods sind auferstanden," 4.
88 Kraft, "Dandies," 22.
89 Niemczyk, "Mods," 33.
90 Lyotard, *Postmodern Condition*; Jameson, *Postmodernism*; Nehring, *Popular Music,* 3–20.
91 Hamm, "Mod Sei Dank!"
92 Wilde, "Britpop-Duell," 40–45.
93 For earlier observations of the Mods' "stealth rebellion," see Wolfe, "The Noonday Un-
 derground."
94 Jenß, "Dressed," 388. For the view that retro-fashions rail against "post-modernist pes-
 simism," see Willis, *Common Culture,* 26–27, 88, 149–150.
95 Jenß, *Sixties Dress,* 177.
96 Welzer et al., *Opa.*
97 Kansteiner, *Germany Memory,* 8–9.
98 Borneman, "Uniting," 288–289.
99 Inthorn, *German Media,* 35, 41; Spierling, "German Foreign Policy," 81.
100 Nayak, *Race*; Stahl, "Tastefully Renovating," 28; Roudometof, "Transnationalism,"113–
 135.
101 Manovich, *New Media,* 94.

102 *Sense-o-rama; The Scene; Inferno Beats; Moz Big Step; Blow Up Club.*
103 *Hip Cat Club;* Biff! Bang! Pow!
104 *Biff! Bang! Pow!*
105 "10th Magic Soul Weekender," "15th All Saints Mod Holiday," "Hot Mod Summer."
106 Jenß, *Sixties Dress*, 176.
107 Featherstone, *Consumer*, 64–80; Bennett, *Culture*, 70–72.

Chapter Three

1 "Gender Trouble" comes from Judith Butler's landmark queer theory work on the "performance" of gender. Butler, *Gender Trouble*.
2 Bleikhorn, *Mini-Mod*, 10.
3 *"American Mod."*
4 "Out in New York."
5 Bane, *Here to Stay*, xiii, 23, 29, 35.
6 Mooney, *(Not) Keeping Up*, 23–25; Bledstein, "Introduction: Storytellers," 1–2, 20–21.
7 Kidwell and Steele, "Introduction," 4.
8 Butler, *Bodies*.
9 Rauser, "Self-Made Macaroni," 101–117.
10 Haulman, "Fashion"; Steele, "Appearance," 16; Pettegrew, *Brutes*, 1–3, 40; Rotundo, *Manhood*, 227–229, 231–232; Slotkin, *Gunfighter*, 30, 66–67, 74; "Urban Population," 502–509; Kimmel, *Manhood*, 58; Mason, *English Gentleman.*"
11 Segal, "Norman Rockwell," 633, 637, 638, 639–640.
12 Packard, *Queer Cowboys*; Billington and Hardaway, eds., *African Americans*; Stewart and Ponce, *Black Cowboys*; Chauncey, *Gay New York*, 52; Banner, *American Beauty*, 227, 239–240; Segal, "Norman Rockwell," 643.
13 Welter, "True Womanhood," 151–174; Kessler-Harris, *Women*, 35–44, 63, 67; Fraundorf, "Labor Force Participation," 401–418.
14 Katz et al., "Women and the Paradox," 67; Kitch, *Girl on the Magazine*, 37–44; Banner, *American Beauty*, 154–159; Barnet, *All-Night Party.*
15 Jeff Hill, *Defining* Moments, 50–51.
16 Ogren, *Jazz Revolution*; Kitch, *Girl on the Magazine*, 122, 131, 133, 135; Zeitz, *Flapper.*
17 "Rockwell's Rosie"; Yellin, *Our Mothers' War*, 43; Wise, *Mouthful*, 1–27.
18 Kessler-Harris, *Women*, 141–143.
19 Leffler, *Soul of Mankind*; LeFeber, *Cold War*; McMahon, "American State," 45–46.
20 May, *Homeward Bound*; Remmers and Radler, *American Teenager*, 31; Savage, *Teenage*, 464.
21 Whyte, *Organization Man;* DeHart, "Containment," 124–155; Savage, *Teenage*, xv; Cohan, *Masked Men*, 203, 252; Gans, *Levittowners*; Riley, *Fever*, xiii, 17–19; Marcus, *Mystery Train*, 120–152; Lipsitz, *Time Passages*, 118–119.
22 Galbraith, *Affluent*; Marler, *Queer Beats*; Leland, *Hip*, 7.
23 Breines, "'Other Fifties,'" 382–408.
24 Steinberg, *Hatless Jack*; Craughwell-Varda, "Jacqueline," 291; Douglas, *Where*, 39–41; Braunstein, "Forever Young," 244.
25 Riley, *Fever*, 36, 43, 45; Warwick, *Girl Groups*; Cyrus, "Selling an Image," 173–193.
26 Marks, *New York Times*, Feb. 6, 1994.
27 "New Madness," 64; "Beatlemania," 104.

28 Gardner, *New York Times*, Feb. 8, 1964; Inglis, "Beatles Are Coming!" 95; Gunderson, *USA Today*, Feb. 24, 2004; Margolis, *Christian Science Monitor*, Feb. 9, 2004.

29 Kaplan, "Teen Spirit."

30 Fricke, "Best in Show."

31 De Hart, "Containment at Home," 133.

32 "Youth in Uniform," *New York Times*, June 7, 1964; Emerson, *New York Times*, July 23, 1964; Carthew, *New York Times*, Nov. 7, 1965; Carthew, *New York Times*, Sept. 6, 1964. For the body as a site for the inscription and display of cultural norms, see Butler, *Gender Trouble*, 8.

33 Evan Davies, "Psychological," 280.

34 Giuliano and Giuliano, *Beatles Interviews*, 67; Geyrhalter, "Effeminacy," 224.

35 "What the Beatles have Done," 58–59; "Beatles Make Long Hairs," *New York Times*, Oct. 14, 1964; "Unkindest Cut," 4; "School Orders Boys," *New York Times*, Dec. 17, 1964; Carthew, *New York Times*, Sept. 6, 1964; Graham, "Flaunting the Freak Flag," 522–543.

36 Nik Cohen, *Awopbopaloobop*, 203.

37 Robins, "British Invasion"; Shelton, *New York Times*, Aug. 11, 1965.

38 Carter, *New York Amersterdam News*, Mar. 11, 2004; "U.S.-Britain Relations,"*Pittsburgh Courier*, May 29, 1965.

39 "Ed Sullivan Show."

40 Whitburn, *Billboard*, 253, 558, 617, 538, 348, 29, 697, 51.

41 Bart, *New York Times*, Jan. 4, 1965; Coates, *Man's, Man's World*, 147–150; Austen, *TV A-Go-Go*, 25–30.

42 "Shindig!"; "English TV Scene," 20; "Shindig! Can TV's Big Time Teen Show Survive?" 54–55, 82; "England's 'Ready, Steady, Go' Girl," 32–35.

43 "Britain Conquers," 31; Kahn, "On the Flip Side," 44; This conclusion came from scanning all available issues of these magazines at the Music and Popular Culture libraries at Ohio's Bowling Green State University.

44 Fuller, "Wonderful Year," 8.

45 Will Fisher, *Materializing*, 131,142; Synott, "Shame," 384.

46 "If You've Got to Go Beatle,'"36–39; The bob was a super-modern, chin-length cut for women in the 1920s, see Banner, *American Beauty*, 271.

47 Laurie, "Mods and Rockers," 68, 115; "Britain Has Its Own," 61–64.

48 Bauer, "Minneapolis Mods," 79; M9.

49 Newman and Benton. "Man Talk," 132

50 Lingeman, "Pop Sex," 185.

51 Guest, "Mods vs. Rockers," 22–23; Guest, "London's Mods: Too Much," 76; Guest, "London's Mods: New Thoughts," 34, 36–37.

52 "No Crew Cuts," 8; "English Boys," 12; "Likes Masculine," 10; "Wake Up," 15.

53 Naomi Klein, *Promiscuities*, 55.

54 "Fashion: Sleek 'Space' Flair," 91–92; "Fashion: It's OP," 52–54; "Courrèges: Space Ladies," 47–65; "Paris: New Jet-eration," 142–145; and "Paris: News," 255–259.

55 "Juvenile Look," 43–48B, 52; LeDuc, "Courrèges: Slaying," 244; "Fashion: Sugar and Spice Look," 99–100; Bleikhorn *Mini-Mod*, 19; Braunstein, "Forever Young," 245.

56 Rowbotham, *Century of Women*, 353–354. For little girls' Mod fashions, see "Gimbels," *New York Times*, Feb. 18, 1966.

57 de Beauvoir, *Second Sex*, 268.

58 Peacock, *Fifties*, 54, 58; *Cosmopolitan* editor and "thirtysomething," Helen Gurley Brown was one of the first to use "girl" in an empowering way. See Helen Gurley Brown, *Sex and the Single Girl.*

59 Friedan, *Feminine Mystique*, 336; Radner, "Introduction," 10.

60 "Courrèges: Space Ladies," 47–65.

61 Lobenthal, *Radical Rags*, 86; Bleikhorn, *Mini Mod*, 70–71, 73, 75.

62 Karlstein, "To Editors," 14.

63 "Fashion: Teen-age Computer," 83.

64 Bicks, "To Editors," 17; Gordon Brown, "To Editors," 17.

65 Bauer, "Mod in America," 47.

66 "Guys Go All Out," 82 – 90; Bauer, "Mod in America," 47.

67 Letters to the editor were seen as "an important reflection of reader involvement." See Abrahamson, *Magazine-Made America*, 59.

68 Pinkham, "To Editors," 20; J. Carey, "To Editors," 12; Baublitz, "To Editors," 20.

69 Vergani, "To Editors," 20; Rugg, "To Editors," 20.

70 Cover, *Teen*, May 1964; "If You've Got to Go Beatle," 36; "Is It a Boy or a Girl?" 7; "He Likes His Hair,"4; "New Fads," 4.

71 "Shapely Classics," 31; "Watermill Jumper," 22; "Life Stride," 62; "Le Voy's," 91.

72 Whiteley, "Throw-Away Culture," 3–27; "Mattel," 7.

73 McLuhan and Leonard, "Future of Sex," 57.

74 Pryce-Jones, "Opinion," 85.

75 "Mattel," 8. For Twiggy collectables, see, "Fashion," *Twiggy Official Site.*

76 *Twiggy: Mod Teen World*, 4, 7.

77 "Arrival of Twiggy," 33; "Fashion: Twiggy Makes," 99–101; "Is It a Girl?," 84–90.

78 Nagel, "To Editors," 14; Coppedge, "To Editors," 14; Staudinger, "To Editors," *Life*, 14.

79 "Youth Invades," 75–83; Cameron, "Bad Scene," 58–59; "Inside the Hippie Revolution.," 58–64; Whitburn, *Billboard*, 677.

80 "Is Mod Dead?," 73–74.

81 "In Memoriam," 38–39. The more popular *Shindig!* and *Hullabaloo*, which had first broadcast in 1964 and 1965, respectively, had been cancelled in 1966.

82 Bodroghkozy, *Groove Tube*, 74. For late 60s, "ethnic fashions," see Rowbotham, *Century*, 356.

83 "The Mod Party," *I Dream of Jeannie*, NBC, Apr. 24, 1967; "Mod, Mod World (Part I)," *That Girl*, ABC, Dec. 7, 1967; "Mod, Mod World (Part II)," *That Girl*, ABC, Dec. 14, 1967.

84 "*Youthquake*," 11.

85 Derek Taylor, *Twenty*, 13.

86 Marwick, *Sixties*, 481–2.

87 For this sixties scholarship, see Gitlin, *Sixties*; Kaiser, *1968*; Echols, *Shaky Ground*; Jenkins, *Decade of Nightmares.*

88 Braunstein, "Forever Young," 252.

89 Edelstein and McDonough, *Seventies*, 141–144, 159–161; Auslander, *Performing Glam*; Buckley, *Elton*, 133–135; Matheu and Bowe, ed., *Creem*, 89.

90 Edelstein and McDonough, *Seventies*, 178–179; Strongman, *Pretty Vacant*; Sinclair, "Punk," 109–116; Hejnar, "Next Decline," 117–122.

91 Davey, *English Imaginaries*, 93.

92 Abbey, *Garage Rock*, 55; Hilburn, *Los Angeles Times*, Nov. 21, 1979; Maslin, *New York Times*, Nov. 2, 1979; Maslin, *New York Times*, Nov. 13, 1979; Japenga, *Los Angeles Times*, Sept. 20, 1982.

93 Arnold, *Los Angeles Times*, Oct. 18, 1982.

94 Batchelor and Stoddart, *1980s*, 31–34.

95 Benson, *Los Angeles Times*, Jul. 21, 1980; Caulfield and Garner, *Los Angeles Times*, May 24, 1981.

96 Long, "Epicenter."

97 Japenga, *Los Angeles Times*, Sept. 20, 1982.

98 Hilburn, *Los Angeles Times*, Mar. 18, 1980; Waller, *Los Angeles Times*, May 23, 1982.

99 Atkinson, *Los Angeles Times*, Aug. 15, 1980.

100 Palmer, *New York Times*, Apr. 3, 1983; Harrington, *Washington Post*, Sept. 28, 1984.

101 Goldstein, *Los Angeles Times*, Dec. 9, 1979; Atkinson, *Los Angeles Times*, Aug. 15, 1980; Lee, *Los Angeles Times*, Jan. 18, 1982; Hilburn, *Los Angeles Times*, June 1, 1982; Japenga, *Los Angeles Times*, Sept. 20, 1982; Spurrier, *Los Angeles Times*, Jan. 30, 1983; Morris, *Los Angeles Times*, Dec. 18, 1983; Lee, *Los Angeles Times*, Dec. 18, 1983.

102 Fred Davis, *Fashion*, 107; Fraser, *Fashionable*, 240.

103 Rollin, *Teen Culture*, 284–285; Batchelor and Stoddart, *1980s*, 31–34; Kompare, *Rerun Nation*, 131–168.

104 Kruse, *Site and Sound*, 16, 19–20, 27, 36, 79, 103.

105 *99th Floor*, 1, 6.

106 Lentz, *Influential*, 116.

107 Straw, "Rock Music Culture: Heavy Metal," 451–461; Waksman, "Grand Funk Live!," 157–161; Waksman, "Cock Rock," 237–276.

108 Arnold, *Los Angeles Times*, Feb. 24, 1982.

109 For gay teens coming out in the 1990s, see Rollin, *Teen Culture*, 344.

110 Ginsberg, "Savoir Blair," 102–109; Pergament, "Mod World," 128–137; "Mod Squad," 196–213; "English Beat," 161–167.

111 For stereotypical gay/lesbian style, see "Men from Venus," *New York Times*, Oct. 19, 2001; Stephanie Taylor, *Washington Post*, May 4, 2004.

112 Rollin, *Teen Culture*, 332–334, 346–347.

113 Price III, *Hip Hop*, 15–16; Rose, *Black Noise*, 7–8.

114 Grossman and Scott, "'Twentysomething," 57–62; Blumenfield and Newman, *New York Times*, May 16, 1993.

115 This came up in several of my interviews.

116 Fraser, *Fashionable Mind*, 240.

117 Barrell, "Fantabulous World."

118 "Lisa Perry."

119 Clugston-Major, *Blue Kids*; Clugston-Major, *Blue: Absolute*; Clugston-Major, *Scooter*.

120 Clugston-Major, *Blue: Kids*, 32.

121 Clugston-Major, *Scooter*, 9.

122 Hartley, *Go-Between*, 1; Adam Atkinson, "MOD-Century," 76.

123 Schou, *Pittsburgh Post-Gazette*, Nov. 5, 2005.

Chapter Four

1 *Girls Sixties*, Spring 2004, 15.

2 John Nelson, *Enduring Identities*, 8.

3 Annalise Nelson, "Kyoto," 414.
4 Schilling, *Encyclopedia*, 263–268.
5 User Comments, "Mods Mayday Tokyo;" Bartz, "Fuzzy Logic;" Chadwick, "Event Review;" Templado, "Blasting."
6 Waley, "Re-Scripting the City," 372.
7 Koestler, "For Better or Worse...," 63–79.
8 McGray, "Japan's Gross National Cool," 44–54.
9 Aoki, *Fruits*; Preston, "Planet;" *Lost in Translation*, Dir. S. Coppola, 2003.
10 The subsequent sections will examine this more thoroughly.
11 Mitsukuni, *Hybrid Culture*, 15–17, 38–40; Buruma, *Inventing Japan*, 9–15; Tipton, *Modern Japan*, 263.
12 Bognar, "Archaeology," 11; Mitsukuni, *Hybrid Culture*, 8–11; Lutum, "Hybrid Consciousness," 2.
13 Kelly, "Sense and Sensibility," 79–106; Qtd. in Hayford, "Samurai Baseball vs. Baseball in Japan"; Whiting, *You Gotta Have Wa*.
14 Kelly, "Introduction: Locating the Fans," 10–11. Images of Japanese "group mentality" can be totalizing and require more nuanced readings for fear of falling into Western stereotyping. Nonetheless, I find this idea of Japanese group mentality an intriguing parallel to Mod culture—a group of "individualists" who also strongly valorize collectivity and community.
15 Fiske, *Reading the Popular*, 10.
16 Preston, "Planet."
17 Matthews and White, *Changing Generations*; Greenfield, *Speed Tribes*; Craig, ed., *Japan Pop!*; Treat, ed., *Contemporary Japan*.
18 David Goodman, *Return*, 19; Hershey, *Hiroshima*.
19 For quotes, see Sheppard, "An Exotic Enemy," 303. For American racism toward the Japanese in World War II, see Dower, *War without Mercy*; Higashi, "Melodrama," 38–61; Zolberg, "Contested Remembrance," 565–590.
20 Buruma, *Inventing Japan*, 138–144.
21 William Chapman, *Inventing Japan*, 5; Buruma, *Inventing Japan*, 129–152; Tipton, *Modern Japan*, 154–162; Cope, *Japrocksampler*, 28–32.
22 Novak, "2·5×6 Metres," 17; Dixon, "Introduction," New Japanese Architecture, 9.
23 Cope, *Japrocksampler*, 35–36; Schilling, *Encyclopedia*, 197–198; Lipton, *Modern Japan*, 187.
24 Hunt, "Editorial," Sept. 11, 1964, 2–3.
25 Buruna, *Inventing Japan*, 113.
26 Koestler, "For Better or Worse...," 90.
27 Quant, "The Young," 87.
28 Zimmermann, "Asia," 45.
29 Burns, "Editorial: Mod Scene Booming," 1.
30 Takarajima, *Encyclopedia*, 16.
31 Jackson, *Sixties*, 109; Fogg, *Boutique*.
32 McNeil, "Myths of Modernism," 281.
33 Collins, "Visionary Drawings," 253, 247; Kurokawa, *Metabolism*, 26–27; Wardell, "Capsule Cure," 42–47; Waley, "Re-Scripting the City," 372.
34 Rougier, "Young in Rebellion," 89; Schilling, *Encyclopedia*, 200.

35 Sadin, "Group Sounds," 177; Cope, *Japrocksampler*, 87–89; Trumbull, *New York Times*, May 22, 1966; Chapin, *New York Times*, July 1, 1966; McKinney, *Magic Circles*, 127; For Japanese radicals, see Igarashi, *Bodies of Memory*, 194–195.

36 Some of this footage is also found in the *Beatles Anthology*, 1995. For quotes, see "1966"; Said, *Orientalism*, 6.

37 Takarajima, *1960nen Daihyakka*, 102, 104, 106; I. Hitomi, "The Spiders."

38 Launey, "Not-so-Big in Japan," 203–225; Atsuko "Japanese Corporations," 317–326; Lash, "Japanese Rock," 12. See also the reprinted 45 sleeves in these CDS: Various Artists, *Wildworld Volume Two: Japan Wild Favorites!* Wildworld 002, CD; Various Artists, *GS Meets Soft Rocks*, Chronicle TECN-25706, CD.

39 Cope, *Japrocksampler*, 93–94; Schilling, *Encyclopedia*, 202–204.

40 Tôru, "Introduction," 259; Sadin, "Group Sounds," 178; Cope, *Japrocksampler*, 99.

41 Sullivan, "'More Popular,'" 313–326; Gould, *Can't Buy Me Love*, 346–347.

42 David Goodman, *Return of the Gods*, 14.

43 Aoyagi, *Islands*, 33.

44 Indra, "It's About Faith," 171.

45 Pilgrim, "The Artistic Way," 285.

46 Lifton, "Individual Patterns," 371.

47 Chidester, "Church of Baseball," 225.

48 "City Guide: Japan."

49 Prieler, "Japanese Advertising's," 239.

50 *Matthew's Best Hit TV.*

51 Twiggy "products" were ubiquitous in Japan in summer 2004. Japanese toy company Medicom launched a line of Twiggy dolls. The packaging for these dolls announces in English, "Mod Queen Twiggy Begins Again!" JCB's "Linda" project team, made up of women in their twenties and thirties, chose 60s-era images of Twiggy for their credit card logo because, per team leader: "When I first saw photos of Twiggy I couldn't believe they were more than thirty years old.... With her fashion and make-up, she could fit right into the 'in' set in Tokyo today" (Kanno, "Twiggy: '60s Fashion Icon Returns"); Tokyo and Osaka have re-created Liverpool's Cavern Club. These "Caverns" feature Japanese Beatles tribute bands. The 2004 exchange rate was 100 Yen to the U.S. dollar.

52 See, for instance, the CD packaging of The Collectors, *More Complete Set of the BAIDIS Years*, Baidis Tecn-35829-30, CD.

53 *2001*, dir. Kubrick, 1968; *Stanley Kubrick.*

54 For this view of "retro-futuristic nostalgia," see Guffey, *Retro*, 23–24.

55 Jackson, *Sixties*, 83, 109.

56 Sakuraba, "Different," *Nikkei Weekly*, Nov. 15, 1999.

57 Katoh, "Swinging London," 51.

58 "Girls 60s Cinema Close Up," 57; "Mod Girl Group," 26–28.

59 Clammer, *Contemporary Urban Japan*, 47; Waley, "Re-Scripting the City," 363, 372–373; Chaplin, *Japanese Love Hotels*, 94.

60 Schivelbusch, *Railway Journey*, 57.

61 Qtd. in "Vespa Obsession."

62 Hebdige, *Hiding in the Light*, 111.

63 It is said that Japan oscillates between a nostalgia for the "quaint Asia" it has never been—that of southeast Asia—and, for instance, idealized Western pasts, like that of the

American 1950s, the styles of which became very popular in the 1980s. See Iwabuchi, "Nostalgia," 549; Marling, "Letter from Japan," 107.

64 Ibid.
65 Qtd. in Lentz, *Influential*, 131.
66 Bartz, "Fuzzy Logic."
67 Muggleton, *Inside Subculture*, 135; Bourdieu, *Distinction*, 170; Thornton, *Club Cultures.*
68 Muggleton, *Inside Subculture*, 135.
69 For possible institutional reasons, see Aspinall, "Paradigm of 'Small Cultures,'" 255–274.
70 Stanlaw, *Japanese English*, 1.
71 "Uppers!"; "Shapes of Things;" "Twist and Shout;" "Readymade Weekend."
72 Stevens, *Japanese Popular Music*, 155.
73 Qtd. in Lentz, *Influential*, 130.
74 Prieler, "Japanese Advertising's," 240.
75 Mitsukuni, *Hybrid Culture*, 115.
76 McRobbie and Garber, "Girls and Subcultures," 209–222.
77 Qtd. in Lentz, *Influential*, 154.
78 Stevens, *Japanese Popular Music*, 147.
79 Haw, "Pizzicato Five Profile."
80 *Girls 60s* is produced in Tokyo by Masahiro Hoizumi and published by Tetsuya Ueda. In July 2004, the second issue had just hit newsstands. The colorful pages feature various fashion spreads of new and vintage clothes of the Mod style, while advertisements run the gamut from selling scooters to wigs.
81 Braunstein, "Forever Young," 251.
82 Iwao, *Japanese Woman*; Liddle and Nakajima, *Rising Suns, Rising Daughters*; Berger, "Japanese Women," 112–123; Kinsella, "Cuties," 220–254.
83 For *kawaii*, see Goy-Yamamoto, "Japanese Youth," 271–282; Kinsella, "Cuties," 220; Hjorth, "Odours of Mobility," 39–55; Allison, "Portable Monsters," 381–395; Drake, "Quest for Kawaii," 46.
84 Aoyagi, *Islands*, 82.
85 Richie, *Image Factory*, 54–56.
86 Keane, *MDH Margaret Keane.*
87 Richie, *Image Factory*, 53.
88 Gardiner, *Bomb*, 133.
89 Appadurai, "Disjuncture," 295–310.
90 Muggleton and Weinzierl, eds., *Post-Subcultures Reader*; Bennett and Kahn-Harris, eds., *After Subculture.*
91 Stahl, "Tastefully Renovating," 28.
92 Curtis, "Highly Mobile and Plastic," 46–63; Whiteley, "Pop," 31–45; Osgerby, *Youth Media*; Atton, *Alternative Internet*, 1–24; Spencer, *DIY*, 70–88.

Conclusion

1 Michener, *New York Times*, Oct. 31, 1965.

Bibliography

1 On file in the Department of Communication, University of Pittsburgh. Hereafter "DCUP."

Bibliography

007 [fanzine], issue #2, circa 1985.

"3 Filme, 3 Geschichten." *Bravo*, Feb. 7, 1966, 16.

"3. Hamburg Allnighter" [handbill]. Circa August 1984, Hamburg. Given to author from Alain Ayadi.

"10th Magic Soul Weekender" [handbill]. Circa May 2007, Madrid. Collected by author.

"15th All Saints Mod Holiday 1992–2007" [handbill advertisement]. Circa Oct. 2007, Lavarone, Italy. Collected by author.

"45 Jahre Star-Club" [flyer] circa April 2007. Collected by author.

99th Floor [fanzine]. Fall 1985–Winter 1986.

"1966." *Beatles Photos and Quotes Database* at http://www.geocities.com/~beatleboy1/db66. html (accessed Nov. 15, 2004).

Abbey, Eric James. *Garage Rock and its Roots: Musical Rebels and the Drive for Individuality.* Jefferson, NC: McFarland, 2006.

Abelson, Lucy. "Pop Thinks." *Honey*, Mar. 1967, 71.

Abrahamson, David. *Magazine-Made America: The Cultural Transformation of the Postwar Periodical.* Cresskill, NJ: Hampton Press, 1996.

Ackerman, Michael. "The Hippie Put-On." *Mademoiselle*, Sept. 1967, 40–44.

Acid Jazz Records at http://www.acidjazz.co.uk/pages/acidjazz.htm (accessed Aug. 14, 2007).

Acland, Charles R. "Fresh Contacts: Global Culture and the Concept of Generation." In *American Youth Cultures*. Edited by Neil Campbell. New York: Routledge, 2000. 31–52.

Allison, Anne. "Portable Monsters and Commodity Cuteness: Pokéman as Japan's New Global Power." *Postcolonial Studies* 6 (2003): 381–395.

"*American Mod.*" *Celebrity Café* at http://thecelebritycafe.com/ movies/full_review/112.html (accessed Aug. 18, 2008).

Aoki, Shoichi. *Fruits.* New York: Phaidon, 2001.

Aoyagi, Hiroshi. *Islands of Eight Million Smiles: Idol Performance and Symbolic Production in Contemporary Japan.* Cambridge, MA: Harvard University Asia Center, 2005.

Appadurai, Arjun. "Disjuncture and Difference in the Global Cultural Economy." *Theory, Culture, and Society* 7 (1990): 295–310.

Applegate, Celia. *A Nation of Provincials: The German Idea of Heimat.* Berkeley: University of California Press, 1990.

"ARESGEE! *Ready Steady Go!,*" *Boyfriend*, Nov. 7, 1964.

"The Arrival of Twiggy." *Life*, Feb. 3, 1967, 33.

Articus, Rüdiger et al. *Die Beatles in Harburg.* Hamburg: Christians, 1996.

Aspinall, Robert W. "Using the Paradigm of 'Small Cultures' to Explain Policy Failure in the Case of Foreign Language Education in Japan." *Japan Forum* 18:2 (July 2006): 255–274.

"Astrid weinte vor Freude." *Musikparade*, June 6, 1966, 1–2.

Atkinson, Adam. "MOD-Century Menswear." *Lux*, Mar. 2008, 76–79.

Atsuko, Kimura. "Japanese Corporations and Popular Music." *Popular Music* 10 (Oct. 1991): 317–326.

Atton, Chris. *An Alternative Internet.* Edinburgh, UK: Edinburgh University Press, 2004.

"Auschwitz: Eine Generation fragt." *Der Spiegel*, Feb. 5, 1979, 30.

Auslander, Phillip. *Performing Glam Rock: Gender and Theatricality in Popular Music.* Ann Arbor: University of Michigan Press, 2006.

Austen, Jake. *TV-A-Go-Go: Rock on TV from American Bandstand to American Idol.* Chicago: Chicago Review Press, 2005.

Avantario, Michele "Von Krawall bis Totenschiff: Punk, New Wave und Hardcore: 1977– 1987." In *Läden, Schuppen, Kaschmmen: Eine Hamburger Popkulturgeschichte.* Edited by Christoph Twickel. Hamburg: Nautilus, 2003. 41–91.

Ayadi, Alain. Oral history interview with author. Digital Recording. Einen Sommer in August café, Berlin, Nov. 13, 2006, DCUP. [1]

Ayto, John. *Movers and Shakers: A Chronology of Words that Shaped Our Age.* Oxford: Oxford University Press, 2006.

Baacke, Dieter. "Being Involved. Internationale-Pop-Zeitschriften in der Bundesrepublik." *Deutsche Jugend* 16 (1968): 552–560.

Badurina, B. "Beat! Beat! Beat!" *Wunschliste* at http://www.wunschliste.de/links.pl?s=4131 (accessed May 5, 2007).

Bahnsen, Uwe und Kerstin von Stürmer. *Die Stadt, die Auferstand: Hamburgs Wiederaufbau 1948–1960.* Hamburg: Convent, 2005.

Bailey, Rob. Oral history interview with author. Digital recording. Sept. 14, 2006, Beat Explosion Weekender, Berlin, DCUP.

Baker, Alex. Oral history interview with author. Analog recording transferred to digital format. Jan. 3, 2003, the Bourgeois Pig Café, Los Angeles, DCUP.

Balfour, Michael. *Withstanding Hitler in Germany, 1933 –1945.* New York: Routledge, 1988.

Bane, Mary Jo. *Here to Stay: American Families in the Twentieth Century.* New York: Basic Books, 1976.

Banner, Louise. *American Beauty.* New York: Alfred A. Knopf, 1983.

Barnes, Richard. *Mods!* London: Plexus, 1979.

Barnet, Andrea. *All-Night Party: The Women of Bohemain Greenwich Village and Harlem, 1913– 1930.* Chapel Hill, NC: Algonquin Books of Chapel Hill, 2004.

Batchelor, Bob and Scott Stoddart. *The 1980s.* Westport, CT: Greenwood Press, 2007.

"BBC On This Day, 1961: Birth Control Pill 'Available to All.'" *BBC* at http://news.bbc.co.uk/onthisday/hi/dates/stories/december/4/newsid_3228000/3228207.stm (accessed Apr. 17, 2008).

Barnes, Richard. *Mods!* London: Plexus, 1979.

Barrell, Helen. "The Fantabulous World of Jessika Madison and Dada Die Brucke Clothing—Interview Part I." *The Uppers Organization* http://www.uppers.org/article.asp? article=275 (accessed Dec. 12, 2002).

Bartz, Simon. "Fuzzy Logic: A Stage-Dive Back into the Mayhem." *Japan Times* at http://search.japantimes.co.jp/print/fm20050612sb.html (accessed Mar. 24, 2006).

Baublitz, Claude Raymond. "To Editors." *Life*, Jun. 3, 1966, 20.

Bauer, Iris. "The Minneapolis Mods." *Look*, Nov. 30, 1965, 79–80.

———. "Mod in America: High Gear...Low Gear." *Look*, July 12, 1966, 47–49.

Bausinger, Hermann. *Typisch Deutsch: Wie deutsch sind die Deutschen?* Munich: C.H. Beck, 2000.

Baxter-Moore, Nick. "This Is Where I Belong: Identity, Social Class, and the Nostalgic Englishness of Ray Davies and the Kinks." *Popular Music and Society* 29 (May 2006): 145–166.

"Beat! Beat! Beat!" TV.com at http://www.tv.com/beat!-beat! beat!/show/31175/summary.html (accessed Apr. 14, 2008).

"Beat-Club." *Radio Bremen* at http://www.radiobremen.de/tv/beatclub/information.html (accessed Aug. 8, 2088).

"Beatlemania." *Newsweek,* Nov. 18, 1963, 104.

"Beatles in Maß Anzugen." *Bravo,* May 24–30 1964, 36–37.

"Beatles Mädchen." *Bravo,* Nov. 29–Dec. 5, 1964, 52.

"Beatles: Vier Liverpudel." *Der Spiegel,* Feb. 26, 1964, 61.

Becker, Jillian. *Hitler's Children: The Story of the Baader-Meinhof Terrorist Gang.* Philadelphia: Lippincott, 1977.

Beckmann, Anja. Oral history interview with author. Digital recording. Prinzen Bar, Hamburg. Oct. 28, 2006, DCUP.

Beckmann, Dieter and Klaus Martens. *Starclub.* Reinbek bei Hamburg: Rowohlt, 1980.

"Bei Uns liebt jemand Cathy McGowan." *OK,* Feb. 7, 1966, 13.

Benesch, Nicole. Oral history interview with author. Digital recording, Apr. 29, 2007, Hamburg, DCUP.

Bennett, Andy. *Culture and Everyday Life.* London: Sage, 2005.

Bennett, Andy and Keith Kahn-Harris, eds. *After Subculture: Critical Studies in Contemporary Youth.* London: Palgrave Macmillan, 2004.

Bennett-England, Rodney. *Dress Optional: The Revolution in Menswear.* London: Peter Owen, 1967.

Berger, Michael. "Japanese Women: Old Images and New Realities." In *Women and Women's Issues in Post World War II Japan.* Edited by Edward R. Beauchamp. New York: Garland, 1998. 112–123.

Berger, Stefan. *Inventing the Nation: Germany.* New York: Oxford University Press, 2000.

Bergfelder, Tim. *International Adventures: German Popular Cinema and European Co-Productions in the 1960s.* New York: Berghahn Books, 2004.

Bernstein, George L. *The Myth of Decline: The Rise of Britain since 1945.* London: Pimlico, 2004.

Bertolino, Paul. Email to Author. Jan. 13, 2003.

Bicks, Julie. "To Editors." *Life,* Aug. 27, 1965, 17.

Biff! Bang! Pow! at http://www.kiwianimal.com (accessed July 20, 2008).

Billington, Monroe Lee and Roger D. Hardaway, eds. *African American on the Western Frontier.* Niwot: University Press of Colorado, 1998.

"Biographie: Frank Dostal." *Gema* at http://www.gema.de/der-verein-gema/organisation/aufsichtsrat/biografiefrankdostal/ (accessed June 30, 2008).

Black, Lawrence and Hugh Pemberton. *An Affluent Society? Britain's Postwar "Golden Age" Revisited.* Burlington, VT: Ashgate, 2004. 187–189.

Bledstein, Burton J. "Introduction: Storytellers to the Middle Class." In *The Middling Sort: Explorations in the History of the American Middle Class.* Edited by Burton J. Beldstein and Robert D. Johnston. New York: Routledge, 2001. 1–30.

Bleikhorn, Samantha. *The Mini-Mod Sixties Book.* San Francisco: Last Gasp, 2002.

Blickle, Peter. *Heimat: A Critical Theory of the German Idea of Homeland.* Rochester, NY: Camden House, 2002.

Blow Up Club at www.blowupclub.de (accessed Sept. 12, 2008).

Bodroghkozy, Aniko. *Groove Tube: Sixties Television and the Youth Rebellion*. Durham, NC: Duke University Press, 2001.

Bognar, Botond. "Archaeology of a Fragmented Landscape: The New Avant-Garde Architecture in Japan." In *The New Japanese Architecture*. Edited by Botond Bognar. New York: Rizzoli, 1990. 11–37.

Booker, Christopher. *The Neophiliacs*. London: Collins, 1969.

Boone, Troy. *Youth of Darkest England: Working-Class Children at the Heart of the Victorian Empire*. NewYork: Routledge, 2005.

Born in the Sixties [fanzine]. Issue 1. circa 1985.

Borneman, John. "Uniting the German Nation: Law, Narrative, and Historicity." *American Ethnologist 20*:2 (May 1993): 288–311.

Boulton, David. *Jazz in Britain*. London: W.H. Allen, 1959.

Bourdieu, Pierre. *Distinction: A Social Critique of Judgement and Taste*. Translated by Richard Nice. Cambridge, MA: Harvard University Press, 1984.

"Boutiquen Boom in Germany." *Twen*. Oct. 1967, 74–75.

Bowen, Victoria. "The Three Basics to Female Mod Style." *Uppers Organization*, Feb. 2, 1997 at http://www.uppers.org/showArticle.asp?article=9 (accessed Dec. 3, 2008).

Bradby, Barbara. "She Told Me What to Say: The Beatles and Girl-Group Discourse." *Popular Music and Society* 28 (July 2005): 359 –392.

Bradley, Dick. *Understanding Rock and Roll: Popular Music in Britain 1955–1964*. Buckingham, UK: Open University Press, 1992.

Bradley, Ian. *The English Middle Classes are Alive and Kicking*. London: Collins, 1982.

Braunstein, Peter. "Insurgent Youth and the Sixties Culture of Rejuvenation."*Imagine Nation: The American Counterculture of the 1960s and 70s*. Edited by Peter Braunstein. New York: Routledge, 2002. 243–273.

"*Bravo* Modetip: Chic von der Alster." Aug. 29, 1966, 30.

"*Bravo* Modetip: Schicker Besuch bei den Stones." *Bravo*, Dec. 6, 1965, 64–65.

"*Bravo* Modetip: Schwarz-weiser Chic."*Bravo*, May 10–16, 1964, 18–19.

"*Bravo* Musik: Beat-Hochzeit in Hamburg," *Bravo*, Mar. 6, 1967, 24.

"*Bravo*–Porträt: The Creation." *Bravo*, May 8, 1967, 82.

"*Bravo*–Porträt: Ein Scherz wurde zum Hit." *Bravo*, May 15, 1967, 26.

"*Bravo*–Porträt: Nr. 1 nach fünf harten Jahren." *Bravo*, Feb. 28–Mar.6 1965, 42.

"*Bravo* Stars von Heute: Die Liverbirds." *Bravo*, Nov. 8, 1966, 32–33.

Bredy, Sabine. "Die Mods sind auferstanden." *Der Stern*, Hamburg Supplement, Apr. 12, 1984, 1–4.

Breines, Wini. "The 'Other Fifties': Beats and Bad Girls." In *Not June Cleaver: Women and Gender in Postwar America, 1945–1960*. Edited by Joanne Meyerowitz. Philadelphia: Temple University Press, 1994. 382–408.

Breyvogel, Wilfried, ed. *Piraten, Swings und Junge Garde. Jugendwiderstand in Nationalsozialismus*. Bonn: Dietz, 1991.

"Brief History of Ska Music and Star Ska Interviews." *BBC* at http://www.bbc.co.uk/ coventry/features/stories/west_indian/history-of-ska-music-the-specials.shtml (accessed Feb. 22, 2008).

"Briefe." *Der Spiegel*, Apr. 4, 1966, 5–9.

"Britain Conquers America." *Dig*, Sept. 1964, 31.

"Britain Has Its Own Long Hot Summer." *Life*, Sept. 18, 1964, 61–64.

Brocken, Michael. *The British Folk Revival, 1944–2002.* Burlington, VT: Ashgate, 2003.

Brown, Gordon. "To Editors." *Life*, Aug. 27, 1965, 17.

Brown, Helen Gurley. *Sex and the Single Girl.* New York: Random House, 1962.

Brown, Timothy S. "Subcultures, Pop Music, and Politics: Skinheads and 'Nazi Rock' in England and Germany." *Journal of Social History* 38.1 (2004): 157–178.

Buckley, David. *Elton: The Biography.* London: Andre Deutsch, 2007.

Bude, Heinz. "The German *Kriegskinder*: Origins and Impact of the Generation of 1968." In *Generations in Conflict: Youth Revolt and Generation Formation in Germany 1770–1968.* Edited by Mark Roseman. Cambridge, U.K.: Cambridge University Press, 1995. 290–305.

Burchardt, Jeremy. *Paradise Lost: Rural Idyll and Social Change in England since 1800.* London: I.B. Tauris, 2002.

Burk, Kathleen and Alec Cairncross. *Good-Bye, Great Britain: The 1976 IMF Crisis.* New Haven, CT: Yale University Press, 1992.

Burkhard and Gesine [only names given], *Aftermath: Tagebuchaufzeichnungenüber die Musikclubszene auf St. Pauli.* Translated by Rainer E. Blöcker. Hamburg: Pan-Foto, e.V. Bildarchiv, 1966.

Burns, Mark. Editorial: "At Last! Mod's Own Magazine!" *The Mod's Monthly*, Mar. 1964, 1.

———. "Editorial: Mod Scene Booming—From England to Japan." *The Mod*, Nov. 1964, 1.

———. "Editorial: Where Have All the Mods Gone?" *The Mod*, Sept. 1965, 1.

Buruma, Ian. *Inventing Japan: 1853–1964.* New York: Modern Library Chronicle Books, 2003.

Bush, John. "Biography: The Equals." *Allmusic* at http://www.allmusic.com/cg/amg.dll?p=amg&sql=11:dmd0yl6jxpbb~T1 (accessed Apr. 17, 2008).

Bushnell, Gary. "Mod Squad." (Originally printed in *Sounds* magazine, August 1979) Gary Bushnell Website at http://www.garry-bushell.co.uk/mod/index.asp (accessed Feb. 29, 2008).

Butler, Judith. *Bodies that Matter: Discursive Limits of "Sex."* New York: Routledge, 1993.

———. *Gender Trouble.* London: Routledge, 1999.

Cameron, Sue. "Bad Scene in San Francisco." *Teen*, Apr. 1966, 58–59.

Carey, J. "To Editors." *Look*, Aug. 23, 1966, 12.

Carey, James W. *Communication as Culture: Essays on Media and Society.* New York: Routledge, 1992.

Carr, Roy and Tony Tyler. *The Beatles: An Illustrated Record.* New York: Harmony, 1975.

Cartmell, Mary. *Dances for Mods and Rockers.* London: Hamilton, 1964.

Cawthorne, Nigel. *Sixties Source Book.* Secaucus, NJ: Quarto, 1989.

Chadwick, Thomas. "Event Review: Mod Mayday 2001." *Adventurasia* at http://www.adventurasia.com/editorials/japan/ tc_modmayday01.php (accessed Mar. 24, 2006).

Chaplin, Sarah. *Japanese Love Hotels: A Cultural History.* London: Routledge, 2007.

Chapman, Robert. "The 1960s Pirates: A Comparative Analysis of Radio London Radio Caroline." *Popular Music* 9 (Apr. 1990): 165 –178.

Chapman, William. *Inventing Japan: The Making of a Postwar Civilization.* New York: Prentice Hall, 1991.

Chauncey, George. *Gay New York.* New York: Harper Collins, 1994.

Chidester, David. "The Church of Baseball, the Fetish of Coca-Cola, and the Potlatch of Rock 'n' Roll." In *Religion and Popular Cutlure in America*. Edited by Bruce Davide Forbes and Jeffrey H. Mahan. Berkeley: University of California Press, 2005. 213–232.

"City Guide: Japan." *Uppers Organization* at http://www.uppers.org/show/Cityguide.asp?country=9&city=0 (accessed Nov. 6, 2008).

Clammer, John. *Contemporary Urban Japan: A Sociology of Consumption*. Oxford: Blackwell Publishers, 1997.

Clarke, John. "Style." In *Resistance through Rituals: Youth Subcultures in Post-War Britain*. Edited by Stuart Hall and Tony Jefferson. London: Hutchinson and Company, 1975. 175–191.

Classen, Christoph. *Bilder der Vergangenheit: Die Zeit des Nationalsozialismus Im Fernsehen der Bundesrepublik Deutschland 1955–1965*. Cologne: Boehlau, 1999.

"Claudia Antwortet: Zum Thema 'Lange Haare.'" *OK*, Dec. 27, 1965, 42–43.

Clayson, Alan. *Hamburg: The Cradle of British Rock*. London: Sanctuary, 1997.

———. *The Yardbirds*. San Francisco: Backbeat, 2002.

Clemens, Gabriele. *Britische Kulturpolitik in Deutschland 1945–1949*. Stuttgart: Franz Steiner, 1997.

"Clothes Shops." *Manchester Beat* at http://www.manchesterbeat.com/shops_other.php.

Clugston-Major, Chynna. "Absolute Beginners." *Blue Monday*. Portland, OR: Oni Press, 2001.

———. "The Kids Are Alright." *Blue Monday*. Portland, OR: Oni Press, 2000.

———. *Scooter Girl*. Portland, OR: Oni Press, 2004.

Coates, Norma. "It's a Man's, Man's World: Television and the Masculinization of Rock Discourse and Culture." Ph.D. diss., University of Wisconsin-Madison, 2002.

Coffey, Amanda. "Sex in the Field: Intimacy and Intimidation." In *Ethical Dilemmas in Qualitative Research*. Edited by Trevor Welland and Lesley Pugsley. Burlington, VT: Ashgate, 2002. 57–74.

Cohan, Steven *Masked Men: Masculinity and the Movies in the Fifties*. Bloomington: Indiana University Press, 1997.

Cohen, Sarah. "Scenes." In *Key Terms in Popular Music and Culture*. Edited by Bruce Horner and Thomas Swiss. Malden, MA: Blackwell, 1999. 239–250.

Cohen, Stanley. *Folk Devils and Moral Panics: Thirtieth Anniversary Edition*. New York: Routledge, 2002.

Cohn, Nik. *Awopbopaloobop Alopbamboom: The Golden Age of Rock*. New York: Grove Press, 1969.

Collins, George R. "Visionary Drawings of Architecture and Planning: 20th Century through the 1960s." *Art Journal* 38:4 (Summer 1979): 244–256.

Cope, Julian. *Japrocksampler: How the Postwar Japanese Blew Their Minds on Rock 'n' Roll*. London: Bloomsbury, 2007.

Coppedge, J.F. "To Editors." *Life*, May 5, 1967, 14.

Costantino, Maria. *Men's Fashions in the Twentieth Century: From Frock Coats to Intelligent Fibres*. New York: Quite Specific Media Group, 1997.

"Courrèges." *Vogue*, Oct. 15, 1964, 188–121.

"Courrèges: Lord of the Space Ladies." *Life*, May 21, 1965, 47–65.

Cover. *Teen*, May 1964.

Craig, Timothy J., ed. *Japan Pop! Inside the World of Japanese Popular Culture.* Armonk, NY: M.E. Sharpe, 2000.

Crane, Susan A. "Writing the Individual Back into Collective Memory." *American Historical Review* 102:5 (Dec. 1997): 1372–1385.

Craughwell-Varda, Kathleen. "Jacqueline Kennedy Onassis." In *The Fashion Reader.* Edited by Linda Welters and Abby Lillethun. New York: Berg, 2007. 271–290.

Cravens, Richard and Gwenyth. "Underground Incorporated." *Mademoiselle,* Apr. 1967, 164–165, 245–249, 258.

Curtis, Barry. "A Highly Mobile and Plastic Environ." In *Art & the 60s.* Edited by Chris Stephens and Katherine Stout. London: Tate Publishing, 2004. 46–63.

Cuxhaven '66 at www.cuxhaven-beat.de (accessed June 18, 2008).

Cyrus, Cynthia J. "Selling an Image: Girl Groups of the 1960s." *Popular Music* 22:2 (May 2003): 173–193.

Davenport, Bart. Email to author. Feb. 26, 2003.

Davey, Kevin. *English Imaginaries: Six Studies in Anglo-British Modernity.* London: Lawrence and Wishart, 1999.

Davies, Dave. *Kink: An Autobiography.* London: Hyperion, 1998.

Davies, Evan. "Psychological Characteristics of Beatle Mania." *Journal of the History of Ideas* 30 (April 1969): 273–280.

Davies, Ray. *X-Ray.* London: Viking, 1994.

Davis, Fred. *Fashion, Culture, and Identity.* Chicago: University of Chicago Press, 1992.

de Beauvoir, Simone. *The Second Sex.* Translated and Edited by H.M. Parshley. New York: Bantam Books, 1961.

De Hart, Jane Sherron. "Containment at Home: Gender, Sexuality, and National Identity in Cold War America." In *Rethinking Cold War Culture.* Edited by Peter J. Kuznick and James Gilbert. Washington, DC: Smithsonian Institution Press, 2001. 124–155.

De La Haye, Amy and Cathie Dingwall. *Surfers, Soulies Skinheads & Skaters: Subcultural Style for the Forties to the Nineties.* Woodstock, NY: Overlook, 1996.

de Launey, Guy. "Not So Big in Japan: Western Pop Music in the Japanese Market." *Popular Music* 14 (May 1995): 203–225.

Dehnärt, Lena. Oral history interview by the author. Digital recording, Dehnärt residence, Cologne, May 29, 2007, DCUP.

"Deutsche Heute: Gesehen von Amerika." *Twen,* Jan. 1, 1965, 70–75.

DeWalt, Kathleen and Billie R. DeWalt. *Participant Observation: A Guide for Fieldworkers.* Walnut Creek, CA: Altamira Press, 2002.

DeWaters, John. "Hard Mods." *Mod Culture,* http://www.modculture.co.uk.interviews/ interview.php?id=1 (accessed Feb. 23, 2008).

"Did It Really Happen? 'Mockers' Anyone?" *Spirit of 59* at http://the59club.com/public_html/mockers.html (accessed Feb. 19, 2008).

"Die Beatles als Filmstars." *Bravo,* Feb. 9–16, 1964, 44.

Diefendorf, Jeffrey M. *In the Wake of War: The Reconstruction of German Cities after World War II.* Oxford: Oxford University Press, 1993.

Dixon, John Morris. "Introduction: Japanese Avant-garde Architects." In *The New Japanese Architecture.* Edited by Botond Bognar. New York: Rizzoli, 1990, 9–10.

"DJ Page." *Biff! Bang! Pow!* at http://www.kiwianimal.com/04DJs, (accessed July 20, 2008).

Doi, Kae. Oral history nterview by author, June 20, 2004, Tokyo. Analog Recording trans-
ferred to digital format. French Blue Scooter Rally Shibuya, Tokyo, DCUP.

Donnelly, Mark. *Sixties Britain: Culture, Society, and Politics.* Harlow, U.K.: Pearson Long-
man, 2005.

Dougan, John. *The Who Sell Out.* New York: Continuum, 2006.

Douglas, Susan J. *Where the Girls Are: Growing Up Female with the Mass Media.* New York:
Times Books, 1994.

Dower, John W. *War without Mercy: Race and Power in the Pacific War.* New York: Pantheon
Books, 1986.

Doyle, Barry. "'More than a Dance Hall, More a Way of Life:' Northern Soul, Masculinity
and Working-Class Culture in 1970s Britain." In *Between Marx and Coca-Cola:Youth Cul-
tures in Changing European Societies, 1960–1980.* Edited by Axel Schildt and Detlef Sieg-
fried. New York: Berghahn, 2006. 313–332.

Drake, Kate. "Quest for Kawaii." *Time International,* June 25, 2001, 46.

Drew, Rob. *Karaoke Nights: An Ethnographic Rhapsody.* Walnut Creek, CA: Altamira, 2001.

Dreysee, Kuno. Oral history interview with author. Digital recording, K&K Center-of-Beat,
Hamburg, Mar. 20, 2007, DCUP.

DuNoyer, Paul. *Liverpool: Wondrous Place.* London: Virgin Books, 2002.

———. "Mr. Brian Epstein." *Q,* Special Edition, *The Beatles: Band of the Century.* Dec. 1999.

Durst, David C. *Weimar Modernism: Philosophy, Politics, and Culture in Germany, 1918–1933.*
Lanham, MD: Lexington, 2004.

Echols, Alice. *Shaky Ground: The '60s and Its Aftershocks.* New York: Columbia University
Press, 2002.

Edelstein, Andrew J. and Kevin McDonough. *The Seventies: From Hot Pants to Hot Tubs.* New
York: Dutton, 1990.

"*Ed Sullivan Show* [Episode Guide]." *TV.com* at http://www.tv.com/the-ed sullivan-
show/show/1156/episode_guide.html?season=17&tag=season_dropdown%3Bdropdown
(accessed Oct. 15, 2008).

Edralin, Francing. Email to Author. Dec. 16, 2008.

Egloff, Christiane "Jani." Oral history interview with author. Digital recording. Oct. 20, 2006,
Egloff residence, Hamburg, DCUP.

Ehrenreich, Barbara, Elizabeth Hess, and Gloria Jacobs. "Beatlemania: Girls Just Want to
Have Fun." Edited by Will Brooker and Deborah Jermyn. *The Audience Studies Reader.*
New York: Routledge, 2003. 180–184.

Ehrhardt, Christiane. *Die Beatles: Fabelwesen unserer Zeit?* Diessen: Tucher, 1965.

Eiglsperger, Hans. Oral history interview with author. Digital recording. Jun. 17, 2007, Café
Cord, Munich, DCUP.

Ellen, Mark. "Ein, Zwei, Drei, Vier!" *Mojo,* Special Edition, Days *of Beatlemania,* 15–17.

Elliott, Claudia. "Too Old to Be a Mod?" *Mod Culture* at http://www.modculture.co.uk/cul-
ture/culture.php?id=4 (accessed Mar. 6, 2008).

Emig, Rainer, ed. *Stereotypes in Contemporary Anglo-German Relations.* Houndsmills, U.K.:
Macmillan, 2000.

Engels, Friedrich. *The Condition of the Working Class in England in 1844* http://
www.marxists.org/archive/marx/works/1845/condition-working-class/ch04.htm.(accessed
Dec. 4, 2007).

"England: Halbstarke-Gutes Gefühl." *Der Spiegel*, May 11, 1964, 113–114.

"England's 'Ready, Steady, Go' Girl: Cathy McGowan." *Teen*, Oct. 1965, 32–35.

"English Beat." *New York Times Style Magazine*, Fall 2007, 161–167.

"English Boys." *Teen*, April 1965, 12.

"The English TV Scene... Swings!" *Hit Parader*, Oct. 1966, 20.

Epstein, Brian. *A Cellarful of Noise*. 1964; New York: Pocket, 1998.

Faithfull, Marianne with David Dalton. *Faithfull: An Autobiography*. New York: Cooper Square Press, 2000.

Faludi, Susan. *Stiffed: The Betrayal of the American Man*. New York: William Morrow, 1999.

Farin, Klaus. "Urban Rebels: Die Geschichte der Skinhead Bewegung." In *Die Skins: Mythos und Realität*. Edited by Klaus Farin. Berlin: Christoph Links Verlag, 1997. 9–68.

"Fashion: It's OP from Toe to Top." *Life*, Apr. 16, 1965, 52–54.

"Fashion: I Was a Teen-Age Computer." *Life*, Aug. 6, 1965, 81–85.

"Fashion: The Sleek 'Space' Flair in Plastics." *Life*, Apr. 9, 1965, 91–92.

"Fashion: Twiggy Makes U.S. Styles Swing Too." *Life*, Apr. 14, 1967, 99–101.

"Fashion." *Twiggy the Official Site* at http://www.twiggylawson.co.uk/fashion.html (accessed Oct. 20, 2008).

Featherstone, Mike. *Consumer Culture and Postmodernism*. London: Sage, 2007.

Fearon, Rosemary. "Mod Mailbag: Real Gear Club." *Mod's Monthly*, Apr. 1964, 16.

Feldman, Simone. *Excerpts from Voices from a Vanished Past: Memories of a Christian Childhood in Hitler's Germany*. Honolulu: Wisdom Foundation Publishing, 2006.

Ferschoff, Wilifried. "Jugendkulturkonzepte aus der bürgerlichen Jugendbewegung und ihre Wirkungen in der Gegenwart." In *Jugend 1900–1970*. Edited by Dieter Baacke et al. Opladen: Leske and Budrich, 1991. 125–141.

Fields, Robert Leroy. Email to Author. January 21, 2009.

"Film and TV" at http://www.modculture.co.uk/films/featurefilms.php (accessed Feb. 29, 2008).

Fisher, Jaimey. *Disciplining Germany: Youth, Reeducation, and Reconstruction after the Second World War*. Detroit: Wayne State University Press, 2007.

Fisher, Will. *Materializing Gender in Early Modern English Literature and Culture*. Cambridge, U.K.: Cambridge University Press, 2006.

Fiske, John. *Reading the Popular*. London: Routledge, 1989.

Fenichell, Stephen. *Plastic: The Making of a Synthetic Century*. New York: Harper Business, 1986.

Fogg, Marnie. *Boutique: A '60s Cultural Phenomenon*. London: Mitchell Beazley, 2003.

Fonarow, Wendy. *Empire of Dirt: The Aesthetics and Rituals of British Indie Music*. Middletown, CT: Wesleyan University Press, 2006.

Fox, Kathryn Joan. "Real Punks and Pretenders: The Social Organization of a Counterculture." *Journal of Contemporary Ethnography* 16:3 (1987): 344–370.

Frankel, Oz. *States of Inquiry: Social Investigation and Print Culture in Nineteenth-Century Britain and the United States*. Baltimore: Johns Hopkins University Press, 2006.

Fraser, Kennedy. *The Fashionable Mind: Reflections on Fashion 1970–1981*. New York: Knopf, 1981.

Fraundorf, Martha Norby. "The Labor Force Participation of Turn-of-the-Century Married Women." *Journal of Economic History* 39:2 (June 1979): 401–418.

Fribbens, Colin. Oral history interview by author. Digital recording. *NUTS* Weekender, Brighton, Aug. 25, 2007, DCUP.

Fricke, David. "Forty Years of Beatlemania." *Rolling Stone*, Feb. 19, 2004 at http://www.rollingstone.com/news/story/5938890/cover_story_forty_years_of_beatlemani a/print (accessed Dec. 1, 2008).

Friedan, Betty. *The Feminine Mystique*. New York: W.W. Norton, 1963.

Frith, Simon and Howard Horne. *Art into Pop*. London: Methuen, 1987.

"From England: Beat-Time with Bobby Shaw." *Musikparade*. Mar. 16, 1966, 17.

Fuji, Yoshiko (a.k.a. "Ronnie Fujiyama), member of the 5678's band. Oral history interview by author. Analog recording transferred to digital format, June 20, 2004, French Blue Scooter Rally-Shibuya,Tokyo, DCUP.

Fuller, Barbara. "A Wonderful Year." *Teen*, May 1965, 8.

"Fünf mit einem Namen." *Bravo*, Feb. 7–13 1965, 8–9.

Furtura, Kotaro. Owner of Jungle Scooters, Tokyo. Oral history interview by author. Analog recording transferred to digital format. June 28, 2004, Jungle Scooters, Tokyo, DCUP.

"Futurology: Die Freizeit wird das Grosse Seelische Problem: Wie der Bundesbürger im Jahre 1975 Leben Wird." *Der Spiegel*, Dec. 21, 1966, 75–83.

Galbraith, John Kenneth. *The Affluent Society*. New York: Houghton Mifflin, 1958.

Gamson, Joshua. "Must Identity Movements Self-Destruct? A Queer Dilemma." *Social Problems* 42:3 (Aug. 1995): 390–407.

Gans, Herbert J. *The Levittowners: Ways of Life and Politics in a New Suburban Community*. New York: Pantheon, 1967.

Gardiner, Juliet. *From the Bomb to the Beatles: The Changing Face of Post-War Britain*. London: Collins and Brown Limited, 1999.

Gay, Peter. *Weimar Culture: The Outsider as Insider*. New York: Harper and Row, 1968.

"Gesellschaft: Antisemitismus- Rechter Boden." *Der Spiegel*, July11, 1966, 36.

"Gesellschaft: Hippies: Sommer der Liebe." *Der Spiegel*, Aug. 28, 1967, 88–89.

"Gesellschaft: Irgendwo Kaputt." *Der Spiegel*, Jan. 8, 1979, 133–134.

"Gesellschaft: LSD-Gefährliche Reise." *Der Spiegel*, Aug. 7, 1967, 48.

"Gesellschaft: Rauchgift: Sanfter laufen." *Der Spiegel*, July 24, 1967, 104–105.

Geyrhalter, Thomas. "Effeminacy, Camp, and Sexual Subversion in Rock: the Cure and Suede." *Popular Music* 15 (1996): 217–224.

Gibson, Michelle. Oral history interview by author. Digital recording. Breakbread Café, Liverpool, Aug. 30, 2007, DCUP.

Giddens, Anthony. *Modernity and Self-Identity*. Palo Alto, CA: Stanford University Press, 1991.

"Gimbels: The Look Is Young" [advertisement]. *New York Times*, Feb. 18, 1966, 8.

Ginsberg, Merle. "Savoir Blair." *W*, Jan. 2003, 102–109.

Giovannini, Maureen. "Female Anthropologist and Male Informant: Gender Conflict in a Sicilian Town." In *Self, Sex, and Gender in Cross-Cultural Fieldwork*. Edited by Tony Larry Whitehead and Mary Ellen Conaway. Urbana: University of Illinois Press, 1986. 103–116.

"Girls 60s Cinema Close Up! *Pussycat! Go! Go! Go!*" *Girls 60s*, Summer 2004, 57.

Gitlin, Todd. *The Sixties: Year of Hope, Days of Rage*. Toronto and New York: Bantam Books, 1987.

Giuliano, Geoffrey and Brenda Giuliano. *The Lost Beatles Interviews*. New York: Plume, 1996.

Goldhagen, Daniel Jonah. *Hitler's Willing Executioners: Ordinary Germans and the Holocaust*. New York: Alfred A. Knopf, 1996.

Goodman, David G. *The Return of the Gods: Japanese Drama and Culture in the 1960s*. Ithaca, NY: East Asia Program Cornell University, 2003.

Goodman, Margaret. "No Quiet on the Northern Front." *Honey*, Feb. 1965, 26.

Goodrum, Alison. *National Fabric: Fashion, Britishness, Globalization*. Oxford: Berg, 2005.

Gould, Jonathan. *Can't Buy Me Love: The Beatles, Britain, and America*. New York: Harmony, 2007.

Goy-Yamamoto, Ana M. "Japanese Youth Consumption: A Cultural and a Social (R)evolution Crossing Borders." *Asia Europe Journal* 2 (2004): 271–282.

Grabowsky, Ingo. "'Wie John, Paul, George, und Ringo': die Beat-Ära." In *Rock! Jugend und Musik in Deutschland*. Edited by Barbara Hammerschmitt and Bernd Lindner. Leipzig: Stiftung Haus der Geschichte der Bundesrepublik Deutschland, 2005. 43–51.

Graham, Gael. "Flaunting the Freak Flag: Karr v. Schmidt and the Great Hair Debate in American High Schools, 1965–1975." *Journal of American History* 91 (Sept. 2004): 522–543.

Gray, Fred. *Designing the Seaside: Architecture, Society, and Nature*. London: Reaktion, 2006.

Grebing, Helga. *Der "deutsche Sonderweg" in Europa 1806–1945: Eine Kritik*. Stuttgart: W. Kohlhammer, 1986.

Green, Adam Isaiah. "Gay but not Queer: Toward a Post-Queer Study of Sexuality." *Theory and Society* 31:4 (Aug. 2002): 521–545.

Green, Jonathan. *All Dressed Up: The Sixties and the Counter-culture*. London: Jonathan Cape, 1998.

Green, Maureen. "The £1,000,000 Mod: Subtitle: John Stephen: The Man Who Tells You What to Wear." *Observer Colour Supplement*, Nov. 8, 1964, 29–33.

Green, Richard. "Guestbook." *This is Radio Luxembourg; Your Station of the Stars* at http://www.offringa.nl/ radioLuxembourg.htm Sept. 11, 2005 (accessed Feb. 11, 2008).

Greenfield, Karl Taro. *Speed Tribes: Days and Nights with Japan's Next Generation*. New York: Harper Perennial, 1995.

Groessel, Heinrich. "Die Beat-Musik: Versuch einer Analyse." *Neue Sammlung* 7 (1967): 240–253.

Groom, Bob. "Whose Rock Island Line?" In *Cross the Water Blues: African American Music in Europe*, Edited by Neil A. Wynn. Jackson: University of Mississippi Press, 2007. 167–182.

Grossman, David M. and Sophronia Scott. "'Twentysomething: Proceeding with Caution." *Time*, July 16, 1990, 57–62.

Guest, Robyn. "London Mods: New Thoughts on Old Ideas." *Teen*, Dec. 1965, 34, 36–37.

———. "London's Mods: Too Much Too Fast?" *Teen*, Nov. 1965, 30–33, 76

———. "Mods vs. Rockers." *Teen*, Jan. 1965, 22–23, 65.

Guffey, Elizabeth E. *Retro: The Culture of Revival*. London: Reaktion Books, 2006.

"The Guys Go All-Out to Get Gawked at." *Life*, May 13, 1966, 82–90.

Haarcke, Dietmar. Oral history interview by the author. Digital recording, Haarcke residence, Hamburg, Germany, Oct. 19, 2006, DCUP.

Halasz, Piri. "London: You Can Walk It on the Grass." *Time,* Apr. 15, 1966, 30+.

Hall, Stuart, and Tony Jefferson, eds. *Resistance through Rituals: Youth Subcultures in Post-war Britain.* London: Hutchinson, 1975.

Halton, Kathleen. "Changing Faces." *Sunday Times Colour Magazine,* Aug. 2, 1964, 12–20.

Hamblett, Charles and Jane Deverson. *Generation X.* Greenwich, CT: Gold Medal Books, 1964.

"Hamburger Oldie Night!" [*Hamburger Morgenpost* newspaper advertisement] circa Jan. 2007. Collected by the author.

The Hamburg Sound: Beatles, Beat, & Grosse Freiheit [Exhibit Guestbook]. Hamburg Museum, June 3, 2006–Jan. 8, 2007.

Hamm, Brigit. "Mod Sei Dank!" *Prinz,* Feb. 1996, 29–31.

Harris, John. *The Last Party: Britpop, Blair, and the Demise of English Rock.* London: Fourth Estate, 2003.

Harry, Bill. "Editorial." *Mersey Beat,* Dec. 19, 1963–Jan. 2, 1964, 2.

———. "The Giants: The Hamburg Scene, Part Two." *Mersey Beat,* Oct. 24–Nov. 7, 1963, 12.

———. "Girl Group for Star Club?" *Mersey Beat,* Dec. 19–Jan. 2, 1964, 16.

———. "Meet the Girls." *Mersey Beat,* Dec. 19–Jan. 2, 1964, 4.

———. *Mersey Beat: The Beginnings of the Beatles.* New York: Quick Fox, 1977.

———. "Mersey Beatle: The Mersey Sound." *Mersey Beat,* Oct. 24–Nov. 7, 1963, 7.

———. "Newsbeat." *Mersey Beat,* Sept. 12, 1963, 12.

Hartley, L.P. *The Go-Between.* New York: Knopf, 1954.

Haslam, Dave. *Manchester: The Story of a Pop Cult City.* London: Fourth Estate, 2000.

"Häßlichkeit verkauft sich gut." *Bravo,* Oct. 11–17, 1964, 52–53.

Haulman, Kate. "Fashion and Culture Wars of Revolutionary Philadelphia." *William and Mary Quarterly* 62:4 (2005) at http://www.historycooperative.org/journals/wm/62.4/haulman.html (accessed on Aug. 22, 2008).

Hayford, Charles. "Samurai Baseball vs. Baseball in Japan." *The Asia-Pacific Journal: Japan Focus,* Apr. 2007 at http://japanfocus.org/_Charles_W__Hayford-Samurai_Baseball_vs__Baseball_in_Japan (accessed Nov. 5, 2008).

Haw, Bill. "Pizzicato Five Profile." *Nippop* at http://nippop.com/artist/artist_id-19/artist_name-pizzicato_five/ (accessed Nov. 13, 2008).

"Heart and Soul of Northern Soul." *BBC Lancashire* at http://www.bbc.co.uk/ lancashire/content/image_galleries/russ_gallery.shtml (accessed Feb. 21, 2008).

Hebdige, Dick. Hiding in the Light: On Images and Things. *London: Routledge, 1988.*

———. *Subculture, the Meaning of Style.* London and New York: Routledge, 1979.

Heckstall-Smith, Dick. *The Safest Place in the World: A Personal History of British Rhythm and Blues.* London: Quartet, 1989.

Hejnar, Mark. "The Next Decline: A Conversation with Penelope Spheeris about the Decline...Part III." In *No Focus.* Edited by Chris Barber and Jack Sargeant. London: Headpress, 2006. 117 –122.

Helfeier, Wolfgang, Waldo Kapenkiel, Ulrich Pudelko, and Hans Rommerskirchen. *Wer Beatet Mehr? Die Live-Beat-Szene der 60er Jahre in Krefeld.* Krefeld: Leporello, 2006.

"He Likes His Hair Long." *Tiger Beat,* June 1966, 4.

Hempel, Stefanie. Oral history interview with author. Digital interview. Hempel residence, Hamburg, Aug. 12, 2007, DCUP.

Henke, James. "Introduction." In *I Want to Take You Higher: The Psychedelic Era, 1965–1969.* Edited by James Henke with Peter Puterbaugh. San Francisco: Chronicle, 1997. 10–11.

Henry, Karen. Unrecorded interview with author. Amtrak "Pennsylvanian" train, Feb. 16, 2009. Pennsylvania

Herf, Jeffrey. *Reactionary Modernism: Technology, Culture, and Politics in Weimar and the Third Reich.* Cambridge, U.K.: Cambridge University Press, 1984.

Hershey, John. *Hiroshima.* New York: A.A. Knopf, 1985.

Hewitt, Paolo. *The Soul Stylists: Six Decades of Modernism—From Mods to Casuals.* Edinburgh, U.K.: Mainstream Publishing, 2000.

Hewitt, Paolo and John Hellier. *Steve Marriott: All Too Beautiful.* London: Helter Skelter, 2004.

Hickson, Kevin. *The IMF Crisis of 1976 and British Politics.* London: Tauris Academic, 2005.

Higashi, Sumiko. "Melodrama, Realism, and Race: World War II Newsreels and Propaganda Films." *Cinema Journal* 37:3 (Spring 1998): 38–61.

Hill, Jeff. *Defining Moments in Women's Suffrage.* Detroit: Omnigraphics, 2006.

Hill, John. *Sex, Class, and Realism: British Cinema, 1956–1963.* London: British Film Institute, 1986.

Hip Cat Club: Swinging-Sixties Night Out at www.hipcatclub.de/index2.htm (accessed July 20, 2008).

Hit Bilanz: Deutsche Chart Singles, 1956–1980 Top Ten. Hamburg: Taurus, 1990.

Hitomi, I. "The Spiders." *Trans-World 60s Punk* at http://60spunk.m78.com/spiders.htm (accessed Nov. 5, 2008).

Hjorth, Larissa. "Odours of Mobility: Mobile Phones and Japanese Cute Culture in the Asia-Pacific." *Journal of Intercultural Studies* 26 (Feb.–May 2005): 39–55.

Höhne, Heinz. "Der Ordern unter dem Totenbkopf: Die Geschichte der SS." *Der Spiegel,* Nov. 7, 1966, 94–107.

Hoggart, Richard. *The Uses of Literacy.* New Brunswick, NJ: Transaction, 1992.

"Homepage."*Mod Culture* at http://www.modculture.co.uk/index.php (accessed on Mar. 29, 2003).

Hopkinson, Sasha. Oral history interview with author. Digital recording. Aug. 26, 2007, *NUTS* Weekender, Brighton, DCUP.

Hopper, Justin. Oral history interview with author. Digital recording. June 9, 2008, 61C Café, Pittsburgh, DCUP.

"Hot Mod Summer on the Lake," [handbill advertisement]. Circa June 2007. Perugia, Italy. Collected by author.

Hotz, Alfred J. "The United Nations since 1945: An Appraisal." *Annals of the American Academy of Political and Social Science* 336 (July 1961): 127–136.

Houlbrook, Matt and Chris Waters. "The Heart in Exile: Detachment and Desire in 1950s London." *History Workshop Journal* 62 (2006):142–165.

Hulanicki, Barbara. *From A to Biba: The Autobiography of Barbara Hulanicki.* London: V&A, 2007.

Hunt, George P. "Editorial." *Life,* Sept. 11, 1964, 2–3.

Hunter, Dave. "Voxes, Vees and Razorblades." *Guitar Magazine*, Jan. 1999 at http://www.davedavies.com/ articles/tgm_0199-01.htm (accessed Apr. 17, 2008).

"Hurra, die Rattles kommen." *Bravo*, May 23–29, 1965, 14–15.

"Hurra, die Rattles kommen!" *Illustrierter Film-Kürier* 91, 1966.

"If You've Got to Go Beatle Go Bob." *Teen*, June 1964, 36–39.

Igarashi, Yoshikuni. *Bodies of Memory: Narratives of War in Postwar Japanese Culture, 1945– 1970*. Princeton, NJ: Princeton University Press, 2000.

Ikeda, Kuzuyo. Oral history interview by author. Analog Recording transferred to digital format. July 8, 2004, Kyoto, DCUP.

Indra, Michael. "It's About Faith in Our Future: *Star Trek* Fandom as Cultural Religion." In *Religion and Popular Culture in America*. Edited by Bruce David Forbes and Jeffrey H. Mahan. Berkeley: University of California Press, 2005. 159–173.

Inferno Beats at www.inferno-beats-64.de (accessed Sept. 12, 2008).

"Informers: Everybody Is Going to the Moon." *Honey*, Nov. 1965, 83.

"Informers: Psychedelic!" *Honey*, Feb. 1967, 46.

Inglis, Ian. "The Beatles Are Coming! Conjecture and Conviction in the Myth of Kennedy, America, and the Beatles." *Popular Music and Society* (2000): 93–108.

"In Memorium: Where the Action Is/Was." *Teen Life*, June 1967, 38–39.

"Inside the Hippie Revolution." *Look*, Aug. 22, 1967, 58–64.

In the Crowd [fanzine]. Issues #6, circa 1980s.

"An Interview with Eddie Piller." *Mod Culture* at http://www.myspace.com/Eddiepiller (accessed Aug. 14, 2007).

Inthorn, Sanna. *German Media and National Identity*. Youngstown, NY: Cambria, 2007.

"Is It a Boy or a Girl?" *Tiger Beat*, Jan. 1966, 7.

"Is It a Girl? Is It a Boy? No it's Twiggy." *Look*, Apr. 4, 1967, 84 –90.

"Is Mod Dead?" *Newsweek*, Mar. 6, 1967, 73–74.

"It's a Mod, Mod World... Boyfriend's New Column Written by Five Top Mods (The Stones!) for You." *Boyfriend*, Nov. 29, 1964, 5.

Iwabuchi, Koichi. "Nostalgia for a (Different) Asian Modernity: Media Consumption of 'Asia' in Japan." *Positions* 10:3 (2002): 547–573.

Iwao, Sumiko *The Japanese Woman: Traditional Image and Changing Reality*. Cambridge, MA: Harvard University Press, 1994.

Jackson, Lesley. *The Sixties: Decade of Design Revolution*. London: Phaidon, 1998.

Jameson, Fredric. *Postmodernism, or The Cultural Logic of Late Capitalism*. Durham, NC: Duke University Press, 1991.

Jasper, Tony, ed. *The Top Twenty Book: The Official British Record Charts, 1955–1983*. Poole, U.K.: Blandford, 1984.

Jenkins, Philip. *Decade of Nightmares: The End of the Sixties and the Making of Eighties America*. New York: Oxford University Press, 2006.

Jenß, Heike. "Dressed in History: Retro Styles and the Construction of Authenticity in Youth Culture." *Fashion Theory* 8:4 (2004): 387–404.

———. *Sixties Dress Only: Mode und Konsum in der Retro-Szene der Mods*. Frankfurt/Main: Campus, 2007.

"Jetzt kommt die Op Zeit." *OK*, Apr. 4, 1966, 54–55.

Jogschies, Rainer. *Wer Zweimal mit derselben pennt... Die befreiten Sechziger.* Ullstein: Frankfurt, 1991.

Jones, Mablen. *Getting It On: The Clothing of Rock and Roll.* New York: Abbeville, 1987.

"Junge Leute spielen verrückt." *Der Stern,* Sept. 9, 1967, 135–141.

"Junior House" [advertisement]. *Mademoiselle,* Jan. 1967, 18.

Jürgens, Achim. Oral history interview with author. Digital recording, Berliner Betrüger Café, Hamburg, Aug. 11, 2007, DCUP.

Jürgens, Ralf. Oral history interview with author. Digital recording. Apr. 29, 2007, Hamburg, DCUP.

"Juvenile Look in Paris Fashions." *Life,* Sept. 4, 1964, 43–48B, 52.

Kahn, Stephen. *"On the Flip Side: Teen Pan Alley Visits Big Beat Britain!" Flip,* June 1965, 44.

Kaiser, Charles. *1968 in America: Music, Politics, Chaos, Counterculture and the Shaping of a Generation.* New York: Weidenfeld and Nicolson, 1988.

Kamp, David. "London Swings! Again!" *Vanity Fair,* Mar. 1997. http://www.vanityfair.com/magazine/archive/1997/03/london199703 (accessed Feb. 29, 2008).

Kane, Larry. *Ticket to Ride.* Philadelphia: Running Press, 2003.

Kanno, Toshihide. "Twiggy: '60s Fashion Icon Returns." *Asahi* at http://www.asahi. com/English/weekend/K2002051900117.html (accessed Jan. 20, 2004).

Kansteiner, Wulf. *In Pursuit of German Memory: History, Television, and Politics after Auschwitz.* Athens: Ohio University Press, 2006.

Kaplan, Fred. "Teen Spirit: What was so Important about the Beatles'Appearances on the *Ed Sullivan Show?" Slate,* Feb. 6, 2004 at http://slate.msn.com/toolbar.aspx?action=print& id=2095079 (accessed Feb. 4, 2005).

Karlstein, Diane. "To Editors." *Life,* June 11, 1965.

Kater, Michael H. *Hitler Youth.* Cambridge, MA: Harvard University Press, 2004.

Katoh, Hisashi. "Swinging London." *Girls 60s,* Spring 2004, 51.

Katz, Michael B., Mark J. Stern, and Jamie J. Fader. "Women and the Paradox of Economic Inequality in the Twentieth-Century." *Journal of Social History* 39:1 (Fall 2005): 65–88.

Keane, Margaret. *MDH Margaret Keane (Tomorrow's Masters Series).* New York: Johnson Meyers, 1964.

Kelly, William W. "Introduction: Locating the Fans." In *Fanning the Flames: Fans and Consumer Culture in Contemporary Japan.* Edited William W. Kelly. Albany: State University of New York Press, 2004. 1–16.

———. "Sense and Sensibility at the Ballpark: What Fans Make of Professional Baseball in Modern Japan." In *Fanning the Flames: Fans and Consumer Culture in Contemporary Japan.* Edited by William W. Kelly. Albany: State University of New York Press, 2004. 79–106.

Kelly-Holmes, Helen. "German Language: Whose Language, Whose Culture?" In *Contemporary German Cultural Studies.* Edited by Alison Phipps. London: Arnold, 2002. 40–60.

Kemp, Gibson. Oral history interviev by author. Digital recording. Apr. 17, 2007, Kemp's English Pub, Hamburg, DCUP.

Kessler, Gregor. Email to author. Dec. 28, 2006.

Kessler-Harris, Alice. *Women Have Always Worked.* Old Westbury, NY: Feminist Press, 1981.

Kidwell, Claudia Brush and Valerie Steele. "Introduction." In *Men and Women: Dressing the Part.* Edited by Claudia Brush Kidwell and Valerie Steele. Washington, DC: Smithsonian Institution Press, 1989. 1–5

Kimmel, Michael S. *Manhood in America: A Cultural History.* New York: Oxford University Press, 2006.

"Kings and Queens." [handbill advertisement]. Circa April 2007, Hamburg. Collected by author.

Kinsella, Sharon. "Cuties in Japan." In *Women, Media, and Consumption in Japan.* Edited by Brian Moeran and Lisa Skov. London: Curzon, 1995. 220–254.

Kitch, Carolyn. *The Girl on the Magazine Cover: The Origins of Visual Stereotypes in American Mass Media.* Chapel Hill: University of North Carolina Press, 2001.

Kirby, M.W. "Blackett in the 'White Heat' of the Scientific Revolution: Industrial Modernisation under the Labour Governments, 1964–1970." *Journal of the Operational Research Society* 50:10 (Oct. 1999): 985–993.

Kirchherr, Astrid. "Forward." In *Read the Beatles.* Edited by June Skinner Sawyers. New York: Penguin, 2006. xv–xvi.

———. "The Last Word." *Mojo,* Special Edition, *Days of Beatlemania,* Oct. 2002, 146.

———. "Vorwort." In *Beatles Guide Hamburg.* Edited by Ulf Krüger. Hamburg: Europa Verlag, 2001, 7–8.

Klein, Naomi. *Promiscuities.* New York: Fawcett, 1997.

Klein, Stefan. "Der Deutscher Herbst 1977: Tage des Schreckens." *Sueddeutsche Zeitung* at http://www.sueddeutsche.de/ deutschland/artikel/960/130732/ (accessed July 1, 2008).

"Kleines OK Wörterbuch." *OK,* Apr. 18, 1966, 11.

Klimke, Martin. "West Germany." In *1968 in Europe: A History of Protest and Activism, 1956–1977.* Edited by Martin Klimke and Joachim Scharloth. New York: Palgrave-Macmillan, 2008. 97–110.

Klitsch, Hans-Jürgen. "Die Rattles: Beat in Germany." [CD booklet] *Smash! Boom! Bang!: The Sixties Anthology.* Bear Family Records, BCD 16456 AR.

———. *Shakin' All Over: Die Beat-Musik in der Bundesrepublik Deutschland 1963–1967.* Frankfurt: Highcastle, 2000.

———. *Lords: Singles, Hits & Raritäten,* [CD booklet] *Beat in Germany: Smash...! Boom...! Bang...! The Sixties Anthology.* Bear Family Records, BCD 16452.

Kloos, Stefan. *Pop 2000: 50 Jahre Popmusik und Jugendkultur in Deutschland.* Hamburg: Ideal, 1999.

Knight, Nick. *Skinhead.* London: Omnibus, 1982.

Kocka, Jürgen. "German History Before Hitler: The Debate about the German *Sonderweg.*" *Journal of Contemporary History* 23 (1988): 40–50.

Koestler, Arthur. "Japan: For Better or Worse Her Course is Set." *Life,* Sept. 11, 1964, 63–79.

"Kommt der Zopf wieder?" *Twen,* Oct. 10, 1965, 62–65.

Kompare, Derek. *Rerun Nation: How Repeats Invented American Television.* New York: Routledge, 2005.

Koreska-Hartmann, Linda. *Jugendstil—Stil der 'Jugend': Auf den Spuren eines alten, neuen Stil- und Lebensgefuehls.* Munich: Deutscher Taschenbuch, 1969.

Kraft, Jens. "Dandies der Achziger: Mods." *Tango.* Mar. 1984, 22.

Krüger, Ulf. *Beatles Guide Hamburg.* Hamburg: Europa Verlag, 2001.

———. *Beatles in Hamburg: Ein kleines Lexikon.* Hamburg: Ellert & Richter, 2007.

———. "Beatles Venues in Hamburg." In *The Hamburg Sound: Beatles, Beat, und Große Freiheit.* Edited by Ortwin Pelc and Ulf Krüger. Hamburg: Ellert and Richter, 2006. 22–39.

————. "Hamburg Beat City." In *The Hamburg Sound: Beatles, Beat, und Große Freiheit*. Edited by Ortwin Pelc and Ulf Krüger. Hamburg: Ellert & Richter, 2006. 12–21.

————. "Mr. Beat—Manfred Weißleder and the Star-Club." In *The Hamburg Sound: Beatles, Beat, und Große Freiheit*. Edited by Ulf Krüger and Ortwin Pelc. Hamburg: Ellert and Richter, 2006. 50–55.

————. Oral history interview by the author. Digital recording. Krüger residence, Hamburg, Feb. 12, 2007, DCUP.

Kruse, Holly. *Site and Sound: Understanding Independent Music Scenes*. New York: Peter Lang, 2003.

Kurokawa, Kisho. *Metabolism in Architecture*. London: Studio Vista, 1977.

Lash, Max E. "Japanese Rock." *Rolling Stone*, Mar. 1, 1969, 12–14.

Laurie, Peter. "Mods and Rockers." *Vogue*, Aug. 1, 1964, 68–69, 129, 135.

————. *The Teenage Revolution*. London: Blond, 1965.

Le Duc, Violette. "Courrèges: A Slaying in the Corrida of Fashion." *Vogue*, May 1965, 209, 244.

Lee, Neil. Oral history interview by author. Digital recording. Sept. 1, 2007, Rampant Lion Pub, Manchester, DCUP.

Leese, Peter. *Britian Since 1945: Aspects of Identity*. Houndsmills, U.K.: Palgrave Macmillan, 2006.

LeFeber, Walter. *America, Russia, and the Cold War, 1945–2005*. Boston: McGraw-Hill, 2008.

Leffler, Melvin P. *For the Soul of Mankind: The United States, the Soviet Union, and the Cold War*. New York: Hill and Wang, 2007.

Leland, John. *Hip: The History*. New York: Harper Perennial, 2004.

Lentz, Graham. *The Influential Factor*. Horsham, U.K.: Gel Publishing, 2002.

Leo, Annette. "Beatle-Aufstand in Leipzig." In *Jugend in Deutschland: Opposition, Krisen und Radikalismus zwischen die Generationen*. Edited by Ute and Wolfgang Benz. München: Deutscher Taschenbuch Verlag, 1982. 72–82.

"Leser-Report London: Mods, Rockers, Beatniks, Spießer!" *Star-Club News*, Aug. 1965, 25.

Lev, Peter. "Blow-Up, Swinging London, and the Film Generation." *Literature Film Quarterly* 17 (1989): 134–137.

————. *The Euro-American Cinema*. Austin: University of Texas Press, 1993.

Levine. Elizabeth Harvey. Email to author. Jan. 22, 2009.

"Le Voy's of Salt Lake City" [advertisement]. *Mademoiselle*, Nov. 1966, 91.

Levy, Shawn. *Ready Steady, Go: The Swinging Rise and Smashing Fall of Swinging London*. New York: Doubleday, 2002.

Liddle, Joanna and Sachiko Nakajima. *Rising Suns, Rising Daughters: Gender, Class, and Power in Japan*. New York: Palgrave, 2000.

"Liebegrüße aus Polen." *Musikparade*, Oct. 24, 1966, 5–7.

"Life Stride Shoes" [advertisement]. *Mademoiselle*, Aug. 1966, 62.

Lifton, Robert Jay. "Individual Patterns in Historical Change: Imagery of Japanese Youth." *Comparative Studies in Society and History* 6:4 (July 1964): 369–383.

"Likes Masculine Boys." *Teen*, August 1964, 10.

Lines, David. *The Modfather: My Life with Paul Weller*. London: William Heinemann, 2006.

Lingeman, Richard R. "Pop Sex: Some Sex Symbols of the Sixties." *Mademoiselle*, Nov. 1965, 184–185, 222–223.

Linne, Gerhard. *Jugend in Deutschland: Vom Sturm und Drang zur APO*. Gütersloh: Bertelsmann, 1970.

Lipsitz, George. *Time Passages: Collective Memory and American Popular Culture*. Minneapolis: University of Minnesota Press, 1990.

"Lisa Perry Bio." *Lisa Perry* at http://lisaperrystyle.com/bio.htm (accessed June 12, 2009).

"Liverbirds: Wir lieben die Germans." *OK*, June 13, 1966, 30.

Lobenthal, Joel. *Radical Rags: Fashions of the Sixties*. New York: Abbeville, 1990.

Long, Kevin. "Epicenter of a Scene." *California Mod Scene* at http://www.california-mod-scene.com/essay.html (accessed July 7, 2008).

Luckett, Moya. "Sensuous Women and Single Girls: Reclaiming the Female Body on 1960s Television." In *Swinging Single: Representing Sexuality in the 1960s*. Edited by Hilary Radner and Moya Luckett. Minneapolis: University of Minnesota Press, 1999. 277–300.

Lull, James. "Thrashing in the Pit: An Ethnography of San Francisco Punk Subculture" In *Natural Audiences: Qualitative Research on Media Uses and Effects*. Edited by Thomas Lindlof. Norwood, NJ: Ablex, 1986. 225–252.

Lummis, Trevor. *Listening to History*. London: Hutchinson, 1987.

Lusk, Irene. ed. *Die Wilden Zwanziger: Weimar und die Welt 1919–1933*. Berlin: Elephanten, 1986.

Lutum, Peter. "Aspects of Hybrid Consciousness in Modern Japan." In *Japanizing: The Structure of Culture and Thinking in Japan*. Edited by Peter Lutum. Berlin: LIT, 2006. 1–22.

Lyotard, Jean-François. *The Postmodern Condition: A Report on Knowledge*. Translated by Geoff Bennington and Brian Massumi. Minneapolis: University of Minnesota Press, 1984.

Maase, Kaspar. *Bravo Amerika*. Hamburg: Junius, 1992.

MacKay, Marina. *Modernism and World War II*. Cambridge, U.K.: Cambridge University Press, 2007.

"Maidenform" [advertisement]. *Mademoiselle*, Aug. 1967, 66–67.

"Maidenform" [advertisement]. *Mademoiselle*, Oct. 1967, 41.

Malvern, Jack. "MoD Takes Aim at Mods in Battle for Target Symbol." *Times* at http://www.timesonline.co.uk/tol/news/uk/article1019561.ece. (accessed Mar. 26, 2008).

Malzacher, Florian and Matthias Dänschel. *Jugendbewegung für Anfänger*. Witzenhausen: Südmarkverlag, 1993.

Manovich, Lev. *The Language of New Media*. Cambridge, MA: MIT Press, 2001.

Marcus, Greil. *Mystery Train: Images of America in Rock 'n' Roll Music*. New York: Dutton, 1982.

Margarete, Andrea, Hans Georg Buchholz, and Lutz Rössner. "Jugend in Beat-Lokalen." *Deutsche Jugend* 17 (1969): 545–552.

Marinetti, F.T. "The Futurist Manifesto." 1909 at http://www.cscs.umich.edu/~crshalizi/T4PM/futurist-manifesto.html (accessed on Feb. 20, 2008).

Marks, Anthony. "Young, Gifted, and Black: Afro-American and Afro-Caribbean Music in Britain 1963–1988." In *Black Music in Britain: Essays on the Afro-Asian Contribution to Popular Music*. Edited by Paul Oliver. Milton Keynes, U.K.: Open University Press, 1990. 102–112.

Marler, Regina. *Queer Beats: How the Beats Turned America on to Sex*. San Francisco: Cleis Press, 2004.

Marling, Karal Ann. "Letter from Japan: Kenbei vs. All-American Kawaii at Tokyo Disney-land." *American Art* 6:2 (Spring 1992): 102–111.

Marrder, Carina. Interview with author. Digital recording. Casino Royale Weekender, Aachen, April 21, 2007, DCUP.

Marsden, Jonathan. Oral History Interview. Digital Recording. Sept. 1, 2007, Rampant Lion Pub, Manchester, DCUP.

Marsh, Dave. "The Who Sell Out" liner notes. *The Who Sell Out*. MCA NR 11268, CD.

Martens, René and Günter Zint. *St. Pauli: Kiez, Kult, Alltag*. Hamburg: Die Hanse, 2000.

Marwick, Arthur. *The Sixties: Cultural Transformation in Britain, France,Italy, and the United States, c. 1958 –c. 1974*. Oxford: Oxford University Press, 1998.

Marx, Ania. Email to author. June 24, 2007.

"Mary Quant: A New Approach Chelsea 1955–1967." *Victoria and Albert Museum* at http://www.vam.ac.uk/collections/ fashion/1960s/exhibition/ quant/index.html (accessed Feb. 11, 2008).

Mason, Philip. *The English Gentleman: The Rise and Fall of an Ideal*. New York: William Morrow, 1982.

Matthew's Best Hit TV at http://www.tv-asahi.co.jp/matthewuv/ (accessed Nov. 6, 2008).

Matthews, Gordon and Bruce White. *Japan's Changing Generations: Are Young People Creating a New Society?* London: Routledge/Curzon, 2004.

"Mattel" [advertisement]. *Life*, Nov. 25, 1966, 7.

"Mattel" [advertisement]. *Life*, Nov. 24, 1967, 8.

Mau, Harald. Oral history interview by author. Digital recording, Mar. 22, 2007, the Mau residence, Hamburg, DCUP.

Max the Mod (no full name given). "Mods." *The Who London 1965* at http://www.westminsterinccom/who1965/index.html (accessed Mar. 26, 2008).

Maximum Speed. [fanzine] Issue 3. Circa 1979.

May, Elaine Tyler. *Homeward Bound: American Families in the Cold War Era*. New York: Basic Books, 1988.

McGray, Douglas. "Japan's Gross National Cool." *Foreign Policy* 130 (May –June 2002): 44–54.

McKay, George. *Circular Breathing: The Cultural Politics of Jazz in Britain*. Durham, NC: Duke University Press, 2005.

McKinney, Devin. *Magic Circles: The Beatles in Dream and History*. Cambridge, MA: Harvard University Press, 2003.

McLean, Roy. *Magic Bus: On the Hippie Trail from Istanbul to India*. New York: Viking, 2006.

McLuhan, Marshall and George B. Leonard. "The Future of Sex." *Look,* July 25, 1967, 56–60, 63.

McMahon, Mary Sheila. "The American State and the Vietnam War: A Genealogy of Power." In *The Sixties: From Memory to History*. Edited by David Farber. Chapel Hill: University of North Carolina Press, 1994. 45–89.

McNeil, Peter. "Myths of Modernism: Japanese Architecture, Interior Design and the West, c. 1920–1940." *Journal of Design History* 5:4 (1992): 281–294.

McRobbie, Angela and Jenny Garber. "Girls and Subcultures." In *Resistance through Rituals: Youth Subcultures in Post-War Britain*. Edited by Stuart Hall and Tony Jefferson. London: Hutchinson, 1975. 209–222.

Mead, Margaret. *Coming of Age in Samoa: A Psychological Study of Primitive Youth for Western Civilization.* 1928; New York: Morrow, 1961.

Melendez, Dan. Email to author. Feb. 6, 2003.

Mannel, Horst D. and Rainer Obeling. *Beat Geschichte(n) im Revier.* Recklinghausen: Journal–Verlag, 1993.

Matheu, Robert and Brian J. Bowe, ed. *Creem: America's Only Rock 'n' Roll Magazine.* New York: Harper Collins, 2007.

Mercer-Taylor, Peter. "Songs from the Bell Jar: Autonomy and Resistance in the Songs of the Bangles." *Popular Music* 17:2 (1998): 187–204.

Merlis Bob and Davin Seay. *Heart and Soul: A Celebration of Black Music Style in America 1930–1975.* New York: Steart, Tabori and Chang, 1997.

Miller, Andy. *The Kinks Are the Village Green Preservation Society.* New York: Continnum, 2003.

Mills, C. Wright. *The Sociological Imagination.* 1959; Oxford: Oxford University Press, 1976.

"Mini-Mode and Musik." *Bravo,* Mar. 13, 1967, 46–47.

"Minty" [no other name given]. "Mod Stories." *Mod Revival* athttp://www.modrevival.net/Modstories.html (accessed Feb. 26, 2008).

Misa, Thomas J. "The Compelling Tangle of Modernity and Technology." *Modernity and Technology.* Edited by Thomas J. Misa, Philip Brey, and Andrew Feenberg. Cambridge, MA: MIT Press, 2003. 1–32.

"Mit Orion auf Traumfahrt." *Musikparade,* Dec. 5, 1966, 16–17.

Mitscherlich, Alexander and Margarete. *The Inability to Mourn: Principles of Collective Behavior.* New York: Grove, 1975.

Mitsukuni, Yoshida. *The Hybrid Culture: What Happened When East and West Met.* Tokyo: Cosmo Public Relations, 1984.

Mod Culture at www.modculture.co.uk (Mar. 20, 2002).

"Mod Girl Group: That's a NoNo!" *Girls 60s,* Summer 2004, 26–28.

"Modern Girl's Room." *Girls Sixties,* Spring 2004, 114–115.

"Mod Mailbag: Really Jumping." *Mod's Monthly,* Apr. 1964, 16.

"MoD's Battle over RAF Symbol." *BBC News* at http://news.bbc.co.uk/2/hi/uk-news/england/32222616.stm (accessed Mar. 26, 2008).

"Mods and Rockers." *Brighton and Hove Museums: The Royal Pavillion, Libraries and Museums Collections* at http://www.virtualmuseum.info/collections/themes/images_gallery/html/mods_rockers.html (accessed Mar. 30, 2008).

"Modstock" [advertisement] at http://www.actionamightybaby.co.uk/modstock_2004_advert.htm (accessed Apr. 20, 2004).

"The Mod Squad." *Vogue,* May 2003, 196–213.

Mohr, Reinhard. *Der diskrete Charme der Rebellion. Ein Leben mit den 68ern.* Berlin: WJS, 2008.

Moir, Gordon. Oral history interview by author. Analog recording transferred to digital format. June 20, 2004, French Blue ScooterRally, Shibuya, Tokyo, DCUP.

Möller, Jan. "Onkel Pö und Fabrik: Die Hamburger Szene, 1969–1979." In *Läden, Schuppen, Kaschmmen: Eine Hamburger Popkulturgeschichte.* Edited by Christoph Twickel. Hamburg: Nautilus, 2003. 11–40.

Möller, Robert G, ed. *West Germany under Construction: Politics, Society, and Culture in the Adenauer Era.* Ann Arbor: University of Michigan Press, 1997.

Mooney, Nan. *(Not) Keeping Up With Our Parents: The Decline of the Professional Middle Class.* Boston: Beacon Press, 2008.

Moore, Allan F. *Rock: The Primary Text.* Buckingham, U.K.: Open University, 1993.

Moz Big Step at www.moz.bigstep.com (accessed Sept. 12, 2008).

"MP Music Pop Poll 66." *Musikparade*, Feb. 13, 1967, 4.

Muggleton, David. *Inside Subculture: The Postmodern Meaning of Style.* Oxford: Berg, 2000.

Muggleton, David and Rupert Weinzierl, eds. *The Post-Subcultures Reader.* Oxford: Berg, 2003.

Muncie, John. "The Beatles and the Spectacle of Youth." In *The Beatles, Popular Music and Society.* Edited by Ian Inglis. New York: St. Martin's Press, 2000. 44–52.

"Musik wie Dynamit." *Bravo*, Jan. 10, 1966, 20–21.

Nagel, Gus. "To Editors." *Life*, May 5, 1967, 14.

Namaste, Ki. "The Politics of Inside/Outside: Queer Theory, Poststructuralism, and a Sociological Approach to Sexuality." *Sociological Theory* 12:2 (July 1994): 220–231.

Nayak, Anoop. *Race, Place, and Globalization: Youth Cultures in a Changing World.* Oxford: Berg, 2003.

Nehring, Neil. *Popular Music, Gender, and Postmodernism: Anger Is an Energy.* London: Sage, 1997.

Nelson, Annalise. "Kyoto." In *Let's Go© Travel Guide: Japan.* Edited by Teresa Elsey. New York: St. Martin's Press, 2004. 392–429.

Nelson, John K. *Enduring Identities: The Guise of Shinto in Contemporary Japan.* Honolulu: University of Hawaii Press, 2000.

Nerke, Ushi. *40 Jahre mein Beat–Club: Persönliche Erlebnisse und Erinnerungen.* Benitz: Kuhle, 2005.

Nevin, Michael. *The Age of Illusions: The Political Economy of Britain, 1968–1982.* New York: St. Martins, 1983.

"New Fads for Boys." *Tiger Beat*, June 1966, 4.

Newman, David and Robert Benton. "Man Talk." *Mademoiselle*, Sept. 1965, 132.

"The New Madness." *Time*, Nov. 15, 1963, 64.

Newton, Esther. "My Best Informant's Dress: The Erotic Equation in Fieldwork." *Cultural Anthropology* 8 (Feb. 1993): 3–23.

Nickel, Ben "Jones." Oral history interview with author. Digital recording, Nickel residence, Hamburg. Oct. 25, 2006, DCUP.

Niemczyk, Ralf. "Mods in Deutschland." *Spex.* Jan. 1984, 30–34.

"Night Club Listings: The Blue Angel." *Liverpool.com* at http://www.liverpool.com/listings/the -blue-angel.html (accessed Mar.30, 2008).

Nimmermann, Peter. "Beat und Beatlokale in Berlin." *Deutsche Jugend* 14 (1966): 495–504.

"No Crew Cuts Please." *Teen*, June 1964, 8.

Norman, Phillip. *Shout!: The Beatles in Their Generation.* 1981; New York: Simon & Schuster, 2005.

"North or South?" *The Mod*, Nov. 1964, 12.

Novak, David. "2·5×6 Metres of Space: Japanese Music Coffeehouses and Experimental Practices of Listening." *Popular Music* 27:1 (2008): 15–34.

Nowell, David. *Too Darn Soulful: The Story of Northern Soul*. London: Robson, 1999.

Nowicki, Damien. "Towns for Trying Out [Hamburg]." *Metro* at http://www.metro.co.uk/travel/article.html?in_article_id =42791&in_page_id=5 (accessed Aug. 8, 2008).

"The Nuremberg Laws." *Shoah Education Project* at http://www.shoaheducation.com/nuremberglaws.html (accessed July 17, 2008).

"NS-Verbrechen: Verjährung- Gesundes Volksempfinden." *Der Spiegel*. Mar. 3, 1965, 30–44.

Obermeier, Uschi. *Das Wilde Leben*. Hamburg: Hoffman und Campe, 2000.

Ogren, Kathy J. *The Jazz Revolution: Twenties America and the Meaning of Jazz*. New York: Oxford University Press, 1989.

Olick, Jeffrey K. and Joyce Robbins. "Social Memory Studies: From 'Collective Memory' to the Historical Sociology of Mnemonic Practices." *Annual Review of Sociology* 24 (1998): 105–140.

Olivier, Stefan. "Die Zeit ist Reif: Ein Roman vom deutschen Schicksal." *Der Stern*, Mar. 23, 1964, 40–52.

Osgerby, Bill. *Youth in Britain Since 1945*. Oxford, U.K.: Blackwell Publishers, 1998.

———. *Youth Media*. London: Routledge, 2004.

Ott, Olaf. Oral History Interview by the author. Digital recording. Ott Residence Hamburg, Germany, Aug.8, 2007, DCUP.

"Out in New York." *American Mod*. at http://www.americanmod.net.out_in_ny.html (accessed Dec. 12, 2002).

Packard, Chris. *Queer Cowboys: And Other Erotic Male Friendships in Nineteenth–Century American Literature*. New York: Palgrave Macmillan, 2005.

Palladino, Grace. *Teenagers: An American History*. New York: BasicBooks, 1996.

Palmer, Alan. *The East End: Four Centuries of London Life*. New Brunswick, NJ: Rutgers University Press, 2000.

"Paris: The News as We See It." *Vogue*, Sept. 1, 1965, 255–259.

"Paris: The New Jet-eration." *Mademoiselle*, Oct. 1965, 142–145.

Peacock, John. *The 1950s*. London: Thames and Hudson, 1997.

Pells, Richard. *Not Like Us: How Europeans Have Loved, Hated, and Transformed American Culture since World War II*. New York: Basic, 1997.

Pergament, Danielle. "Mod, Mod World." *Allure*, Aug. 2003, 128–137.

Peter, Bettina. Oral history interview with the author. Digital recording, May 28, 2007. Hotel Vater Rhein restaurant, Bad Breisig, Germany, DCUP.

Peters, Karsten. "Ein ganz neues Beatle-Gefühl." *Deutsche Jugend* 12 (1964): 373–374.

Peterson, Richard A. and Andy Bennett, eds. *Music Scenes: Local, Translocal, Virtual*. Nashville, TN: Vanderbilt University Press, 2004.

Pettegrew, John. *Brutes in Suits: Male Sensibility in America, 1890–1920*. Baltimore: Johns Hopkins University Press, 2007.

Pilgrim, Richard B. "The Artistic Way and the Religio-Aesthetic Tradition in Japan." *Philosophy of East and West* 27:3 (July 1977): 285–305.

Piller, Eddie. *Extraordinary Sensations* [fanzine]. Christmas '82 issue, Issues 12, and Issue 13, circa early 1980s.

———. Oral history interview by the author, digital recording, The Owl and the Pussycat public house, Bethnal Green, London, Aug. 16, 2007, DCUP.

Pinkham, Gladys G. "To Editors." *Life*, June 3, 1966, 20.

Plant, Steve. Oral history interview by the author. Digital recording. Rampant Lion Pub, Manchester, Sept. 1, 2007, DCUP.

Poiger, Uta G. *Jazz, Rock, and Rebels: Cold War Politics and American Culture in a Divided Germany*. Berkeley: University of California Press, 2000.

Polhemus, Ted. *Streetstyle: From Sidewalk to Catwalk*. New York: Thames and Hudson, 1994.

Prange, Gordon W., ed. *Hitler's Words: Two Decades of National Socialism, 1923–1943*. Washington, DC: American Council on Public Affairs, 1944.

Preston, Laura Jane. "Planet of the Nu Mods." *NTouch* at http://www.arts.ac.uk/ntouch/content/new/looks/mods.htm (accessed Sept. 14, 2008).

Price III, Emmett G. *Hip Hop Culture*. Santa Barbara, CA: ABC Clio, 2006.

Prieler, Michael. "Japanese Advertising's Foreign Obsession." In *Japanizing: The Structure of Culture and Thinking in Japan*. Edited by Peter Lutum. Berlin: LIT, 2006. 239–271.

Pryce-Jones, Alan. "An Opinion: Young Men's Looks." *Mademoiselle*, Feb. 1966, 84–85.

"Punk." *100 Club* at http://www.the100club.co.uk/history.asp#punk (accessed Feb. 23, 2008).

"*Quadrophenia* Walking Tour of Brighton." *Quadrophenia* at http://www.quadrophenia.net/walkingtour/index.html (accessed Mar. 30, 2008).

Quant, Mary. "The Young Will Not Be Dictated To." *Vogue*, Aug. 1, 1966, 87.

Rabinovitz, Lauren and Abraham Geil. *Memory Bytes: History, Technology, and Digital Culture*. Durham, N.C.: Duke University Press, 2004.

Radner, Hilary. "Introduction: Queering the Girl." In *Swinging Single: Representing Sexuality in the 1960s*. Edited by Hilary Radner and Moya Luckett. Minneapolis: University of Minnesota Press, 1999. 1–38.

Rauser, Amelia. "Hair, Authenticity, and the Self-Made Macaroni." *Eighteenth-Century Studies* 38:1 (2004): 101–117.

Rave, Jamie. "*Quadrophenia*: A Film about Mods?" *The Uppers Organization* at http://www.uppers.org/showArticle.asp?article=116 (accessed Dec. 8, 2002).

Ravel, Rhona. "Coming Mod Trends." *Mod's Monthly*, Mar. 1964, 10.

Rawlings, Terry. *Mod: A Very British Phenomenon*. London: Omnibus Press, 2000.

"Readymade Weekend" [handbill]. Osaka. Circa July 2004.

"Rechts ab zum Vaterland." *Der Spiegel*, Apr. 17, 1967, 72–93.

Reidelberger, Eric Colin. Email to author. Aug. 19, 2008.

Reimann, Susanne. Oral history interview with author. Digital recording, Einen Sommer in August café, Berlin, Nov. 10, 2006, DCUP.

Remmers H.H. and D.H. Radler. *The American Teenager*. Indianapolis: Bobbs-Merrill, 1957.

Rich, Frank. "Reliving the Nazi Nightmare." *Time*, Apr. 17, 1978 at http://www.time.com/time/magazine/article/0,9171,916079,00.html?promoid=googlep (accessed July 23, 2008).

Richie, Donald. *The Image Factory: Fads and Fashions in Japan*. London: Reaktion, 2003.

Riley, Tim. *Fever: How Rock and Roll Transformed Gender in America*. New York: St. Martin's Press, 2004.

Robbins, Bruce. "Actually Existing Cosmopolitanism." In *Cosmopolitics: Thinking and Feeling Beyond the Nation*. Edited by Pheng Cheah and Bruce Robbins. Minneapolis: University of Minnesota Press, 1998. 1–19.

Robins, Ira A. "British Invasion." *Encyclopedia Britannica* at http://search.eb.com eb/article-9105702 (accessed Aug. 13, 2008).

"Roboter Sound." *Bravo*. Feb. 7, 1966, 6–7.

"Rockwell's Rosie the Riveter Painting Auctioned." *Rosie the Riveter World War II/Home Front National Historical Park Website* at http://www.rosie theriveter.org/index.htm (accessed Aug. 23, 2008).

Rohkohl, Brigitte. *Rock Frauen.* Hamburg: Rowohlt, 1979.

Rollin, Lucy. *Twentieth-Century Teen Culture by the Decades.* Westport, CT: Greenwood Press, 1999.

"The Rolling Stones—Mod or Not?" *The Mod,* Oct. 1964, 1.

Roper, Katherine Larson. "Images of German Youth in Weimar Novels." *Journal of Contemporary History* 13 (July 1978): 499–516.

Rose, Tricia. *Black Noise: Rap Music and Black Culture in Contemporary America.* Hanover, NH: University Press of New England, 1994.

Roseman, Mark, ed. *Generations of Conflict: Youth Revolt and Generation Formation in Germany, 1770–1968.* New York: Cambridge University Press, 1995.

Roudometof, Victor. "Transnationalism, Cosmopolitanism and Glocalization." *Current Sociology* 53:1 (2005): 113–135.

Rotundo, Anthony. *American Manhood: Transformations in Masculinity from the Revolution to the Modern Era.* New York: Basic Books, 1993.

Rougier, Michael. "Japan: The Young Rebellion." *Life,* Sept. 11, 1964, 86A–92.

Rowbotham, Sheila. *A Century of Women: The History of Women in Britain and United States.* London: Viking, 1997.

Rowe, Myra. "Guestbook." *This is Radio Luxembourg; Your Station of the Stars* at http://www.offringa.nl/radioLuxembourg. July 13, 2005 (accessed Feb. 11, 2008).

Rozsak, Theodore. *The Making of the Counterculture: Reflections on the Technocratic Society and its Youthful Opposition.* Garden City, NY: Doubleday, 1969.

Rugg, Stephen. "To Editors." *Life,* June 3, 1966, 20.

Rycroft, Simon. "The Geographies of Swinging London." *Journal of Historical Geography* 28 (2002): 566–588.

Sadin, Glenn. "Group Sounds and Japanese Pop." In *Bubblegum Music is the Naked Truth.* Edited by Kim Cooper and David Smay. Los Angeles: Feral House, 2001, 177–180.

Said, Edward. *Orientalism.* New York: Vintage Books, 1978.

Savage, Jon. *Teenage: The Creation of Youth Culture.* London: Chatto and Windus, 2007.

Saxe, Phil. Oral history interview by author. Digital recording. Rampant Lion Pub, Manchester, Sept. 1, 2007, DCUP.

The Scene at www.thescene.de (accessed Sept. 12, 2008).

Schäfer, Hans Dieter. "Bekenntnisse zur Neuen Welt: USA-Kult vor dem 2.Weltkrieg." In *Schock und Schöpfung. Jungendästhetik im 20. Jahrhundert.* Edited by Willi Bucher, Klaus Pohl, and Michael Andritzky. Stuttgart: Deutscher Werkbund and Württembergischer Kunstverein, 1986. 383–388.

Scheler, Max. "Beatles wie Sand am Meer." *Der Stern,* Apr. 26, 1964, 38–48.

Scheler, Max and Hans Krammer. "Alle Beatles sind schon da." *Der Stern,* Apr.26, 1964, 42–44.

Schildt, Axel. "Across the Border: West German Youth Travel to Western Europe." In *Between Marx and Coca-Cola: Youth Cultures in Changing European Societies, 1960–1980.* Edited by Axel Schildt and Detlef Siegfried. New York: Berghahn, 2006. 149–160.

————. *Rebellion and Reform: Die Bundesrepublik der Sechzigerjahre*. Bonn: Bundeszentrale für politische Bildung, 2005.

Shivelbusch, Wolfgang. *The Railway Journey: The Industrialization of Time and Space in the 19th Century*. Berkeley: University of California Press, 1977.

Schilling, Mark. *The Encyclopedia of Japanese Pop Culture*. Boston: Weatherhill, 1997.

Schmidt, Thomas. Oral history interview by author. Digital recording, Schmidt residence, Hamburg, Aug. 12, 2007, DCUP.

Schultz, Andreas "Andi." Oral history interview with author. Digital recording, May 29, 2007. Hammond Bar, Cologne, DCUP.

Schultz, Markus "Wodka." Oral history interview with author. Digital recording, July 21, 2007. Apropo Bar, Cologne, DCUP.

Schwämmlein, Dani. Oral history interview with author. Digital recording, July 5, 2007, Einen Sonntag in August café, Berlin, DCUP.

Segal, Eric. "Norman Rockwell and the Fashioning of American Masculinity." *Art Bulletin* 78:4 (Dec. 1996): 633–636.

Sense-o-rama at www.sense-o-rama.org (accessed Sept. 12, 2008).

"Shapely Classics: Carnaby Street" [advertisement]. *Mademoiselle*, July 1966, 31.

"Shapes of Things" [handbill]. Tokyo. Circa July 2004. Collected by author.

Sheffield, Rob. "The Jam," *Rolling Stone*. http://www.rollingstone.com/artists/thejam/biography (accessed Feb. 26, 2008).

Sheppard, W. Anthony. "An Exotic Enemy: Anti-Japanese Musical Propaganda in World War II Hollywood." *Journal of the American Musicological Society* 54:2 (Summer 2001): 303–357.

"*Shindig!* [Episode guide]." *TV.com* at http://www.tv.com/shindig/show/2198/summary.html? tag=tabs;summary (accessed Sept. 3, 2008).

"*Shindig!* Can TV's Big Time Teen Show Survive the Ratings and Adult Pressure?" *Teen*, Jan. 1965, 54 –55, 82.

"Shopping." *Mod Culture* at http://www.modculture.co.uk/shopping/ (accessed Aug. 12, 2008).

Siegfried, Detlef. *Time Is on My Side: Konsum und Politik in der westdeutschen Jugendkultur der 60er Jahre*. Göttingen: Wallstein, 2006.

Sinclair, Lance. "Punk Must Be Humiliated So That It May Survive: Three Movies by Penelope Spheeris." In *No Focus*. Edited by Chris Barber and Jack Sargeant. London: Headpress, 2006. 109–116.

Slezkine, Yuri. *The Jewish Century*. Princeton, NJ: Princeton University. Press, 2004.

Slotkin, Richard. *Gunfighter Nation: The Myth of the Frontier in Twentieth-Century America*. New York: Harper Perennial, 1982.

Smith, Alan "Chalky." Oral history interview by author. Digital recording, Sept. 1, 2007, Rampant Lion Pub, Manchester, DCUP.

"Sommer-Sonne Ferien Tips: London für Teens." *OK*, May 23, 1966, 42–43.

Sonnenberg, Christof. Oral history interview by author. Digital Recording. Casino Royale Weekender, Aachen, Germany, Apr. 21, 2007, DCUP.

Spencer, Amy. *DIY: The Rise of Lo-Fi Culture*. London: Marian Boyars, 2005.

Spierling, James. "German Foreign Policy after Unification: The End of Cheque Book Diplomacy?" *West European Politics* 17:1 (1994), 73–97.

Spitz, Bob. *The Beatles: The Biography*. New York: Little and Brown, 2005.

Spizer, Bruce, and Walter Cronkite. *The Beatles Are Coming: The Birth of Beatlemania in America*. New York: Four Ninety-Eight Productions, 2003.

Stahl, Geoff. "Tastefully Renovating Subcultural Theory: Making Space for a New Model." Edited by David Muggelton and Rupert Weinzierl. *The Post-Subcultures Reader*. Oxford: Berg, 2003. 27–40.

Stambolis, Barbara. *Mythos Jugend: Leitbild und Krisensymptom*. Schwalbach: Wochen Schau Verlag, 2003.

Stanlaw, James. *Japanese English: Language and Culture Contact*. Hong Kong: Hong Kong University Press, 2004.

Stanley Kubrick Website at http://www.stanleykubrick.de/eng.php?img=img-l6&kubrick=news letter14-eng (accessed Nov. 30, 2008).

Staudinger, Mary. "To Editors." *Life*, May 5, 1967, 14.

Steele, Valerie. "Appearance and Identity." In *Men and Women: Dressing the Part*. Edited by Claudia Bush Kidwell and Valerie Steele. Washington, D.C.: Smithsonian Institution Press, 1989, 6–21.

Steinberg, Neil. *Hatless Jack: The President, the Fedora, and the History of an American Style*. New York: Plume, 2004.

Stevens, Carolyn S. *Japanese Popular Music: Culture, Authenticity, Power*. New York: Routledge, 2008.

Stewart, Paul W. and Wallace Yvonne Ponce. *Black Cowboys*. Broomfield, CO: Phillips Publishers, 1986.

Straw, Will. "Characterizing Rock Music Culture: The Case of Heavy Metal." In *The Cultural Studies Reader*. Edited by Simon During. 1999; New York: Routledge, 1993. 451–461.

Strongman, Phil. *Pretty Vacant: A History of Punk*. London: Orion, 2007.

Struck, Jürgen. *Rock around the Cinema*. Hamburg: Rowohlt, 1985.

Sturm, Erko. *...And the Beat Goes on..Die Berliner Musikszene in den sechziger Jahren*. Marburg: Tectum Verlag, 2004.

"The Sugar and Spice Look." *Life*, May 28, 1965, 99–100.

Sullivan, Mark. "'More Popular than Jesus': The Beatles and the Religious Far Right." *Popular Music 6* (Oct. 1987): 313–326.

"Superbrands Case Study: Easy Jet." *Brand Republic*, June 4, 2004 at http://www.brandrepublic.com/Industry/Travel/News/213006/Superbrands-casestudies-EasyJet/ (accessed Mar. 30, 2008).

Sureck, Manuel. Oral history interview with author. Digital recording, Spilles Youth Center, Düsseldorf, July 23, 2007, DCUP.

Synnott, Anthony. "Shame and Glory: A Sociology of Hair." *British Journal of Sociology* 38 (Sept. 1987): 381–413.

Szatmary, David P. *Rockin' in Time: A Social History of Rock-and-Roll*. Upper Saddle River, N.J.: Pearson Prentice Hall, 2007.

Takarajima, Henshubu, ed. *1960nen Daihyakka* [*Encyclopedia of the 1960s*]. Tokyo: JICC, 1991.

Tamagne, Florence. *A History of Homosexuality in Europe: Berlin, London, Paris, 1919 –1939*, Volume 2. New York: Algora, 2006.

Taylor, Derek. *It Was Twenty Years Ago Today*. New York: Simon & Schuster, 1987.

Taylor, Johnnie. "Ready, Steady, Gone." Mod Culture at http://www.modculture.co.uk/culture/culture.php?id=22 (accessed Dec. 12, 2008).

"Teens Take over TV!" *Flip*, June 1965, 42.

Templado, Louis. "Blasting into the Past with Japan's thoroughly Modern Mods."*Asahi* at http://www.asahi.com/English/weekend/K2002060100253.html (accessed Jan. 2, 2004).

Thompson, E.P. *The Making of the English Working Class*. New York: Pantheon, 1964.

Thompson, F.M.L. *The Cambridge Social History of Britain, 1750–1950*, Volume 1: *Regions and Communities*. Cambridge, U.K.: Cambridge University Press, 1990.

Thompson, Paul. *The Voice of the Past: Oral History*. Oxford: Oxford University Press, 2000.

Thornton, Sarah. *Club Cultures: Music, Media and Subcultural Capital*. Middletown, CT: Wesleyan University Press, 1996.

Till, Rupert. "The Blues in the Beatles, the Rolling Stones, and Led Zeppelin." In *Cross the Water Blues: African American Music in Europe*. Edited by Neil Wynn. Jackson: University Press of Mississippi, 2007. 183–201.

Tipton, Elise K. *Modern Japan: A Social and Political History* [Second Edition]. New York: Routledge, 2008.

"Topteen Boutique." *Musikparade*. Feb. 1966, 42–43.

"Top Teen Mode." *OK*, Mar. 14, 1966, 43–44.

Tôru, Mitsu. "Introduction: Japanese Issue." *Popular Music* 10:3 (Oct. 1991): 259–262.

Trachtenberg, Alan. *The Incorporation of America: Culture and Society in the Gilded Age*. New York: Hill and Wang, 1982.

Treat, John Whittier, ed. *Contemporary Japan and Popular Culture*. Honolulu: University of Hawaii Press, 1996.

Tribone, Mary Michael. Email to author. February 16, 2009.

Trommler, Frank. "Mission ohne Ziel: Über den Kult der Jugend im modernen Deutschland." In *Mit uns zieht die neue Zeit: Der Mythos Jugend*. Edited by Thomas Köbner, Janz Rolf-Peter, and Frank Trommler. Frankfurt am Main: Surkamp, 1985. 14–49.

Twickel, Christoph. "Editorial." In *Läden, Schuppen, Kaschmmen: Eine Hamburger Popkulturgeschichte*. Edited by Christoph Twickel. Hamburg: Nautilus, 2003. 5–10.

Twiggy, *Twiggy: An Autobiography*. London: Hart-Davis MacGibbon, 1975.

Twiggy: Her Mod, Mod Teen World, limited edition magazine, 1967.

"Twiggy Makes U.S. Styles Swing Too." *Life*, Apr. 14, 1967, 99–101.

"Twist and Shout" [handbill]. Osaka. Circa July 2004.

"United Kingdom, Flag of the." *Encyclopedia Britannica* http://search.eb.com/eb/article-9074268 (retrieved Mar. 26, 2008).

"The Unkindest Cut for Student Moptops." *Life*, Sept. 24, 1965, 4.

Unterberger, Richie. *Unknown Legends of Rock 'n' Roll*. San Francisco: Miller Freeman Books, 1998.

"Uppers!" [handbill]. Tokyo. Circa June 2004. Collected by author.

The Uppers Organization at http://www.uppers.org (accessed Aug. 20, 2002).

"Urban Population of the United States in 1890." *Journal of the Royal Statistical Society* 54 (Sept. 1891): 502 –9.

User Comments, "Mods Mayday Tokyo." *Uppers Organization*, Sept. 11, 2001, http://www.uppers.org/show/Article.asp?article=283 (accessed Dec. 3, 2004).

Usui, Daisuke. Oral history interview by author. Analog recording transferred to digital. July 21, 2004, Elephant's Nest Pub, Nagoya, DCUP.

Utley, Philip Lee. "Radical Youth: Generational Conflict in the Anfang Movement, 1912 – January 1914." *History of Education Quarterly* 19 (Summer 1979): 207–228.

Varon, Jeremy. *Bringing the War Home: The Weather Underground, the Red Army Faction, and Revolutionary Violence in the Sixties and Seventies.* Berkeley: University of California Press, 2004.

Veloso, Caetano and Christopher Dunn. "The Tropicalista Rebellion." *Transition* 70 (1996): 116–138.

"Venues." *Brightonbeat* at http://www.brightonbeat.com/home.htm (accessed Mar. 30, 2008).

"Venues." *Manchester Beat* at http://www.manchesterbeat.com/venues.php (accessed Mar. 30, 2008).

Verangi, Letitia. "To Editors." *Life*, June 3, 1966, 20.

Verguren, Enamel, ed. *This is a Modern Life: The 1980s London Mod Scene.* London: Helter Skelter Publishing, 2004.

"Vespa Obsession." *Piaggio Vespa* at www.vespa.org (accessed Feb. 27, 2003).

Vogel, Harry. Oral history interview with author. Digital recording. Mar. 2, 2007, Vogel residence, Munich.

Vollmer, Jürgen. *The Beatles in Hamburg: Photographien 1961.* Munich: Schirmer Mosel, 2004.

von Dirke, Sabine. *All Power to the Imagination! The West German Counterculture from the Student Movement to the Greens.* Lincoln, Nebraska: University of Nebraska Press, 1997.

"Von Euch für Euch: Das ist der Cavern Club." *Musikparade*, July 4, 1966, 32–33.

"Von Euch für Euch: Kölner Beatbirds erobern London." *Musikparade*, Aug. 29, 1966, 38.

von Reth, Volker. Oral history interview with author. Digital recording. Jul. 24, 2007. Hammond Bar, Cologne, DCUP.

Voormann, Klaus. Oral history interview with author. Digital recording. Tutzing, Germany, Mar. 5, 2007, DCUP.

———. *'Warum spielst du Imagine nicht auf dem weissen Klavier, John': Erinnerungen an die Beatles und viele andere Freunde.* Munich: Heyne, 2003.

"Wake Up, Men!" *Teen*, Apr. 1965, 15.

Waksman, Steve "Grand Funk Live! Staging Rock in the Age of the Arena." In *Listen Again: A Momentary History of Pop Music.* Edited by Eric Weisbard. Durham, NC: Duke University Press, 2007. 157–161.

———. "Heavy Music: Cock Rock, Colonialism, and the Music of Led Zeppelin." In *Instruments of Desire: The Electric Guitar and the Shaping of Musical Experience*, edited by Steve Waksman. Cambridge, MA: Harvard University Press, 1999. 237–276.

Waley, Paul. "Re-Scripting the City: Tokyo from Ugly Duckling to Cool Cat." *Japan Forum* 18:3 (2006): 361–380.

Wallace, Charles. Oral history interview by author. Analog recording transferred to digital format. Oct. 11, 2002, New York, DCUP.

Walker, David. "Five Must-Buy Books on Mod." *Modculture* at http://www.modculture.co.ukculture/culture.php?id=46 (accessed Feb. 29, 2008).

Waller, Sam. Oral history interview with author. Digital recording. Aug. 26, 2007, *NUTS*, Weekender, Brighton, DCUP.

Walser, Robert. *Running with the Devil: Power, Gender, and Madness in Heavy Metal Music.* Middletown, CT: Wesleyan University Press, 1993.

Ward, Harry. "The Real *Quadrophenia*" Mod Culture at http://www.modculture.co.uk/culture/culture.php?id=21 (accessed Mar. 6, 2003).

Wardell, Steven. "Capsule Cure." *Atlantic Monthly*, Oct. 1997, 42–47.

Warwick, Jacqueline. *Girl Groups, Girl Culture: Popular Music and Identity in the* 1960s. New York: Routledge, 2007.

"The Watermill Jumper by Stanley Wyllins" [advertisement]. *Mademoiselle*, August 1966, 22.

Waters, Harry F. and Betsy Carter. "Holocaust Fallout." *Newsweek*, May 1, 1978, 72.

Wedge, Don. "Wo Treffen sich Londons Teens und Twens?" *OK*, Feb. 28, 1966, 26–27.

"The Watermill Jumper by Stanley Wyllins" [advertisement]. *Mademoiselle*, Aug. 1966, 22.

Weißleder, Manfred. "International Rock-Band-Festival." *Star-Club News*, Aug. 1964, 2.

Weitz, Eric D. *Weimar Germany: Promise and Tragedy.* Princeton, NJ: Princeton University Press, 2007.

Weller, Paul. "Art School," "Eton Rifles," "Down in the Tube Station at Midnight," "'A' Bomb in Wardour Street." *The Jam* at http://www.thejam.org.uk/jamlyr1.html#JAM1.3 (accessed Feb. 29, 2008).

Wellhofer, E. Spencer. "'Two Nations:' Class and Periphery in Late Victorian Britain, 1885–1910." *American Political Science Review* 79 (Dec. 1985): 977–993.

Welsby, Paul and The New Breed, "Spotlight on a DJ: Roger Eagle (originally printed in a 1985 fanzine, *The Cat*)," found under "Blog Archive 2007." *Jack the Cat That Was Clean.* http://jackthatcatwasclean.blogspot.com (accessed Feb. 20, 2008).

Welter, Barbara. "The Cult of True Womanhood: 1820–1860." *American Quarterly* 18:2 (Summer 1966): 151–174.

Welzer, Harald, Sabine Moller, and Karoline Tschuggnall. *Opa war kein Nazi:Nationalsozialismus und Holocaust im Familiengedächtnis.* Frankfurt: Fischer, 2002.

West, Richard. "Goethe wurde genauso verdammt wie die SS: Der Deutschenhass der Briten." *Der Spiegel*, Sept. 15, 1965, 127–128.

Weymar, Hans-Peter. Oral history interview by author. Digital recording. Café Kaffee X, Hamburg, Apr. 27, 2007, DCUP.

"What the Beatles Have Done to Hair." *Look*, Dec. 29, 1964, 58–59.

"What is There to Get Excited About?" *Boyfriend*, Feb. 22, 1964, 27.

Whitburn, Joel. *The Billboard Book of Top 40 Hits.* New York: Billboard Books, 2004.

Whiteley, Nigel. "Pop, Consumerism, and the Design Shift." *Design Issues* 2 (Autumn 1985): 31–45.

———. "Toward a Throw-Away Culture, Consumerism, 'Style Obsolescence' and Cultural Theory in the 1950s and 1960s." *Oxford Art Journal* 10:2 (1987): 3–27.

Whiting, Robert. *The Chrysanthemum and the Bat: Baseball Samurai Style.* New York: Dodd, Mead, 1977.

———. *You Gotta Have Wa: When Two Cultures Collide on the Baseball Diamond.* New York: Vintage Books, 1990.

Whitman, Stuart. Oral history interview by author. Digital recording. Aug. 26, 2007, NUTS Weekender, Brighton, DCUP.

Whyte, William H. *The Organization Man.* New York: Doubleday, 1956 at http://writing.upenn.edu/~afilreis/50s/whyte-chap1.html (accessed Aug. 19, 2008).

"Wie angle ich mir einen englischen Beatboy?" *OK*, Feb. 7, 1966, 16 –17.

Wiener, Martin J. *English Culture and the Decline of the Industrial Spirit, 1850–1980*. Cambridge, U.K.: Cambridge University Press, 1981.

Wilde, Jon. "Das Britpop-Duell: Weller & Gallagher streiten über Mod und die Welt." *Rolling Stone* [Germany], Feb. 2007, 40–45.

Wilde, Peter "Speed." Oral history interview by author. Digital recording. Aug. 25, 2007. NUTS Weekender, Brighton, DCUP.

"Wilkommen in Hamburg: zum Inernationalen Folk- und Beat-Festival." *OK*, June 30, 1966, 23.

Willis, Paul. *Common Culture: Symbolic Work at Play in the Everyday Cultures of the Young*. Milton Keynes, U.K.: Open University Press, 1991.

Wilson, Jane. "Young London." In *Len Deighton's London Dossier*. Edited by Len Deighton. London: Jonathan Cape, 1967. 22-38.

Wise, Nancy Baker. *A Mouthful of Rivets: Women at Work in World War II*. San Francisco: Jossey-Bass, 1994.

Wolfe, Tom. "The Noonday Underground" [from *The Pump House Gang*, 1968] in *The Sharper Word: A Mod Anthology*. Edited by Paolo Hewitt. London: Helter Skelter, 1999. 62–72.

Woodbridge, Max. *Rock 'n' Roll London*. New York: St. Martin's, 2002.

Wynandz, Arthur. Oral history interview with author. Digital recording. Cologne, July 19, 2007, DCUP.

Wyneken, Gustav. *"Was ist Jugendkultur?": Öffentlicher Vortrag, gehalten am 30. October 1913 in der Pädagogischen Abteilung der Münchner Freien Studentenschaft*. Munich: George G. Steinide Verlage, 1919.

Yamano, Naoko, member of Shonen Knife band. Oral history interview by author. Analog recording transferred to digital format. July 12, 2004, Club Quattro, Osaka, DCUP.

Yellin, Emily. *Our Mothers' War: American Women at Home and at the Front during World War II*. New York: Free Press, 2004.

"The Young London-Look: Die Fahnen hoch." *OK*, Jan. 20, 1966, 28–31.

"Your Letters." *Brumbeat* at http://www.brumbeat.net/letters.htm (accessed Mar. 30, 2008).

"Your Sixties Memories." *Victoria and Albert Museum* at http://www.vam.ac.uk/collections/fasion/1960s/memories/index.html (accessed Feb. 16, 2008).

"Youth Invades Los Angeles's Gaudiest Street: The Mad New Scene on Sunset Strip." *Life*, Aug. 26, 1966, 75–83.

Youthquake [advertisement]. *Look*, May 16, 1967, 11.

Yow, Valerie Raleigh. Recording *Oral History: A Guided for the Humanities and Social Sciences*. Walnut Creek, CA: Altamira, 2005.

Zdatny, Steven. *Hairstyles and Fashion: A Hairdresser's History of Paris, 1910–1920*. Oxford: Berg, 1999.

Zeitz, Joshua. *Flapper: A Madcap Story of Sex, Style, Celebrity, and the Women Who Made America Modern*. New York: Three Rivers Press, 2007.

Zimmermann, Gereon. "Asia." *Look*, July 11, 1967, 37–53.

Zint, Günter. *Große Freiheit 39: Vom Beat zum Bums; vom "Starclub" zum "Salambo."* Munich: Heyne, 1987.

Zolberg, Vera L. "Contested Remembrance: The Hiroshima Exhibit Controversy." *Theory and Society* 27:4 (Aug. 1998): 565–590.

Zuberry, Nabeel. "'The Last Truly British People You Will Ever Know': Skinheads, Pakis, and Morrissey." In *Hop on Pop: The Politics and Pleasures of Popular Culture.* Edited by Henry Jenkins. Durham, NC: Duke University Press, 2002. 539–555.

Index